The publisher gratefully acknowledges the generous contribution to this book provided by Barclay and Sharon Simpson as members of the Literati Circle of the University of California Press Associates.

For Lorran —
with many thanks for
all your help with the
many garden related
events and festivities.

Betsy

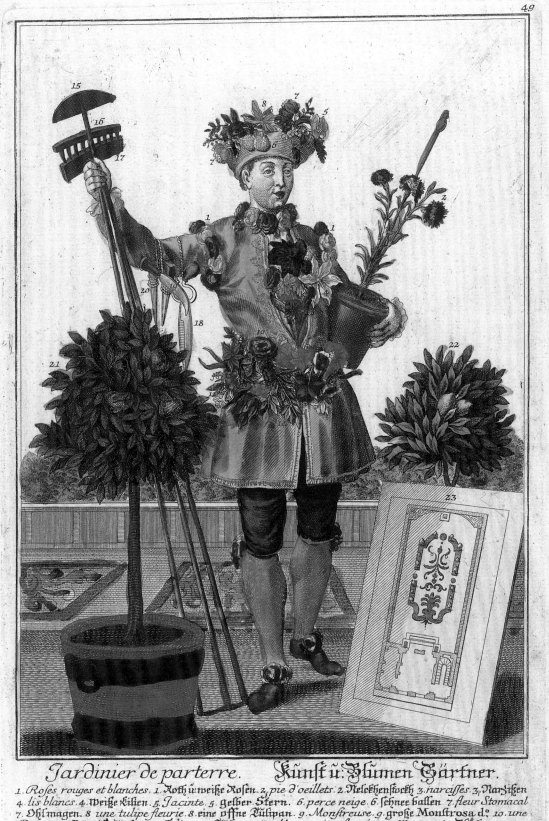

Jardinier de parterre. Kunst u: Blumen Gärtner.

1. Roses rouges et blanches. 1. Roth u: weiße Rosen. 2. pie d'oeillets. 2. Nelckhenstockh. 3. narcisses. 3. Narzißen
4. lis blancs. 4. weiße Lilien. 5. Jacinte. 5. Gelber Stern. 6. perce neige. 6. schnee ballen 7. fleur Stomacal
7. Ohl magen. 8. une tulipe fleurie. 8. eine offne Tulipan. 9. Monstreuse. 9. große Monstrosa d.º 10. une
Pionne. 10. Beonien Rosen. 11. Tulipe. 11. Tulipan. 12. Marguerites fleuries. 12. Margranßen Blüth. 13. coque-
licoq. 13. Klaprosen. 14. Laurier. 14. Lorber Blätter. 15. unis soir. 15. eine Britsche. 16. rateau. 16. ein
Rechen 17. Sarcloir. 17. ein stoßeisen den weg zu bützen. 18. Ciseaux. 18. ein Gartenscher. 19. Serpettes. 19. ein Re-
ben meßer. 20. pivot à tirer au cordeau. 20. die eiserne Spißen zu der Schnuer. 21. Oranger. 21. Pomeranßen
baum. 22. Citronnier. 22. Zitronen baum. 23. plan d'un parterre. 23. Auffriß von einem Garten. 24. Cuvier.
24. ein Gewächs Kübel.

Cum Priv. Maj. Mart. Engelbrecht excud. A.V.

The CHANGING GARDEN

FOUR CENTURIES OF EUROPEAN AND AMERICAN ART

Betsy G. Fryberger

WITH ESSAYS BY PAULA DEITZ, ELIZABETH S. EUSTIS,
DIANA KETCHAM, CLAUDIA LAZZARO, AND CAROL M. OSBORNE

Iris & B. Gerald Cantor Center for Visual Arts
AT STANFORD UNIVERSITY

University of California Press
BERKELEY LOS ANGELES LONDON

THE IRIS & B. GERALD CANTOR CENTER FOR VISUAL ARTS AT STANFORD UNIVERSITY, JUNE 11—SEPTEMBER 7, 2003

THE DIXON GALLERY AND GARDENS, MEMPHIS, TENNESSEE, OCTOBER 19, 2003—JANUARY 11, 2004

THE UNIVERSITY OF MICHIGAN MUSEUM OF ART, ANN ARBOR, MICHIGAN, MARCH 13—MAY 23, 2004

THE EXHIBITION AND CATALOGUE HAVE BEEN MADE POSSIBLE THROUGH THE GENEROUS

SUPPORT OF THE LATE DR. A. JESS SHENSON AND AN ANONYMOUS DONOR.

ADDITIONAL SUPPORT WAS PROVIDED BY THE DUCOMMUN AND GROSS FAMILY FOUNDATION

AND THE OAK CREEK APARTMENTS' GRANT FOR STUDENT INTERNS WHO ASSISTED WITH THE PROJECT.

UNIVERSITY OF CALIFORNIA PRESS, BERKELEY AND LOS ANGELES, CALIFORNIA

UNIVERSITY OF CALIFORNIA PRESS, LTD., LONDON, ENGLAND

FRONTISPIECE: MARTIN ENGELBRECHT, *MALE DESIGNER OF FORMAL GARDENS*

(*KUNST UND BLUMEN GÄRTNER*), C. 1735, THE MINNEAPOLIS INSTITUTE OF ARTS

(THE MINNICH COLLECTION, THE ETHEL MORRISON VAN DERLIP FUND) (CAT. 48A).

LIBRARY OF CONGRESS CATALOGING-IN-PUBLICATION DATA

FRYBERGER, BETSY GERAGHTY.

THE CHANGING GARDEN : FOUR CENTURIES OF EUROPEAN AND AMERICAN ART /

BETSY G. FRYBERGER ; WITH ESSAYS BY PAULA DEITZ . . . [ET AL.].

P. CM. — (THE AHMANSON-MURPHY FINE ARTS IMPRINT)

"THE IRIS & B. GERALD CANTOR CENTER FOR VISUAL ARTS AT STANFORD UNIVERSITY,

STANFORD, CALIFORNIA, JUNE 11—SEPTEMBER 7, 2003, THE DIXON ART GALLERY AND

GARDENS, MEMPHIS, TENNESSEE, OCTOBER 19, 2003—JANUARY 11, 2004, THE UNIVERSITY

OF MICHIGAN MUSEUM OF ART, ANN ARBOR, MICHIGAN, MARCH 13—MAY 23, 2004."

INCLUDES INDEX.

ISBN 0-520-23882-6 (CLOTH : ALK. PAPER) — ISBN 0-520-23883-4 (PAPER : ALK. PAPER)

1. GARDENS IN ART—EXHIBITIONS. I. DEITZ, PAULA. II. IRIS & B. GERALD CANTOR CENTER

FOR VISUAL ARTS AT STANFORD UNIVERSITY. III. DIXON GALLERY AND GARDENS.

IV. UNIVERSITY OF MICHIGAN. MUSEUM OF ART. V. TITLE. VI. SERIES.

N8217.G36 F79 2003

760'.04434—DC21 2003002796

MANUFACTURED IN CANADA

12 11 10 09 08 07 06 05 04 03

10 9 8 7 6 5 4 3 2 1

Dedicated to Dr. A. Jess Shenson for his enduring

support of the arts and Stanford University

CONTENTS

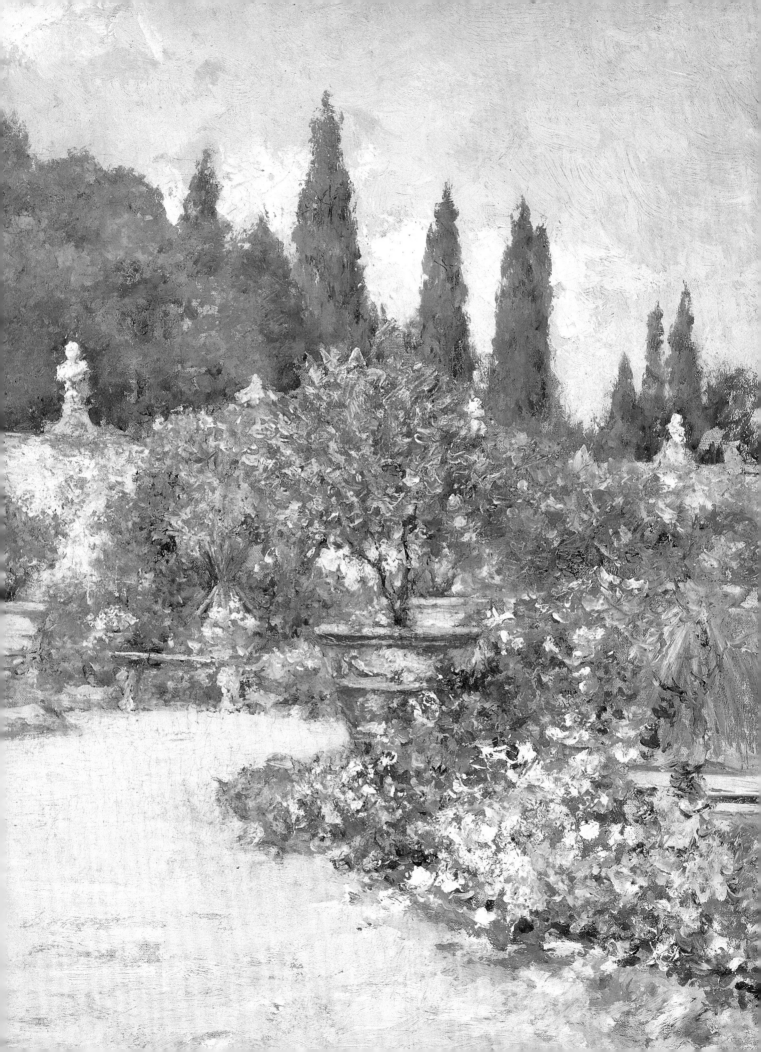

DIRECTOR'S FOREWORD

In recent years, Stanford University has witnessed a period of enormous building activity, which has been accompanied by a significant landscaping program. At the Schwab Residential Learning Center, designed by Ricardo Legorreta, interior courtyards were dramatically landscaped by Peter Walker, who also designed the landscape plaza in front of the Center for Clinical Sciences Research, by Sir Norman Foster. Across the campus, colleagues have assisted us in the siting and installation of numerous works of outdoor art and sculpture gardens, including the New Guinea Sculpture Garden, the completion of the B. Gerald Cantor Rodin Sculpture Garden, and *Stone River* by Andy Goldsworthy. Additionally, under the thoughtful guidance of the university architect, David Neuman, there have been restorations of older garden areas (some designed by Thomas Church); new functional plantings; and, generally, a high level of attention devoted to the overall organization of the campus, keeping in mind the siting of build-

[DETAIL] William Merritt Chase, *An Italian Garden*, c. 1909 (cat. 19).

ings within the university's general plan and the importance of axial perspectives.

Growing up in San Francisco and later working as a curator at the M. H. de Young Memorial Museum in Golden Gate Park were parts of my life experience. While an undergraduate at Stanford I learned about Frederick Law Olmsted's work from his plans for the campus. In the 1960s I went to Europe and saw such major gardens as the Villa d'Este in Tivoli and visited Japan, where I toured many beautiful gardens (as a summer job I even tried to build Japanese-style gardens for friends of my parents). Japanese gardens, with their firm sense of structure, integration of landscape and buildings, and pervasive air of serenity, continue to resonate with me. Later, in the mid-1980s, while working on an exhibition drawn from the collections of the Vatican Museums for the de Young, I had the opportunity to visit the papal gardens and to experience the vestiges of their history set amid a later English-style landscape.

In 1991, very shortly after joining Stanford University as director of the museum, I became involved in design questions pertaining to the rebuilding of the historic structure that had been so badly damaged by the 1989 earthquake. I was very much engaged with our architects and designers as plans for the old building, the new wing, and adjacent landscaping were formulated.

Thus, when Betsy Fryberger, curator of prints and drawings, initially presented the idea for an exhibition about the history of garden design, I was very receptive. I knew from having visited her own Palo Alto garden that she had firsthand experience and a considerable passion for the subject. I thought this was a good idea that could become an engaging exhibition and catalogue. Betsy has been exploring and refining aspects of the project for over five years, and I am delighted with the result.

During the project's development, many individuals and institutions have contributed greatly. Interns have assisted Betsy in her research, locating works in museum collections, writing catalogue entries, and much more. Staff members have been unfailingly supportive. Assistant curator Alicja Egbert helped create digital files at the beginning of the project and, as the planning progressed, exhibition coordinator Sarah Miller and loan registrar Katie Clifford were unstinting in their efforts. Through her fundraising work, Mona Duggan secured the support that made the project possible.

The idea for the exhibition has become a reality through the generous support of many donors. Our longtime friend the late Dr. A. Jess Shenson, to whom the catalogue is dedicated, early on underwrote research and travel expenses, and later supported the presentation of the exhibition at Stanford. In dedicating the catalogue to him, we acknowledge his sustained interest in this and many of our other programs.

In addition, I want to thank the generous anonymous donor who has provided major support for both the exhibition and an ambitious commission of a contemporary landscape/garden to be built on the campus. Designed by Meg Webster, it will remain long after the exhibition as a lasting part of the garden history at Stanford. We are also grateful to the Ducommun and Gross Family Foundation. We recognize Oak Creek Apartments for providing the grant that supported student interns who assisted with the project.

Without the interest and generosity of lenders, exhibitions would not progress past the planning stage. We thank the many institutions and private collectors who are sharing some of their treasures with our visitors. Finally, I want to thank our two partners, the Dixon Gallery and Gardens in Memphis and the University of Michigan Museum of Art in Ann Arbor, for hosting the exhibition after its initial showing at Stanford.

THOMAS K. SELIGMAN
John & Jill Freidenrich Director

ACKNOWLEDGMENTS

In the early phases of this project new contacts and conversations with visiting lecturers, scholars, and gardeners encouraged me to explore a wide range of possibilities. What followed was the painful pruning of ideas and material to shape them for the catalogue and exhibition. Elizabeth S. Eustis, author of an essay on French prints, has been a marvelous bibliographical resource. The Canadian Centre for Architecture in Montreal has been a most generous lender; Nicholas Olsberg, director, offered encouragement, and Pierre-Edouard Latouche provided much documentation. Our major lenders include several midwestern museums with which I have long enjoyed a close relation, even dating back to my years at the Art Institute of Chicago. The Minneapolis Institute of Arts' Minnich Collection is rich in works appropriate to this subject.

At the Cantor Center, I have been fortunate to have had the assistance of museum interns who helped bring the project to completion. Four were graduate students in

Stanford's Department of Art and Art History: Lela Graybill, Mary Salzman, Louise Siddons, and Susana Sosa. Mary Salzman has participated in its development over three years. She researched and wrote many catalogue entries on eighteenth-century art, as well as helped in the editing. Susana Sosa contributed computer and library skills, as well as her knowledge of nineteenth-century French art. With great efficiency, Lela Graybill handled much of the early research and organization, locating works in museum collections and initiating loan inquiries. Louise Siddons investigated British and American works. Three research assistants, outside Stanford's art history department, made substantial contributions. Early in the project volunteer Arlene Gray's bibliographic searches helped to establish the groundwork for later research. Kerry Morgan, graduate student at the University of Kansas, helped set up the organization of the nineteenth-century American research. The last intern to join the team was the lawyer Judy Koong Baeth, who brought her skills to the complicated task of handling rights and reproductions. She also contributed research and wrote entries on contemporary art, as well as helped coordinate the Stanford garden/landscape commission with Meg Webster and other exhibition-related activities.

Throughout the course of this project I have benefited from discussions, suggestions, and encouragement from many, including Elizabeth S. Eustis, Jane Harris, Carol M. Osborne, Marilyn Symmes, Marc Treib, and Guy Walton. Fronia W. Simpson's judicious editing greatly strengthened the final form of the manuscript. I thank my husband, David, for being so supportive of this prolonged effort. As exhibitions become ever more complex to organize, exhibition and registrarial staffs shoulder much of that burden, at both the organizing and lender institutions. My thanks to all for helping to cultivate this garden.

BETSY G. FRYBERGER
Curator

LENDERS TO THE EXHIBITION

Allen Memorial Art Museum,
Oberlin College, Oberlin, Ohio

Bowdoin College Museum of Art,
Brunswick, Maine

Marion Brenner, Berkeley, California

Brooklyn Museum of Art

Collection Centre Canadien d'Architecture/
Canadian Centre for Architecture, Montréal, Canada

Iris & B. Gerald Cantor Center for Visual Arts
at Stanford University, Stanford, California

G. B. Carson, Berkeley, California

The Art Institute of Chicago

Chrysler Museum of Art, Norfolk, Virginia

Cincinnati Art Museum

Becky Cohen, Leucadia, California

Cooper-Hewitt National Design Museum,
Smithsonian Institution, New York

Margo Davis, Palo Alto, California

Susan and John Diekman, Atherton, California

Fine Arts Museums of San Francisco

Fogg Art Museum, Harvard University
Art Museums, Cambridge, Massachusetts

Hargreaves Associates, San Francisco

Jeffrey E. Horvitz, Boston

The Huntington Library, Art Collections,
and Botanical Gardens, San Marino, California

Herbert F. Johnson Museum of Art,
Cornell University, Ithaca, New York

Fred M. Levin and Margaret Livingston,
Mill Valley, California

The Metropolitan Museum of Art, New York

Milwaukee Art Museum

The Minneapolis Institute of Arts

Mount Holyoke College Art Museum,
South Hadley, Massachusetts

New Orleans Museum of Art

The New York Public Library

Private collectors who wish to remain anonymous

Elizabeth K. Raymond, Berkeley, California

Stanford University Libraries, Department
of Special Collections, Stanford, California

University of California,
Environmental Design Archives, Berkeley

The University of Michigan
Museum of Art, Ann Arbor

Walker Art Center, Minneapolis

Michael J. Weller, San Francisco

Stephen Wirtz Gallery, San Francisco

Yale Center for British Art,
Yale University, New Haven, Connecticut

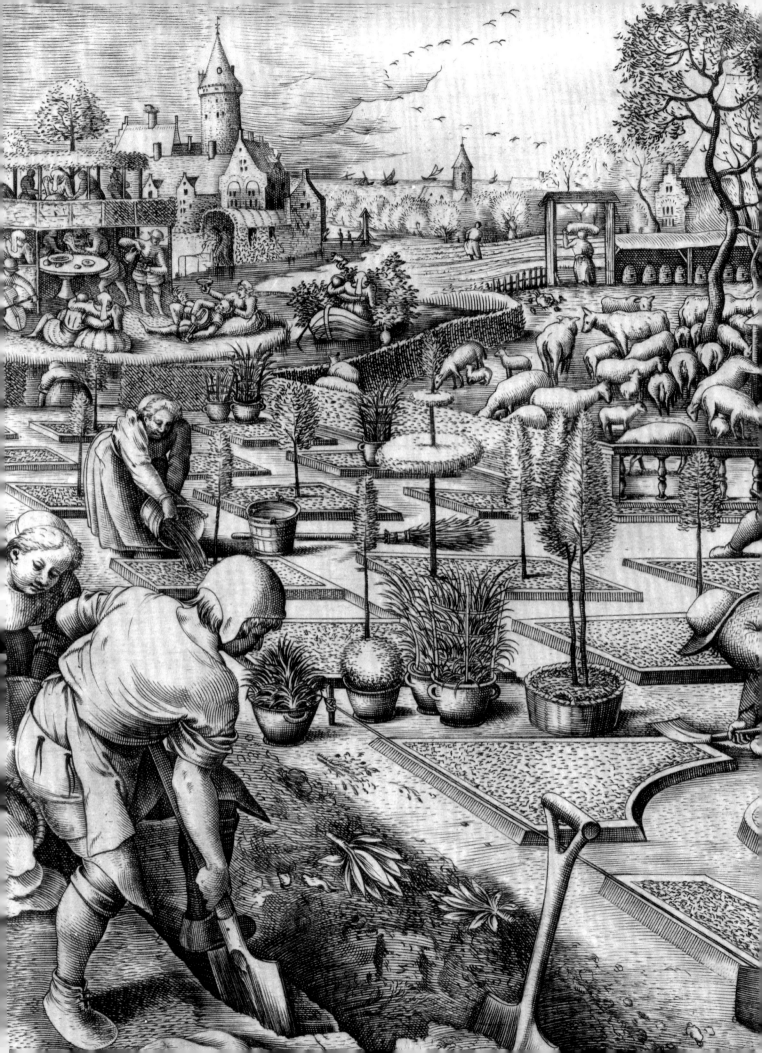

The Artist and the Changing Garden

BETSY G. FRYBERGER

Artists have long observed gardens. Their diverse representations confirm the changing character and history of gardens from the privileged courts of the Villa d'Este at Tivoli and Versailles to the democratic spaces of New York City's Central Park and San Francisco's newly reconfigured Crissy Field. *The Changing Garden: Four Centuries of European and American Art* brings together close to two hundred prints, drawings, photographs, and paintings of gardens.

With a subject so rich and visual evidence so varied, inevitably any selection cannot include all that one might wish. This catalogue emphasizes the innovative sequential contributions made in Italy, France, Britain, and the United States. There are relatively few drawings included by garden designers, because this is not an examination of the practicalities of design. The focus is on the garden and its changing character as perceived and experienced by artists.

· *1* ·

[DETAIL] Pieter van der Heyden, *Spring* (after Pieter Bruegel the Elder), 1570 (cat. 46).

Garden experiences are endlessly diverse. No two gardens are alike, and even a single, familiar garden changes with the light of a particular moment, the mood of each season, and the longer cycles of renewal and decay. To these physical changes must be added the weight of memories and associations. More than thirty years ago, in escaping from a Chicago winter while reading *Diaries and Letters of Harold Nicolson*, I discovered the world of gardens and garden literature.[1] Entering through a side gate that led from my apartment into the world of the writer Vita Sackville-West and her diplomat husband, Harold Nicolson, I was transported back to the 1930s, when they purchased a property with ruins of a Tudor castle and a derelict barn in Sissinghurst in Kent. I followed these two strong-minded individuals of opposing temperaments and convictions as they created what has become an icon of the artistic garden. Much has been written about Vita and her garden, but the extent of her husband's contributions is less well known. As designer and planner of the garden's "bones," he wrote letters to Vita making clear his deep attachment in practical suggestions and anxieties about her impulsive decisions. I went on to read an anthology of her gardening columns and, a few years later, visited Sissinghurst. Knowing about their collaboration added to my growing appreciation of the complex layering of garden experiences.

Over time, as my development as an amateur backyard gardener became grafted onto the stronger branch of curatorial expertise, I began to investigate the visual evidence of garden history. Within its larger compass, works of art offer insights enhancing the fuller documentation of the written record. The significant visual medium has been prints, rather than drawings or paintings, because prints have been far more influential as a vehicle for the transmission of information. From the sixteenth to the mid–nineteenth century, thousands of prints depicting gardens were published. In this massive archive, general views predominate. Detailed images of plantings occur less fre-

quently, sometimes with many individual botanical illustrations in horticultural magazines.

Printed garden views enjoyed a wide popularity, not only for their information but as decoration and as souvenirs. On the one hand, they constitute an invaluable reference tool for designers and gardeners; on the other, their pleasant scenes enhanced the reputation of the garden owners, who often commissioned them. Offering enjoyment for viewers, they could be seen as a form of entertainment, at times theatrically altered to heighten such effects. By the 1860s, with the advent of photography, this multiple role essentially ended; photographs became the primary source of visual documentation. From about 1885 to 1910, however, a veritable Indian summer occurred in paintings of modern life set in private gardens and public parks.

Then followed the long chill of winter. In the aftermath of World War I, with its severe economic disruptions and shortages of labor, many large gardens were abandoned. Moreover, with twentieth-century art moving into nonrepresentational stylistic avenues, garden subjects were of little interest. Even as the peace and prosperity of the late twentieth century brought gardens ever widening popularity with homeowners and readers, they vanished as subjects for most artists. They are, however, photographed endlessly as glossy color illustrations, but few photographers have looked with perception.

I want to encourage garden lovers to dig deeply into the nourishing literature. Historically, garden literature has ranged from essays and poetry to diaries, travel notes, and treatises. Anthologies of such garden writing are rewarding because they enlarge our frame of reference through the descriptions, metaphors, memories, or fantasies of the authors. Sir Roy Strong's literary anthology, *A Celebration of Gardens*, includes Geoffrey Chaucer, John Evelyn, Alexander Pope, Jane Austen, and Virginia Woolf.[2] Betty Massingham's anthology features the British designers Joseph Paxton, William Robinson, Gertrude Jekyll, and Vita Sackville-West.[3] In several anthologies of American

authors and designers, Thomas Jefferson, Andrew Jackson Downing, and Frederick Law Olmsted make expected appearances, but then such editors as Allen Lacy, Bonnie Marranca, and Diane Kostial McGuire choose quite differently. Lacy has organized his book by such topics as fragrances, native plants, and lawns.[4] McGuire has chosen excerpts from the landscape architects-designers Thomas Church, Garrett Eckbo, and Fletcher Steele.[5] Marranca includes the *Washington Post* columnist Henry Mitchell, who described the beginnings of Sissinghurst as "brambles and bracken and dock, maybe broken up by patches of stinging nettles. Amenities include the remains of an old pig sty. You convert it, let's say, into one of the sweetest gardens in the world, with roundels of clipped yew and a little alley of lindens. . . ."[6]

The Roman poet Pliny the Younger wrote for his contemporaries, but two thousand years later we still read him for his love of gardens.[7] His villas, one in the Tuscan hills, the other on the water near Rome, were catalysts for the design of Renaissance gardens. Among travel diarists, the enthusiasm of John Evelyn in the seventeenth century for Italian gardens—their statuary, fountains, and water tricks—remains infectious.[8] Evelyn helped create the taste for Italianate gardens in England. Two hundred fifty years later, in 1904, Edith Wharton wrote in *Italian Villas and Their Gardens* about rediscovering the same villas and introduced Americans to their splendors.[9] Recently, Vivian Russell described retracing Wharton's steps.[10] Wharton's influential book was preceded by that of a young American artist, Charles A. Platt, who later developed into an architect and garden designer.[11] His impressionistic text, while no match for Wharton's insight and clarity, coupled with his sketches and photographs, showed his precocious comprehension. Wharton designed a garden for herself in the Berkshires near Lenox, Massachusetts; Platt planned his garden in Cornish, New Hampshire—both were Italianate in character. Sadly, their lives were brief, but efforts are under way to restore Wharton's estate. Gardens are inherently fragile and unlikely to survive. Those that do have been changed by nature's cycles in subtle and more obvious ways: intermittent disasters of high winds or severe frosts, political or economic disruptions, and evolving social usage.

Garden preservation and restoration often involve detective work as well as dedication and perseverance. Shortly before 1910 Gertrude Jekyll created a garden at Upton Grey in Hampshire, a fine example of her mingling the formal with the informal, and of her impressionistic borders of annuals and perennials, chosen with an artist's eye for color and texture. Jekyll's many articles and books, esteemed in her day, were largely forgotten, and then reprinted in a cycle that parallels the fate of the garden at Upton Grey.[12] In 1983, when Rosamund Wallinger and her husband bought the old manor house, no evidence remained of Jekyll's garden. Wallinger has written a book tracing her adventurous journey beginning with a reference in a London library to the satisfaction of finding the plans for Upton Grey at the University of California at Berkeley. She details the hard months of demolition, relocating the old garden's lines, rebuilding, and planting, with the rigors of continuing maintenance.[13] Several of Jekyll's plans for Upton Grey and photographs of its current state have been included in this catalogue (cats. 7, 8). With increased preservation efforts, a more precise vocabulary has emerged, as has clarification of what constitutes reconstruction, rehabilitation, and true preservation. But, even as we understand more about these issues, we need to read and learn more.

Garden history has gained the attention of cultural and interdisciplinary scholars, as well as its more expected academic allies in architecture and art. Each year, the number of scholarly publications grows, among them those documenting the proceedings of the annual symposia at Dumbarton Oaks in Washington, D.C. Increasingly, universities offer courses on garden history. At the University of Pennsylvania, the garden historian John Dixon Hunt continues his distinguished academic work as the preeminent author

and editor, instrumental in establishing *The Journal of Garden History* (now *Studies in the History of Gardens & Designed Landscapes*).

In the last two decades, as American museums have begun to explore garden history, new material has been highlighted in such exhibitions as *Gardens on Paper* at the National Gallery of Art in Washington, D.C., *Gardens of Earthly Delight: Sixteenth and Seventeenth Century Netherlandish Gardens* at the Frick Art Museum in Pittsburgh, and *Fountains: Splash and Spectacle* at the Cooper-Hewitt, National Design Museum, in New York.[14] To these, the Cantor Center's exhibition adds a broader perspective, embracing design, historical, and social points of view.

The first section of the catalogue of the exhibition focuses on principles of garden design, moving from general views and plans to modifications of the natural terrain, then to choices of plant material and sculptural or architectural features. This demonstration of the diversity of ideas and strategies allows us to comprehend the vocabulary from which gardens have been created. The second section highlights specific historical examples of innovative design and enduring influence with visual comparisons from the time of construction to later periods of neglect, and the gardens' present state. Gardens once designed for the Medici or Louis XIV later became public parks; other parks were conceived of as public spaces. The third section focuses on activities that take place in garden settings—from public ceremonies and festivities to private repose and conversation.

THE ART OF GARDEN REPRESENTATION

Sixteenth Century

The first prints representing actual gardens were published during the last decades of the sixteenth century, a period that witnessed the construction of what we still regard as some of the most splendid of Italian gardens: those at the Villa Lante in Bagnaia, the Villa Far-nese in Caprarola, and the Villa d'Este in Tivoli. These villas, built in the hills around Rome, are among the fortunate survivors; although altered by time, the originality and power of their design can still be appreciated by today's visitors. In the 1570s several publications, including one of the Villa d'Este, heralded a new printmaking speciality. In conception and transcription these prints drew from disparate artistic and intellectual sources: architectural and garden surveys, single general views, and scenes of garden activities. Geographically they hailed from the major publishing centers of their day—Antwerp, Rome, and Paris.[15]

Early printed garden views were most often represented in an architectural vocabulary. Thinking of the area closest to the residence as an extension of the building, the architect considered the garden as one element within the overall design. In contrast to the number of surviving architectural studies, however, there is far less evidence of the garden's design. This may point to its lesser importance for the architect-designer—or it may suggest that much was not formally designed on paper but rather composed in the garden. Although early prints show such major features as the parterre (the flat terrace next to the residence usually planted in decorative patterns), paths, fountains, pools, formal groves, even an orchard area, generally the plantings were so schematically rendered that identification of specific plants is difficult. With recent research in estate inventories, however, precise information about plant material is becoming better known.[16]

About 1550 an ambitious French architectural survey was undertaken by the architect and draftsman Jacques Androuet Du Cerceau. While visiting many châteaux, he made ink drawings on vellum that became the basis for the engravings published in *Les Plus Excellents Bastiments de France*, in 1576 and 1579.[17] Androuet Du Cerceau understood gardens in architectural terms and presented them as nature that has been regularized. He depicted the parterre compartments from earlier in the century, when the garden began to

expand from its small medieval confines. However, by the date of his publication that Renaissance style was already becoming obsolete.

Etienne Dupérac, a French printmaker and architect, published in 1573 a general view of the Villa d'Este in Tivoli (still being built), showing that garden's innovative design (cat. 53). The engraving's widespread influence is evident in its reissue and the many copies that soon followed, as Elizabeth S. Eustis describes in her catalogue essay. Such general views, or prospects as they were called, although loosely based on architectural and mapping techniques, did not include measurements. Instead, a legend identified the major areas.

While some artists found the decorative aspects of the garden beguiling, others were attracted by its activities. A third example from the 1570s of a printed garden subject originated in the eye and imagination of the painter Pieter Bruegel the Elder. In *Spring* Bruegel humanizes the garden, celebrating the hard work of digging, planting, and pruning—the physicality of labor that is rarely portrayed (cat. 46).

By the late sixteenth century, garden images broadened to encompass diplomatic and festive occasions. Catherine de' Medici is shown receiving the Polish ambassadors in the Tuileries in 1573 in a drawing by Antoine Caron (Harvard University Art Museums, Cambridge, Mass.); in another scene he depicts a mock naval battle staged at Fontainebleau, with the participants costumed as Roman soldiers (National Gallery of Scotland, Edinburgh).[18] Such exhibition battles continued to be popular entertainments (cat. 102A).

The powerful patrons who commissioned gardens sometimes also commissioned portraits of their gardens, as did the Medici of their villas in and around Florence, which Claudia Lazzaro examines in her catalogue essay. Occasionally, garden features were brought inside the palazzo, as at the Villa d'Este, where fountains and grottoes decorate the interior, as do frescoes of river gods and nymphs.

Seventeenth Century

Only a privileged few saw such frescoes, but many more had access to prints. In Rome, several generations of the Rossi family figured among preeminent publishers. Many of the city's gardens were featured in their *Li giardini di Roma* (c. 1675) with views by the architect and printmaker Giovanni Battista Falda. Using an (unrealistically) high vantage point allowed him to include in the overview the individual palazzo's architectural features, the abundance of garden statuary, and such major features as parterres, clipped hedges, fountains, and rows of cypresses.

With recently constructed aqueducts bringing a far greater water supply to Rome, many fountains were erected. The four volumes of *Le Fontane di Roma* and *Le Fontane della Ville de Frascati, nel Tusculano*, also published by Rossi with views by Falda, celebrate fountains in gardens and as urban features (cat. 26A). However, it was not Falda, but his successor, Giovanni Francesco Venturini, who composed the charming views of the Villa d'Este included in this publication (cat. 55). Where Falda concentrates on topographic and architectural description, Venturini evokes an actual garden experience. The engraved inscriptions on Venturini's plates not only identify him as the artist but also help make clear the other contributions within the dictates of commerce and the politics of censorship. Generally on such engravings, the painter (*pinxit*) or designer (*delineavit* or *invenit*) and printmaker (*fecit* or *sculpsit*) are cited to the left; to the right appears information about the privilege to publish with the name of the publisher (*excudit*).

Although one is tempted to read such visual evidence as fact, caution is necessary. Most workshop engravers had little or no direct experience of the site, and even those who clearly had visited the gardens, including Dupérac, Falda, and Venturini, altered, exaggerated, and invented to some degree, often including parts of the garden still unbuilt—and sometimes never completed. Since two-dimensional views cannot depict either the full extent or specific detail of a three-

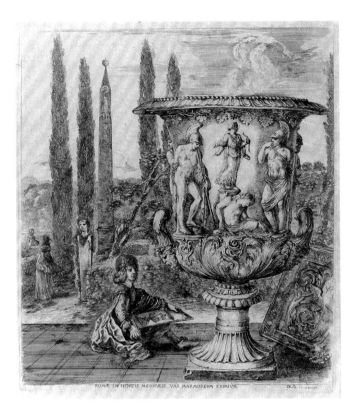

FIG. 1. Stefano della Bella, *The Young Cosimo III Drawing the Medici Vase*, 1656. Etching. Iris & B. Gerald Cantor Center for Visual Arts at Stanford University. (Cat. 33)

dimensional garden, attempts to compress information result in compromises and liberal interpretations. Also problematic are the changing attitudes toward accuracy; in some early publications actual views were combined with imagined reconstructions of ancient gardens. Often the publication was commissioned by the patron whose desires were influential: since he wanted his property to be shown at its best, the views were selective, emphasizing fashionable visitors and minimizing workers or any disorder. Visual evidence must be used in conjunction with archaeological data and checked against other documentation such as maps and estate archives.[19]

Accuracy also depends on firsthand information: surveying and mapmaking techniques are the essential tools. How can a garden be pictured except by experiencing it, walking and measuring the lay of the land and its boundaries? The garden designer needs such information for calculations in reconfiguring the terrain —whether leveling it for a terrace or excavating for a sunken area, channeling a local river into a canal or enlarging it into a lake. Mathematics and engineering, therefore, were integral to garden design. The same publishers who commissioned printed views often specialized in maps as well. A map was often essential, particularly for sets of views of such extensive grounds as Versailles.

During the seventeenth century, as domestic garden scenes became more frequently portrayed, they also reached a wider audience. Some scenes were presented within such allegorical contexts as the Four Temperaments or Twelve Months, as in Abraham Bosse's sets of the *Four Seasons* and *Five Senses* (cat. 115). In contrast, a design for a print by David Vinckboons depicts a court reception in which participants stroll, dance, boat in Venetian gondolas, listen to music, and dine in an immense garden (National Gallery of Art, Washington, D.C.).[20] The garden was generally still shown within the tradition of a prospect, as in Jacques Callot's etching *The Parterre of the Palace at Nancy* of 1625, which boasts a large cast on a parterre stage, with the background set of architecture (cat. 98). Both Cal-

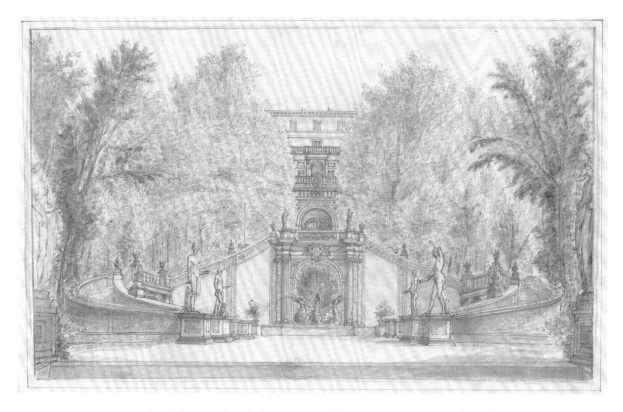

FIG. 2. Israël Silvestre, *The Villa d'Este: Fountain of the Dragons*. Pen and brown ink, graphite, with pink and brown washes. Fogg Art Museum, Harvard University Art Museums. (Cat. 54B)

lot and the younger Stefano della Bella worked at the Medici court in Florence. Della Bella helped design and record their celebrations in the Boboli Gardens (cat. 99). He also drew views of the family's gardens in Rome (fig. 1) and at Pratolino (cat. 52). In the 1660s for Louis XIV at Versailles, the elaborate court celebrations were duly recorded by artists observing from a discreet distance (cat. 100).

The prime example of the increasing importance of printed garden views is found in the work of Israël Silvestre, who visited and recorded more gardens than any of his contemporaries, and whose many etchings were officially distributed through the French court. In the 1640s as a young artist in Italy, he drew at the Villa d'Este (fig. 2). By the 1660s back in France, he sketched at Vaux-le-Vicomte, the lavish new estate of Louis XIV's finance minister Nicolas Fouquet, the first of the great gardens designed by André Le Nôtre.

After Fouquet's downfall, Le Nôtre and later Silvestre joined Louis XIV's court staff. At Versailles, symbol and manifestation of Louis XIV's absolute monarchy on which Le Nôtre labored for more than thirty years, Silvestre recorded ongoing alterations. In a plan of 1674, Silvestre shows the Upper Terrace near the château with many small compartments. In that of 1680 the area has been greatly enlarged, the old parterre replaced by the addition of the two long reflecting pools seen today.[21] As Le Nôtre designed or reconfigured gardens at other royal châteaux, Silvestre sketched.

Silvestre represented a garden's changing vistas through a sequence of views, much like strolling through its grounds. Starting from a general view taken at a distance, the artist then moved closer, portraying the front facade, the side, sometimes the orangery and kitchen garden, before entering the major

area behind the château with its decorative parterre and fountains, and finally arriving at the cascades and canals. Silvestre animated his scenes with strolling couples, horseback riders, and carriages, but only occasionally a gardener. Variants of this sequence were employed by other French view makers.

The royal châteaux were located within a day's travel of each other in the Ile-de-France, several situated along the Seine between Versailles and Paris. At Saint-Cloud and Saint-Germain-en-Laye, Le Nôtre enlarged the formal areas and created grids of intersecting tree-lined paths, which visually and symbolically established the dominance of the monarch's garden over difficult, irregular terrain.

Le Nôtre came from a family of royal gardeners who lived on the grounds of the Tuileries. In addition to his firsthand garden experience, he studied painting in the studio of Simon Vouet, who was also knowledgeable about architecture. Seventeenth-century painting did not aspire to imitate nature's imperfections, but rather to correct them. The same philosophical orientation lay behind Le Nôtre's designs, as is clear in an annotation on a plan of Versailles of 1693 that reads, "remedying the defects that Nature had left there by the utmost efforts of Art."[22] Le Nôtre, using the more accurate surveying tools that had been developed, was able to create optical tricks and perspectives that made his gardens seem even grander than they were and to introduce subtle variations and visual surprises.

As Le Nôtre's success grew, he collected paintings by prominent seventeenth-century artists, among them Claude Lorrain and Nicolas Poussin, as well as some twenty albums of prints. (Claude's landscapes depicted a more naturalistic landscape; Poussin's carefully constructed compositions offer a closer analogy to Le Nôtre's designs.) In 1665 Le Nôtre guided the brilliant Italian sculptor and architect Gianlorenzo Bernini on tours of his gardens. On seeing the Grand Cascade at nearby Saint-Cloud, Bernini demurred that "one should disguise art more and seek to give things a more natural appearance, but in France, generally speaking everyone seeks the opposite."[23] When Le Nôtre visited Rome in 1679, Bernini referred to prints (probably by Silvestre or members of the Perelle family), saying that "they [their design] partook of a rare genius." Even the pope asked about the views of Versailles that he "had heard so much about."[24] Antoine-Joseph Dézallier d'Argenville's treatise, *La théorie et la pratique du jardinage* (1709), offered an interpretation of Le Nôtre's ideas and designs, with plans and elevations.[25] Of great influence, it was reprinted and rapidly translated into English. For pictorial information, however, the views of Silvestre, the Perelle family, Pierre Aveline the Elder, and others played a crucial role. By the mid–seventeenth century, Paris was becoming the major European publishing center, and from there the style of Le Nôtre glorifying the power of Louis XIV was disseminated to courts in England, Holland, Germany, and Sweden, where similar, if more modest, gardens soon flourished.

Eighteenth Century

Concurrent with the major shift in garden aesthetics from rigid geometry to a more naturalistic informality that was originating in England, the print trade experienced changes of character and production. Publishing ventures became more international with the growing tourist audience in mind. Often editions were printed in several languages, most often in French and English, sometimes in German as well. Publications were issued in larger editions, whose views were increasingly produced by stables of topographic printmakers after designs by others.

Prints played an important role in the first French encyclopedia, organized under the joint auspices of Denis Diderot and Jean Le Rond d'Alembert. The text was published in seventeen volumes (1751–65). The separate illustrations were gathered in eleven volumes (1762–72); gardening was grouped with agriculture (*Agriculture et Jardinage*). Diderot, whose breadth of learning made him the more influential of the partners, took great interest in the quality and production of the twenty-five hundred engravings designed to elu-

cidate the various processes and crafts (cat. 49).[26] Articles were gathered under three main headings: the sciences, the liberal arts, and the mechanical arts. The text included more than two hundred entries by Dézallier d'Argenville, many derived from his earlier treatise.

In England, a newly prosperous country gentry, eager to display its wealth, supported publications that mapped its estates. This market was more diverse and less regulated than that in France under Louis XIV. Johannes Kip and Leonard Knyff's *Britannia Illustrata* (1707) and the third volume of the architect Colen Campbell's *Vitruvius Britannicus* (1725) included country estates laid out in formal patterns, even as that style was beginning to wane.[27] England, with little indigenous printmaking tradition, had to import workers to help produce these books. At first, the newly arrived Dutch and French printmakers recorded views of the older garden style but soon helped to introduce the new landscape park. Such was the case of the French Huguenot Jacques Rocque, who within a few years of his arrival in London was active as a surveyor, printmaker, and occasional publisher, as well as executing royal commissions for work at Richmond and Kew. Rocque's varied talents found expression in a distinctive format of a map framed with vignettes of pavilions and temples (cat. 37).

English landscape designers began to reject formalism in favor of a seemingly naturalistic landscape, a revolution that can be clearly followed at Stowe in Buckinghamshire, the most famous landscape park of its day. Its sophisticated patron, Lord Cobham, engaged Charles Bridgeman, whose original layout at Stowe emphasized well-placed structures and monuments. In an unusual circumstance, it was not Lord Cobham but Bridgeman (probably to spread his reputation and attract new clients) who commissioned Jacques Rigaud to record the grounds. Rigaud's preparatory drawings (Metropolitan Museum of Art, New York) and engravings show the garden being enjoyed informally by Cobham, his wife, and friends (cat. 80). As in his earlier French views, *Les Maisons royales de France*, Rigaud staged scenes: figures are clustered in the foreground with the garden as the setting. Bridgeman died before Rigaud's views were published, and control of the garden rapidly passed to William Kent. Trained as a landscape painter, Kent, who had traveled in Italy, sought to frame the landscape in successive views reminiscent of the Roman Campagna. Where an earlier garden had opened onto a separate woods (once a deer park for hunting), the new landscape enveloped and domesticated it with small monuments and follies. In addition to a classical temple, obelisk, and Gothic ruin, there arose monuments to Modern Virtue and to the British Worthies—references to contemporary politics. In 1741 Lancelot "Capability" Brown added his contributions to Stowe in a new area, the Grecian Valley. Buildings, which continued to proliferate, included several designed by Kent and an early interpretation of a Chinese house. Stowe became popular and much visited by "polite society." Thomas Rowlandson's lively watercolors were either directly observed or cleverly adapted from other sources (cat. 82B,C). Elsewhere, while some owners followed the new path taken by Cobham at Stowe and used their gardens to express a political or philosophical stance, many more owners of smaller estates continued to use designs in the older, geometric grids.

English designers, with Kent as a leading proponent, looked back to the spirit of antiquity. This was transmitted through paintings, in particular Claude Lorrain's bucolic scenes of classical ruins in a "natural" (but artfully composed) landscape. Further, it is probable that Kent's knowledge of certain engravings of Chinese gardens led to his landscaping effects of clumping trees, creating small mounds and serpentine paths. The French adapted Kent's ideas in their Anglo-Chinese gardens and cited him in their literature.[28] As his influence spread throughout Europe, such radical ideas resulted in the widespread and rapid destruction of formal gardens to create a greener, more natural look. These alterations were not minor: parterres were destroyed, hedges, allées, and canals removed, and reflecting pools reconfigured into streams or lakes.

Changes made in the name of "naturalism," however, must not be taken as absolute, for that notion evolved from one generation to the next.[29] The grandeur of the initial conception shrank to a more popular picturesque interpretation.

The poet Alexander Pope's garden at Twickenham, outside London, paid homage to his Roman predecessor Horace, who had advocated a simple life, away from politics, but surrounded by friends. Pope's Palladian villa was set on a lawn sloping down to the Thames; in its nearby grotto he meditated and wrote. The philosophy of garden design became a touchstone for other authors: the garden was perceived by some as Nature's Perfection. Horace Walpole grandly characterized England's contribution, "We have given the true model of gardening to the world; . . . original by its elegant simplicity . . . softening Nature's harshness and copying her graceful touch."[30] The poet William Cowper described Kent's fellow revolutionary, Capability Brown: "omnipotent magician, Brown, appears. . . . He speaks. The lake in front becomes a lawn; woods vanish, hills subside, and vallies rise."[31]

While innovative designs and spirited garden rhetoric, tinged with nationalism, flourished in England, the situation in France was subdued, for Louis XIV's vast military campaigns and his building and garden expenditures helped push the country to the point of bankruptcy. Coupled with the decline in construction and in maintenance, there rose a greater appreciation for earlier gardens. After Jean-Antoine Watteau arrived in Paris in 1712, he became a frequent visitor to the garden of his patron Pierre Crozat at Montmorency. Originally designed by Le Nôtre, its formality softened by neglect, the garden set the mood for Watteau's elegiac paintings. Another ruin from an earlier time, the prince of Guise's garden at Arcueil, attracted a number of artists, including François Boucher and Jean-Baptiste Oudry. The latter made eloquent studies in black chalk, heightened with white, on bluish gray paper (fig. 3). Much as a conductor leads an orchestra, Oudry balanced his instruments—the soft, shifting canopy of trees played against clipped hedges,

trelliswork, paths, stairs, balustrades, and fountains, under a changing sky. Traditionally thought to depict only Arcueil, the location of many of these studies cannot be firmly identified; further, a contemporary noted Oudry's outings to gardens at Saint-Germain and Chantilly.[32]

While Oudry drew gardens in the Ile-de-France, students in Rome at the French Academy were out sketching the Roman Campagna, a practice initiated by Nicolas Vleughels when he was director and continued by his successor, Charles Natoire. Among other nearby picturesque sites, the Villa d'Este in Tivoli was a favorite, its decay adding to its attraction for students familiar with Roman ruins. During the summer of 1760 the abbé de Saint-Non rented the villa for over a month; Jean-Honoré Fragonard joined him, making some of his finest, most fluid garden evocations (cat. 56). It is probable that his friend and fellow artist Hubert Robert also visited there.[33] During the decade Robert spent in Rome, he became known as "Robert des ruines" for his paintings of ruins. In Paris, however, connoisseurs began to collect his drawings, preferring the lighter tone of his Italianate garden sketches to the heavier architectural paintings.

A decade later, Giovanni Battista Piranesi's view of the Villa d'Este offers a dark interpretation of the garden, emphasizing its remaining statuary (cat. 57). Fascinated by Roman architecture, Piranesi had a workshop near the French Academy and was known to have gone sketching with Robert. On more than one occasion, Natoire sent groups of Piranesi's etchings back to Paris, and they were avidly collected by British tourists. No doubt, Piranesi's etching of the Villa d'Este coincided with a trip to nearby Hadrian's Villa, where he was educating himself about its statuary. Representing the Villa d'Este from the garden's lowest level, Piranesi looked up its steep hillside, balancing the rhythm of the ascending paths with the oversize antique statues on the lower level. Nature played only a supporting role in Piranesi's powerful conception.

Robert, who returned to France in 1765, remained attracted to rich, layered historical associations and,

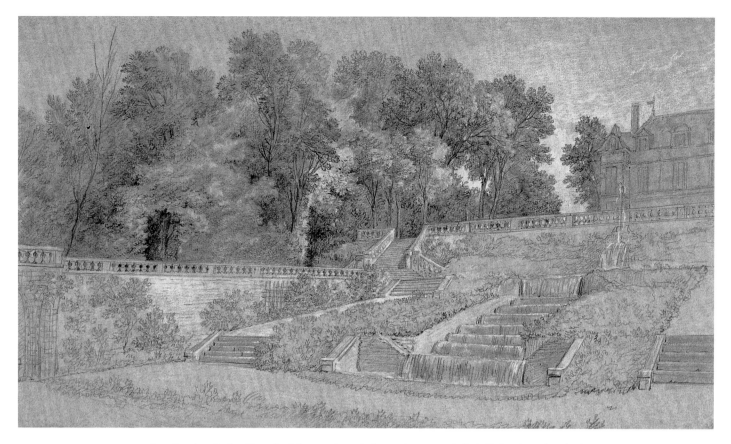

FIG. 3. Jean-Baptiste Oudry, *View of a Château in the Park of Arcueil*, c. 1745. Black chalk, heightened with white, on blue-gray paper. Fine Arts Museums of San Francisco, Achenbach Foundation for Graphic Arts. (Cat. 15)

while continuing to paint Italianate landscapes, became involved in garden design. At Versailles from 1774 to 1776, he painted its desolation as hundreds of the original trees, old and diseased, were cut down. One destroyed area had housed the white marble sculptures of the Baths of Apollo. Robert's plan for a new setting for the statuary was accepted, and his cavernous grotto in the English manner was completed in 1778. Its repudiation of Louis XIV's style still shocks in the garden's formal setting. As the first Designer of Royal Gardens since Le Nôtre, Robert worked further at Versailles at the Trianon, collaborating on the Hamlet, where Marie-Antoinette played at farming. Rustic buildings were becoming part of the new garden vocabulary. For some, they offered escape and the fantasy of a simple life; for others, however, they represented serious philosophical ideas that joined man and nature in harmony and productivity.

As early as 1757 the English architect William Chambers, who had spent almost ten years in China, published a book about Chinese buildings and gardens. He continued his advocacy of that style in his designs for and book about Kew Gardens (1763), where his 165-foot-high pagoda attracted much attention.[34] Among Chambers's projects in the Chinese style is a proposal for a bridge at Sanssouci in Potsdam (cat. 45). Chambers endorsed the principles—not merely the decorative value—of Chinese gardens. Although critics have contested the accuracy of his descriptions, he was nevertheless of considerable influence. The French, in particular, respected his approach. In the 1780s a French visitor found Kew "the most interesting [garden] that I have ever seen; the most skilful art cannot be better disguised; every thing breathes nature and freedom; every thing is grand, noble and graceful. . . . How aukwardly [*sic*] and ridiculously have we imitated the En-

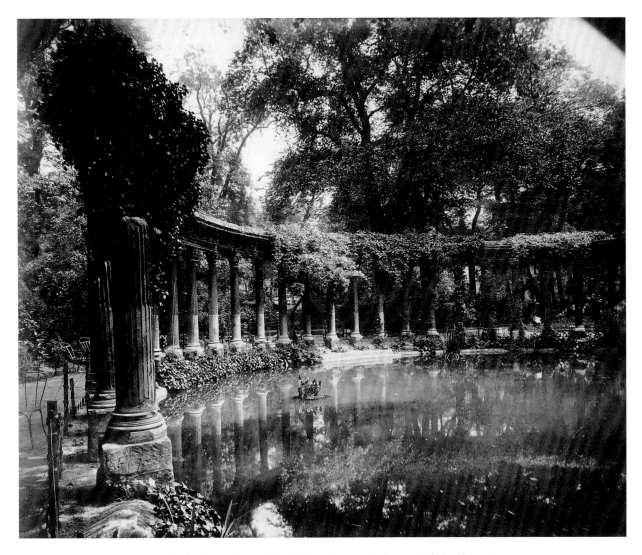

FIG. 4. Eugène Atget, *Roman Colonnade, Parc Monceau, Paris*, 1911. Gelatin-silver print.
Collection Centre Canadien d'Architecture/Canadian Centre for Architecture, Montréal. (Cat. 41)

glish gardens, with our little divisions, our ruins, . . . our affectation of gloominess, that assemblage of contradictions and monuments only fit to be laughed at!"[35] Where the English favored Gothic ruins and a hermit's hut, the French preferred more exotic follies.

In the mid-1770s, Louis Carrogis (called Carmontelle), a designer of theatricals and elegant small portraits who worked for the Orléans family, planned an eccentric garden for the duke of Chartres, just north of Paris, near Monceau. He reproduced its itinerary in a twelve-foot watercolor, which was unrolled and viewed through a peep box (J. Paul Getty Museum, Los Angeles). The garden was entered through a Chinese gate; visitors were escorted by servants costumed as Turks. The itinerary included a merry-go-round, Dutch windmill, Turkish tent, Egyptian obelisk, and Roman colonnade (fig. 4). With its many follies, it has, perhaps inevitably, been compared with Stowe. Parc

Monceau, however, has generally been understood to have been a make-believe, even an operatic, world. Yet some critics have noted that the duke was a mason and have seen Masonic symbols in the design. The park has survived in a reduced, less eccentric form; rescued and refurbished in the 1860s, it is now in the fashionable eighth arrondissement (cat. 44).

As the last volumes of the Diderot and d'Alembert *Encyclopédie* appeared, Georges-Louis Le Rouge, a publisher of maps, was undertaking a comprehensive survey of the new Anglo-Chinese style of garden.[36] For over a decade, from 1776 to about 1787, *Détail des nouveaux jardins* appeared, beginning with the English examples of Stowe and Chiswick, where Kent worked, as well as Chambers's pagoda at Kew. The remarkable German garden Weissenstein (later called Wilhelmshöhe) near Kassel, which drew inspiration from Kew, was also included, as well as plates copied after Chinese engravings of the emperor's gardens. Le Rouge's publication offered close to five hundred engravings, ranging from general views to details or diagrams with measurements. In spite of the uneven and relatively low artistic quality of the engravings, the lack of a substantial text, and an incoherent sequence (with the general index appearing halfway through the twenty-one portfolios), it stands as a unique visual document of the garden as an enlightened patron's private, philosophical retreat. The most illustrated garden was the eccentric Désert de Retz, published in twenty-six views, with its Chinese house specially featured (cat. 86B). A diagram of Parc Monceau showed a hothouse, grotto entrance, and dining area in a rocky cavern. A generic plan for a green theater included details for a raised stage, clipped hedges as wings, and a generous seating area. Unlike the temporary theaters erected for Louis XIV, many private eighteenth-century gardens had their own green theaters, where spectators watched and sometimes performed.

One of the last gardens built in France before the Revolution of 1789, and one of the most ambitious, was at Méréville (cats. 91–92), which Diana Ketcham discusses in her catalogue essay. Robert contributed to its creation, as he had done earlier at Ermenonville (cats. 88–90). After the Revolution, the building of Anglo-Chinese gardens ceased, as did any demand for lavish garden publications. An exception was a book about those very gardens by Alexandre Laborde, son of Méréville's patron.[37] Finally published in three languages in 1808, its illustrations show gardens whose follies were no longer isolated curiosities but integrated into the landscape.

Eighteenth-century garden printmaking was mainly dominated by large surveys of topographical prints. French painters such as Oudry, Fragonard, and Robert interpreted deserted and decaying gardens, glimpsed through the veil of history. On the other hand, English artists painted family portraits, or conversation pieces, as they were called, which were clearly set in the new, larger landscape.

Late in the century, prints of people enjoying public gardens in London and Paris proliferated. In the 1760s Gabriel-Jacques de Saint-Aubin, the chronicler of Parisian life, sketched the Tuileries, with throngs crowding its paths and competing for chairs (cat. 107).[38] In London, Thomas Rowlandson took the pulse of the pleasure garden at Vauxhall in one of his finest satires (cat. 105). In Paris, Philibert-Louis Debucourt critiqued a fashionably attired crowd (cat. 106). Elsewhere in Europe new public gardens opened: one in Milan in 1787, and another in Munich in 1791, a nine-hundred-acre park designed in the English style known as the Englischer Garten. In the words of the garden historian Virgilio Vercelloni, the garden itself had become "the theater of life."[39]

Nineteenth Century

In the 1820s changes made to the British royal estate at Windsor Great Park were indicative of the direction of garden activities of the general public as well as those more affluent. The intellectual concepts and political agendas of eighteenth-century gardens, which found expression in temples and follies, gave way to less exalted goals, which were realized in more practical

structures. At Windsor Great Park's lake, Virginia Water, the king called for designs for a boathouse and fishing temple. Even as George IV and the royal family relaxed at Windsor Great Park, parts of Virginia Water were being opened to the public. In London, in 1833, an urgent plea for urban parks was made to Parliament by the Select Committee on Public Walks and Places of Exercise. In Paris, as former estates of royalty and nobility passed to the government, many allowed the public entrance. Finally, the railroad brought mobility to many who had never before left home; their travels encouraged gardening in new directions.

Increased access to gardens was accompanied by changes in published views and their audience. Most eighteenth-century garden representations (regardless of medium—painting, drawing, or a print) were created primarily for an elite audience. In the nineteenth century as that market contracted, demand for popular prints expanded. For example, among illustrated calendars and fashion publications, women's seasonal outfits with broad-brimmed hats and parasols for summer were shown in gardens (cat. 110B). In the 1820s George Cruikshank caricatured the parade of fashionable excesses on display in London's parks (cat. 109).

Underlying the growing pressure for additional public space was the recognition that cities were becoming increasingly crowded, dirty, unhealthy, and polluted. "Green belts" were thought to improve general health and considered an important component of urban design. Not all public spaces were reserved as parks; common land included tree-lined boulevards, malls, even cemeteries. Among the first to perceive the need for such "breathing spaces" was John Claudius Loudon, founder and editor of *The Gardeners' Magazine*. Loudon addressed topics of interest for owners of small gardens as well as promoted the social good of gardening. Recognizing the pressure brought about by London's rapid growth (its population had doubled between 1800 and 1830), Loudon was prominent in saving Hampstead Heath's two hundred acres as an open space, rather than developing them. Loudon believed

that "Garden design, Gardening, in all its branches, will be most advantageously displayed where the people enjoy a degree of freedom."[40]

Although parks were mainly landscaped areas, some also functioned as pleasure gardens offering entertainments from concerts to sports. Others included educational botanical gardens. Urban design was chosen and implemented through layers of committees—not by a single patron or designer. This major shift in the decision-making process was accompanied by a significant change in goals: design was no longer determined by aesthetic considerations alone. Practical and utilitarian concerns came to the fore—and still hold firm today.

In Great Britain, the designer and author Humphry Repton, who coined the term "landscape gardener," advocated the garden as a place for enjoyment, but also as a civilizing influence on the lower classes. Over his long career, Repton's design proposals—presented in before-and-after comparisons initially in his Red Books, then synthesized in published works—gained a large following. Distrustful of the idea of a garden as an ideal landscape, in 1816 Repton wrote: "The Scenery of Nature, called Landscape and that of a Garden, are as different as their uses: one is to please the eye, the other is for the comfort and occupation of man: one is wild, and may be adapted to animals in the wildest state of nature; while the other is appropriate to man in the highest state of civilization and refinement."[41]

In France, Gabriel Thouin's *Plans raisonnés de toutes les espèces de jardins* (1820) was a pioneering effort to categorize garden design by a method similar to that used in plant classification.[42] His book, initially published in installments and paid for by subscription, proved so popular that it was reissued in 1823 and 1828. Thouin first divided gardens by function into vegetable, orchard, botanical, or *plaisance ou d'agrément* (pleasant or agreeable), then further separated the pleasant garden into natural, exotic, formal, and so forth. Thouin's plans, although intended for private gardens large enough to accommodate a pattern of serpentine paths, could easily be adapted to smaller public parks. A

reader could choose not only a garden plan but also such practical and decorative additions as bridges, gates, swings, benches—all generously illustrated after the author's designs (fig. 5). Thouin, like Repton, considered "orderly and regular" gardens more practical and useful, in contrast to "irregular" ones, which he considered more beautiful.[43]

The concept for a new public garden integrated into the city lay behind John Nash's design for Regent's Park in London. Nash, who had earlier worked with Repton, followed some of his ideas in developing and redesigning London's parks. Built between 1811 and 1826, Regent's Park was lined by a handsome band of residences, also designed by Nash, whose owners' leaseholds helped cover its costs—an early example of fiscally driven urban planning. The park included a zoo that attracted large crowds. However, Thomas Shotter Boys's *London as it is* (1842) featured St. James's Park and Hyde Park (cat. 93). Both dated back to the sixteenth century, when Henry VIII designated the areas as deer parks. Both were redesigned by Nash in the 1820s.

Joseph Paxton, when he died in 1865, was recognized as one of the greatest gardeners of his time. Working for the duke of Devonshire at Chatsworth in the 1830s, he designed an innovative glass house. Later he refined this glass-and-steel technology, most famously for the Crystal Palace of the Great Exhibition of 1851. His ideas and innovations impressed a young American visitor, Frederick Law Olmsted, who in 1850 visited Birkenhead Park in a suburb of Liverpool, which Paxton had designed. Olmsted later wrote that he "was ready to admit that in democratic America there was nothing to be thought of as comparable with this People's Garden." He further noted that he "was glad to observe that the privileges of the garden were enjoyed about equally by all classes."[44]

The influential American architect, landscape designer, and author Andrew Jackson Downing also advocated the importance of green, open space. Writing in 1849, he praised the concept of rural cemeteries and their natural beauty, citing Mount Auburn in Cambridge, Massachusetts; Greenwood in Brooklyn; and

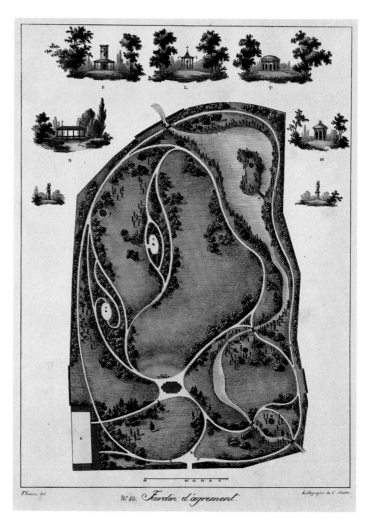

FIG. 5. Gabriel Thouin (France, 1717–1829). *No. 43 Jardin d'Agrement.* From *Plans raisonnés de toutes les espèces de jardins* (Paris, 1820). Lithograph, colored by hand, printed by C. Motte. Private collection.

Laurel Hill near Philadelphia. These cemeteries were much visited, since most American cities did not have large parks. Downing's belief in parks as a force to help civilize the populace was followed by Olmsted, who spoke of the public park as a "common, spontaneous movement, of that sort which we conveniently refer to as the Genius of Civilization."[45] Olmsted and Calvert Vaux's 1858 proposals for Central Park in New York addressed Downing's ideals and incorporated what Olmsted had learned on his travels (cat. 95). Olmsted wrote extensively, presenting ideas and plans for many public parks. He was challenged to turn swamps and marshland into parks in Buffalo and Chicago, and to accommodate a mountain in Montreal. Among his largest private commissions was the Vanderbilt estate, Biltmore, in North Carolina (cat. 25).

In Paris, public parks assumed increased significance during the reign of Napoleon III. Baron Haussmann's extensive renovations of the 1860s were not limited to improving traffic congestion and to serving preemptive military needs during political or civil disturbances. He aimed to transform the city into a modern and progressive entity, as evidenced in many new tree-lined boulevards whose handsome street lamps contributed to both beauty and public safety. Adolphe Alphand, in charge of plantings and parks, had a powerful voice in the new order, establishing many parks and refurbishing others, including Parc Monceau (cats. 41, 44). A major project was the substantive redesign of the Bois de Boulogne, which had been laid out in the seventeenth century. Charles Marville set up a temporary studio in the Bois to photograph the project (cat. 94). Alphand, in his comprehensive publication, *Les Promenades de Paris* (1867–73), included illustrations of the many new gatehouses and cafés in the Bois, as well as crowds enjoying a theater performance at the Pré Catalan or night ice-skating.[46]

In the 1860s this hugely popular winter sport was pictured in scenes of the Bois, Regent's Park, and New York's Central Park (fig. 6). Olmsted, whose vision was of open space unencumbered by buildings or sports facilities, did not favor specialized sporting areas. How-

ever, belief in the importance of sports and their health benefits brought mounting pressure to provide such spaces in New York and elsewhere. Similar pressure continued into the early twentieth century and still exists. For example, in Germany an association for parks for the people (Deutscher Volksparkbund) declared that parks "must not in the future be equipped mainly or only for walking, with few areas set aside for other activities. To fulfill their primary function they must provide large spaces for games of all sorts, which must be available to all."[47] By the end of the nineteenth century in the United States, park activities had expanded to include folk dancing, handcrafts, and areas set aside for community gardens, children's playgrounds, and baseball diamonds.

For private gardens Americans increasingly chose flowers as the focal point. Alice Morse Earle promoted the old-fashioned garden in her articles and books about colonial America. Writing in *Scribner's Magazine* in 1896, she praised their "crowding abundance, the over-fullness of leaf, bud and blossom."[48] Mariana Griswold van Rensselaer stressed the relationship of art to gardening in *Art Out-of-Doors: On Good Taste in Gardening* and the desirability of native "American" plants.[49] For Earle, certain plants were important for past associations: boxwood hedges not only provided structure and "unique aroma" but also recalled early New England gardens. Earle preferred perennials to annuals and compared them to "long-established neighbors, like old family friends, not as if they had just 'moved in' and didn't know each other's names and faces."[50] The 1876 Centennial celebration in Philadelphia spurred interest in historic gardens, and Chicago's 1893 World's Columbian Exposition featured an old-fashioned garden. Such exhibits were widely illustrated on postcards, stereo views, and other souvenirs collected by visitors.

During this prolonged period of American prosperity, which stretched from after the Civil War up to the Great Depression, newly wealthy financiers, industrialists, and railroad tycoons were building large estates. New Yorkers constructed lavish summer homes on

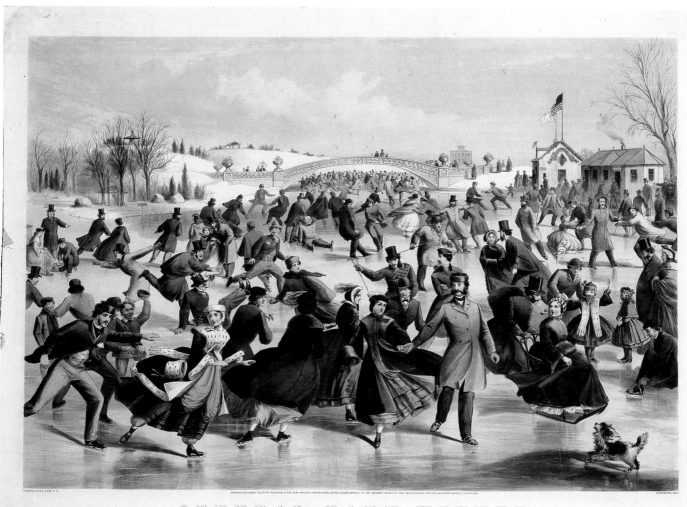

CENTRAL - PARK, WINTER.
THE SKATING POND.

FIG. 6. After Charles Parsons, *Central Park, Winter: The Skating Pond*, 1862. Lithograph, colored by hand. Published by Currier and Ives. The New York Public Library. (Cat. 132)

Long Island, Bostonians along the North Shore and in Maine, and Chicagoans in Lake Forest or Lake Geneva. Among San Franciscans who built summer homes south of the city on the warmer peninsula was Milton Latham (cats. 24, 122). Both Latham and his neighbor Leland Stanford on his Palo Alto Stock Farm exhibited two extremes: a dry Arizona Garden and a large lawn (see fig. 28, p. 70). These Arizona Gardens featured large specimens of cacti and succulents in densely arranged scalloped beds or long ribbons in the prevailing Victorian taste. Rudolph Ulrich designed these

private gardens as well as the grounds at the Hotel del Monte in Monterey and the Hotel Raymond in Pasadena, which became tourist attractions with people posing amid the giant saguaro (cat. 23).[51] But fashions, such as that for Arizona Gardens, fade. After the Stanford family's garden became part of the university's grounds, it endured decades of neglect; only recently have efforts at restoration been undertaken.

As the century progressed, in this country and especially in Great Britain exotic gardens gained favor. Specialized nurserymen were required to provide the

plants and larger staffs of gardeners to maintain them. The fashion for a Blue Garden, Rhododendron Dell, tender annuals, scented geraniums, cacti or succulents, old-fashioned perennials, topiary, parterres, rockeries, ferneries, bamboo, and Japanese maples— all required considerable sums of money. The hybridization of exotics, cannas with vividly striped leaves from South America, for example, demanded increasingly high prices. Maintenance on bedding gardens was intensive; watering and weeding were time-consuming. Conservatories and lathe houses were essential (cat. 39). With such a wealth of plant material, bouquets were brought indoors for display. The cut flowers contributed to the aesthetic of excess that dominated Victorian interior decoration.

Behind the desire for novelty or one-upmanship, more serious gardening subtexts were surfacing. After the Franco-Prussian War of 1870–71, the French, in a nationalistic mood, rediscovered the beauty, structure, and logic of Le Nôtre's grand designs, and a generation of *nouveaux riches* purchased run-down seventeenth-century properties and renovated them. Attempts to restore Le Nôtre's plan at Vaux-le-Vicomte illustrate the vicissitudes of such undertakings. It took almost fifty years of off-and-on restoration before Vaux's great parterres were finally restored by Henri and Achille Duchêne, who consulted Silvestre's seventeenth-century prints and other historic documents. Today, these parterres—Le Nôtre as interpreted by Duchêne—are among the glories of Vaux (cat. 65).[52] In Italy, as different regions vied for political power in the long struggle for a national identity, there was a resurgence of interest in their Renaissance and Baroque gardens, many of which had, during the eighteenth century, been made over in the "English" style. And, in the United States, middle-class gardeners chose old-fashioned "grandmother's" flowers, with their patriotic associations (but not until the more recent bicentennial was there widespread interest in historic American gardens).

Artists increasingly preferred the stimulus of painting in the open air. Country fields and haystacks, as well as modern urban streets and parks, were no longer painted in subdued browns, grays, and blacks, but in lighter, more vibrant tonalities. Working rapidly, artists painted "impressions" of contemporary life. They frequented and painted public parks, private gardens, cafés, and the theater. By the 1890s, among Parisian artists delighting in such plein-air subjects were Edouard Vuillard and Ker-Xavier Roussel (cats. 125, 126). Probably the most celebrated representation of people enjoying a park is Georges Seurat's painting of 1884–86, *Sunday at the Grande Jatte* (Art Institute of Chicago).

Artists not only depicted gardens but also established their own—as did Claude Monet at Giverny. In his paintings he re-created its intense and colorful realm of iris beds and pond with water lilies. Among other French artists who portrayed their gardens, Gustave Caillebotte painted his family relaxing and gardeners at work among the vegetables.

James McNeill Whistler, while living in Paris in the 1890s, frequently drew in the Luxembourg Gardens (cats. 118, 124).[53] He also enjoyed sketching in his small garden on the rue de Bac, as he had earlier done in his London garden. His contemporary James-Jacques-Joseph Tissot often pictured his garden in London with its pergola and reflecting pool (cat. 131). Describing the view of the Tuileries from his window on the rue de Rivoli as "superb," Camille Pissarro began a series of paintings during 1899 and 1900 (cat. 6).[54] Pissarro found painterly interest in Le Nôtre's enduring design framed by an urban skyline, a scene at once new and old.

From before 1900 into the 1920s Eugène Atget documented Paris, its streets and parks, including Parc Monceau and the courtyard garden of today's Musée Carnavalet (cats. 17, 41). Unlike Marville, who was commissioned to photograph the Bois de Boulogne, Atget worked from personal dedication. At Versailles, early in his project, he portrayed its vast collection of statuary (cats. 70–73, 77). In later views of Versailles and Saint-Cloud, he focused less on details and more on the garden's character. In contrast to the animated

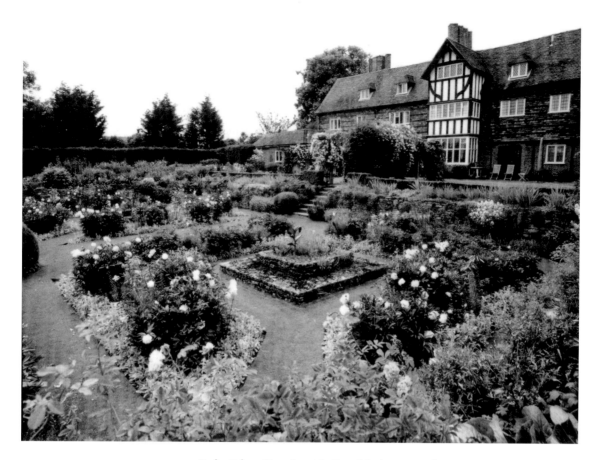

FIG. 7. Becky Cohen, *Upton Grey: The Formal Garden in Front of the Manor House*, 2000. Gelatin-silver print. Becky Cohen. (Cat. 8A)

groups enjoying parks depicted in Impressionist paintings, Atget's later images portray deserted gardens, whose austere geometry has been softened by leaves and falling branches. Their melancholy mood recalls that of Oudry and Fragonard.

Twentieth Century

As the century dawned, women emerged as independent and influential garden designers. In London, Gertrude Jekyll took a firm stand against Victorian planting schemes. Jekyll, trained as an artist, was attracted to William Morris's floral designs and was well read on the theory of color harmony (which was crucial to the subtle crescendos of her borders). After her failing eyesight prevented her from doing needlework and painting, from 1890 into the 1930s, she designed many private gardens, such as Upton Grey (fig. 7).[55]

Her harmonious, impressionistic perennial borders—still highly admired—show her sensitivity to the interplay of textures and structure (cats. 7, 8).

Jekyll adjusted her palette seasonally: for spring, soft pastel colors and whites in bulbs, roses, clematis, and wisteria; for early summer, robust reds and yellows in annuals and perennials; and for late summer and approaching autumn, the muted tones of daisies, asters, and chrysanthemums. These borders were her most original and artistic contribution. Of the many rambling roses she used, her favorite was the Garland, with its small, white blossoms and draping habit. Recognizing the dynamics of whites and grays, textures and scale, Jekyll often punctuated the end of a bed with the spike of a yucca. In her many published essays and books, she offered knowledgeable horticultural descriptions and advocated the use of native plants. In the decades after her death, her influence waned, but

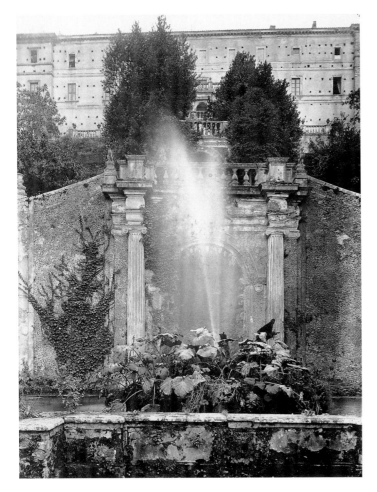

FIG. 8. Gustave Eugène Chauffourier, *The Villa d'Este: Fountain of the Dragons*, c. 1871–73. Albumen-silver print. Collection Centre Canadien d'Architecture/ Canadian Centre for Architecture, Montréal. (Cat. 60B)

has since revived with the reprinting of her books. Jekyll's current audience includes many suburban gardeners.

In 1907 in Sussex, Frances Wolseley opened a College for Women Gardeners, with the names of Miss Jekyll, Mrs. Earle, and Miss Ellen Willmott listed as patrons on the prospectus. Although the emphasis was practical, instruction had a higher purpose: that gardening should be socially acceptable for women and make a positive contribution to the greater community. The program included classes on horticulture, maintenance, and greenhouses, as well as visits to Gravetye, the garden of the influential William Robinson, who, earlier than Jekyll, had espoused naturalistic plantings.

Americans turned for ideas, not to Robinson or Jekyll, but to older, more architectural Italianate gardens, which they found more desirable as models. Edith Wharton's well-phrased praise brought the Italianate style to the attention of a wide audience when she wrote, "The inherent beauty of the garden lies in the grouping of its parts—in the converging of the lines of its long ilex-walks, the alternation of sunny open spaces with cool woodland shade, the proportion between terrace and bowling green, or between the height of a wall and the width of the path."[56] Her 1904 book on Italian gardens was generously illustrated, with photographs and reproductions of paintings by Maxfield Parrish, who visited the same gardens Wharton did, but not at the same time. John Singer Sargent's many watercolors and paintings of Italian, Spanish, and Portuguese gardens capture the interplay of nature and art in scenes bathed in light (cats. 28, 31, 130). Late in his career, the American painter William Merrit Chase regularly summered in Florence, where he painted his handsome garden (cat. 19).

At home, American artists continued to depict gardens, both public and private, as gathering places. Maurice Prendergast's pageants of parks and beaches celebrate the delights of everyday outings, especially those of children (cat. 103). Whether in Paris or New

York, William Glackens sketched and painted children playing games, rolling hoops, skating, and sledding (cat. 133). Glackens, George Bellows, and John Sloan, artists associated with the so-called Ash Can School because of their gritty urban scenes, took occasional note of the pleasurable experiences of strolling or playing in Central Park and the more working-class Union Square (cats. 114, 127).

World War I did not devastate the United States as it did Europe. The prosperity of the 1920s resumed the pattern of the halcyon days before the war. Americans, now traveling rapidly by the new steamships, flocked to Europe. They returned to create such gardens as Pierre du Pont's Longwood, outside Philadelphia, with its conservatories and fountains—inspired by trips to Vaux-le-Vicomte, Versailles, and the Villa d'Este (fig. 8). On the San Francisco Peninsula, James Duval Phelan's Italianate Villa Montalvo was conceived of and continues to be used as an artistic center with music and theatrical performances in a garden setting. Farther south along the mountainous coast, William Randolph Hearst's spectacular castle San Simeon rose, situated amid citrus and Roman statuary. Santa Barbara's warm climate, hilly terrain, and nearby Santa Inez mountains were sought out by eastern and midwestern industrialists, who escaped winter's hardships via private railroad cars. Their villas, replete with echoes of the Villa Lante and the Villa d'Este, included Spanish notes as well—Islamic pools, for example, with small jets of water.

In 1899, when the American Society of Landscape Architects was organized, Beatrix Jones (later Farrand) was the only female founding member. A niece of Edith Wharton, Jones moved in high social circles. Gardening came to her early at her grandmother's estate at Newport, Rhode Island. Among her commissions were designs for retreats at Bar Harbor and Seal Harbor, as well as year-round gardens in Connecticut and on Long Island. John D. Rockefeller and J. Pierpont Morgan were among her clients.

Farrand lacked Jekyll's artistic sensitivity to color, but her extensive library and collection of prints (now at the University of California at Berkeley) demonstrates her thorough study of historical gardens. Her most famous design, created over many years, was for Robert Woods Bliss and his wife, Mildred, at Dumbarton Oaks, their estate in Washington, D.C. The history of that garden provides a useful example of how gardens must adapt in order to endure. Farrand divided the hilly site into a succession of balanced, differentiated areas, which flowed together gracefully, some linked by paths lined with unclipped boxwood, as she had seen in Medici gardens. Having overseen the garden for many years, she helped plan its evolution from private residence to public space, when Mildred Bliss gave the property to Harvard University. Anticipating changes, Farrand expressed her concern to keep its "seclusion"; worried about replanting trees, she suggested that it might be useful to start "a small nursery for Box, Yew, Holly, Oaks, and other plants which are costly to buy in large size."[57] Among later changes, the original tennis court became a shallow, pebbled reflecting pool. Farrand also acted as a garden consultant to such universities as Princeton, Yale, and Chicago. In contrast to these large projects is her proposal for a small suburban garden (cat. 9).[58]

The early decades of the twentieth century witnessed a profusion of American gardens built in historic styles. In France, however, the emerging art styles of Cubism and Art Deco helped shape the modernist garden. Emphasizing clean lines and bright colors, such plans featured unexpected placements of diagonal paths and shrubbery planted in angular configurations. The brothers André and Paul Vera combined their talents for architecture with design in their geometric garden patterns (cat. 12). Their books, *Le Nouveau jardin* (1911) and *Les Jardins* (1919), provided handsome illustrations for ideas not easily adapted.[59] The American designer Fletcher Steele was influenced by their modernist interpretations. His 1938 designs for Mabel Choate's Naumkeag in Stockbridge, Massachusetts, included a bold staircase, the Blue Steps, with

white curved Art Deco railings silhouetted against surrounding birch trees.

The Great Depression and World War II brought a halt to gardens designed on a grand scale. Instead, in this country people were encouraged to help raise their own food by planting Victory Gardens. The glory days when gardens and parks attracted artists had drawn to a close.

APPROACHING THE PRESENT

During the closing decades of the twentieth century, the concepts of garden and park acquired new connotations and reconnected with earlier meanings. The rise of the sculpture garden, for example, while recalling statuary collections of Roman and Renaissance models, is a welcome contemporary development. At the Kröller-Müller Museum's Sculpture Garden, set in wooded sand dunes in Otterloo, the Netherlands, discovery is part of the unfolding experience, as individual pieces gradually emerge or suddenly appear at a turn in the path. In this country as corporations became major architectural patrons, they also commissioned gardens and sculpture gardens. The interaction of sculpture and the larger landscape can be seen at Storm King on the Hudson River in New York State, which spreads over a hilly terrain. In contrast, the Minneapolis Sculpture Garden is bound by a freeway, the Walker Art Center, and the Guthrie Theater. Imaginative in design, this sculpture garden offers a welcome wit in Claes Oldenburg's *Spoonbridge and Cherry* fountain and Frank Gehry's oversize glass-scaled fish (fig. 9, cat. 35). Several recent urban sculpture gardens feel restricted by their spaces, for example, those of the Hirshhorn Museum and the National Gallery of Art in Washington, D.C. In contrast, the small enclosed garden of the Museum of Modern Art in New York, as originally designed in the 1950s by Philip Johnson, was a model of elegant repose and restraint in which a few sculptures were well placed among trees. As the landscape designer Laurie Olin noted, the experience offered "clarity and intensity."[60]

The word "park," now used in conjunction with theme parks, recalls that use in earlier pleasure parks —Vauxhall in London, the Prater in Vienna, and the Tivoli Gardens in Copenhagen—but without their seamier elements. Reincarnated in Disney's sanitized theme parks, the point is still entertainment—at a price. Yet another variant can be seen in the wildly ambitious garden plantings and musical fountains that sprout almost overnight in Las Vegas—attempts to upstage the Villa d'Este and Versailles.

Artists, however, have had little to do with these commercialized entertainments. Their recent involvements have been in the direction of land art, or site-specific sculpture. Christo and his wife and collaborator, Jeanne-Claude, have organized many projects that have temporarily transformed the landscape. Their proposal for a Central Park project has recently been revived. The Minimalist Robert Irwin has designed a surprisingly textured and densely planted garden for the Getty Center in Los Angeles (cat. 18). Irwin has described his design as a "sculpture in the form of a garden aspiring to be art."[61] Ian Hamilton Finlay, in his Little Sparta garden in southern Scotland, has introduced into the landscape words and phrases, engraved in stone, such as Saint Just's, "The present order is the disorder of the future." The inscriptions are at once innovative but also recall earlier inscriptions at Bomarzo in Italy and Ermenonville in France (cat. 90B). The artist Niki de Saint-Phalle built a tarot garden for herself in Tuscany, and even if one cannot see it, one should visit its irresistible website.[62]

Gardens continue to be reconfigured or newly built. In Great Britain, Lord Rothschild commissioned a design for a millennium parterre in rainbow hues for Waddesdon Manor.[63] Established public gardens are better maintained as more is understood about the importance of timely replanting for future generations. Issues of restoration versus innovation are increasingly fine-tuned, as priorities and vocabularies are refined to distinguish between what is desirable and what is possible through restoration, rehabilitation, and reinvention. For example, in Paris the new axis

from the Pyramid at the Louvre to the Arc de la Dé-
fense has encouraged interpretations that, while ac-
knowledging multiple layers of the past, seek expres-
sion in a contemporary form. In the Tuileries, for
example, rows of new hedges have been planted in di-
agonals, between which Aristide Maillol's sculptures
have been placed.[64] Maillol had bequeathed these
works to the government and they had formerly been
placed in, then removed from, and now returned to the
Tuileries. The renewed conjunction of sculpture and
plantings offers an imaginative reinterpretation of
France's distinctive tradition of classic formality.

As cities grow and change, unexpected areas are
being reclaimed as parks. In Paris, the site of an old
Citroën factory has been reborn as the Parc André
Citroën. Children dance on its water parterre, glass
buildings house exotics, formal paths lead through
handsome plantings of trees and hedges, and on a great
meadow balloon rides are offered—in short, some-
thing for everyone, and located at the end of a métro
line. In California, along the San Francisco Bay, as
municipalities fill up their garbage quotas, they have
created parks on top of the fill. Palo Alto's Byxbee
Park, designed by George Hargreaves, features a field
of poles and other site-specific art.[65] It is frequented
mainly by walkers, joggers, and bird-watchers. Neigh-
boring Mountain View's Shoreline Park hosts an am-
phitheater, golf course, artificial pond, and lawn. It is
enjoyed by families picnicking, playing games, boat-
ing, or windsailing. In San Francisco, an old military
installation, Crissy Field, has been transformed by
Hargreaves from an ageing asphalt strip into a natural-
istic shoreline, whose configuration changes with the
tides. The diversity of such parks is welcome.

Photography has become the ubiquitous mode for
representing gardens. Images of improbably intense
colors flood popular magazines; individuals record the
splendor of their hybrid tea roses on appropriately
brightly contrasting film. During the last decades of
the twentieth century, however, a few photographers
have examined gardens closely, often working in black-
and-white with subtle tonalities. Michael Kenna in *Le*

FIG. 9. Claes Oldenburg, *View of Spoonbridge and Cherry,
with Sailboat and Running Man*, 1988. Pastel and paper
collage on paper. Collection Walker Art Center. (Cat. 30B)

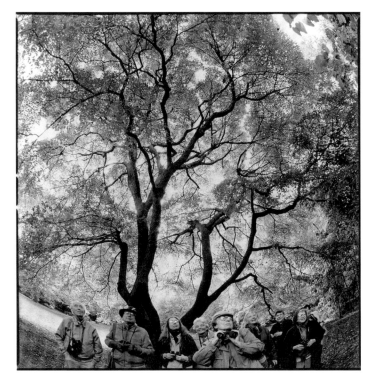

FIG. 10. Bruce Davidson, *Untitled* (Bird-watchers under the Tree Canopy). Gelatin-silver print. Iris & B. Gerald Cantor Center for Visual Arts at Stanford University. (Cat. 135C)

Nôtre's Gardens (1997) has found the structure and textures of French formal gardens compelling and chooses images that surprise (cat. 64).[66] *Viewing Olmsted: Photographs by Robert Burley, Lee Friedlander, and Geoffrey James* (1996), organized by the Canadian Centre for Architecture in Montreal to celebrate Olmsted's designs, includes New York's Central Park, as well as private estates (cats. 97, 25).[67] Bruce Davidson has photographed Central Park from a more personal perspective, examining its role in the lives of New Yorkers, from East Side matrons to the homeless. In *Central Park* (1995), he has observed people riding, in-line skating, sunbathing, and bird-watching, as well as recording the landscape's rocky heights and the park's pigeons and songbirds (fig. 10).[68]

Just as gardens inhabit the same changeable space over time, this catalogue's essays represent different temporal and disciplinary perspectives. The art historian Claudia Lazzaro, with her special expertise in Italian sixteenth- and seventeenth-century gardens, writes about the prints of that period. The garden print historian Elizabeth S. Eustis focuses on the political control exercised in the time of Louis XIV over the publication of prints. The architectural and garden historian Diana Ketcham relates her firsthand explorations of several little-known late-eighteenth-century French gardens and, in particular, the role played by the painter Hubert Robert in the design of Méréville. The art historian and museum curator Carol M. Osborne describes how American artists depicted the garden as a social setting in the late nineteenth and early twentieth century. The editor and journalist Paula Deitz's concluding essay describes George Hargreaves's creative reuses of urban spaces. These differing perspectives contribute to a richer understanding of the significance of gardens not only to artists but to all of us. For as the French critic Michel Le Bris has written, "Gardens are not innocent playthings; they are the landscape within us, constantly registering our relationships with our fellow men, with the world and with God."[69]

NOTES

1. Harold George Nicolson, *Diaries and Letters of Harold Nicolson*, ed. Nigel Nicolson (New York: Atheneum, 1966–68). For many years Vita Sackville-West wrote gardening columns, which have been collected in various editions. The following two are organized by seasons: Vita Sackville-West, *A Joy of Gardening* (New York: Harper & Brothers, 1958) and, more recently, Sackville-West, *The Illustrated Garden*, intro. Robin Lane Fox (New York: Atheneum, 1986).

2. Roy Strong, ed., *A Celebration of Gardens*, with decorations by Julia Trevelyan Oman (London: HarperCollins, 1991).

3. Betty Massingham, ed., *A Century of Gardeners* (London: Faber and Faber, 1982).

4. Allen Lacy, ed., *The American Gardener: A Sampler* (New York: Farrar, Straus & Giroux, 1988).

5. Diane Kostial McGuire, ed., *American Garden Design* (New York: Macmillan, 1994).

6. Henry Mitchell, "On the Defiance of Gardeners," quoted in Bonnie Marranca, ed., *American Garden Writing* (New York: Penguin Books, 1988), 72.

7. Pliny the Younger, *The Letters of the Younger Pliny*, trans. and intro. Betty Radice (Harmondsworth and Baltimore: Penguin Books, 1969).

8. John Evelyn, *The Diary of John Evelyn* (Oxford: Clarendon Press; New York: Oxford University Press, 2000).

9. Edith Wharton, *Italian Villas and Their Gardens* (New York: The Century Co., 1904).

10. Vivian Russell, *Edith Wharton's Italian Gardens* (Boston: Little Brown and Co., 1997).

11. Charles A. Platt, *Italian Gardens* (1894), reprinted with an overview by Keith N. Morgan (Portland, Ore.: Sagapress/Timber Press, 1993).

12. Gertrude Jekyll, *Wood and Garden* (London: Longmans, Green, and Co., 1899; Woodbridge: Antique Collectors' Club, 1981), and Jekyll, *Colour Schemes for the Flower Garden* (London: Country Life Ltd., 1908; Woodbridge: Antique Collectors' Club, 1982).

13. Rosamund Wallinger, *Gertrude Jekyll's Lost Garden* (Woodbridge, Suffolk: Garden Art Press, 2000).

14. Kahren Hellerstedt, *Gardens of Earthly Delight: Sixteenth and Seventeenth Century Netherlandish Gardens*, exh. cat. (Pittsburgh: Frick Art Museum, 1986); Virginia Tuttle Clayton, *Gardens on Paper: Prints and Drawings, 1200–1900*, exh. cat. (Washington, D.C.: National Gallery of Art, 1990); and Marilyn Symmes, *Fountains: Splash and Spectacle*, exh. cat. (New York: Rizzoli and Cooper-Hewitt National Design Museum, 1998).

15. Elizabeth S. Eustis has shared a trove of useful information about early printed garden views based on her research at the Metropolitan Museum of Art and at Cooper-Hewitt, National Design Museum, Smithsonian Institution, as well as at other collections. I have further benefited from numerous stimulating conversations with her, and she has generously made available "The First Century of Etched and Engraved Garden Views: 1573 to 1673," her 1998 thesis, Masters Program in the History of the Decorative Arts, Cooper-Hewitt, National Design Museum, and Parsons School of Design, New York.

16. Penelope Hobhouse, *Plants in Garden History* (London: Pavilion, 1997); Claudia Lazzaro, *The Italian Renaissance Garden* (New Haven and London: Yale University Press, 1990), 323ff.

17. Françoise Boudon notes that careful study of the drawings is needed because the rather crude engravings do not fully convey Androuet Du Cerceau's detailed observations. The drawings are preserved mainly in such collections as the British Museum in London, the Bibliothèque Nationale in Paris, the Vatican Library in Rome, and the Morgan Library in New York. See Boudon, "Illustrations of Gardens in the Sixteenth Century: 'The Most Excellent Buildings in France,'" in *The Architecture of Western Gardens*, ed. Monique Mosser and Georges Teyssot (Cambridge, Mass.: MIT Press, 1991), 100–102.

18. Annette Dixon, *Women Who Ruled: Queens, Goddesses and Amazons in Renaissance and Baroque Art*, exh. cat. (London: Merrell; Ann Arbor: The University of Michigan Museum of Art, 2002), 56, no. 21. For the drawings at Harvard and in Edinburgh, see William Howard Adams, *The French Garden: 1500–1800* (New York: George Braziller, 1979), 34–36, figs. 27, 28.

19. Dianne Harris, "Landscape and Representation: The Printed Views and Marc'Antonio dal Re's Ville de Delizie," in Mirka Benes and Dianne Harris, *Villas and Gardens in Early Modern Italy and France* (Cambridge and New York: Cambridge University Press, 2001), 178–206.

20. Clayton, *Gardens on Paper*, 48, no. 29 (ill.), n. 20. The highly finished drawing of about 1602 was engraved by Nicholaes de Bruyn. See also John Dixon Hunt, *Greater Perfections: The Practice of Garden Theory* (Philadelphia: University of Pennsylvania Press, 2000), 170, fig. 109, for the painting by Lucas van Valkenborch.

21. F. Hamilton Hazlehurst, *Gardens of Illusion: The Genius of André Le Nostre* (Nashville: Vanderbilt University Press, 1980). Hazlehurst illustrates many prints and drawings by Silvestre, the Perelles, and anonymous printmakers, as well as plans by Le Nôtre, Claude and Pierre Desgots, Silvestre, and anonymous hands. Drawings by Le Nôtre are in the collections of the Institut de France in Paris and the Nationalmuseum in Stockholm, in the Tessin-Hårleman-Cronstedt Collection. In his Appendix II Hazlehurst lists some one hundred gardens attributed to Le Nôtre but

cautions that there is little substantiated evidence for many of these. See also Pierre-André Lablaude, *The Gardens of Versailles*, trans. Fiona Biddulph (London: Zwemmer, 1995), for a generous selection of prints, drawings, and paintings of Versailles. See also Thomas F. Hedin, "The Petite Commande of 1664: Burlesque in the Gardens of Versailles," *The Art Bulletin* 93, no. 4 (December 2001): 651–85. Hedin describes earlier projects by Charles Perrault and his brother Claude for statuary at Versailles that displayed a rustic humor. The statues were soon removed and burlesque was replaced by grandeur. Prints made at the time of the earlier statues not only are indispensable for understanding their appearance but help prove their existence.

22. Translated in Hazlehurst, *Gardens of Illusion*, 59.

23. Translated in Hazlehurst, *Gardens of Illusion*, 286 n. 26. A design for the cascade by Le Nôtre is illustrated on 287. The cascade that was built was designed by Antoine Le Pautre.

24. Thierry Mariage, *The World of André Le Nôtre*, trans. Graham Larkin, foreword by John Dixon Hunt (Philadelphia: University of Pennsylvania Press, 1999), 97–99, 98 n. 13, quotation from Père Desmolets of Le Nôtre's 1679 visit.

25. Antoine-Joseph Dézallier d'Argenville, *La théorie et la pratique du jardinage. . . .* (Paris: J. Mariette, 1709). Editions followed in 1713 and 1747; it was translated into English in 1728.

26. Terence M. Russell and Ann-Marie Thornton, *Gardens and Landscapes in the Encyclopédie of Diderot and D'Alembert*, 2 vols. (Aldershot: Ashgate, 1999). The text of the *Encyclopédie, ou Dictionnaire Raisonné des Sciences, des Arts, et des Métiers, par une société de gens de lettres* included some 260 entries signed "K," for Dézallier d'Argenville, the garden theorist (many derived from his earlier treatise). A long entry by Diderot, signed ★, began: "Tree: the gardener is concerned with the selection, preparation, planting, propagation, and maintenance of trees. We will look briefly at the general rules. . . ." An entry on water signed "K" began: "To water: nothing is more useful than watering plants: it is the only remedy for the midsummer heat and spring winds."

27. Johannes Kip and Leonard Knyff, *Britannia Illustrata* (London: David Mortier, 1707), and Colen Campbell, *Vitruvius Britannicus: or, the British Architect*, vol. 3 (London: the author, 1725).

28. Dora Wiebenson, *The Picturesque Garden in France* (Princeton: Princeton University Press, 1978), 34–35.

29. For a discussion of eighteenth- and nineteenth-century garden theories, see Georges Teyssot, "The Eclectic Garden and the Imitation of Nature," in Mosser and Teyssot, *The Architecture of Western Gardens*, 359–70.

30. Quoted in Roger Turner, *Capability Brown and the Eighteenth-Century English Landscape* (London: Weidenfeld and Nicolson, 1985), 7.

31. Quoted in ibid., 8.

32. Hal Opperman, *Jean-Baptiste Oudry*, exh. cat. (Fort Worth:

Kimbell Art Museum, 1983), 190, cats. 68–70. Opperman credits the 1950 study by A. Desguine as the best effort to reconcile Oudry's drawings with documents and other descriptions of the property at Arcueil. Its grounds were largely destroyed by 1752, but an aqueduct establishes the location. *Jardins en Ile-de-France/Dessins d'Oudry à Carmontelle*, exh. cat. (Sceaux: Musée de Ile-de-France, Orangerie du Château de Sceaux, 1990), 80, cats. 30–36; several are dated 1744, 1745, and 1747.

33. Victor Carlson, *Hubert Robert: Drawings and Watercolors*, exh. cat. (Washington, D.C.: National Gallery of Art, 1978), 38, cat. 6. Also Jean Cayeux, *Hubert Robert et les Jardins* (Paris: Herscher, 1987); and Jean Cayeux, "The Gardens of Hubert Robert," in Mosser and Teyssot, *The Architecture of Western Gardens*, 340–43.

34. William Chambers, *Designs of Chinese Buildings . . . Temples, Houses, Gardens, &c.* (London: the author, 1757), and *Plans . . . of Gardens and Buildings at Kew in Surrey. . . .* (London, 1763).

35. Quoted in Wiebenson, *The Picturesque Garden in France*, 236 n. 77.

36. Georges-Louis Le Rouge, *Détail des nouveaux jardins à la mode anglo-chinois. . . .* [also known as *Des Jardins anglo-chinois*], 21 cahier (Paris: Le Rouge, 1776–87?).

37. Alexandre Laborde, *Description des nouveaux jardins de la France et de ses anciens châteaux* (Paris: Imprimerie de Delance, 1808–15).

38. Victor Carlson and John Ittmann, *Regency to Empire: French Printmaking, 1715–1814*, exh. cat. (Baltimore: Baltimore Museum of Art; Minneapolis: The Minneapolis Institute of Arts, 1985).

39. Virgilio Vercelloni, *European Gardens: An Historical Atlas* (New York: Rizzoli, 1990), 81.

40. Quoted in Alessandra Ponte, "Public Parks in Great Britain and the United States: From a 'Spirit of the Place' to a 'Spirit of Civilization,'" in Mosser and Teyssot, *The Architecture of Western Gardens*, 373–86, at 384 n. 23.

41. Quoted in ibid., 376 n. 8; Stephen Daniels, "On the Road with Humphry Repton," *Journal of Garden History* 16, no. 3 (autumn 1996): 170–91.

42. Gabriel Thouin, *Plans raisonnés de toutes les espèces de jardins* (Paris: Thouin, 1820). See also Vercelloni, *European Gardens*, pls. 145, 166–67.

43. Quoted from Repton's *Fragments on the Theory and Practice of Landscape Gardening*, 1816, in Ponte, "Public Parks," 377.

44. Quoted in ibid., 383 n. 19.

45. Quoted in ibid., 386 n. 29.

46. Adolphe Alphand, *Les promenades de Paris. . . .* (Paris: J. Rothschild, 1867–73).

47. Quoted in Marco De Michelis, "The Green Revolution: Leberecht Miggi and the Reform of the Garden in Modernist Germany," in Mosser and Teyssot, *The Architecture of Western Gardens*, 409 n. 1.

48. Quoted in May Brawley Hill, *Grandmother's Garden: The Old-*

Fashioned American Garden, 1865–1915 (New York: Harry N. Abrams, 1995), 78.

49. Mariana Griswold van Renssalaer, *Art Out-of-Doors: On Good Taste in Gardening* (1893), quoted in ibid., 65.

50. Quoted in ibid., 80.

51. [Julie Cain,] "The Stanford Arizona Garden," *Ex Libris* (News from the Associates of the Stanford University Libraries) 11, no. 1 (spring–summer 1999): 10–13.

52. *Henri et Achille Duchêne/Le Style Duchêne*, intro. Michel Duchêne (Paris: Editions du Labyrinthe, 1998).

53. *The Lithographs of James McNeill Whistler*, ed. Harriet K. Stratis and Martha Tedeschi, 2 vols. (Chicago: The Art Institute of Chicago, 1998).

54. Richard R. Brettell and Joachim Pissarro, *The Impressionist and the City: Pissarro's Series Paintings*, exh. cat. (New Haven and London: Yale University Press, 1992).

55. Judith B. Tankard and Michael R. Van Valkenburgh, foreword by Jane Brown, *Gertrude Jekyll: A Vision of Garden and Wood* (New York: Abrams, 1989).

56. Quoted in Eleanor M. McPeck, "A Biographical Note and a Consideration of Four Major Gardens," in Diana Balmori, Diane Kostial McGuire, and Eleanor M. McPeck, *Beatrix Farrand's American Landscapes: Her Gardens and Campuses* (Sagaponack, N.Y.: Sagapress, 1985), 23 n. 28.

57. Quoted in Balmori, "Campus Work and Public Landscape," in Balmori, McGuire, and McPeck, *Beatrix Farrand's American Landscapes*, 190 n. 74.

58. Now part of the extensive archive, called the Reef Point Collection, that Farrand donated to the University of California at Berkeley. Its library includes books by Repton, Robinson, and Jekyll; prints by Silvestre, Rigaud, and others; and as many of Jekyll's drawings and albums of photographs that Farrand was able to save.

59. Dorothée Imbert, *The Modernist Garden in France* (New Haven and London: Yale University Press, 1993); André Vera, *Le Nouveau jardin*, illustrated by Paul Vera (Paris: Emile-Paul, 1911), and *Les Jardins* (Paris: Emile-Paul Frères, 1919).

60. Laurie D. Olin, "The Museum of Modern Art Garden: The Rise and Fall of a Modernist Landscape," *Journal of Garden History* 17, no. 2 (summer 1997): 140–62.

61. Quoted in Karen L. Dardick, "Babylon Revisited? The Getty Gardens Are Creating a Buzz in Both Art and Gardening Circles," *The American Gardener* 77, no. 5 (1998): 51.

62. The website of Niki de Saint-Phalle is Nikidesaintphalle.com/biography.html.

63. Bernard Lassus, "The Landscape Approach of Bernard Lassus, Part II," trans. and intro. by Stephen Bann, *Journal of Garden History* 15, no. 2 (summer 1995): 67–106. The garden belongs to Lord Rothschild; see Michael Hall, *Waddesdon Manor: The Heritage of a Rothschild House* (London: Abrams, in association with Waddesdon Manor, 2002), 286, 292 (ill.).

64. Stephen Bann, "The Tuileries: A Reinvented Garden (1900)," *Journal of Garden History* 15, no. 2 (summer 1995); Marc Treib, "Sculpture and Garden: A Historical Overview," *Design Quarterly* 141 (1988): 44–58.

65. Reuben M. Rainey, "Environmental Ethics and Park Design: A Case Study of Byxbee Park," *Journal of Garden History* 14, no. 4 (1994): 171–78.

66. Michael Kenna, *Le Nôtre's Gardens*, photographs by Michael Kenna, text by Eric T. Haskell (Santa Monica, Calif.: RAM Publications, 1997).

67. *Viewing Olmsted: Photographs by Robert Burley, Lee Friedlander, and Geoffrey James*, ed. Phyllis Lambert (Montreal: Canadian Centre for Architecture, 1996).

68. Bruce Davidson, *Central Park*, preface by Elizabeth Barlow Rogers, commentary by Marie Winn (New York: Aperture, 1995).

69. Quoted from Michel Le Bris, *Les paradis perdu* (Paris, 1981), in Monique Mosser, "Henri and Achille Duchêne and the Reinvention of Le Nôtre," in Mosser and Teyssot, *The Architecture of Western Gardens*, 446 n. 1.

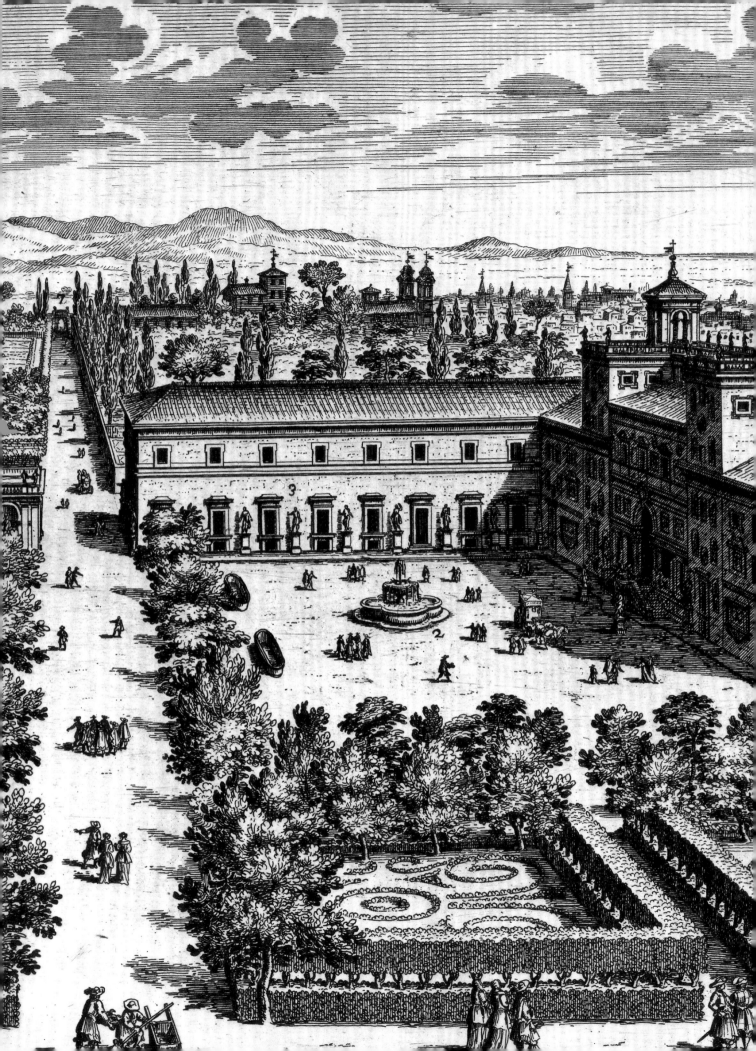

Representing the Social and Cultural Experience of Italian Gardens in Prints

CLAUDIA LAZZARO

In Italy a great number of suburban villas and country estates with lavish gardens were built from the early sixteenth through the eighteenth century for the wealthy and powerful. The gardens that survive do so because they contain enduring materials—sculpture of marble and bronze, fountains, architecture, and stone supporting-walls for the terraces on hillsides. These same gardens, and many others that have perished over the centuries, were represented in innumerable views, some painted or drawn, but mostly in prints (engravings, then etchings). The views follow a set of changing conventions, depicting those aspects of the gardens that were most significant to their contemporaries and suggesting the ways in which they were perceived and enjoyed. We know the gardens as well through written accounts—some long descriptions listing their principal features, but above all the travel journals of visitors, which complement the visual

· 29 ·

[DETAIL] Giovanni Battista Falda, *Perspective View of the Villa Medici, Rome*, 1683 (see fig. 13, p. 34).

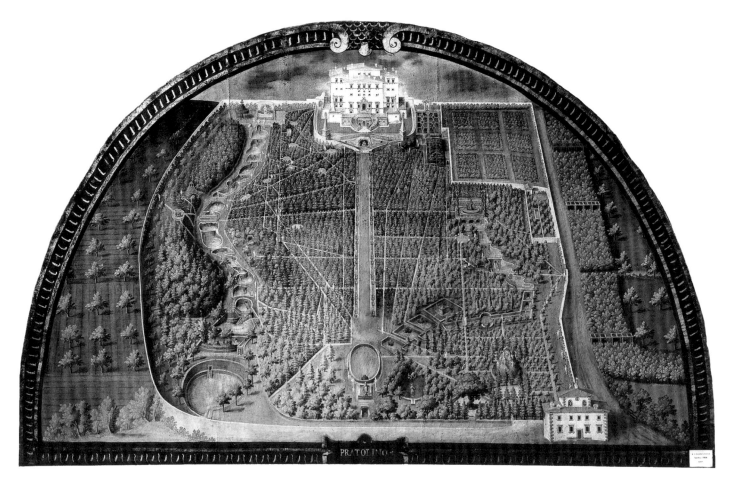

FIG. 11. Giusto Utens (the Netherlands, d. 1609), *View of Pratolino*, 1599.
Tempera on canvas, 145 × 245 cm. Museo Storico Topografico "Firenze Com'era," Florence.

records and also chronicle changes in the appreciation of them over time.

Throughout the Renaissance and Baroque periods, Italian gardens were conceived as an interaction of art and nature. Nature was ordered by art to reveal the underlying scheme of the cosmos, and art vied with nature to re-create its effects in natural-seeming grottoes and cascades. The relationship between art and nature was always shifting and often playful, with parts of the garden ranging from the highly artificial to the illusionistic, and even to areas left in their original state.

Printed views of gardens likewise highlight the varying relationships between art and nature, some emphasizing the ordering of nature, others imitating the rustic and natural aspects.

The earliest prints of Italian gardens date from the last quarter of the sixteenth century, with Etienne Dupérac's very large engraving of the Villa d'Este at Tivoli of 1573 (cat. 53), probably the first such view of any Italian garden. In the same decades views of gardens were painted inside their palaces, among them the 1599 lunettes of Medici villas by Giusto Utens (fig. 11).

The late-sixteenth-century examples are all characterized by a very high bird's-eye point of view, which emphasizes the grid plan that structured the gardens, the whole subdivided into geometric units. These units included terraces, which were linked by grand architectural fountains and sweeping staircases, all inspired by classical antiquity. The conventions of the views, however—the one-point perspective system and high horizon line in addition to the high point of view—resulted in a tilted ground plane, which minimizes the steep slope of the hillside, gives little sense of the terracing, and makes the lowest terrace appear splayed.

Later views reflect both the interests and artistic conventions of their respective time periods and the changing condition and understanding of the gardens. In his etching of Tivoli (cat. 57) two centuries after Dupérac's, Giovanni Battista Piranesi selected a much lower viewing position, which highlights the elevation on the hillside, rather than the ordered structure.[1] His view provides a sense of the whole garden as it might hypothetically be seen, not possible from any actual viewing position. The exaggerated scale of trees and foreground statues, particularly in comparison with the very small figures, suggests a grand garden past its prime, while Dupérac's more or less consistent rendering of scale serves to convey precise information about the garden's original state. Piranesi's accentuation of overgrown nature implies a simile between the lost classical past and the effects of time on the natural world, whereas in the Renaissance the ancient past was felt to be very much alive.

Italian Renaissance gardens were conceived as a whole made up of discrete and enclosed units with linking elements. On each of the terraces, the units were created through plant materials, which both prints and Utens's paintings depict in great detail, especially their role of articulating the order of the garden. Hedges or low trellised fences surrounded the square units, called compartments, as they did for the next two centuries, although they grew progressively taller. At Tivoli (cat. 53) the great cross-pergola on the lowest terrace (made of wood covered with grapevines and ivy) reinforced the geometry of the design, as did the square labyrinths of trellised hedges on either side. These, the familiar low borders, and trees planted in rows are indicated distinctly in Dupérac's engraving and in many other sixteenth-century views. The grid that is stressed in the bird's-eye views represents the fundamental notion of a garden as nature ordered and contrasts with the surrounding hills and unaltered nature. Since the regularity and geometry in the gardens are also apparent in contemporary painting and architecture, one might suggest a parallel between order as a design principle and the social order in the hierarchical society that produced these gardens.

The flourishing of these grand gardens resulted in part from two great and closely linked interests—the natural world and classical antiquity. The gardens functioned as a site for the display of collections of both art and nature. Little survives now to suggest the comprehensive variety of plant materials that they contained, including rare and exotic specimens, especially costly bulbs imported from Asia and the Americas.[2] The presence of these plants corresponds with a strong and wide-ranging interest in the natural sciences in the sixteenth and especially the seventeenth century in major Italian cities.

The garden was also a setting for collections of Roman antiquities. From the fifteenth century ancient sculpture was displayed in courtyards and enclosed gardens in Rome, then from the 1540s among the vegetation and integrated into the garden design, increasing in number into the eighteenth century.[3] At the Villa d'Este at Tivoli, for example, a large collection of ancient sculpture was dispersed throughout the garden, often sited to reinforce the themes conveyed through fountains and statues.[4] In the sixteenth-century Medici gardens, Roman statues accentuated significant garden areas, as at Pratolino, where thirteen ancient statues in trellised niches surrounded the lawn below the statue of the Apennine Mountains

(cat. 52F).[5] Ancient sculptures were brought to the Boboli Gardens in successive stages, beginning in the seventeenth century and into the nineteenth. They punctuate the tall hedges of the Viottolone, the broad avenue traversing the early-seventeenth-century addition, while at Castello those in architectural niches date from the late-eighteenth-century renovation.[6]

Already, from the late sixteenth century, the Villa Medici in Rome housed one of the great collections of ancient sculpture in the city, with objects installed in the garden, on the garden facade of the palace, and in both its loggia and its interior. Among these was the six-foot-tall Medici Vase, purchased by Ferdinand de' Medici in 1571 and brought to the palace loggia in 1606 after its restoration.[7] A half century after its arrival there, Stefano della Bella etched the vase (fig. 1), its huge size dwarfing the finely dressed youth (the son of his patron) sketching it. This image also alluded to the general practice of copying from sculpture in gardens, particularly this one, a practice observed by an anonymous French visitor in 1677.[8]

From the late sixteenth century large numbers of foreign travelers visited Italy on the Grand Tour, and the major gardens inevitably were included on their itinerary of sites to see. In their journals they recounted all the marvels of the gardens and noted equally, and often in the same sentence, the rare plants and antiquities or, as the English traveler of the 1640s, John Evelyn, would say, artificial and natural rarities.[9] Visitors understood the garden as similar to other common types of display—a cabinet of curiosities, a collection of precious objects and antiquities, or a museum of natural science, all of which commonly included works of both art and nature. These two preoccupations met in the person of the naturalist Ulisse Aldrovandi, famous for his multivolume natural history as well as his systematic collection of the antiquities of Rome.[10] For contemporaries the study of nature was equally a return to the classical texts that pioneered it. Visitors to Italian gardens were from the same groups of social elite, cognoscenti, and self-

enriching tourists who sojourned to Aldrovandi's natural science collection in Bologna and signed his guest book.

Those same visitors experienced the gardens as collections of art and nature, a microcosm of the ordered cosmos, and also as an unfolding set of related images and themes, through the familiar imagery of fountains and statues. Large fountains were often linked visually along the major avenues of the garden and sometimes were connected thematically as well. Geographic themes were common in Renaissance gardens, as at the Villa Medici at Castello and the Villa d'Este, where the sculpture, water displays, and other garden ornaments together re-created the region in microcosm. At Castello, a short distance outside Florence, there were fountains that personified the Apennine Mountains (the ultimate source of the water in the garden), the local rivers, and the city of Florence. At Pratolino, located farther north of Florence in the foothills of the mountains, the personification of the Apennines is a crouching giant, half man, half mountain, originally with water dripping over his stalactite-encrusted body, whose craggy character is suggested in Stefano della Bella's etching (cat. 52F). The Villa d'Este is unusual in that the geographic theme runs along the cross axis of the garden, and in that both ancient and modern sculpture conveyed the second, intersecting theme, celebrating the owner, along the central, vertical axis. Other statues and fountains generally refer to the natural world—personifications of aspects of nature, like river gods, mythological gods associated with nature (Neptune, god of the sea, for example), and figures populating the rustic environment, such as shepherds and various animals. There are some indications that for many visitors guidance was needed to interpret the subjects of statues and fountains and to make the thematic connections. For this reason, perhaps, most of the prints include captions in the lower margin, numbered to correspond with those in the image.

Along with the increased interest in gardens in the seventeenth century—on the part of both creators

and visitors—the number of garden prints multiplied dramatically (figs. 12, 13). Some views were produced and sold in single sheets; others were bound in volumes, often produced in different editions.[11] From the early seventeenth century several books illustrating fountains in Rome were published.[12] The most famous and successful of them was *Fountains of Rome*, published by Giovanni Battista Falda from 1675 and composed of four books, two devoted to a single garden. Book two, illustrating the fountains of the Villa Aldobrandini at Frascati, includes Falda's *Fountain of the Shepherds* (cat. 26A), and book four, etched by Giovanni Francesco Venturini, represents the fountains of the Villa d'Este at Tivoli (cat. 55). Falda also etched another series, *Gardens of Rome*, which was begun about 1670 and published posthumously in a bound volume in 1683.

Fountains of Rome commemorates one of the most striking characteristics of papal Rome from the late sixteenth century—the water brought to the city by aqueduct, reinstating the fresh water supply that was the crowning achievement of ancient Rome.[13] The abundance of water and the engineering skills in manipulating it in fountains and creative waterworks were distinctive features of Italian gardens, noted among the marvels most appreciated by visitors. As with the study of the natural world, the elaborate fountains in cities and gardens signaled a revival of the achievements of classical antiquity. The fountains at Frascati, like those in Rome, also celebrated the plentiful water from a new aqueduct, which Cardinal Pietro Aldobrandini constructed there, and which served both town and his garden.[14] (Most of these still survive, but the Fountain of the Shepherds was destroyed in World War II.)

In Falda's *Gardens of Rome* two complementary views replace the single bird's-eye view that was conventional in the sixteenth century. One of the pair is essentially a plan view, looking straight down, which reveals the geometric design, although all the architecture, trees, and hedges are depicted at an angle, to make them legible and distinctive. The other of the pair is a perspective view (fig. 13), as that of the Villa

Medici in Rome, site of the Medici Vase in della Bella's etching (fig. 1). These are great, broad panoramas seen from an elevated viewpoint, with the garden avenues receding in one-point perspective to the high horizon line. The inconsistencies and exaggerations in the views are not obvious, but they add importantly to the effect of sweeping spaces and grandeur, in contrast to the small figures, which diminish too rapidly for their surroundings. With the taste for much larger estates in the seventeenth century, even views of earlier gardens of more modest dimensions, such as the Villa Medici, were represented so that they too appeared to be of a vast scale. Unlike earlier prints, those from the seventeenth century show figures—moving through the garden, at different points in space, and in a variety of activities, including, importantly, looking.

The many foreign visitors who recorded the sites they saw in innumerable travel journals must have formed a good part of the market for garden prints. Whether bound or simply viewed in series, the prints parallel the sequential experience of the garden or recreated it for those who could not visit. One such series is Stefano della Bella's six views of the Villa Medici at Pratolino of about the mid–seventeenth century (cat. 52). Pratolino differed from the gardens at Tivoli, Castello, or the Villa Medici in Rome in that it was for the most part a wooded park, not a geometric garden, because of the high altitude, lack of water, and steep slope, as well as its role as a country retreat, perhaps for hunting.[15] The painting of the villa by Utens (fig. 11) represents only the lower park and the palace, which was destroyed in 1821. Utens clearly depicts the fir trees that dominated the planting, along with beech and pine, all of which could withstand the cold. Della Bella's etchings of the villa could be viewed in an order that would parallel the passage from the entrance in the lower park near the Tree House (fig. 12), at the lower right in Utens's painting, up to the palace (cat. 52C), and finally to the colossal personification of the Apennine Mountains (cat. 52F) above the palace in the upper park, one of the few elements that survive. As in Falda's view of the Villa Medici in Rome (fig. 13), in

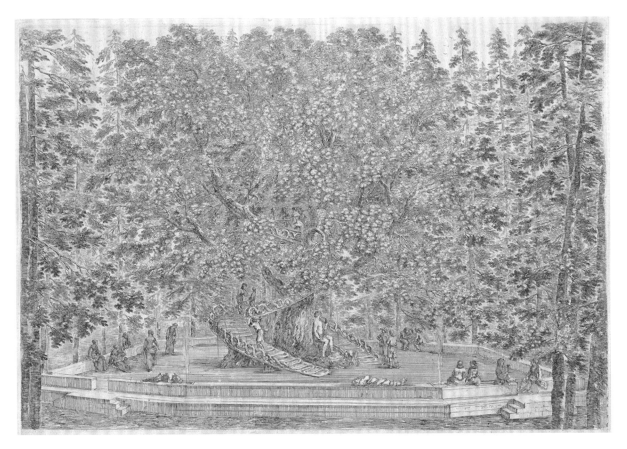

FIG. 12. Stefano della Bella, *The Ancient Oak with a Tree House*, c. 1650–55.
Etching. Herbert F. Johnson Museum of Art. (Cat. 52A)

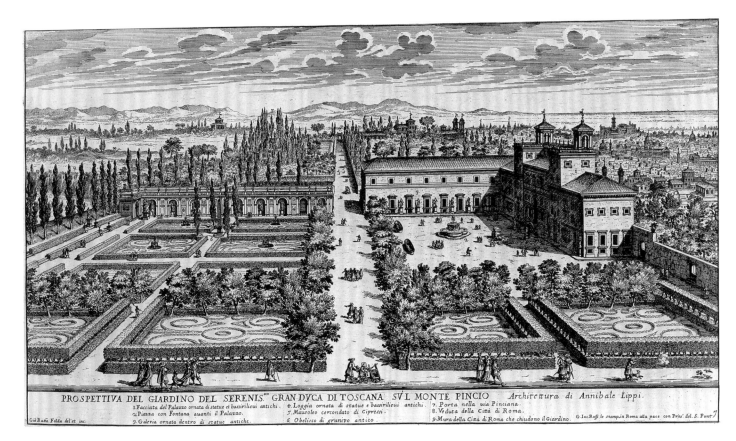

PROSPETTIVA DEL GIARDINO DEL SERENIS.mo GRAN DVCA DI TOSCANA SVL MONTE PINCIO *Architettura di Annibale Lippi.*

1. Facciata del Palazzo ornata di statue et bassirilievi antichi. 4. Loggia ornata di statue e bassirilievi antichi. 7. Porta nella via Pinciana.
2. Piazza con Fontana auanti il Palazzo. 5. Mausoleo circondato di Cipressi. 8. Veduta della Città di Roma.
3. Galeria ornata dentro di statue antiche. 6. Obelisco di granito antico. 9. Mura della Città di Roma che chiudono il Giardino.

Giõ Batã Falda del et inc: G. Iac Rossi le stamp.in Roma alla pace con Priu.l del S. Pont.

FIG. 13. Giovanni Battista Falda (Italy, 1648–1678), *Perspective View of the Villa Medici, Rome*. Engraving from *Li Giardini di Rome* (Rome: G. G de' Rossi, 1683). Dumbarton Oaks, Studies in Landscape Architecture, Washington, D.C.

The Avenue of the Fountains (cat. 52B), the broad central avenue leading up to the palace, della Bella depicts figures at the entrance to the avenue and far along it, inviting the viewer to move through the garden similarly in imagination.

How well della Bella's style and technique convey the character of a wilder natural setting is evident in the contrast between his *Tree House* at Pratolino (fig. 12) and Falda's *Fountain of the Shepherds* (cat. 26A). The great architectural fountain in Falda's view, like those at the Villa d'Este, supports the steep rise in ground level, with stairs at the sides and a great cascade of water down the center. With the angle view and a skillful use of one-point perspective, Falda stresses the fountain's massive structure and classical architectural forms against the foil of the luxuriant vegetation of the wooded hillside.[16] Emphatic contrasts of light and dark and cast shadows drench the scene in the strong Roman sunlight. In della Bella's *Tree House* instead, nature forms the architecture—a gigantic oak tree with entwining staircases and a platform for dining, which in the print is framed by tall trees. The dense foliage of the tree house and surrounding trees entirely fills the frame, and della Bella's looser, scumbly, tonal technique gives the sense of sunlight filtering through the deep shade of the wooded realm.[17]

Renaissance and Baroque gardens also playfully blurred the distinction between natural and artificial, which was particularly manifest in grottoes and automata. Man-made grottoes were encrusted with a rustic surface, obtained from limestone deposits in natural mountains and petrified materials in river- and lake beds, and some appeared deceptively natural. At Pratolino the interior of the grottoes in the lower level of the palace, including those of Pan and Fame (cat. 52D), and the exterior of the grotto of Cupid (cat. 52E) display the rough surfaces that for contemporaries signified the wild in nature. The architect Bernardo Buontalenti, who designed the great grotto at the Boboli Gardens in Florence, also designed the automata in the grottoes at Pratolino, life-size figures animated by

water power, moving mises-en-scènes from classical mythology. At the Villa d'Este the hydraulic devices instead produced musical sounds in the water organ, birdsong, and the crashing noises of artillery. Visitors to the garden delighted in these tricks to eyes and mind, with a sensibility and sense of humor very different from our own.

The gardens were, above all, places of public spectacle—to be seen, to converse, to participate in banquets and games, to encounter other social classes, and to watch theatrical events. While escape from the city and solitary contemplation of nature also feature in the idea of gardens inherited from classical antiquity, prints of the gardens instead emphasize their social aspect. In them we can distinguish roughly four categories of people: workers; the general public relaxing and playing; elegantly dressed visitors viewing and admiring the natural and artificial marvels of the garden; and princes and nobles arriving in a carriage, with a servant, or greeted with appropriate deference, all of which can be seen in Falda's perspective view of the Villa Medici in Rome (fig. 13). The stylish upper class, in families, couples, or male pairs, stop, look, and gesticulate toward the fountains, the men sometimes with their walking sticks or swords, and they converse with each other about what they see. Gardeners are a noticeable presence in Falda's fountains and gardens of Rome, even in the foreground of the Villa Medici view, as well as in Venturini's etchings of Tivoli. They hold shovels or rakes, push wheelbarrows, or cart clippings or a potted plant.[18] They are not an invisible presence; they inhabit the garden together with the leisure class.

The prints also represent gardens as a site of leisure and play. Figures stroll, sit, lounge, and lie on stone ledges, hold a goblet of wine, picnic, and play, particularly escaping the hidden water jets that so captivated all social classes, as in Falda's *Fountain of the Shepherds* (cat. 26A). The loungers, youths, and more rustically dressed visitors may be local residents who spend time in their neighborhood gardens. In Rome from the Renaissance there was a tradition of the right of public ac-

cess to gardens, the *lex hortorum*, for all Romans and anyone who wished to enter.[19] This was the case at the Villa Lante at Bagnaia as well, since public land was appropriated for the garden, and may have been true at the Villa d'Este at Tivoli, constructed through a similar appropriation, controversial in both cases.[20] But the prints, especially della Bella's images of Pratolino, suggest that it may have been true of gardens elsewhere as well.

Particularly noteworthy in the prints, and absent from almost all written documents, are women in the gardens, sometimes accompanied by children. These, along with the lower-class figures in garden prints, contrast starkly with the evidence of some other collections. For example, at Ulisse Aldrovandi's natural science museum the guest book was classified by profession and social rank, and those not distinguished in any of its categories were not invited to sign and record their appearance. Only one woman, Ippolita Paoletti, signed Aldrovandi's guest book, although we know that Caterina Sforza visited in 1576 along with an entourage of fifty women and over one hundred fifty gentlemen.[21] Their presence and that of all other female visitors does not appear in the written records of either Aldrovandi's museum or gardens. The travel journals, for example, never mention a female in a garden. Of the tree house at Pratolino one observer at the end of the sixteenth century noted that on the platform in the great oak "many men" could dine, but in della Bella's etching (fig. 12) it is instead women who sit, drink wine, and dine there.[22] Women in each of the four social classes and in significant numbers appear in these seventeenth-century prints, in conventional poses but present nonetheless. The gardens are represented in the prints as a social space, one in which all classes and both sexes worked, played, and interacted.

The entertainment in gardens extended beyond tree-house dining and escaping unsuspected water jets to lavish spectacles produced for visiting popes or nobility, jousts, tournaments, grand banquets, fireworks, theatrical performances, and operatic productions.[23]

The garden was both the setting of these events and a stage set in theatrical productions, many widely reproduced in prints, in Florence by the court printmakers Jacques Callot and later della Bella.[24] Florence was especially noted for its theatrical machinery and magical illusions, from the automata in sixteenth-century gardens, like those in the grotto of Pan and Fame at Pratolino (cat. 52D), to the extravagant special effects in seventeenth-century spectacles.[25] The marriage of Grand Duke Ferdinand II with Vittoria della Rovere in 1637 featured a stunning opera, *The Wedding of the Gods*, in the Pitti Palace courtyard, with extravagant stage sets for each of the gods, most in an appropriate natural setting—woodland (Diana), sea (Neptune), grotto (Vulcan), and garden (Venus) (cat. 99B), all recorded in seven etchings by della Bella. Equestrian ballets were another speciality of Florence,[26] and they featured in the 1637 wedding festivities, as well as those in 1661 for Ferdinand's son, Cosimo III (the youth drawing the colossal Medici Vase in della Bella's etching) and Marguerite Louise of Orléans. These events were moved from city squares to the Boboli Gardens in the seventeenth century, when the amphitheater of greenery behind the Pitti Palace was transformed into one of stone. Equestrian ballets such as *The Rejoicing World* (fig. 14) for the 1661 wedding featured both horsemen and cavaliers forming elaborate geometric patterns, often in a carousel formation around a central figure or float, here Ferdinand Tacca's giant Atlas, which was then magically transformed into his namesake, Mount Atlas.[27] The floats and equestrian ballets would be easily visible from seating all around the amphitheater and the palace, as della Bella suggests with his depiction of the vast audience of twenty thousand. The incredible extravaganzas aimed to astound the spectators and to demonstrate the power and prestige of the court, and in the case of Florence, the marriages signaled significant political alliances. The twenty days of festivities for the 1661 marriage belie the fact that by then the fortunes of the Medici had seriously declined. Many of the prints of

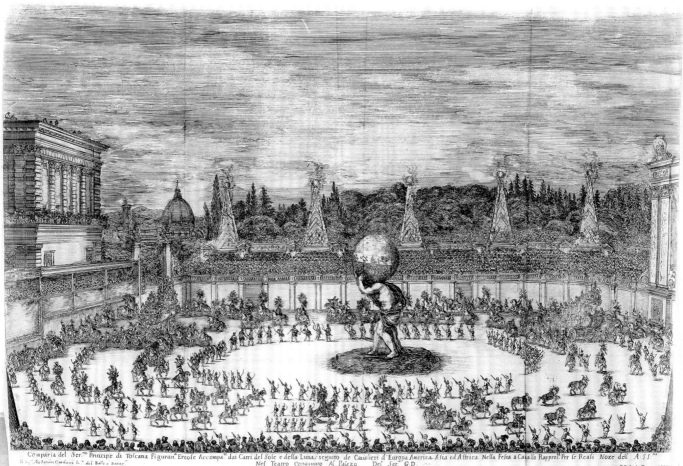

FIG. 14. Stefano della Bella (Italy, 1610–1664), *The Rejoicing World. The Entrance of Hercules*, from G. A. Moniglia, *Il Mondo Festeggiante*, 1661. Etching, 29 × 44 cm. The Metropolitan Museum of Art, New York (Harris Brisbane Dick Fund, 1940, 40.61.1).

Medici spectacles, including the two wedding festivities, accompanied published texts describing them. The libretto of 1661 with three of della Bella's etchings, for example, was produced in an edition of four hundred.[28] As with the prints of gardens themselves, those of the spectacles served as a key to sorting out the complicated mythological characters while the performance was in process, as a reminder for those who had attended, and as wide publicity for all those who did not.

Throughout the centuries foreigners remained strongly interested in Italian gardens from the first wave of visitors on the Grand Tour in the sixteenth century to French and English artists such as Jean-Honoré Fragonard (cat. 56), François-Marius Granet (cat. 58), and James Baker Pyne (cat. 59), who drew more intimate and evocative scenes of the gardens in the eighteenth and nineteenth centuries. The gardens themselves increasingly evidenced the effects of time and neglect, and in the early photographs of the gar-

dens, such as Gustave Eugène Chauffourier's of the Villa d'Este (cat. 60), we can see the attraction they might have for foreigners as the overgrown vegetation and changes in planting considerably softened the order and symmetry of the original garden. By the time that Charles A. Platt visited Tivoli at the end of the nineteenth century, it was in a state of "great dilapidation and decay."[29] This condition appealed to the many British and American visitors around the turn of the twentieth century, who found Italian gardens "full of mystery, of haunting beauty, of magic."[30] These authors, among them Edith Wharton, sought models for their own Italianate garden creations, and the declined condition of the gardens and their practical aims allowed them to see in them a harmony between art and nature, created out of foliage, stonework, and water.[31] In their view this harmony avoided the extremes of the formal French garden on the one hand and the natural English garden on the other. The photographs and watercolors that these visitors made likewise attempted to capture the telling detail that signaled for them the character of the whole, or a broader view that conveyed the harmony they perceived between art and nature.[32]

Many restorations of Italian gardens took place in the twentieth century, spurred on by the interest of foreign visitors, but even more inspired by nationalism and, in the Fascist era, the desire to claim them as demonstrations of cultural supremacy. Italian authors, along with the architects who restored them, emphasized, instead of harmony with nature, the order and architectural aspect of the gardens, even the domination and subjugation of nature by the hand of man.[33] Since they are constantly changing, gardens, more than any other art form, vividly exemplify the instability of the past and the difficulty of recovering an original, fixed work of art. Nature, the most essential and most ephemeral aspect of gardens, is also the most subject to change, at the hands of time, of taste, and of interpretation. The surviving Italian Renaissance and Baroque gardens cannot be other than a palimpsest of these changes over time.

NOTES

1. I thank James Cutting for his valuable comments on the perspective system and perception in these prints.

2. Claudia Lazzaro, *The Italian Renaissance Garden: From the Conventions of Planting, Design, and Ornament to the Grand Gardens of Sixteenth-Century Central Italy* (New Haven and London: Yale University Press, 1990), chap. 2; and Elisabeth Blair MacDougall, "A Cardinal's Bulb Garden: A *Giardino Segreto* at the Palazzo Barberini in Rome," in *Fountains, Statues, and Flowers: Studies in Italian Gardens of the Sixteenth and Seventeenth Centuries* (Washington, D.C.: Dumbarton Oaks, 1994), 221–35.

3. Elisabeth Blair MacDougall, "An Introduction to Roman Gardens of the Sixteenth Century," in *Fountains, Statues, and Flowers*, 1–22; and David R. Coffin, *Gardens and Gardening in Papal Rome* (Princeton: Princeton University Press, 1991), 17–27.

4. David R. Coffin, *The Villa d'Este at Tivoli* (Princeton: Princeton University Press, 1960), chap. 2.

5. Luigi Zangheri, *Pratolino: il giardino delle meraviglie*, vol. 2 (Florence: Edizioni Gonnell, 1979), 148.

6. Caterina Caneva, *Il giardino di Boboli* (Florence: Becocci Editore, 1982), 34–60, for a catalogue of sculpture, ancient and modern, in the garden. Some of the ancient statues at Castello are illustrated in Cristina Acidini Luchinat and Giorgio Galletti, *Le ville e i giardini di Castello e Petraia a Firenze* (Florence: Pacini Editore, 1992), 60, 104–7.

7. Carlo Gasparri, "La collection d'antiques du cardinal Ferdinand," in *La Villa Médicis*, vol. 2, *Etudes* (Rome: Académie de France à Rome, 1991), 446–47, 458, 479.

8. *Specchio di Roma barocca: una guida inedita del XVII secolo*, ed. Joseph Connors and Louise Rice (Rome: Edizioni dell'Elephante, 1991), 157.

9. John Dixon Hunt, "'Curiosities to Adorn Cabinets and Gardens,'" in *The Origins of Museums: The Cabinet of Curiosities in Sixteenth- and Seventeenth-Century Europe*, ed. O. Impey and A. MacGregor (Oxford: Clarendon Press, 1985), 196, for Evelyn and generally 192–99.

10. Horst Bredekamp, *The Lure of Antiquity and the Cult of the Machine: The Kunstkammer and the Evolution of Nature, Art, and Technology*, trans. Allison Brown (Princeton: Markus Wiener Publishers,

1993), 11–19; and Paula Findlen, *Possessing Nature: Museums, Collecting, and Scientific Culture in Early Modern Italy* (Berkeley and Los Angeles: University of California Press, 1994), passim and 136–46 on visitors to Aldrovandi's museum.

11. Travelers and collectors might construct their own compilations of views and bind them in volumes. One extreme example is in the New York Public Library, a collection of seventy-two volumes of Italian prints by an English traveler, bound in London in 1752, noted by Diane K. McGuire, "Giovanni Battista Falda and the Decorative Plan in Three Italian Gardens," *Connoisseur* 159 (1965): 63 n. 1.

12. Giovanni Maggi's *Fontane diverse . . . di Roma* of 1618 was followed by Domenico Parasacchi's *Raccolta delle Principali Fontane . . . di Roma* in two different editions in 1637 and 1647, discussed in Elisabeth B. MacDougall and Naomi Miller, *Fons Sapientiae: Garden Fountains in Illustrated Books* (Washington, D.C.: Dumbarton Oaks, 1977), 58.

13. Maurizio Gargano, "Villas, Gardens and Fountains of Rome: The Etchings of Giovanni Battista Falda," in *The Architecture of Western Gardens*, ed. Monique Mosser and Georges Teyssot (Cambridge, Mass.: MIT Press, 1990), 166–68.

14. Cesare d'Onofrio, *La Villa Aldobrandini di Frascati* (Rome: Staderini, 1963), 102, for the aqueduct, from a description by Gian Battista Agucchi of 1611 written for the cardinal's old friend, Duke Carlo Emmanuele I of Savoy, and pl. 72 for the fountain.

15. For contemporary hunting practices and the suggestion that hunting on horseback for large wild game took place at Pratolino, see D. R. Edward Wright, "Some Medici Gardens of the Florentine Renaissance: An Essay in Post-Aesthetic Interpretation," in *The Italian Garden: Art, Design and Culture*, ed. John Dixon Hunt (Cambridge: Cambridge University Press, 1996), 49–58.

16. McGuire, "Falda and the Decorative Plan," 59–63.

17. Sue Welsh Reed and Richard Wallace, *Italian Etchers of the Renaissance and Baroque*, exh. cat. (Boston: Museum of Fine Arts, 1989), 239–40.

18. Coffin, *Gardens and Gardening*, 224–26, and see 222–23 on garden tools.

19. David R. Coffin, "The 'Lex Hortorum' and Access to Gardens of Latium during the Renaissance," *Journal of Garden History* 2 (1982): 201–32.

20. Claudia Lazzaro, "The Sixteenth-Century Central Italian Villa and the Cultural Landscape," in *Architecture, Jardin, Paysage*, ed. Jean Guillaume (Paris: Picard, 1999), 37–38; and Coffin, *Villa d'Este*, 7–8.

21. Findlen, *Possessing Nature*, 143–44.

22. Agostino del Riccio, Agricoltura teorica, Biblioteca Nazionale Centrale Firenze, Targioni Tozzetti, 56, fol. 30.

23. Coffin, *Gardens and Gardening*, 227–34, for the entertainment in Roman gardens, similar to that elsewhere.

24. Arthur R. Blumenthal, *Theater Art of the Medici*, exh. cat. (Hanover, N.H.: Dartmouth College Museum and Galleries, 1980); and *The Age of the Marvelous*, exh. cat., ed. Joy Kenseth (Hanover, N.H.: Hood of Museum Art, 1991), 386–415.

25. Mark S. Weil, "Love, Monsters, Movement, and Machines: The Marvelous in Theaters, Festivals, and Gardens," in *The Age of the Marvelous*, 159–69.

26. Wright, "Some Medici Gardens of the Florentine Renaissance," 46–47.

27. Blumenthal, *Theater Art of the Medici*, 194–99; and Luigi Zangheri, "Il Maxiautoma dell'Átlante e Ferdinando Tacca," *Psicon* 6 (1976): 116–23.

28. Zangheri, "Il Maxiautoma," 116, 117 n. 4.

29. Charles A. Platt, *Italian Gardens*, ed. Keith N. Morgan (Portland, Oreg.: Sagapress/Timber Press, 1993), 51.

30. George R. Sitwell, *On the Making of Gardens* (London: J. Murray, 1909), 19.

31. Edith Wharton, *Italian Villas and Their Gardens* (New York: The Century Co., 1904), 7.

32. For the understanding of these British and American authors, see Claudia Lazzaro, "The Italian Garden in the Early Twentieth Century: Two Different Concepts / Il Giardino all'Italiana nel Primo Novecento: Due Concetti Diversi," in *Ville e giardini italiani: I disegni dell' American Academy in Rome*, ed. Vincenzo Cazzato (Rome: American Academy and Soprintendenza dei Monumenti, 2001), 1ff.

33. This is discussed at length in Claudia Lazzaro, "Politicizing a National Garden Tradition: The Italianness of the Italian Garden," in *Donatello among the Blackshirts: History and Modernity in the Visual Culture of Fascist Italy*, ed. Roger Crum and Claudia Lazzaro, forthcoming.

The Garden Print as Propaganda, 1573–1683

ELIZABETH S. EUSTIS

The age of absolute monarchy in Europe produced a correspondingly absolute garden style that characterized courtly gardens of the seventeenth and eighteenth centuries. Originating in Italian Renaissance revivals of imperial Roman architecture, the absolute garden served not only as an amenity but also as a metaphor for supreme rank and power, "absolute" in its ultimate artistry, implied expanse, strict geometry, and especially in the authoritarian will and means of its owner. Following the invention of the printed garden prospect in the early 1570s, publishers and printmakers expanded the reach of such potent symbolism through the creation and widespread dissemination of etched and engraved views, initially for a commercial audience. By the 1660s the French king and his ministers, especially Jean-Baptiste Colbert, had recognized the potential of garden prints as propaganda, advertising the realm of the monarch as an ideally ordered world—marvelous, desirable, and perfect. From the expansion

· *41* ·

of Versailles until the British ascendancy in the eighteenth century with its attendant promotion of a counter-aesthetic in the English landscape garden, the absolute garden view served as a vehicle for the glory of the king and his centralized modern state.

The propagandistic garden print evolved primarily in France but, like the absolute garden itself, developed from the Italian revival of classical prototypes in monumental garden architecture. In about 1505 Donato Bramante reintroduced symmetrical grandeur on the ultimate Roman scale in an outdoor extension of palace architecture, the Vatican Belvedere Court. From 1516 to 1520 Raphael created the seminal classically inspired garden for Cardinal Giulio de' Medici, later Pope Clement VII, at the Villa Madama outside Rome. Shortly after the Medici were restored to rule in Florence in 1537, Niccolò Tribolo designed for Duke Cosimo I de' Medici at Castello the first modern garden with an iconographic program promoting dynastic and political power. During the 1550s and 1560s, the notoriously ambitious Cardinal Ippolito d'Este created stupendous gardens at his Villa d'Este at Tivoli, with an elaborate sculptural program largely signifying his own importance and worthiness of the papacy. Not to be outdone, Grand Duke Francesco de' Medici commissioned equally marvelous gardens at Pratolino outside Florence in the decade after 1570. With their elaborate statuary and waterworks, Tivoli and Pratolino established the new standard for garden grandeur that was to be adopted by the French monarchy.

ROYAL GARDENS OF THE FRENCH RENAISSANCE

In 1533 the fourteen-year-old orphan Catherine de' Medici, sole legitimate descendant of the great Cosimo and Lorenzo de' Medici, was married off by her uncle Pope Clement VII to the provincial prince who would later become the French King Henri II. Widowed by a jousting accident, she became queen-regent in 1560, more powerful as the "Mother of Three Kings"

than as a neglected wife. She followed the great garden-making precedents of her papal uncle and her cousin Francesco, building the Tuileries Palace from 1564 to 1572 with the largest gardens in Paris. In the Italian Renaissance style new to France, numerous rectilinear garden compartments were aligned on a unified axis with the palace, although the intended symmetry of the overall design was not fully achieved. Italianate features also included fountains, a labyrinth, formal groves, arcade-arbors, pavilions, and a naturalistic ceramic grotto.[1] In 1573 Catherine staged there a famous reception for the ambassadors who came to offer the throne of Poland to her son, effectively inaugurating the principal Parisian garden creation of the century with the first French performances of ballet, violin playing, and castrato singing.[2] In a primitive example of official printmaking, woodcuts including an image of a silver mountain bearing ladies of the court illustrated a commemorative poem written by the royal poet (fig. 15).[3]

In the same year, Etienne Dupérac, a French architect and printmaker active in Rome, applied Renaissance techniques of perspective to the first published large garden prospect, a simulated view of the new gardens of the Villa d'Este at Tivoli based on a design in the process of construction (cat. 53).[4] Commissioned by Cardinal Ippolito d'Este, a close friend of the French court, as a drawing to be given to the Holy Roman Emperor, Dupérac's prospect was originally intended as a privileged communication from one aristocrat to another in a sophisticated new visual language conveying the wealth, taste, and power of his patron. His drawing became a popular image only after the cardinal's death, when Antoine Lafréry, the leading commercial publisher in Rome, issued the artist's etching of the same prospect.

This new visual language was in itself sovereign. A contemporary book of city views described the expansive prospect, not as a bird's-eye, but as a God's-eye view.[5] The composition itself had meaning, conveying to the observer a supernatural capacity to comprehend

a vast area in a gaze, not as a schematic map, but almost as if it were really before one's eyes.

Dedicating his print to Queen Catherine, Dupérac advertised his virtuosic achievement and sought the patronage of the French regent, not as a draftsman or printmaker (he published no further prints after his return to France), but as an architect and decorative artist.[6] He clearly wished to associate himself with the design of the Villa d'Este, and he probably made contributions to its configuration on paper.[7]

Dupérac's view was reissued time and again by the original publisher and his heirs, and copied and imitated by other printmakers for eighty years or more.[8] His idealized design, more perfectly geometric and more complete than the garden, was copied by subsequent printmakers, rather than corrected by reference to the actual garden. The print remained constant as a model of garden design even more widely influential than the garden itself.

In 1595, as the French Wars of Religion drew to a close and a new royal building program began, Dupérac was finally appointed royal architect by the new king, Henri IV. After his death, the royal gardener Claude Mollet, who credited Dupérac with introducing the large-scale *parterre de broderie* to France, praised him as "that very illustrious personage the late Sire du Perac, grand Architect of the King."[9] We know too little of his achievements, but based on the print evidence, he probably designed the terraced, axial gardens at the royal country palace of Saint-Germain-en-Laye (fig. 16). Strongly influenced by the Vatican Belvedere and the Villa d'Este, both of which he had portrayed, Dupérac was able at Saint-Germain to achieve classical symmetry, rather than relying on artistic license to perfect a picture as in his Tivoli view.[10] The use of symmetry on such a scale, based on imagined reconstructions of Roman designs—a speciality of Dupérac during his Italian period—suggested rule over an ideally ordered world.

The other important French architect-printmaker influenced by Italian Renaissance models was Jacques

FIG. 15. Jean Dorat (France, 1508–1588), *Ladies of the Court*. Woodcut from *Magnificentissimi Spectaculi, A Regina Regum Matre in hortis suburbanis editi, In Henrici Regis Poloniae invictissimi nuper renunciati gratulationem, Descriptio* (Paris: F. Morel, 1573). Houghton Library, Harvard University.

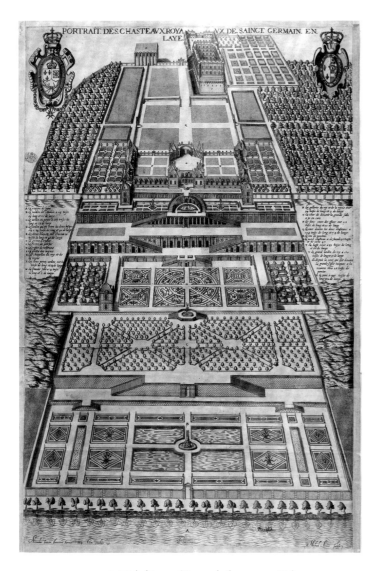

FIG. 16. Michel Lasne (France, before 1590–1667),
after Alessandro Francini. *Portrait Des Chasteaux Royaux
De Sainct Germain En Laye*. Etching and engraving, 82.4 × 54 cm.
British Library, King's Topography Collection LXVI.4.D.

Androuet Du Cerceau, who was motivated by the patronage of Catherine de' Medici to publish the first national compendium of design.[11] *Les Plus Excellents Bastiments de France* expanded the given repertoire of architectural drawing to include the first prospects of palatial French gardens. Androuet Du Cerceau advocated the classical ideal of unified design and advertised French grandeur triumphing over decades of civil strife. Today his volumes are valued as essential documents of Renaissance architecture and garden history. However, based on the evidence of imitations, they were less influential than Dupérac's view: only a few of them were copied once in the 1630s.[12] Paris was not yet a printmaking center comparable to Rome, and France did not yet export fashion.

The rise of absolute monarchy in France developed in tandem with the royal garden view. In 1576, the same year that Androuet Du Cerceau's first volume appeared, Jean Bodin published the seminal modern theory of sovereignty, according to which the king is the source and the enforcer of all civil law.[13] Amid the chaos of civil war, there was a perceived need to establish one absolute authority to restore order and prosperity. Previously, a more hierarchical social order had been regarded as divinely ordained, with a powerful feudal nobility and clergy, in which kings had their place with balanced privileges and responsibilities, theoretically subservient to the Holy Roman Emperor and the pope. The social breakdown of the sixteenth century, when noble families led internecine conflicts extending even to regicide, prompted a new differentiation of power, reducing the prominence of the clergy and the nobility, while strengthening the position of the monarch. Over the next fifty years, subsequent political theorists grafted Bodin's theory onto the old idea of the divine right of kings to assert a new concept of absolute monarchy. By the time Cardinal Richelieu became prime minister in 1624, the stage was set for his promotion of absolute power on behalf of Louis XIII (whom he in fact manipulated and controlled).

SALOMON DE CAUS AND THE GARDEN OF SOVEREIGNTY

Throughout the seventeenth century, as sovereigns jockeyed for position in a changing European political order, the creation of important gardens accompanied ascendancy to the highest rank of power. Emerging from the dominance of emperor and pope, European territories developed autonomous identities as states ruled by independent sovereigns. The garden of sovereignty symbolized the well-ordered delight and prosperity of a domain and the beneficence of its government. Prevalent ideas of decorum mandated that degrees of extravagance in gardens, as in all other forms of display, correlate appropriately to the owner's rank. The importance of orange trees in princely gardens and references to them as "the golden apples of the Hesperides"—a divinely bestowed reward to Hercules for the completion of his Labors—reflected some insistence that horticultural luxury was a God-given prize merited by the heroic resident lord.

The itinerant career of the French Huguenot Salomon de Caus illustrates the demand for a leading designer and engineer of gardens, grottoes, and fountains.[14] After studying garden design and hydraulics in Italy and Germany, he worked in Brussels for the Spanish Infanta Isabella and her husband, Archduke Albert VII of Austria. His new gardens and elaborate fountains corresponded to Isabella and Albert's increased status as sovereigns of the newly independent southern Netherlands. By 1610 he had moved to England, where he created Italianate gardens at Richmond Palace and Somerset House for the young Stuart heir Prince Henry and his mother. After the sudden death of the prince, de Caus followed a new rising patron, Princess Elizabeth Stuart, who moved to Heidelberg on her marriage to the Elector Palatine, Frederick V. This union confirmed the position of Frederick V as the leading champion of Protestant Europe. He too manifested his heightened importance by commissioning vast and marvelously engineered garden terraces at Heidelberg, with fountains, grottoes, and automata, all designed by de Caus.

In about 1616 Frederick's court artist, the Flemish painter Jacques Foucquier, painted a prospect of the Hortus Palatinus combining a Medici type of garden view emblematic of dynastic sovereignty with a Flemish landscape style invented by Pieter Bruegel the Elder.[15] Like Bruegel's landscapes, Foucquier's composition stretches from a high mountainous vantage point along a river to a far horizon, with a plethora of details of daily life receding into the distance. When Frederick and Elizabeth became king and queen of Bohemia in 1620, Matthaeus Merian reproduced this painting on four copperplates, attaching their printed impressions together to create the most imposing garden print of its time (fig. 17). An early example of the garden print as political propaganda, the Hortus Palatinus advertised Frederick's domain as an endless vista of natural beauty improved by artistry, technology, and the power to command them.

Within a year, however, armies of the Habsburg emperor drove Frederick and Elizabeth from the Bohemian throne. Heidelberg was invaded and its famous gardens were pillaged. Their destruction carried the same symbolic importance as their creation and publication.

THE LUXEMBOURG PALACE OF MARIE DE' MEDICI

In 1610 Marie de' Medici became the second Medici queen-regent of France on the death of her husband, Henri IV. Moving swiftly to purchase the Hôtel de Luxembourg and its adjacent lands, she built the new Luxembourg Palace with the second-largest gardens in Paris. Like her birthplace, the Pitti Palace in Florence, this functioned as a suburban villa just across the river from the walled city, and like her father's creation at Pratolino, its gardens and fountains excited international admiration.

Marie's strong interest in flowers and gardens stimulated the development of new French horticultural

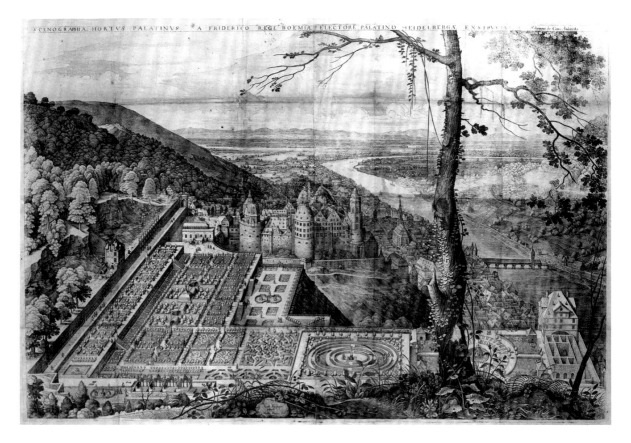

FIG. 17. Matthaeus Merian the Elder (Switzerland, 1593–1650), after Jacques Foucquier, *Scenographia Hortus Palatinus A Friderico Rege Boemia Electore Palatino Heidelbergae Exstructus 1620 Salomone de Caus Architecto*. Engraving, 63.8 × 98.9 cm. The Dumbarton Oaks Research Library and Collections, Washington, D.C.

fashions. As early as 1608 Pierre Vallet dedicated to her a book portraying flowers from the royal botanical gardens, the second florilegium ever to be published, praising her as "the Flower of all Queens, . . . this divine flower of Florence united with the lily of France by Heavenly edict. . . ."[16] Her garden designers were among the first to publish and export French garden style in several parterre pattern series.[17]

The close alliance of the ducal court at Nancy with Marie de' Medici influenced the garden setting and dedication of an etching by Jacques Callot of 1625, *The Parterre of the Palace at Nancy* (cat. 98). This innovative portrayal of a sovereign at leisure presents the parterre as a stage for the performance of noble recreation. Formerly an artist to the Medici court in Florence, Callot had recorded festivities set in the gardens of the Pitti Palace and fully understood the value to a patron of publicizing dynastic open-air celebrations. In his parterre scene he depicted the young Nicole, duchess of

Lorraine, at the center of a proscenium-like terrace in a garden composition based more on the single-point perspective of Florentine stage-set design than on the architecture at Nancy.[18] Here, the theatrical aspect of the garden expands beyond the special effects of any grotto or ephemeral festival to encompass the life of the court.

THE PRIVATE GARDENS OF CARDINAL RICHELIEU

In 1624 Cardinal Richelieu became chief minister to the council of Louis XIII. Like Catherine and Marie de' Medici before him, Richelieu began to express his new power by creating extravagant palaces and gardens. From the time of Marie's exile in 1630, Richelieu took over the role of building the most important new gardens in France. He had earlier overseen construction of the Luxembourg as superintendent of the queen's

household and finances, a formative experience that taught him the promotional value of various art forms, including gardens. All three of these leading Parisian garden-makers had risen from families of mercantile origin regarded as outsiders by the old nobility. Their embellishment of great landholdings represented a claim to preeminent social as well as political status.

At the Palais Cardinal (now the Palais Royal) Richelieu commissioned the third-largest gardens in Paris after the Tuileries and Luxembourg gardens, lauded by the playwright Corneille as superb. Richelieu expanded the modest ancestral Château de Richelieu into one of the first model towns, planned on an axis with palatial new gardens. At Rueil he developed delightful gardens later coveted by Louis XIV.

It is notable that Richelieu—a master of political propaganda—did not widely advertise his gardens: printed views of them did not exist during his lifetime. Instead, he fortified his own position by promoting the king's magnificence as absolute monarch. Although Louis XIII cared little for aesthetic display, Richelieu appointed François Sublet de Noyers to oversee costly improvements at Fontainebleau. In 1642 Sublet de Noyers sponsored *Le Trésor des Merveilles de la Maison Royale de Fontainebleau*, the first French monograph on the architecture, art, and gardens of a château, glorifying the Bourbon monarchy by association with the principal seat of Valois artistic patronage.[19]

THE GARDEN *VEDUTA*

Meanwhile in Rome, a new kind of view developed known as the *veduta:* a human's-eye view of a real place, directly observed by the artist and drawn on-site from a realistic vantage point. Johann Wilhelm Baur of Strasbourg produced the first *vedute* of gardens in 1636, small, informal etchings that focus internally on parts of the garden.[20] His delicate handling of the etching needle was stylistically allied to northern landscape art and book illustration rather than to the plans, semicartographic style, and theatrical compositions of most topographical garden prints. He abandoned the grandeur of the prospect required by a lordly patron in favor of a personally inspired, unpretentious picture. Bringing a new spontaneity and immediacy to his subject, Baur introduced the lively incident of visitors fleeing from water tricks (fig. 18).

Two young French printmakers in Italy, Israël Silvestre and Dominique Barrière, absorbed the lessons of Baur's garden views. During the 1640s and early 1650s Silvestre transmitted the *veduta* style to France, traveling from place to place, drawing châteaux, gardens, and landscapes that were published as minor souvenirs, sometimes as small as large postage stamps. Meanwhile Barrière remained in Rome, advancing from schematic fountain elevations to reproductive prints and landscape views. Retained by the Aldobrandini family to portray their new villa at Frascati, he dedicated the resulting series to the young Louis XIV in 1647.[21] Within a year of this publication, Barrière was commissioned by the family of Pope Innocent X to publicize their lavish new Villa Pamphili and extensive sculpture collection.[22]

Barrière invented the sequential progression of views through a single garden. A comparison of his two series reveals that while his views of the Villa Aldobrandini are of various sizes, the Pamphili views were clearly planned from the outset as an integral group of uniform format. He assembled his Aldobrandini plates as a journey from the surrounding landscape to the house and garden, from its architectural water theater to a remote fountain in naturalistic surroundings. At the Villa Pamphili, he moved from a frontal elevation to a symmetrical view over the garden, to an oblique composition showing the pope promenading beneath a parasol, to the water theater and grottoes, and finally to a wild garden with fountain, cascade, and rustic pool. In each work, this exterior progress is followed by reproductions of works of art housed at the villa.

Following Barrière's innovation, Silvestre began to create sets of views of French gardens. In 1649 his early Fontainebleau series progressed through court and garden to the rustic grotto.[23] Whereas Barrière expanded the scale of his work to meet the requirements

of his lordly patrons, Silvestre retained the small size and spontaneity of Baur's *vedute*, presumably for visitors' souvenirs. His little etching of the Jardin de l'Estang shows the unpretentious informality of his early period (fig. 19).

In 1650 Silvestre's friend and sometime collaborator, Stefano della Bella, returned to Florence after almost a decade in Paris. At Pratolino he made his only series of garden prints, showing the Medici gardens almost eighty years after their creation (cat. 52A–F). These *vedute* retain the spontaneous informality of Baur's and Silvestre's views, with figures picnicking in a tree house, napping, bowing, drinking from a fountain.

After his last trip to Italy in 1653, Silvestre developed a more polished style, probably influenced by della Bella and Barrière, and began to receive commissions from noble French patrons to portray their gardens. In 1661, some twenty years after Richelieu's death, his gardens at Rueil were at last published in a series of views commissioned by his heir from Silvestre.

NICOLAS FOUQUET AND VAUX-LE-VICOMTE

The centralized power of the chief ministers to the French crown continued from Cardinal Richelieu, through his protégé Cardinal Mazarin, to the younger rivals Nicolas Fouquet and Jean-Baptiste Colbert. Like Richelieu and Mazarin before him, Fouquet, the minister of finance, used his position to increase his wealth and spent much of his money developing a reputation as the nation's leading patron of the arts. Fouquet, however, lacked Richelieu's brilliant understanding of power, politics, and personalities; moreover, unlike his predecessor, he could not dominate his king.

Following the precedent of Richelieu, Fouquet set out in 1656 to create a splendid château with gardens on a long axis at Vaux-le-Vicomte (cat. 63). There he harnessed the architect Louis Le Vau, the painter and decorator Charles Le Brun, and the garden designer André Le Nôtre to work together for the first time. He

also commissioned Silvestre to move to Vaux to make views of his new creation, probably inspired by Barrière's Pamphili series. Silvestre expanded the scale of his work to magnify the new French garden of supremacy. His large symmetrical prospect overlooking the parterres from the palace is a prototype of the formal "infinite vista" in print. Following Le Nôtre's design, Silvestre effectively ironed out the kinks in the old Flemish "world landscape," substituting for a naturalistic universe the illusion of limitless artful control.

Fouquet, a bourgeois newcomer to the upper echelons of French society and governmental authority, followed Richelieu's precedent in manifesting his new importance by outdoing the old nobility in palace and garden design. Unlike Richelieu, however, he offended his king in the process. For Louis XIV, unlike his father, cared enormously about architecture and gardens as demonstrations of his own primacy. Whereas Richelieu had initiated royal garden works at the same time as his private projects, Fouquet never involved himself in enhancing the royal châteaux—that was left to the wilier Colbert. In Louis's view, Fouquet overstepped the bounds of propriety by challenging the preeminence of royal splendor. In 1661, a few weeks after an extravagant fête for the king that brought the royal court to Vaux for the first time, Fouquet was arrested and charged with misappropriation of government funds. The king himself ordered that he spend the rest of his life in solitary confinement. Colbert, who had fueled Louis's mistrust of Fouquet, became the king's senior minister. Throughout his career, Colbert took care not to outshine his sovereign, working ceaselessly to enhance and broadcast the king's glory and thereby the glory of France.

COLBERT AND ROYAL GARDEN PROPAGANDA

Following the disgrace of Fouquet, Colbert assigned the three designers of Vaux to transform the palace and gardens of Versailles. While the king's armies waged wars to expand the boundaries of the nation, Le Nôtre

transposed the infinite garden vista to Versailles to connote Louis's beneficent mastery of the world. With the expansion of Versailles during the 1660s and 1670s, and with Louis's extraordinary command in 1682 that this rural pleasure palace should become the seat of government and the permanent residence of his court, the garden attained an unprecedented degree of political importance.

Almost a century after the first publication of a garden prospect, Colbert recognized the potential of the garden view as a vehicle for promoting the glory of France. In the tradition of Richelieu, he made himself the mastermind of all aspects of French royal propaganda, introducing a highly sophisticated level of printmaking into the machinery of political propaganda as an instrument of royal and national prestige.

Just as he appropriated the talents that made Vaux, Colbert also attached Silvestre to his staff. He commissioned Silvestre to record the royal tournament of 1662, where Louis first appeared costumed as the Sun King. Silvestre became Draftsman and Printmaker to the King in 1663, with specific responsibility for drawing "architecture, views and perspectives of the Royal Houses, tournaments and other public assemblies."[24] Colbert instructed him to make large prints of the first great fête in the gardens of Versailles in 1664 (cat. 100). He sent Silvestre and Adam van der Meulen traveling to draft on-site views of royal châteaux and conquered territories. He also employed other leading printmakers to record garden festivities and ornaments, such as Sébastien Le Clerc's views of Aesop's-fable fountains in the labyrinth of Versailles.

Colbert regulated all French printmaking and specifically restricted publication of royal garden views, granting access to artists only by his personal approval. Most important, he conceived of the *Cabinet du Roi* as an encyclopedic series of prints of uniform size showing the king's most prized possessions and demonstrating royal patronage of the arts and sciences. He orchestrated dissemination of the *Cabinet*, instructing ambassadors and envoys to distribute its volumes as diplomatic favors. Only in 1679, as the costs of this

FIG. 18. Johann Wilhelm Baur (Germany, 1607–1642), *Vedute di Giardini* (Rome: C. Ferranti, 1636). Etching, 10 × 12.9 cm. New York Public Library. Astor, Lenox and Tilden Foundations, Print Collection, Miriam and Ira D. Wallach Division of Art, Prints and Photographs.

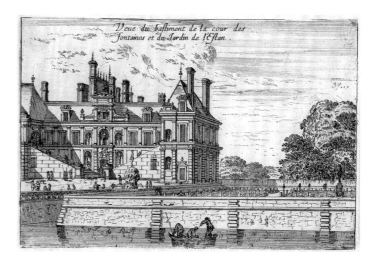

FIG. 19. Israël Silvestre (France, 1621–1691), *Veuë du bastiment de la cour des fontaines et du Jardin de l'Estan*, Paris, 1649? Etching, 10.5 × 16.1 cm. Houghton Library, Harvard University, Typ 615.50.791PF (I. 39).

project became too cumbersome for a government struggling to meet the expenses of war, did Colbert allow controlled commercial issue of these plates. After his death in 1683, royal print commissions declined precipitously.

In 1670 the royal historiographer André Félibien, directed by Colbert to describe the king's residences and celebrations, summarized the royal printmaking enterprise:

> As there is nothing in all the Arts that the King does not make useful to his People and the glory of his reign, he does not content himself with raising magnificent Edifices, or with decorating his Palaces . . . , or with employing an infinity of persons on all the Works that may embellish his Kingdom: he wishes further that far-away Peoples may enjoy them in some way, and that by Descriptions and Figures of his superb Buildings, and of his Royal enterprises, they may know the excellence thereof. It is with this thought that His Majesty . . . brings to light Collections such as this one . . . that they may one day be precious Monuments of all that which is made today, and that those who come after us may be in some way spectators of the marvels of which we are witnesses.[25]

NOTES

1. Planting was directed by Catherine's garden "commissioner intendant" Bernardo Carnessecchi, a highly paid Florentine gentleman with full authority over the garden plantings, probably extending to their design. The surrounding wall was defined by the architect Philibert de l'Orme. See P.-M. Bondois, "Bernardo Carnessecchi Jardinier de Catherine de Médicis," *Revue du Seizième Siècle* 14 (1927): 389–92; and Jean-Marie Pérouse de Montclos, *Philibert de l'Orme Architecte du Roi* (Paris: Mengès, 2000), 233–37.

2. Jean Orieux, *Catherine de Médicis*, 2 vols. (Paris: Flammarion, 1986), 2:148–51.

3. Jean Dorat, *Magnificentissimi Spectaculi*, *A Regina Regum Matre in hortis suburbanis editi*, *In Henrici Regis Poloniae invictissimi nuper renunciati gratulationem*, *Descriptio* (Paris: F. Morel, 1573). Dorat is identified on the title page as royal poet, and Morel as royal printer. The woodcuts have been tentatively attributed to Olivier Codoré.

4. In Italian, the word *prospettiva* meant both perspective and prospect and was often applied specifically to what we now call a bird's-eye view.

5. George Braun and Frans Hogenberg, *Civitates Orbis Terrarum* (Cologne, 1572), vol. 1, prefatory colloquium, lines 21–25: "*Nec videor minus. . . .*"

6. The erroneous statement persists that he published in Paris a series of views of Tivoli. See most recently Dana Arnold's entry in the *Grove Dictionary of Art*, ed. Jane Turner (New York: Macmillan, 1996), 9:398.

7. In his dedication Dupérac states: "It pleased His Serene Illumineedness to make use of me to do the *disegno* [for the emperor]: which, having reduced to a smaller form and sending it forth for public contentment, I took courage to dedicate to Your Most Christian Majesty knowing how much . . . she delights in beautiful buildings and pleasant gardens" (author's translation). The Italian word *disegno* was used to refer equally to a design or a drawing.

For discussions of attribution primarily to Pirro Ligorio, see David R. Coffin, *The Villa d'Este at Tivoli* (Princeton: Princeton University Press, 1960), 92–97; also David Dernie, *The Villa d'Este at Tivoli* (London: Academy Editions, 1996), 8–10.

8. Although copying was not uncommon, an extraordinary number of copies were made of this print, including those by Mario Cartaro in 1575, Ambrogio Brambilla in 1581 working for Lafréry's heir Claude Duchetti, G. Orlandi for Duchetti in 1602, Francesco Corduba (published by Goert van Schaych in a composite collection of views mostly by Matthaeus Greuter in 1620, later reissued by Giovanni Domenico de' Rossi and again, after 1654, by Giovanni Giacomo de' Rossi), Jacopo Lauro in 1628, and Johannes Blaeu in a book of Italian plates in 1633 republished in 1663, 1704, and 1724; not to mention crude imitations in guidebooks such as Totti's *Ritratto di Roma Moderna* (Rome: P. Totti, 1638), 524, and G. Roisecco's *Roma Antica e Moderna* (Rome: G. Roisecco, 1750). Even the original copperplate passed through various hands: in the King's Topography Collection of the British Library there are two impressions of Dupérac's original etching, LXXXII.12-B-2 and 12-C-1, the first published by Petri de Nobilibus and the second by Joannes Dominicus de Rubeis [Giovanni de' Rossi].

9. Claude Mollet, *Theatre Des Plans Et Jardinages* (Paris: Charles de Sercy, 1652), 199–201, but written ten to thirty years earlier. A *parterre de broderie* is a flat expanse of garden beds filled with embroidery-like patterns, usually made of boxwood and gravel or sand.

10. The first dated print by Dupérac, showing the Vatican Belvedere Court in 1565, introduced the composition he used again

at the Villa d'Este, looking down from a centered vantage point over a rising symmetrical design that fills the dimensions of the plate to a high horizon line. An even closer resemblance can be seen in the 1614 view of Saint-Germain-en-Laye, vertically presented like the Belvedere, which I believe to be based on a lost drawing by Dupérac unacknowledged by the signator of the print, Alessandro Francini. Francini signed his view *figuravit*, indicating specifically that he made the preparatory drawing for the print. By contrast, he later signed his original architectural designs *invenit*. Dupérac's unparalleled immersion in the Italian models strongly suggests that he designed the Saint-Germain gardens, where he is known to have worked in some capacity.

All three designs are notable for grand terraces connected by lateral ramps of stairs modeled on the Temple of Fortuna at Praeneste, the largest ancient Roman sanctuary in Italy.

11. Jacques Androuet Du Cerceau, *Les Plus Excellents Bastiments de France* (Paris: J. Androuet Du Cerceau, 1576, 1579), vol. 1, dedication to Queen Catherine de' Medici: "... all must be attributed to you, as I would not have undertaken such a long and arduous work except to follow your commandment, nor persevered but by your liberality" (author's translation).

12. Five of an unsigned series of six views of châteaux, published in Paris by Melchior Tavernier before 1639 and attributed to Daniel Rabel, adapt compositions by Androuet Du Cerceau with the addition of contextual landscape and fashionable visitors.

13. Jean Bodin, *La République* (Paris: Jacques du Puys, 1576).

14. Salomon de Caus is unusually well documented, in part by his published works on perspective, harmonics, fountain design and hydraulics, and the *Hortus Palatinus* (Frankfurt: Johann-Theodore de Bry, 1620). His biography was written by Christina Sandrina Maks, *Salomon de Caus, 1576–1626* (Paris: Imprimerie Jouve, 1935).

15. About 1600 the Flemish painter Giusto Utens had created a series of views of the Medici villas for the walls of the reception hall of the villa at Artimino (fig. 11).

16. Pierre Vallet, *Le Jardin Du Roy Tres Chrestien Henry* (Paris: P. Vallet, 1608). "You are the Flower of all Queens, ... you are this divine flower of Florence united with the lily of France by Heavenly edict...." (author's translation).

17. Among them were the following works by royal garden designers: Daniel Rabel, *Livre de Differants Desseings de Parterres* (Paris: Melchior Tavernier, 1630); and Jacques Boyceau de la Barauderie, *Traité du Jardinage Selon Les Raisons De La Nature Et De Lart* (Paris: M. van Lochom, 1638). Claude Mollet's *Theatre Des Plans Et Jardinages* was also written sometime during the 1620s and 1630s.

18. Callot's composition resembles Florentine stage sets of a type not introduced to France until 1641. It was also similar to a May scene by Adrian Collaert after Josse de Momper, as pointed out by H. Diane Russell, *Jacques Callot: Prints and Related Drawings*, exh. cat. (Washington, D.C.: National Gallery of Art, 1975), 11, 12. Finally, Callot borrowed Salomon de Caus's technique for drawing a *parterre de broderie* design in perspective from the *Hortus Palatinus*.

19. R.F.P. Dan, *Le Trésor des Merveilles de la Maison Royale de Fontainebleau* (Paris: Sebastien Cramoisy, 1642).

20. Johann Wilhelm Baur, *Vedute di Giardini* (Rome: Calisto Ferranti, 1636). Etching; illustrated title and five views, approximately 10 × 12.9 cm.

21. Dominique Barrière, *Villa Aldobrandina Tusculana sive varii illius Hortorum et Fontium prospectus* (Rome: for the author, 1647), twenty-two etchings, of which eight are views of the villa and gardens.

22. Dominique Barrière, *Villa Pamphilia eiusque Palatium cum suis Prospectibus, Statuae, Fontes, Vivaria, Theatra, Areolae, Plantarum, Viarumque Ordines, Cum eiusdem Villae absoluta Delineatione* (Rome: G. G. de' Rossi, [c. 1676]), usually with eighty-two plates in this edition, including five views of the villa and its gardens by Barrière.

The dominant Roman print publisher Giovanni Giacomo de' Rossi apparently bought the original copperplates of both series. He instructed his employee-printmakers Giovanni Battista Falda and Simon Felice to copy views by Barrière and signed the resulting prints in their names. Consequently, Barrière's view of the Aldobrandini water theater is often misattributed to Falda, as is his third Pamphili prospect, copied by Felice but included in Falda's *Giardini di Roma*, published by Rossi. Israël Silvestre also copied Barrière's third Pamphili prospect, and as late as 1761 it was adapted by Giuseppe Vasi in his *Magnificenze di Roma*, vol. 10.

23. Israël Silvestre, *Divers Veuës du Chasteau et des Bastiments de Fontaine belleau dessiné et gravé par Israel Silvestre* (Paris: Israël Henriet, [c. 1649]). Etching, approximately 11.2 × 16.1 cm.

24. Royal accounts, 1664, published in an appendix to *Lettres, Instructions et Mémoires de Colbert*, ed. Pierre Clément (Paris: Imprimerie Nationale, 1868), 5:457.

25. André Félibien, *Tapisseries du Roy* (Paris: Imprimerie Royale, 1670), *avertissement* [preface], author's translation.

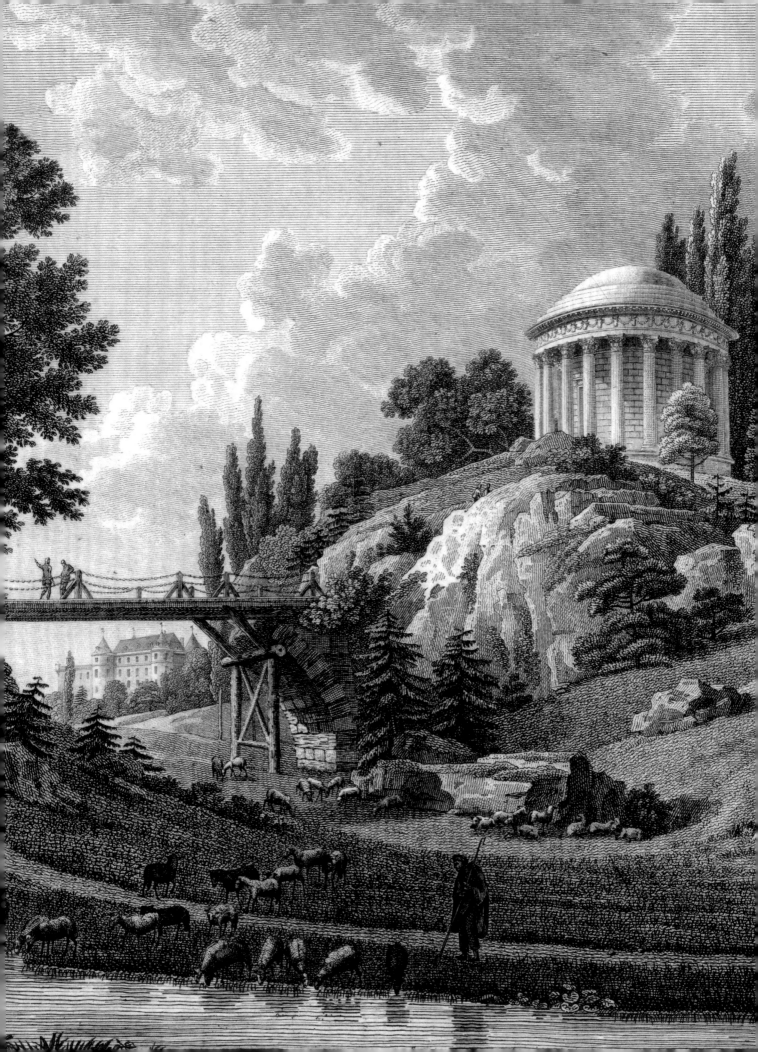

Méréville

Last Masterwork of the Eighteenth-Century
Landscape Garden in France

DIANA KETCHAM

The story of the eighteenth-century French garden concludes with the private gardens built on the eve of the Revolution of which the long-forgotten Méréville is the premier example (fig. 20).[1] These private gardens ranged in size from the many thousand-acre properties at Méréville, Ermenonville, and Betz to the hundred-acre folly garden of the Désert de Retz, to intimate urban gardens.[2] Created by the same designers who contributed to the royal projects of the time, including the painter Hubert Robert, the landscapers Jean-Marie Morel and Thomas Blaikie, and the architect François-Joseph Bélanger, the private gardens nevertheless display social and aesthetic agendas that set them outside the conventions of royal garden building. In the case of Ermenonville and Méréville, they were the occasion for new design methods. An understanding of these methods, in turn, sheds valuable light on the career of Hubert Robert,

· 53 ·

one of the century's key figures in both painting and garden design.

As expressions of the picturesque style, these pre-Revolutionary gardens were organized around composed views, or "pictures," in which an array of architectural follies, or *fabriques*, embellished a natural-looking landscape. As such, they marked the apogee of a century of competitive imitation of the English landscape garden in France.[3] Although this experiment ended abruptly with the Revolution, its legacy was lasting. It helped break the hold of formal and ornamental conventions of garden design that had persisted since the Renaissance. Its influence lives on in the eclectic aesthetic and program of the urban public park, whose emergence in Europe and America was to be the major development in garden history of the next, the nineteenth, century.

The most fully realized of the pre-Revolutionary gardens was Méréville, built in the valley of the river Juine sixty miles southeast of Paris near the town of Etampes. It was created by one of France's wealthiest private citizens, Jean-Joseph Laborde, in an ambitious effort to surpass his English models.[4] The enterprising Laborde began his career as a provincial drapery merchant and ended it as the last banker of King Louis XVI, who granted him the title of marquis in 1784, the same year Laborde purchased the dilapidated château and park at Méréville. Within two years he had reshaped its terrain and commissioned architectural monuments remarkable in their scale, meticulous construction, and lavish use of fine materials. His intensive building program would continue until Laborde was sent to the guillotine in April 1794, at age seventy.

What Laborde built during those ten years is routinely described in the twentieth century as having been one of the great French achievements in its genre. Writing in the 1940s, the Swedish art historian Osvald Sirén called Méréville "at the time doubtless one of the very finest of the great landscape parks in France, a mature product of the French interpretation of nature,"[5] an evaluation echoed by the garden historian Dora Wiebenson, who called Méréville "the ultimate expression of the picturesque garden in France."[6] Méréville was a virtuoso undertaking in several respects. Unusual for a French garden was its profuse supply of water, provided by the river Juine, which allowed for extravagant water features. An elaborate site plan involved rerouting the river to create two looping branches, two lakes, and three waterfalls. Three to four hundred men at a time labored to transform the shallow river basin into two intersecting valleys, providing a complex topography with multiple vistas.

Of the more than a dozen follies designed for this landscape, the Round Temple, the Grand Column, and the Dairy were oversize versions of the playful tributes to classical architecture in earlier picturesque gardens. Conceived without humor or irony and built on a massive scale, they have the air of institutional buildings. The Grand Column is as large as the column in Place Vendôme in Paris. Even the grottoes and rustic bridges are elaborate constructions in stone, a far cry from the rubble and plaster used for the *fabriques* at the Désert de Retz, for example.

HOW MÉRÉVILLE WAS DESIGNED

Working in the late 1780s, the creator of Méréville could draw on his century's profusion of treatises on garden building. The most radical of these was the 1777 *De la composition des paysages* by the liberal Anglophile René-Louis de Girardin. Its ostensible subject was how the author designed his own estate at Ermenonville, best known as the final home of Jean-Jacques Rousseau, who died and was buried there in 1778 (cat. 89). Writing in the era when the formal plan was being abandoned, Girardin asserted that the natural garden, no less than its predecessor, the formal, could and should be planned in detail. Even more novel was his insistence that the painter was key to this planning process. "Take the painter with you," he exhorts the designer, outlining the precise steps by which the painter should analyze the site, producing first sketches and then finished paintings that would be the basis for the actual work.[7]

Pl. 57.

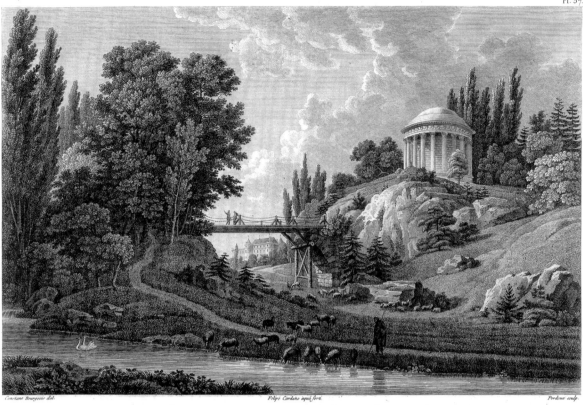

Constant Bourgeois del. Felipe Cardano aqua forte. Perdoux sculp.

Vue du TEMPLE à MÉRÉVILLE.

Ansicht des TEMPELS zu MEREVILLE. View of the TEMPLE at MEREVILLE.

FIG. 20. Constant Bourgeois (France, 1767–1841), Plate 57: *View of the Temple at Méréville.*
Engraving, from A. Laborde, *Description des nouveaux jardins de la France et de ses anciens châteaux*
(Paris, 1808–15). University of California, Berkeley. Environmental Design Library.

In practice, the owner of Ermenonville did most of the planning himself. Instead, it was Laborde, at Méréville, who may have first implemented Girardin's radical philosophy regarding the role of the painter.[8] According to garden historian Olivier Choppin de Janvry, Laborde was unusual as a patron of the garden arts who did not fancy himself a designer. He allowed uncommon latitude to the artists he employed, who included the sculptors Augustin Pajou and Pierre Julien, the architect Bélanger, and the painters Joseph Vernet and Hubert Robert—a veritable roster of the prominent artists of the day. In his arrangements with Ro-

bert, Laborde gave him the authority to engage and supervise a team of other artists and artisans.[9]

A commanding figure in the history of French art, Hubert Robert (1733–1808) was a painter of both picturesque landscapes and monumental architecture. His architectural subjects ranged from classical ruins, real and imaginary, to the settings of his own time. Robert would have been at the height of his powers when he began work at Méréville in 1786.[10] An important result of his involvement there is the largest body of surviving paintings by Robert of any contemporary subject, estimated at nineteen.[11] The Méréville in Ro-

FIG. 21. Marion Brenner (U.S.A., b. 1944), *Méréville: Grotto*, 1995. Gelatin-silver print. Marion Brenner.

bert's paintings corroborates its reputation among writers as the most magnificent of the French landscape gardens. In a typical accolade, the historian Petit de Bachaumont wrote in 1786: "The banker Laborde is building an English garden, without a doubt the most remarkable that one can imagine."[12] Now that the original garden has been dismantled, Robert's paintings are invaluable in evaluating such praise.[13] His landscapes of Méréville are indeed stunning, characterized by a striking purity and poise of composition, in which sumptuous architecture and bold natural features stand in confident balance. Their deep vistas and complex topography are a testimony to how the French picturesque style matured in the course of the eighteenth century, as it developed from flat "pictures," perceived from a fixed point, to three-dimensional "scenes" in which the observer participated.[14]

MÉRÉVILLE IN DECLINE

If Méréville was indeed a masterpiece, why is it not better known today among students of the eighteenth-century garden? Construction stopped after Robert's arrest in 1793 and Laborde's execution the next year. Under temporary owners through most of the nineteenth and twentieth centuries, its high-maintenance landscape deteriorated. In 1897 the four most imposing architectural follies, the classical Temple, Dairy, Tomb of Cook, and Rostral Column, were salvaged and installed at the Parc de Jeurre, twelve miles away. Where comparable royal properties were either destroyed in the Revolution or purposefully rebuilt afterward, Méréville, as a private estate, was merely neglected. Overgrown with trees and shrubs, its valleys were impassable until 1993, when restoration work began.[15] The next year, the garden photographer Marion Brenner and I were able to move freely about the park and examine the sites of the principal follies. We walked through the grottoes, where some chambers still sparkled with gilt, turquoise, and mica (fig. 21), and we located the footprint of the Round Temple. The

high points of land had been visibly eroded and the lakes filled in. The last of the original trees had been cut down in 1955. However, enough remained so that we could experience the designed vistas we knew from Robert's paintings, and which are corroborated by guide-book engravings from the same period.[16]

What does Méréville have to teach us in its present deteriorated state? In general, it confirms the important principle that there is always something to be learned at a reputedly "vanished" site. In particular, it bears on the long-standing debate over whether the French ever produced a masterwork in the English garden style. Méréville proves they did. The modern-day observer can travel quickly between the denuded park and its transplanted follies twelve miles away. One can hold the two images in the mind's eye—the architecture without its garden setting and the garden without its architecture—and grasp the impact it would have as a whole. Thus imagined, Méréville lives up to its reputation as a triumph of composition. One can see that it avoided the historical weakness of the French natural garden: that architecture overwhelms nature.[17] From the evidence of both sites today, one is convinced that its buildings would have been in scale with the water and landforms, with each major folly the centerpiece of a carefully composed scene.

HUBERT ROBERT AND THE ACHIEVEMENT OF MÉRÉVILLE

If the evidence supports Méréville's reputation as a masterpiece, what were the ingredients of its success? First, it had the advantages of a wealthy patron and a promising site. At Ermenonville, by contrast, Girardin was short of funds and heir to flat and featureless terrain, marred in the center by the existing château and village road. The second factor was the talent of Hubert Robert. By the time he began work at Méréville, Robert was France's preeminent painter on the popular theme of classical ruins in the landscape. His mastery of this subject was rooted in the thirteen years

he lived in Italy as a young man, following the example of such French painters as Jean-Honoré Fragonard. When he returned to France, Robert was appointed garden designer to King Louis XVI. He soon won attention in 1778 for a bold renovation of the Baths of Apollo at Versailles, where he inserted an expressionistic grotto not far from Le Nôtre's formal parterres. For Queen Marie-Antoinette, Robert worked on the English gardens at the Petit Trianon and at Bagatelle, Rambouillet, and at the Hamlet at Versailles. In such royal projects, Robert was adding to an existing scheme, where earlier designers had already made their mark. Méréville is significant as Robert's tabula rasa, where he would have been able to carry out his own ideas. Yet what were his ideas? Art historians have ventured few speculations as to Robert's precise responsibilities at the gardens where he was involved prior to Méréville.[18]

Uncertainty about how Robert operated as a designer is indicated by the number of his paintings named for gardens that they barely resemble. Such a case involves two paintings entitled *Ermenonville*. Both show the Temple of Philosophy as differing from the actual surviving *fabrique* (cat. 90A). In the first, *The Washerwomen, Park of Ermenonville* (fig. 22), the temple has columns in the Tuscan order, as does the actual. However, in the painting, these columns have become elongated and refined and they sit on a tall, slender podium that does not exist at Ermenonville. Also, there appears to be a complete circle of twelve columns, whereas in the actual only six columns are standing, with fragments of others scattered on the ground. In the second, *The Park of Ermenonville* (private collection), the same temple is set on a hilltop and viewed from below. From this angle, its proportions and distinctive broken roofline establish its similarity to the hilltop Temple of the Sybil at Tivoli, a much-painted Roman ruin Robert is certain to have known firsthand. Is *The Washerwomen* a view of Tivoli, misidentified as Ermenonville? Are both paintings Robert's proposals for Ermenonville, which Girardin altered in

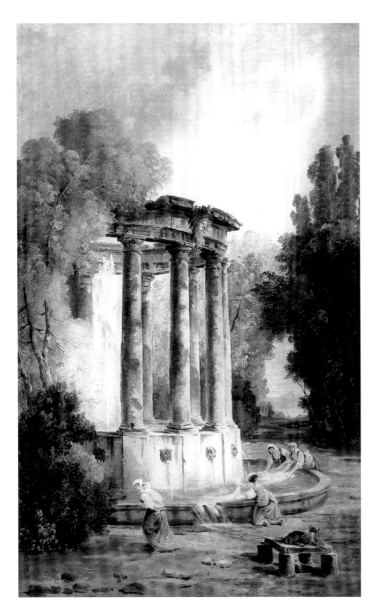

FIG. 22. Hubert Robert (France, 1733–1808), *The Washerwomen,
Park of Ermenonville*, 1792. Oil on canvas, 105 × 55 cm.
Cincinnati Art Museum (Gift of Mrs. Alfred Anson, 1952.401).

the building? Why does this variant temple appear in the same paintings as features of Ermenonville, such as the Isle of Poplars, that are faithful to what was constructed?

It is a truism that Robert is not a painter from whom one expects archaeological exactitude. His gift was for synthesizing the actual and the imaginary. In his views of contemporary gardens, two circular temple forms appear repeatedly; both are composites. The first is squat and roofless and echoes the basic form of the Temple of the Sybil at Tivoli. The second has the vertical form of the Temple of Vesta in Rome, combined with the Corinthian orders of the Tivoli temple, with the addition of a shallow domed roof. The second of these standard Robert temples appears in two of his paintings identified as the Temple de l'Amour at the Trianon, *Night Celebration at Trianon* (Musée des Beaux-Arts, Quimper) and *Temple of Love at Trianon* (private collection). Yet, the building is unmistakably not the one at Trianon. It is the Round Temple at Méréville, both as we see it today at the Parc de Jeurre and as depicted in a half dozen paintings by Robert entitled *Méréville*. What is the status of the "Trianon" paintings in Robert's oeuvre, given that he was both garden designer and painter of contemporary and historic gardens? Are they fantasies, proposals, or documents?

In a letter to the mistress of Méréville, Madame de Laborde, in the first year of his employment there, 1786, Robert writes: "To give ... an idea of the area where the obelisk will go, I am in the process of working on a painting, a general view that will show at a glance the effect and the relations of the temple, the grotto, and the obelisk with the plantings for that area."[19] He goes on to mention "two paintings that I am going to make for the execution of different objects that you want." The prominent scholar Jean de Cayeux has called such paintings by Robert "veritable models in paint."[20] On the basis of these letters, Cayeux has argued for Robert's recognition as the designer of Méréville.[21] Such arguments are immeasurably strengthened by an examination of the "models in paint" themselves. They are even further strengthened by ex-

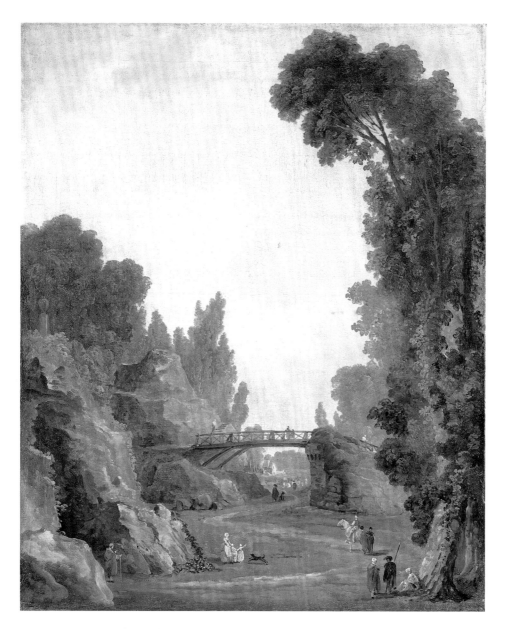

FIG. 23. Hubert Robert (France, 1733–1808), *The Rustic Bridge, Château de Méréville*,
c. 1785. Oil on canvas. The Minneapolis Institute of Arts. (Cat. 91)

aminations of the present physical sites, such as Brenner and I were able to conduct.

Likely examples of Robert's proposals are the compositionally similar paintings *Rustic Bridge, Château de Méréville* (fig. 23) and *The Wooded Grove of the Large Rocks, the Bridge of the Large Rocks, the Grand Cascade, and the Golden Pavilion* (private collection). Both show the same steep valley, crossed by a wooden bridge, with a rocky outcropping on one side. In the second painting, Robert has added five major *fabriques*. The Grand Cascade pours over the grotto and the pavilion has been added next to the bridge. The classical Dairy, fronted by a lake, has been inserted at the end of the valley, with the Round Temple on a hilltop above it. These follies represent the actual architecture, just as it appears today at the Parc de Jeurre, but their placement identifies the painting as a proposal rather than a document of built work. For as one can see by visiting the original, the sight lines would not have allowed all of these structures to be seen from the vantage point

of the observer. Perhaps the two circular temples that haunt Robert's work over the years are proposals waiting to be executed, as his Tivoli-Vesta composite was, finally, magnificently realized in the Round Temple at Méréville.

In theory, all of Robert's known Méréville paintings could have been done as proposals. Those most closely resembling the finished garden would be the ones that were executed. The significance for garden history is that Robert's status as a garden designer is confirmed once and for all. Moreover, he can be credited with at least one masterpiece, the garden of Méréville.

CONCLUSION

In the sweeping judgment of the garden historians Denise and Jean-Pierre Le Dantec, Méréville signifies even more. For them, it marks the historical ascendancy of the painter over the architect as the shaping genius of the garden.[22] If, as it seems, Laborde gave Robert this role, in what direction did he take the garden as the eighteenth century was ending? He led it away from the literary, nostalgic, and sentimental evocation of antiquity of its early English model, William Shenstone's The Leasowes, which Frenchmen including Girardin and Bélanger studied firsthand. At Ermenonville, Shenstone's influence is seen in the many small informal monuments, such as the modest stone markers bearing Rousseau's writings, as well as the major false ruin, the Temple of Philosophy, bearing the names of Voltaire, Rousseau, Isaac Newton, Montesquieu, René Descartes, and William Penn.

Twenty years later at Méréville, the convention of the false ruin, the sentimentality, and the philosophical program have been abandoned. Méréville's classical structures are not only intact but, as shown in Robert's paintings, appear ablaze with dazzling newness. As commemorative architecture, they possess scant literary or philosophical content. Instead, Méréville's constructions in bronze, mica, and blue-veined marble hewn in Paris appear to celebrate craft and materials for their own sake. The frame of reference of these sumptuous monuments is less historical and cultural than contemporary and individualistic; it is limited to the virtues of the Laborde family. The Round Temple celebrates the devotion of their children to the estates' owners. The Temple to Cook evokes the explorer of the Pacific in its commemoration of two Laborde sons lost in a shipwreck off the coast of California. The individuals remembered here are men of action, not thinkers and writers as at Ermenonville. With Méréville, we have traveled far beyond the inspiration of the English garden, steeped as it was in literature and liberal philosophy, even beyond the inspiration of Rousseau. With its forthright celebration of magnificence and grandeur, Méréville leads us toward the age of Napoleon.

NOTES

1. See Dora Wiebenson, *The Picturesque Garden in France* (Princeton: Princeton University Press, 1978).

2. See Diana Ketcham, *Le Désert de Retz: A Late Eighteenth-Century French Folly-Garden* (Cambridge, Mass., and London: MIT Press, 1994).

3. Jean-Joseph Laborde's contemporaries Arthur Young and Horace Walpole were among the English observers convinced that competing with England was the aim of those who had experimented with the irregular garden in France. See Arthur Young, *Travels during the Years 1787, 1788, and 1789. . . .* (Bury St. Edmonds:

J. Rackham, for W. Richardson, 1792), 11; and Horace Walpole, *On Modern Gardening* (London: Brentham Press, 1975).

4. Ibid.

5. Sirén examined and photographed the remains of Méréville in the 1940s, leaving one of the few descriptions in the last century of the "wealth of old trees" (these were cut down in the 1950s and replaced by a tree farm), and of such fragile structures as the wooden Pavilion of the Grand Cascade that appears above the bridge in the view by Hubert Robert of one of the main valleys, *Passerelle de bois dans le parc de Méréville*. See Osvald Sirén, *China and*

the Gardens of Europe in the Eighteenth Century (New York: Ronald Press Co., 1950), 153–57.

6. Wiebenson, *The Picturesque Garden in France*, 105. A similar claim is made by William Howard Adams, *The French Garden, 1500–1800* (New York: Braziller, 1979), 129.

7. René-Louis de Girardin, *De la composition des paysages, ou, Des moyens d'embellir la nature autour des habitations, en joignant l'agréable à l'utile* (Geneva and Paris: Chez P.-M. Delaguette, 1777), translated by Daniel Malthus, father of the economist, as *An Essay on Landscape, or, on the means of improving and embellishing the country round our habitations* (London: Dodsley, 1783), 22–34.

8. In the view of Adams, Méréville was the "finest interpretation of the principles" outlined by the owner of Ermenonville, Girardin, in his *De la composition des paysages. The French Garden*, 129.

9. The most authoritative analysis of Laborde's intentions as a patron is provided by Olivier Choppin de Janvry, "Méréville," *L'Oeil* 182 (December 1969): 30–41, 83, 96. For a full factual description of the park and its history, see François d'Ormesson and Pierre Wittmer, *Aux jardins de Méréville….* (Neuilly: Editions du Labyrinthe, 1999).

10. Jean de Cayeux, "Hubert Robert dessinateur des jardins et sa collaboration au parc de Méréville," *Bulletin de la Société de l'Histoire de l'Art Français*, 1968, 130–31. See also Jean de Cayeux, *Hubert Robert* (Paris: Fayard, 1989), 150–66. Cayeux analyzes a collection of forty-two letters he was given access to by descendants of Laborde to dispute claims made earlier in the century by Louis Hautecoeur and Ernest de Ganay in favor of claims to the design of Méréville by other artists, including Joseph Vernet and François-Joseph Bélanger.

11. D'Ormesson and Wittmer, *Aux jardins de Méréville*, 105.

12. Petit de Bachaumont, *Mémoires secrets pour servir à l'histoire de la république des lettres en France* (London: 1777–89), quoted in Choppin de Janvry, "Méréville," 39. See also Elisabeth-Louise Vigée-Lebrun, *Souvenirs de Madame Vigée-Lebrun* (Paris: Fournier, 1835–37), 240.

13. Alexandre Laborde, *Description des nouveaux jardins de la France et de ses anciens châteaux* (Paris: Imprimerie de Delance, 1808–15), 98. This typical description, written by one of Laborde's sons, calls Méréville, "an oasis of Ammon, set in the middle of the desert, and where its inhabitants live eternally in a garden perfumed by rivers." His account, contained in this survey of twenty-seven gardens of the period—including Ermenonville, the Désert de Retz, and Monceau—is no more adulatory than that of other observers such as Bachaumont and Vigée-Lebrun.

14. See Wiebenson, *The Picturesque Garden in France*, for the standard account of this development.

15. For an account of the restoration, see d'Ormesson and Wittmer, *Aux jardins de Méréville*.

16. The fullest visual record of the newly built garden is the thirteen engravings in Laborde, *Description des nouveaux jardins de la France*, 95–112.

17. In the famous critique by Laborde's contemporary Thomas Blaikie, the French are taken to task for cluttering their "English" gardens with too many structures, badly placed. This critique is summarized by Adams in *The French Garden*, 112. Its waspish exponents included Horace Walpole as well as Blaikie, the Scots gardener of Louis XVI and author of the delightful *Diary of a Scotch Gardener at the French Court at the End of the Eighteenth Century* (reprint; London: George Routledge and Sons, 1931).

18. The other sizable landscape gardens where Robert worked included Betz and Ermenonville, but his associations there lack the rich documentation provided by his correspondence with the Labordes.

19. Quoted in Cayeux, "Hubert Robert dessinateur des jardins," 131–32.

20. Cayeux, *Hubert Robert*, 158.

21. Cayeux, "Hubert Robert dessinateur des jardins," 122–33.

22. Denise and Jean-Pierre Le Dantec, *Reading the French Garden* trans. Jessica Levine (Cambridge: MIT Press, 1990), 127. In this thoughtful account of the history of the French garden, the Dantecs describe Robert's work as garden designer as "composing landscapes that deserved to be painted."

City Parks and Private Gardens in Paintings of Modern America, 1875–1920

CAROL M. OSBORNE

First in Paris and then in New York, the park reform movement of the mid–nineteenth century brought city people out into the fresh air and provided settings for plein-air painters seeking scenes of life around them. Not since Jean-Antoine Watteau (cat. 116) and the teasing eroticism of the Rococo had artists so often chosen garden settings, both public and private, for colorful scenes of people at leisure. In Paris, when palace gardens were turned over to public use, park space—including the newly designed Bois de Boulogne—expanded from 50 acres in 1848 to 4,500 in 1870.[1] Painters of modern life like Edouard Manet and Claude Monet seized the day with imagery of gatherings in landscape settings that introduced an epoch-making view of Parisian society. In later years, American artists, too, such as James McNeill Whistler (cats. 118, 124), John Singer Sargent (cat. 117), and Maurice Prendergast (cat. 113) made

[DETAIL] Thomas Hill, *Palo Alto Spring*, 1878 (see fig. 28, p. 70).

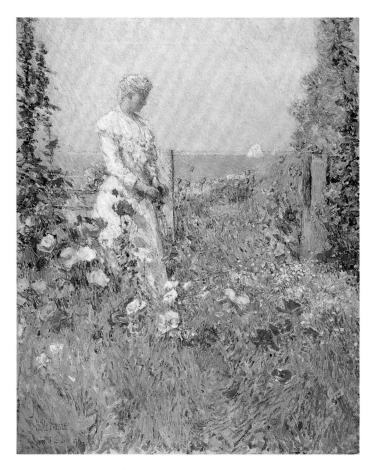

FIG. 24. Childe Hassam (U.S.A., 1859–1935), *In the Garden (Celia Thaxter in Her Garden)*, 1892. Oil on canvas, 56.2 × 46 cm. Smithsonian American Art Museum, Smithsonian Institution, Washington, D.C. (Gift of John Gellatly, 1929.52).

good use of the gardens of the Tuileries and the Luxembourg Palace.

In New York in 1858 Frederick Law Olmsted and Calvert Vaux's Greensward design for Central Park opened 950 acres to visitors; this was soon followed by their plans for Brooklyn's Prospect Park and a rash of public parks from Boston to Detroit.[2] What the public gardens of Paris had been for French modernists in the 1860s and 1870s, New York's parks became for American painters in the 1880s and 1890s. But they became so with a decided emphasis on the pastoral aspect of *rus in urbe*—escape from the pressure of the modern city, not involvement in its frivolous pleasures and complexities. A retreat from the noise and dirt of the industrial city was also found in private gardens up and down the East Coast. Favored by painters like Childe Hassam (fig. 24) and John Twachtman (fig. 25), these were not the landscapes of grand estates, but old-fashioned gardens informally planted with native flowers. Typical of the colonial revival styles that had come to life with the Philadelphia Centennial, they were often created by women, whom feminist writers encouraged to garden because, like exercise, it was good for their health.

In the belief that simply to look on natural beauty was both morally uplifting and health-giving, Olmsted and Vaux had chosen for Central Park a naturalist design in the English tradition, shaped partially by Birkenhead, a "People's Park" Olmsted had visited outside Liverpool, and by rural American cemeteries like Greenwood across the river in countrified Brooklyn. A kindred spirit was William Cullen Bryant, one of the earliest promoters of New York's new park and its rural setting. Believing keenly in nature's curative grace, Bryant had a garden of his own on Long Island to which he escaped for long country walks. Visitors flocked to it for cuttings and seeds as mementoes of the much-admired Romantic poet, one of many American literary giants whose gardens were open to tourists.[3] Like Olmsted, Bryant held that the purpose of a great city park was to bring peace and calm to society—not for the few, but for the many.

Olmsted envisioned Central Park as exercising "a

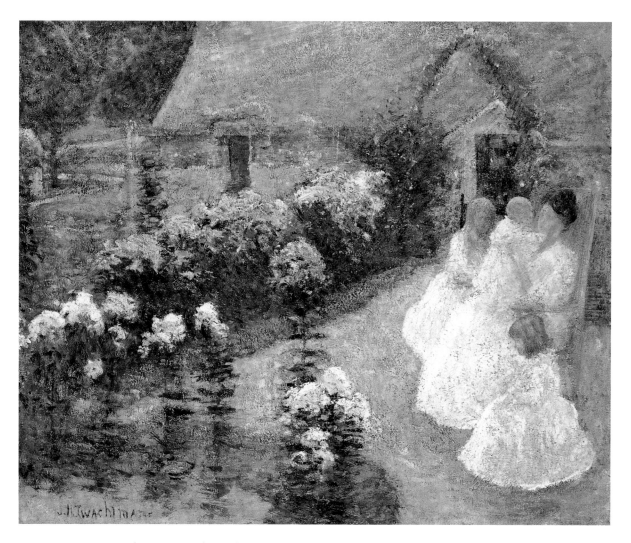

FIG. 25. John Henry Twachtman (U.S.A., 1849–1916), *On the Terrace*, 1897. Oil on canvas, 64.1 × 76.5 cm.
Smithsonian American Art Museum, Smithsonian Institution, Washington, D.C.

distinctly harmonizing and refining influence upon the most unfortunate and most lawless classes of the city —an influence favorable to courtesy, self-control, and temperance."[4] Long after belief in romantic naturalism had lost its sway and the politics and demographics of New York had changed, American genre paintings of Central Park still reflected the high-minded intentions of the great landscape designer.[5]

For William Merritt Chase, a cosmopolitan New Yorker, city life in the 1880s was typically captured in quiet park scenes of middle-class women and their pretty babies at leisure. Indeed, American Impressionism made its debut on the native scene in the exquisite series of plein-air canvases that Chase painted in Central Park and Brooklyn's Prospect and Tompkins Parks (fig. 26) during visits he made there from 1886 to 1890, often with his wife and child. "There are charming bits in Central Park and Prospect Park, Brooklyn," Chase observed to an interviewer in 1891. "When I have found the spot I like, I set up my easel, and paint the picture

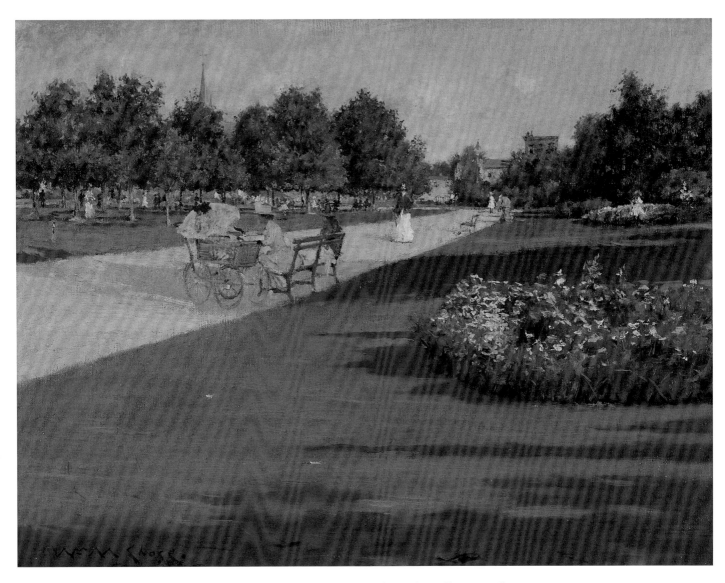

FIG. 26. William Merritt Chase (U.S.A., 1849–1916), *Tompkins Park, Brooklyn*, 1887. Oil on canvas, 44 × 56.8 cm. Colby College Museum of Art (Gift of Miss Adeline F. and Miss Caroline R. Wing, 1963.040).

on the spot. I think that is the only way rightly to interpret nature. . . . You must be right out under the sky."[6] The size of the paintings—most are under twenty inches in the largest dimension, many are smaller—implies that they could be transported handily from home to park bench, and their beguiling imagery suggests the pleasure of leisurely strolls through well-kept grounds and summer visits to lakes where miniature sailboats glide.

Even though park use had swelled by then to accommodate the crowded city's recreational needs, the serenity and calm of Chase's paintings remained true to Olmsted's midcentury concept of pastoral grace in the heart of the city. Although the park was originally cre-

ated in the interest of New York's wealthiest, with an eye to its value-adding effect on real estate, its elitism gave way over years of burgeoning immigration to more open and democratic ways as the city's population increased from one and a half million in 1870 to five million in 1915. But when the naturalist Greensward concept was first entered into the competition for Central Park's design, it was the one preferred by New York's Yankee park commissioners, Republican men who "would feel at home in a beautiful 'rural' park where they could admire the scenery and one another."[7]

Hassam, too, made Central Park one of several settings for Impressionist views of the city he had come to love after moving there from Boston, the city of his birth. Manhattan park scenes like the one portrayed in *Descending the Steps, Central Park*, 1895 (fig. 27), share with the urban genre of Paris the favored subjects of well-dressed women and children and the golden touch of Hassam's staccato brushstrokes as seen in his painting *Parc Monceau*, 1897 (Frye Museum, Seattle). But city parks and squares formed only a portion of Hassam's work; beguiling scenes of passersby on lower Fifth Avenue near Washington Arch vied with Union Square in springtime and hansom cabs in Madison Square and other city sites to form a sort of portrait album of the town. "New York is the most beautiful city in the world. . . . There is no boulevard in Paris that compares to our own Fifth Avenue," he observed years later when painters were turning away from Europe to reestablish their connections with America.[8]

One American artist who never turned away from Europe was the expatriate James McNeill Whistler, whose paintings and prints were often situated in parks. In the 1870s Cremorne Gardens, an amusement park near his London home in Chelsea, provided the setting for a celebrated series of seven oils and a number of watercolors and drawings. Its fireworks and misty lights inspired Whistler's *Nocturne in Black and Gold: The Falling Rocket* (Detroit Institute of Arts), the painting that incurred the critic John Ruskin's fury and resulted in the famous trial of 1877. At Cremorne Gar-

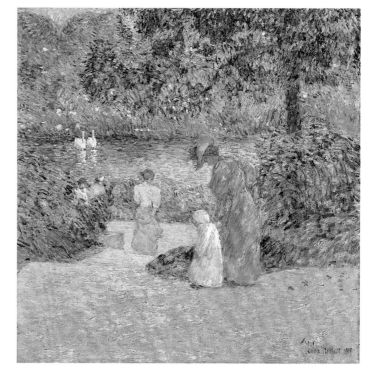

FIG. 27. Childe Hassam (U.S.A., 1859–1935), *Descending the Steps, Central Park*, 1895. Oil on canvas, 88.9 × 87.9 cm. Virginia Museum of Fine Arts, Richmond (Gift of Estate of Hildegarde Graham van Roijen, 93.112).

dens, two theaters, a banquet hall, a dance platform large enough to accommodate four thousand people at a time—all elements denied to Central Park in its earliest years—and many other popular entertainments offered up anonymous spectacle and tonal atmosphere for the art-for-art's-sake style that was to influence an entire generation of painters. So modern was the subject, David Park Curry writes, that "Whistler's Cremorne series argues for the American-born painter as a principal respondent to Baudelaire's painter of modern life."[9] Pleasure gardens, once under discussion for Central Park, were routed off to the world of the theater. William Glackens catches a hint of Whistler's anonymous demimondaine in *Hammerstein's Roof Garden*, about 1901 (Whitney Museum of American Art, New York).

Nor did lovers join the progression of well-dressed mothers and nursemaids and baby carriages in New York park paintings of this time—nobody resembling the elegant couple strolling across the promenade in Sargent's 1879 painting of the Luxembourg Gardens (cat. 117). Here, in contrast to the color-dissolving effects of sunlight in the Impressionist gardens that were to follow from his summers at Broadway (1886–89), Sargent—a great lover of gardens—grays down his palette to twilight color schemes reminiscent of Whistler's *Nocturnes*. The association is explored in the exhibition catalogue *American Impressionism and Realism: The Paintings of Modern Life, 1885–1915*, where the diffident young man smoking a cigarette in Sargent's painting is thought to capture "the consummate *flâneur*" of Baudelairean legend.[10] The scene is set on the Luxembourg's terrace in front of the balustrade; to the southeast, beyond the trees, a glimpse of the dome of the Pantheon gives us the compass direction. The promenade was an enormously popular spot for artists as well as for local residents. In the 1890s Whistler used the same architectural setting for a group of prints of women conversing and nursemaids congregating with their charges (cats. 118, 124), and Prendergast, too, sought it out for his 1907 oil of the Luxembourg Gar-

dens (cat. 113), though his vantage point was more frequently turned to the livelier activity that surrounded the park's fountain.

Yet couples take the air in Central Park in American fiction of the period. With marriage in mind, Basil Ransom escorts Verena Tarrant to the park for a seductive scene in *The Bostonians* (1886), a novel by Sargent's friend Henry James. Together, the couple travel by elevated railway from Verena's lodgings on West Tenth Street to the park's entrance on Fifty-ninth Street—"The beauty of the 'elevated' was that it took you up to the Park and brought you back in a few minutes, and you had all the rest of the hour to walk about and see the place."[11] They visit the zoo, see swans in the lake, thread their way through the Ramble, sit talking on a "sequestered bench." Nature works its charms and, gradually, Verena, who is famous for her evangelistic speechifying on behalf of women's suffrage and other radical views, finds herself questioning her attitudes of mind. So rattled is she by Basil's charms that, instead of taking the elevated back to her lodgings, she walks the five miles home alone.

Chase and Hassam might have caught an impression of just such a solitary figure in any one of a number of paintings of well-dressed women walking alone on the park's paths and terraces, figures that seem to advertise the safety of the environment for women of the middle class. On the other hand, they may also imply a hint of availability. In Edith Wharton's novel *The Custom of the Country* (1913), the divorced Undine Spragg goes to Central Park alone for a clandestine meeting with her former husband in the wisteria arbor on the park's west side. "The habit of meeting young men in sequestered spots was not unknown to her."[12]

Although notions of the restorative value of pastoral calm and tranquility govern the subject choices made by Chase, Hassam, and other painters of the time, their conservative views of mothers and babies ignore both the activity of women in the workplace and agitation on behalf of female suffrage and women's rights. On the contrary, "they gave visual expression to the

middle-class idea that the child was to be nurtured, exonerated from labor and protected from the harsh realities of everyday life."[13] Indeed, around 1900, artists made their choices from a very restricted sphere, deliberately isolated from much of urban life. Their serene paintings clearly belie the observations of other park visitors. The diarist James Herbert Morse, for example, recorded of Central Park in the 1870s and 1880s that panhandlers had approached him there for pennies, that children ignored the keep-off-the-grass signs to run over lawns where old men sat "smoking pipes and reading scandal papers, and an elderly woman in a 'shabby gray shawl' and with 'ill-shod feet' picked dandelions to sell."[14]

Chase's paintings, by contrast, stay close to the story of his family life. In the spring and summer of 1887, when he and his wife, Alice, and their first child, Cosy, were living with Chase's parents on Marcy Street in Brooklyn not far from Tompkins Park, he found a setting there for plein-air scenes once thought to have been placed in Prospect Park. Barbara Dayer Gallati clears up past inaccuracies by dwelling on biographical facts surrounding the baby's birth a day after the parents' marriage.[15] She speculates that the exhibition history of Chase's oil *The Open Air Breakfast*, 1887 (Toledo Museum of Art), set in the backyard of the Marcy Street house, alludes to the couple's embarrassment over the matter. The casual scene, which includes the artist's sister, his wife, his baby, and his sister-in-law, was evidently not exhibited for more than a quarter of a century—it remained in the family until it was sold by Alice Chase after her husband's death. Gallati conjectures that this history tallies with middle-class notions of the impropriety of putting domestic arrangements on public display, a convention intensified by the facts of the marriage. "To render the informality of the private sphere public," she writes, "and to populate it with portraits of family intimates violated the social rules of the time in which the professional and domestic arenas were decidedly separate."[16]

In San Francisco, however, Leland Stanford, former governor of California and president of the Central Pacific Railroad, held the opposite view. With a politician's shrewd eye for the mythic effect of mixing home and office, he commissioned Thomas Hill to portray a family reunion in the garden of the Stanfords' newly acquired country home. In the style of the English eighteenth-century conversation piece, *Palo Alto Spring*, 1878 (fig. 28), portrays the reunion of several generations of family members gathered together under the shade of centuries-old trees. The genre was much loved by the Victorians as an indication of family cohesion, prosperity, and status—of "family values."[17] And when the huge canvas was completed and installed in the Stanford mansion on San Francisco's Nob Hill, public and press were invited to see it. How else was the world to know of the domestic bliss that awaited a transcontinental railway crossing? While little is made of the landscape in this canvas, a cactus garden—an Arizona Garden—was installed elsewhere on the Stanfords' ranch by Rudolph Ulrich.

The painting evidently marked the tenth birthday of Leland Stanford Junior, the son and heir, in striped socks seated at left, with a game of croquet for the boy and his cousins. Advertised as a "family sport" when it was introduced in the 1860s, croquet was a game in which women had the rare opportunity of challenging men on the playing field and beating them. (Some said they won because their long skirts made cheating possible.[18]) The arrangement of men and women on the croquet lawn of the private garden also attracted Winslow Homer, who painted oils of five such settings from 1865 to 1869;[19] Louisa May Alcott found a place for the game in *Little Women* and so, unforgettably, did Lewis Carroll in *Alice in Wonderland*.

In the early 1900s a hint of increasingly democratic use of the public park was implied by Prendergast's many paintings and watercolors of Central Park. Having often portrayed scenes of working-class visitors to Franklin Park after his return to Boston from Paris in the 1890s, Prendergast was soon adding a lively mix of

FIG. 28. Thomas Hill (U.S.A., 1829–1908), *Palo Alto Spring*, 1878. Oil on canvas, 220 × 351.5 cm.
Iris & B. Gerald Cantor Center for Visual Arts at Stanford University.

men, women, and playful children to the breezy spectacle of urban leisure in Central Park. His colorful picture *The Mall*, 1901 (Art Institute of Chicago), hints at the large crowds that filled the walkways on Sundays—the only day such outings were possible for most working-class New Yorkers. "Oh my God, what a treat it was to go to Central Park," a child of Italian immigrants later recalled, remembering how her mother lectured the family not to pick the flowers —"The flowers are for beauty."[20] Elsewhere on the grounds, Prendergast's schoolchildren celebrate May Day with picnics and maypoles (cat. 103) that suggest the park's changed ambience from rural retreat to people's park. May Day picnics were forbidden until the 1870s, when Tammany Democrats took over the running of the park, eventually attracting thousands of children—thirteen thousand, in fact, in 1904, when the leader of the Nineteenth Assembly District organized the handing out of five hundred gallons of ice cream to picnicking children from the West Side.[21]

But it took the animated imagery of John Sloan to capture a sense of ordinary folks enjoying the use of park space, and then it was not to Central Park that the artist turned his sights, but rather downtown for *Sunday Afternoon in Union Square*, 1912 (cat. 114), or to public parks in New Jersey, like the one in Bayonne that served as the setting for *Picnic Grounds*, 1906–7 (Whitney Museum of American Art, New York). Yet even Realist painters, for all the spontaneity of their more rugged style and truer sociology, continued, like Chase and Hassam, to accentuate the charms of park settings, and not to describe the "deplorable deterioration" that, as the *New York Herald* reported in 1907, had befallen the grounds of city parks after the turn of the century.[22]

Since commercial pleasure gardens, like group picnics, had been voted out of the original plan for Central Park, artists lacked an opportunity for capturing, out-of-doors, the atmosphere of the dance hall. But there was one area in Central Park that brought crowds together in a spirited way right from the start: the skating pond. Completed in time for the skating season in 1858, the pond was one of the first elements to be available for public use. No sooner had it been made ready—drainage pipes were laid to bring the run-off from rainwater in the Ramble into the lake, and, for the safety of skaters, its twenty acres were terraced to a four-foot depth—than its lively use was captured by Currier and Ives (cat. 132). While at the same time accentuating the rural charm of country life transposed to the city, skaters not only provided the color and rhythm painters sought but also awakened a memory of childhood pleasures in the minds of nostalgic New Yorkers who might also be patrons of art and likely to buy such imagery.[23] Forty years later William Glackens, who had studied in Paris and traveled widely in Europe, rendered *Central Park: Skaters* (cat. 133) in a style reminiscent of Pierre-Auguste Renoir's *Skaters in the Bois de Boulogne*, 1868 (private collection).

During much of the 1890s, Hassam, like other painters who lived in New York, was escaping to the country during the hot summer months. This was a time when artists sought out the camaraderie of one another in colonies all along the northern East Coast, from Connecticut to Maine. To speak of Hassam in the context of the park setting without following him to the Isles of Shoals near Portsmouth, New Hampshire, would be to miss the paintings that came of his visits to his friend Celia Thaxter's fabled garden on Appledore, a gathering place for artists, musicians, and writers. Thaxter, a highly popular poet, wrote an influential book on gardening, *An Island Garden*, which Hassam illustrated. His portrait of her standing among the hollyhocks and poppies, *In the Garden*, 1892 (fig. 24), formed the book's frontispiece. Thaxter's tall figure, at one with the natural setting, is a handsome example of myriad paintings in which the female figure is identified with nature, a simile that goes back to the Renaissance. Revivified by the high-keyed tonality and chromatic palette of Monet, American paintings of women in gardens proliferated in the late nineteenth century.

The mid-1880s were the years that brought Monet's garden at Giverny into the spotlight. Seen at first-hand by American artists like Theodore Robinson, the extraordinary setting was filtered through him and his colleagues to others at home. Moreover, four dozen Monets were included in an exhibition of 290 French Impressionist paintings that was brought to New York in 1886 by the dealer Paul Durand-Ruel, who opened a gallery in the city two years later. French art seeded the blossoming of Impressionist garden paintings all along the East Coast, where earlier the ground had been prepared by artists true to Ruskin's aesthetics of fidelity to nature. Especially notable among such paintings were Twachtman's landscapes of his Connecticut garden (fig. 25). Twachtman found the American scene a comfort to both eye and spirit when he returned to the United States in the mid-1880s, after years of study in Munich and Paris. "I feel more and more contented," he wrote to his friend and colleague John Ferguson Weir, "with the isolation of country life. To be isolated is a fine thing and we are then nearer to nature."[24] He bought a seventeen-acre farm near Greenwich. Native flowers—asters and goldenrod—that flourished in his old-fashioned garden appeared in his paintings of the 1890s, although his greater interest lay in tonal Whistleresque evocations of the farm's brook and its snow-covered hills.

Twachtman's retreat to the countryside was mirrored not only by contemporary artists but also by workers from other spheres. The need for leisurely escape from the intensive work schedules enforced by industrialization found more and more urban dwellers seeking out vacation spots that took them into nature. As suburban living became attractive, community gardening groups were formed, and in about 1900 garden publications proliferated. The old-fashioned home garden grew in popularity on the eastern seaboard as well as in the west. Acquiring a country house south of San Francisco in 1926, Theodore Wores, who had admired the gardens of the Generalife in Granada and executed many paintings of Japanese gardens, did several oils of the plantings around his new home in Saratoga (cat. 22).

Escaping to their own gardens for comforts not found in the industrialized city, American artists of the late nineteenth century gave a conservative, middle-class slant to their leisurely representations of modern life. For them, Central Park was the embodiment of a privileged space expressed visually in chromatic landscapes tinged with nostalgia for the country life of America's recent past.

NOTES

1. Robert L. Herbert, *Impressionism: Art, Leisure, and Parisian Society* (New Haven and London: Yale University Press, 1988), 141, cites progressive ideas brought back to France after Louis-Napoleon's long exile in England for park reform leading to "health, progress and morality."

2. Witold Rybczynski, *A Clearing in the Distance: Frederick Law Olmsted and America in the Nineteenth Century* (New York: Scribner, 1999), provides an account of Olmsted's designs for public parks throughout the continent, including not only Central Park but also Prospect Park in Brooklyn (1865), Mount Royal in Montreal (1877), Belle Isle in Detroit (1883), and Franklin Park in Boston (1891).

3. For a reproduction of Cullen's garden, see May Brawley Hill, *Grandmother's Garden: The Old-Fashioned American Garden, 1865–1915* (New York: Harry N. Abrams, 1995), 19. Descriptions of the gardens of other poets, writers, and artists are provided together with historic photographs.

4. Quoted in Roy Rosenzweig and Elizabeth Blackmar, *The Park and Its People: A History of Central Park* (Ithaca and London: Cornell University Press, 1992), 131.

5. The consistency between Olmsted's aesthetics and the contemplative aura of Central Park paintings long after actual usage had changed the park's character is emphasized in the enormously informative exhibition catalogue by H. Barbara Weinberg, Doreen Bolger, and David Park Curry, *American Impressionism and Realism: The Painting of Modern Life, 1885–1915* (New York: The Metropolitan Museum of Art, 1994), 148.

6. Quoted in Weinberg, Bolger, and Curry, *American Impressionism and Realism*, 144; from A. E. Ives, "Suburban Sketching Grounds I: Talks with Mr. W. M. Chase, Mr. Edward Moran, Mr. William Sartain, and Mr. Leonard Ochtman," *Art Amateur* 25 (September 1891): 80.

7. Rosenzweig and Blackmar, *The Park and Its People*, 120.

8. Quoted in William H. Gerdts, "Three Themes," in *Childe Hassam, Impressionist* (New York: Abbeville Press, 1999), 316.

9. David Park Curry, *James McNeill Whistler at the Freer Gallery of Art*, exh. cat. (New York: W. W. Norton, 1984), 74.

10. Weinberg, Bolger, and Curry, *American Impressionism and Realism*, 136.

11. Henry James, *The Bostonians*, edited with an introduction by Alfred Habegger (1885–86; reprint, Indianapolis: Bobbs-Merrill, 1976), 309. By 1880 three elevated lines and five horse-car lines could bring visitors close to Central Park—if they had the carfare.

12. Edith Wharton, *The Custom of the Country*, with an introduction by Lorna Sage (1913; reprint, New York: Random House, 1994), 75.

13. Weinberg, Bolger, and Curry, *American Impressionism and Realism*, 293. Sharp social differences are here discussed and referenced to the work of Philippe Ariès, *Centuries of Childhood* (New York: Knopf, 1962), and Viviana Zelizer, *Pricing the Priceless Child: The Changing Social Value of Children* (New York: Basic Books, 1985).

14. Quoted in Rosenzweig and Blackmar, *The Park and Its People*, 333.

15. Barbara Dayer Gallati, *William Merritt Chase: Modern American Landscapes, 1886–1890*, exh. cat. (Brooklyn: Brooklyn Museum of Art, 1999), 78.

16. Gallati, *William Merritt Chase*, 61.

17. Sentimental cohesion brought together several absent family members: Stanford's mother, who had been dead for several years; his brother Thomas Weldon, who lived in Australia and had never been to the Palo Alto house; and his brother-in-law, Charles Lathrop, who remained in New York the entire year.

18. See Jon Sterngrass, "Cheating, Gender Roles, and the Nineteenth-Century Croquet Craze," *Journal of Sport History* 25, no. 3 (fall 1998): 398–418.

19. David Park Curry, *Winslow Homer: The Croquet Game*, exh. cat. (New Haven: Yale University Art Gallery, 1984).

20. Quoted in Rosenzweig and Blackmar, *The Park and Its People*, 407.

21. Rosenzweig and Blackmar, *The Park and Its People*, 389–90.

22. Quoted in Weinberg, Bolger, and Curry, *American Impressionism and Realism*, 155.

23. Bryan F. Le Beau makes the point that Currier and Ives's "pictorial typing reflected the mental typing of that population to which it appealed—the white, middle-class majority of nineteenth-century America, more often than not from cities and large towns, and women, to whom [their prints] were heavily marketed." *Currier & Ives: America Imagined* (Washington, D.C.: Smithsonian Institution, 2001), 6.

24. Quoted in Kathleen A. Pyne, "John Twachtman and the Therapeutic Landscape," in Deborah Chotner et al., *John Twachtman: Connecticut Landscapes*, exh. cat. (Washington, D.C.: National Gallery of Art, 1989), 53.

Resurrection

The Built Landscapes of George Hargreaves

PAULA DEITZ

Walking and thinking, to breathe the site. This is how the landscape archi-
tect George Hargreaves works best to achieve his mission of weaving ideas
and spaces into masterful combinations, reconnecting cities with their
postindustrial derelict lands. And because his designs are perceived as figurative, rather
than scenic, to experience them also evokes clarity of thought and observation. The
promenade or circuit becomes the tangible thread connecting people to a series of events
in these sculpted landscapes that retain a sensitivity to their environments and to their
previous histories. Where others see destitution, Hargreaves sees restitution.

Hargreaves found his vision through his own circuitous route, one that began with an
epiphany on the summit of Flattop Mountain while backpacking in Colorado's Rocky
Mountain National Park. Emerging above the tree line onto a summer snowcap dotted

FIG. 29. Robert Campbell (U.S.A., b. 1944). *Crissy Field*, c. 2001. Digital photograph. Hargreaves Associates.

with flowers, he looked out over Bear Lake to a view of the peaks beyond. It was a spatial experience that made him feel at one with nature and the landscape. When he recounted the feeling to an uncle, who was dean of forestry at the University of Georgia, the older man responded: "Have you ever heard of landscape architecture?"

From then on Hargreaves traveled in a straight line. After completing his bachelor of landscape architecture at the University of Georgia School of Environmental Design, he earned his master's degree at Harvard University's Graduate School of Design, where he has taught since 1986 and now chairs the Department of Landscape Architecture. During graduate school came a second revelation. He discovered earthworks of the 1970s like Robert Smithson's *Spiral Jetty* in Great Salt Lake and *Amarillo Ramp* in Texas. While artists like Smithson and Michael Heizer, whose *Double Negative* cut trenches in a Nevada mesa, saw their works purely as sculptural objects in the landscape, Hargreaves explored them as new elements exposed to the shaping effects of water, wind, and gravity. He further developed these concepts in workshops devoted to landforms—spheres, cones, pyramids—that would serve as space makers the way other designers would insert walkways or plantations. In his 1996 entry to the Festival International des Jardins at Chaumont-sur-Loire, France, he compressed these ideas into something akin to poetry. On a small site, he constructed a spiral mound alongside serpentine beds of grasses and perennials, suggesting agricultural furrows, and an abstract forest of fiberglass rods. The arrangement invited a promenade to the top of the mound for an uplifting view of the Loire River.

While traveling abroad as a young professional, he embarked on another formative experience, that of appreciating the complexity of history and culture that marks places like Stowe in England and Courances in France. Stowe provides the most evocative long walk in England through a vast property that was shaped in succession in the eighteenth century by Charles Bridgeman, William Kent, and Lancelot "Capability"

Brown, who became head gardener in 1741. On the circuit around fields and lakes and across bridges and into small temples and monuments, there is a moment at Stowe when suddenly the majestic scheme, though based on disparate influences, comes together. The enchanting seventeenth-century park at the Château de Courances, said to have been designed by André Le Nôtre and repaired in the late nineteenth century by Achille Duchêne, is planned on a more domestic scale than Le Nôtre's grander designs for Vaux-le-Vicomte and Versailles. It is fed by ten natural springs that establish such diverse water features as a moat, a horseshoe fountain, a mirror lake, a stepped canal, and, the culmination, the striking image of a long, somber canal lined navelike with black poplar trees. The fact that the landscapes of both Courances and Stowe have survived the centuries in a composite, readable form indicates a respect for their individual parts.

Cumulative history rather than complex theory is what most affected Hargreaves's view of landscape design. And yet, looking closer at work by "Capability" Brown and Humphry Repton during his travels in Britain, he found that their smooth approaches to grading and tame clumps of trees sanitized rather than invigorated the surrounding nature. Instead, Hargreaves preferred the richness of the wilder approach in New York's Central Park, where Frederick Law Olmsted and Calvert Vaux unleashed nature by scattering plants and trees and by creating a geological basis with rocky outcrops. Many landscape architects, Hargreaves believes, "lift" the substance of Olmsted without truly understanding his style. (Like many of Hargreaves's own projects, the idealized landscape of Central Park itself was constructed on vacant swampland, as was its inspiration, Birkenhead Park near Liverpool, the oldest free-entry municipal park in Britain, designed by Joseph Paxton.)

Hargreaves followed the forcefulness of nature one step further as he witnessed the destructive powers of a hurricane destroy a beach in Hawaii. He saw in this disorder a beauty that countered the static norms of American landscapes and recognized the greater pos-

sibilities of kinetic potential in a human rapport with the land.

Since 1983 Hargreaves Associates of San Francisco and Cambridge, Massachusetts, have traveled the world with their original concepts of engagement and narrative in rediscovering the underlying essence of landscapes. The plaza for the Sydney Olympics 2000, a waterfront park on landfill for Lisbon's Expo '98, and landforms tying Japan Science World to Tokyo Bay are only a few of their international commissions. But for Hargreaves, Northern California was like the Land of Oz, a magical but somewhat bizarre, windswept country where anything was possible. Following his professional path in the Bay Area, where he lives, reveals not only the historical evolution of the land itself but also the continuity and fluidity of a practice that has developed, as he says, into three different stages. He describes early work, like Byxbee Park in Palo Alto, as abstract and bare, pushing beyond the limits of normal ideas about landscape and relying for materials on dirt and the remaining detritus on the site. The middle period, represented by Guadalupe River Park in San Jose, brought a dramatic turnaround to fringe or marginalized areas closer to populous downtowns and demonstrates a full command of the requisite supporting technologies. And the third and most recent stage addresses locations at the very heart of a culture, requiring ever more complex solutions, like Crissy Field in San Francisco (fig. 29). At the interface of land and water, all of these remnant sites were also the edges inhabited by Native American tribes whose spirits can be reimagined as people once more promenade along these shores.

Byxbee Park was a garbage mound before it became a park in 1991 (fig. 30). Now, paths of crushed oyster shells weave through a series of landforms that blend with adjacent baylands and encourage the return of wildlife. A walk there is similar to hikes in the English Lake District, where the natural hills form an immediate horizon that dissolves when one approaches the next rise. This perceived increase in space and distance through valleys and elevations is something that Olm-

FIG. 30. Becky Cohen (U.S.A., b. 1947). *Chevrons, Byxbee Park, Palo Alto*, 2001. Pigment print. Becky Cohen.

sted understood when he created the illusion of deep perspectives with undulating paths leading toward a near horizon crested with trees. There are no trees, though, in the thirty-five acres of Byxbee Park, for fear that the roots would disturb the one-foot-thick impenetrable clay cap sealing the landfill under two feet of soil.

In collaboration with two environmental artists, Hargreaves has made a powerful combination of elements that integrate the reclaimed site with its history and location. Waves of nonirrigated native purple stipa grass give the landscape a velvety appearance, changing from green in early spring to a rich golden hue by May. Surrounded on two sides by water, the Mayfield Slough and the Mayfield Marsh, the park may be isolated on a peninsula, but it also meshes visually with the larger landscape beyond.

Striking out across the northern slope, the visitor climbs along a series of eight massive chevrons, formed by concrete highway barriers embedded at right angles as a directional motif for airplanes heading to the nearby municipal airport. From there the path proceeds through a narrow pass between two landforms that open into the park's protected area. Here clusters of hillocks (reminders of Ohlone Indian shell heaps) planted with lupines and other wildflowers offer both shelter from the wind and a lookout over the long vistas.

On the descending slope, five berms of compacted soil and rock infill, set in ever larger arcs for erosion control, give the impression of rippling water. A sculpture installed at the head of this procession, called *Wind Wave Piece*, echoes the rippling motion—a square arc with hanging ropes that wave in the afternoon northwest wind. The path proceeds along the slough and passes the flare needed for burning off methane gas from the underlying garbage. The thick hedgerows lining the banks of Mayfield Slough are interspersed with triangular, cedar-plank viewing platforms for bird-watching over the wetlands.

As the walk continues around the point, a conceptual forest comes into view, a dramatic grid of weath-ered green cedar posts. These create an exciting visual rhythm as the grid shifts and finally disperses into randomness as one turns the corner. The patterns recall the experience of passing telephone poles on a drive in the country and reflect as well the processional aspect of power pylons across the slough. The pole field, as it is called, is sliced off at the top in a slanted plane gesturing down to the marsh.

Hargreaves's design for Byxbee Park includes a small gem of architecture: the triangular restroom at the parking lot entrance. An unmistakable reference to Louis Kahn's famous 1950s bathhouse for the Jewish Community Center of Trenton, New Jersey, it is elegantly simple and practical. Hargreaves's crisp little pavilion has a translucent roof for natural light, thereby eliminating the need for electricity, while the gap between the roof and cedar walls provides ventilation.

A few miles south in San Jose, Hargreaves engineered an entire series of parks around the Guadalupe River that have transformed and rejuvenated the city. The river, a valuable water source, has also been an instrument of vast destruction during periodic flooding. But Hargreaves brought to the assignment an understanding of both natural and man-made landforms that provided the solution to the hydrological challenge. In a sense, he has designed a string of city parks as a vast controlled water garden. Few landscape architects since Olmsted have had the opportunity to work on such a grand scale in one urban location.

Downstream from the city, the river flows innocently through its narrow bed, but on the embankment of Guadalupe River Park the braided network of alluvial berms resembles in accentuated form the buildup of striated sediment in a river delta. Intermittent channels contain the periodic overflow before redirecting it to the riverbed. In dry periods, the graceful undulating landscape along serpentine paths with plantations of oaks and bay trees belies the technological precision of the engineered landforms that are narrowed on the upstream ends to reverse the torrents. The woody plant habitat on the riverbanks—cotton-

wood trees, scrub willow, snowberry, and gooseberry—possesses the wildness that Hargreaves believes brings richness to the landscape and also guarantees low maintenance.

In San Jose itself, where the Guadalupe River meets the Los Gatos Creek, Hargreaves designed Confluence Park as a meeting place for crowds converging on the San Jose Arena for sports events. Stately rows of poplar trees along the green are like those seen in the French countryside. The sloped Arena Green amphitheater is configured with pyramidal landforms and pocket spaces for picnicking within groves of trees. It recalls the green amphitheater at Claremont Garden in Surrey designed by William Kent. The park crosses the creek via a pedestrian bridge to Confluence Point, a cool, wet naturalistic woodland on a spit of land formed by the two rivers. The handsome Cor-ten steel bridge has all the stately elegance of the Palladian Bridge at Stowe.

In downtown San Jose, with its combination of old Spanish-style and contemporary office buildings, the threat of the Guadalupe River was even more dangerous, as it flowed through the heart of the city. Hargreaves secured the riverbanks with a wall of terraced gabions that have filled up with enough soil and pioneer plants to sprout a genuine riparian plant community. (Gabions—metal cages filled with rocks used in roadway fortifications—have become one of the most attractive and useful industrial products available to landscape architects.) These terraces, combined with long serpentine steps along the riverbank, allow the water to rise step by step, both controlling and speeding up the river as it travels through the city. A new corporate headquarters constructed by the Silicon Valley giant Adobe on the riverbanks is proof of renewed confidence.

Hargreaves's Plaza Park is San Jose's main square, crisscrossed daily by pedestrians on angled paths typical of town commons. Its central promenade retraces the historic Camino Real, the route that led to the California missions. Here, water has been captured and tamed in the first fountain the landscape architect de-

signed. Its spouts, at intersecting points of a grid of glass blocks, are flush with the ground. They produce mist in early morning, provide playful geysers for children at midday, and at night, illuminated through the glass blocks, glow in a magical terrain. A grid of jacaranda trees recalls the satisfying beauty and regularity of orchards that once dotted the region; mature redwoods, live oaks, and sycamores shade pathways lined with park benches. Hargreaves also leaves his mark with the angled green walls of an informal amphitheater.

While accommodating every aspect of outdoor enjoyment, Crissy Field, now a national park in San Francisco, redefines the process of a public landscape. George Hargreaves and his associates, particularly his longtime collaborator Mary Margaret Jones, peeled back layers of the site's natural and man-made history to discover a configuration of elements that overlap in time. Hargreaves often speaks of the poetry of landscape, which suggests a compression of language and forms that reveal ideas without overelaboration. Urban parks are never natural landscapes, but they may be designed to enhance appreciation of nature. Waterfront parks, like Crissy Field on San Francisco Bay, have the added advantage of facing the beauty and unpredictability of the sea.

Located at the bottom of the Presidio, the old Spanish garrison turned U.S. military post, Crissy Field was originally a tidal marsh where the Ohlone Indians harvested shellfish. In 1912 it was filled in as an automobile racetrack for the upcoming Panama-Pacific International Exposition of 1915; in 1921, as a grassy meadow, it became an airfield for biplanes named after the aviation pioneer Major Dana A. Crissy. The airfield was paved over in 1935 and remained in use by the military until 1974. Since then, the beach has become a haven for windsurfers who appear even today to fly through the waves on glinting Mylar sails like a flock of low-flying seabirds.

Crissy Field extends one hundred acres from east to west, from a stand of cypress trees just beyond Marina Green to the Golden Gate Bridge. The major elements

of the park are a vast tidal marsh, a lagoon fed with seawater, and, overlooking it, a lush kidney-shaped grassy meadow of an airfield. Running the entire length of the park along the sandy beach and boulder-strewn shore is a 1.3-mile-long windy esplanade, wide enough never to appear crowded even on a holiday. The airfield itself is a giant berm of red fescue grass that rises several feet above the promenade at one end and slants down to ground level at the other. The parking area at the eastern end, for windsurfers and visitors, fades into a meadow with finger-splayed mounds and a grid of trees. At the far end, red-roof structures with weatherboard siding in groves of palm trees preserve a bit of Army vernacular but also serve as a refreshment area. Complex swirls of berms protect picnic areas and challenge children more than most conventional playgrounds do. In general, though, the flatness of the landscape makes richer all the fine details: the wisps of color of thousands of native plants growing in the dune gardens or the boardwalk leading to a standing grove of Monterey cypress on the beach.

But what is public may also be private. While the flow of people proceeds along the esplanade, anyone can walk out on the bridge crossing the lagoon and quietly watch the birds settle in the twilight as the rosy clouds of sunset gather over the Golden Gate Bridge. Hargreaves has no doubt been walking and thinking there himself to breathe in the site, motivated to re-create in other people's lives the sensation of his existential experience at Flattop Mountain, "to make moments and places more than what they are in a redefined picturesque for the twenty-first century."

In every era, individuals emerge with a singular creativity—part genius, part opportunity—that takes their art or science to a new level of realization, but without departing entirely from the cultural past. Stowe, Courances, Central Park, and countless other sources have played a role in Hargreaves's education.

In architecture, spectacular results are achieved by variations of form and function combined with new materials and advancements in engineering. The challenge has always been greater, though, in landscape architecture, where the substance of design remains the same: earth, water, stone, plant life, and sky as a source of light and shadow. Add to this list time, memory, people, and the natural history of a site. And more often than not, today these sites represent cultural wastelands depleted of both character and characteristics, abandoned brown fields at the edges of cities. George Hargreaves's goal is resurrection.

CATALOGUE OF THE EXHIBITION

Each entry includes a physical description of the work with measurements given in centimeters and height preceding width. For prints measurements are for the image or plate only, unless otherwise noted; those for drawings and paintings are for their sheet size or canvas.

Designing Gardens

The first section of the exhibition introduces plans and prospects; parterres, mazes, and hedges; textures, shapes, and colors; water displays; statuary; structural features; and gardeners at work. Organized from the largest design features—the reshaping and subdividing of the terrain—to ornamental details—fountains, statuary, and gazebos—this section illustrates how nature is molded into a work of art. A site is terraced and then divided with hedges or planted in geometric patterns, though sometimes garden designers choose to retain the look of a more natural and open landscape. Once fundamental spatial divisions are established, decisions of texture, shape, and color of plantings follow. Special areas are traditionally set aside for mazes or specific kinds of plants, or for kitchen gardens or orangeries. Water animates gardens by surprising and enchanting as it trickles over the rims of basins, roars in cascades, or murmurs in streams, enhancing garden experiences by its varied appearances and sounds, as well as providing essential nourishment for the plantings. Garden structures include winter shelters for citrus trees and hothouses to protect exotic plants. Statuary and architectural accents, such as pyramids, temples, colonnades, or obelisks, function not only as decoration but as emblems of the garden's meaning, often linking it to a greater geographic and historic context. Gates were designed to greet, and impress, approaching visitors. Trelliswork, benches, tree houses, and swings all contribute to a garden's aesthetic character, as well as offering pleasant diversions. This section concludes with representations of workers, who remain largely invisible in many views, and, when represented, are often treated as decoration or objects of humor.

Prospects and Plans

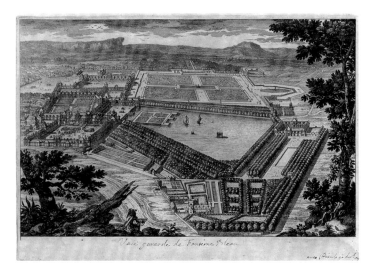

1a

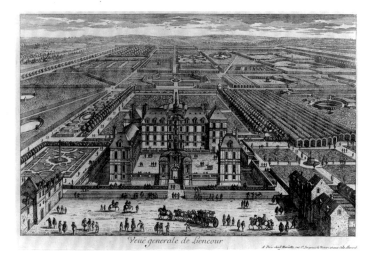

1b

1

Gabriel Perelle (France, 1604–1677) and/or
 Adam Perelle (France, 1638–1695)

A. *Fontainebleau: General View* c. 1670–90
B. *Liencour: General View* c. 1670–90

Etchings, 19.5 × 28.2 cm; 19.2 × 28.2 cm

Iris & B. Gerald Cantor Center for Visual Arts at Stanford
 University (Committee for Art Acquisitions Fund,
 1988.29; Mortimer C. Leventritt Fund, 1977.191)

Late in the seventeenth century, the Perelle family of print-
makers made a large number of views of French royal
châteaux, featuring André Le Nôtre's newly designed gar-
dens for Louis XIV. At Fontainebleau, where Louis XIV was
born, the older château is shown at the left of the print and
a pleasure lake in the center; Le Nôtre's immense terrace
(*parterre*) is toward the top of the print. In contrast to the
irregularities of the older layout of Fontainebleau, Lien-
cour's symmetric plan shows long vistas extending far into
the flat, neatly divided countryside. Both views taken from
high, imaginary perspectives provide wide-angle coverage.
Gabriel and his son, Adam, made more than a thousand such
prints.

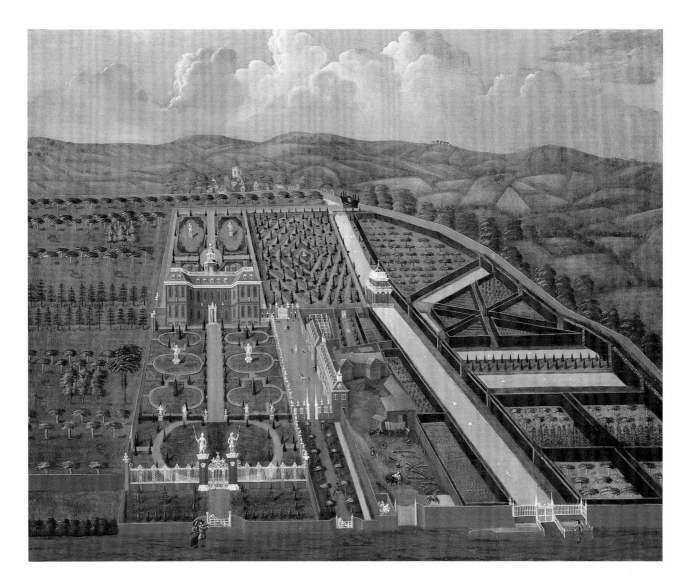

2

Anonymous (England, late 17th century)

A Perspective View of Denham Place,
 Buckinghamshire c. 1695

Oil on canvas, 101.6 × 126.4 cm

Yale Center for British Art (Paul Mellon Collection,
 B.1976.7.116)

This painting of an English country house, rather naively pictured, is characteristic of many late-seventeenth-century views made by itinerant artists, whose speciality was making portraits of properties. Like most general views, this was taken from a high angle to show the extent of the patron's holdings. Dating from the same time as the Perelle prints of French royal châteaux, Denham Place is clearly based on the French formal plan. However, its embellish-ments show an exuberance of spirit that is Dutch, especially in the profusion of statuary. When William and Mary as-sumed the British throne in 1688, they introduced Dutch fashion for such statuary as well as a greater interest in plant diversity. A century later, the formal garden at Denham Place was destroyed by the garden designer Lancelot "Ca-pability" Brown, who replaced it with the newly fashion-able, more naturalistic landscape.

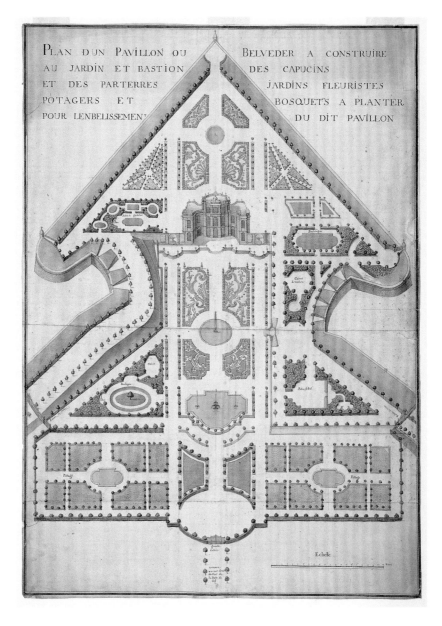

Plan D'un Pavillon ou au Jardin et Bastion et des Parterres Potagers et pour l'embelissement — Belveder a construire des Capucins Jardins Fleuristes Bosquets a planter du dit Pavillon

Echelle

3

Anonymous (France, mid–18th century)

Perpignan: Plan for a Pavilion and Garden c. 1750

Pen, in black and red inks, with watercolor over graphite,
95.2 × 68.1 cm

Collection Centre Canadien d'Architecture/Canadian
Centre for Architecture, Montréal (DR 1979.0039)

In contrast to the preceding prospects of gardens designed for an open landscape, this is a plan for a pavilion and garden in Perpignan to be built within the outlines of a medieval bastion—part of the old wall that once defended the city. It is one of a pair of mid-eighteenth-century proposals for a garden area, this one with many small beds and tree-lined paths. Its abundant plantings of trees is an urban feature that is still welcome, as is the thoughtful reuse of space.

To convert this awkward space, whose original use had become obsolete, administrators of the growing city examined several plans. That this garden design is in the classic French formal style is worth noting because Perpignan, being so close to the Spanish border, had strong Catalan ties. On two plans from the 1760s (Canadian Centre, acc. nos. 1979.40–41), inscriptions indicate that the area was associated with the university and might include a botanic garden, reservoir, and hothouse.

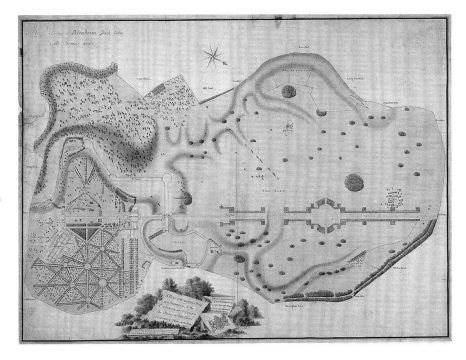

4

John Spyers (Great Britain,
active mid–18th century)

A Survey Plan of Blenheim Park 1763

Pen and black and brown ink with
watercolor over graphite, 53.2 × 72.1 cm

Annotated, inscribed, and dated:
"A Plan of Blenheim Park/and Gardens
etc., in the/County of Oxford./
the Seat of His Grace/The Duke
of Marlborough./1763"

Collection Centre Canadien
d'Architecture/Canadian Centre
for Architecture, Montréal
(DR1985:0416)

This long-unknown plan offers valuable insights into the
changes made at Blenheim between the time the architect of
the palace, John Vanbrugh, and the gardener, Henry Wise,
ended their efforts in 1716, at the time of the death of the
first duke of Marlborough, and when the fourth duke, John
Spencer, hired "Capability" Brown in 1764.[1] Although much
of the 1763 plan is based on an engraving published in vol-
ume 3 of Colen Campbell's *Vitruvius Britannicus: or, the Brit-
ish Architect* (1725), the drawing provides evidence of alter-
ations that were probably made for the first duke's widow,
Sarah. In recent years aerial photography has shown that a
system of canals, which are evident on Spyers's drawing, lay
beneath the great lake created by Brown. Although Brown
has been credited with planting many tree groupings, the
1763 plan already shows clumps near the house and else-
where. Spyers's survey, drawn for Brown, makes clear that
the subsequent changes were neither as radical nor as de-
structive of earlier work as has been thought. This is not to
deny Brown's genius in creating a vast and harmonious land-
scape, but to clarify the historical record.

NOTE

1. David W. Booth, "Blenheim Park on the Eve of 'Mr. Brown's
Improvements,'" *Journal of Garden History* 15, no. 2 (summer 1995):
107–23.

5

Anonymous (Germany, c. 1900)

A. *Children's Garden Game* (see p. 122)

Plaster, hand-painted, 2.1 × 27.7 × 22.6 cm

B. *Directions for a Children's Garden Game*

Lithographs, each c. 14 × 18.4 cm

Collection Centre Canadien d'Architecture/Canadian
Centre for Architecture, Montréal (TS2301.T7.P5K27)

This game encouraged children to arrange their own garden
layouts by moving the many small pieces decorated with
roses, flowers, grass, and paths. The directions offered sev-
eral solutions. Although the manufacturer's label has been
lost, the game has tentatively been identified as belonging
to a series made by Karl Max Siefert in Dresden about 1900.
Its tidiness and symmetry of design partake of the spirit of
Wiener Werkstätte patterns. Earlier popular prints of gar-
den subjects designed for children include sheets of paper
printed with features such as trees, fences, and a gazebo, to
be cut up and arranged as desired (cat. 42).

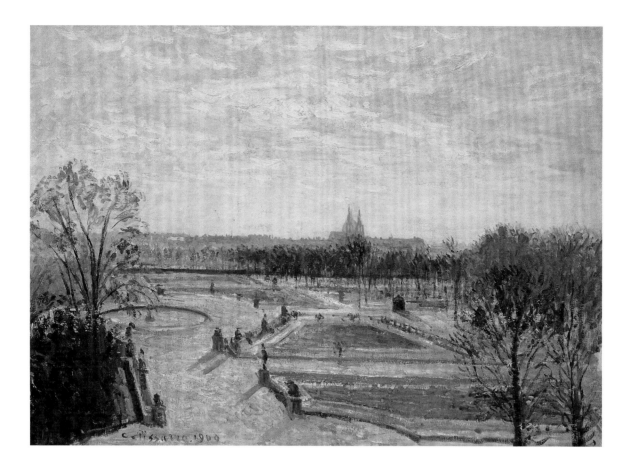

6

Camille Pissarro (France, b. Denmark, 1830–1903)
Garden of the Tuileries in Winter 1900
Oil on canvas, 66 × 91.4 cm
The New Orleans Museum of Art (On loan from the
Mrs. Frederick M. Stafford Collection, EL.1977.12)

Among Pissarro's paintings is a series that includes thirty views of the Tuileries, made during 1899 and 1900, when he wintered in Paris. After finding an apartment overlooking the Tuileries, he wrote enthusiastically to his son Lucien in a letter of December 8, 1898: "We have secured an apartment, 204 Rue de Rivoli, opposite the Tuileries, with a magnificent view of the garden, the Louvre to the left, the houses at the bottom, the embankments behind the trees in the garden, the dome of the Invalides to the right, the spires of Sainte-Clothilde behind the clump of chestnut trees—it's most attractive."[1] From his window, looking to the east, Pissarro had a clear view of the large reflecting pool and the Louvre's Pavillon de Flore. This was one of three vantage points from which he painted as he looked out across the garden.

Parts of the Tuileries date back to Catherine de' Medici's reign. Extensively modified by André Le Nôtre in the 1670s, its wide paths and circular pool still animate the central open space. Surrounding this focal point are neatly divided geometric beds; the paths framing the garden are lined by two rows of trees. When Pissarro painted the large pool, paths, and patterns of green lawn bordered by statuary and fences, the trees' canopy sometimes obscured certain areas; in winter, however, the spaces between their brown limbs allowed a fuller view. Working in morning light, late afternoon, and deepening evening, Pissarro captured the garden's many moods with tonalities ranging from pale pinks, greens, and tans (sunny days) to dusty browns and purples (late afternoons), to grays and whites (snowy days). In good weather, strollers clustered around the central pool; on rainy or snowy days, the garden was nearly deserted.

NOTE

1. Richard R. Brettell and Joachim Pissarro, *The Impressionist and the City: Pissarro's Series Paintings*, exh. cat. (New Haven and London: Yale University Press, 1992), 103 n. 6.

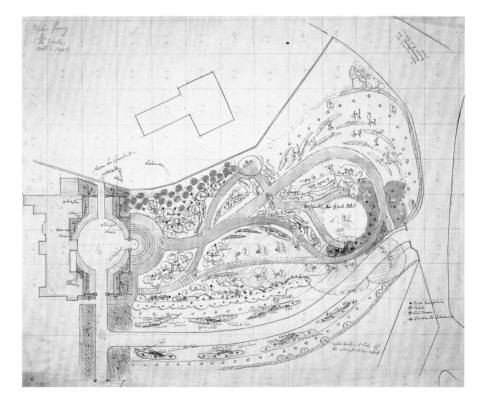

7

Gertrude Jekyll (Great Britain, 1843–1932)

A. *Upton Grey: Planting Plan for the Rose Lawn and Wall* c. 1908

B. *Upton Grey: Plan for the Wild Garden* c. 1908

Pen and wash, colored pencil and graphite, 13.9 × 53.3 cm; 53.6 × 66.3 cm

Environmental Design Archives, University of California, Berkeley (Gertrude Jekyll Collection, 1955-1)

Jekyll, the influential British garden designer, advocated informal arrangements using native plants. Her plans for Upton Grey in Hampshire show the level of detailed organization and plant selection that went into achieving her designs. Her client, Sir Charles Holme, was a distinguished figure in the Arts and Crafts movement and founder of the magazine *The Studio*. In 1904–7, on the remains of an old Tudor manor, the architect Ernest Newton designed a handsome half-timbered house for Holme. Jekyll designed two very different gardens for it, as can be seen in the plans. In the first, the formal area in front of the manor house includes a terrace, steps to a lower level, stone walls with perennial borders, and roses planted in squares on the lower lawn. This garden continues down a sloping hill, divided by brick walls and hedges. In contrast, at the back of the house a path leads to a wild garden, where roses ramble over trees and carpets of bulbs spring into view amid ferns and other woodland plantings.

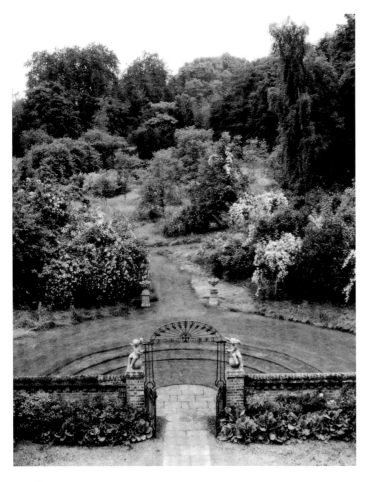

8b

8

Becky Cohen (U.S.A., b. 1947)

A. *Upton Grey: The Formal Garden in Front of the Manor House* 2000 (see fig. 7, p. 19)

B. *Upton Grey: The Wild Garden in the Back* 2000

Gelatin-silver prints, each 19 × 25.5 cm

Becky Cohen

The garden at Upton Grey, looking so established and well-tended in Cohen's recent photographs, appears to have enjoyed a long and tranquil existence, but nothing could be further from the truth. In 1983, when Rosamund Wallinger and her husband purchased the run-down manor at Upton Grey, it was not known that a Jekyll garden had ever existed there. Through detective work they discovered the original Jekyll plans at the University of California at Berkeley and were able to re-create nineteen borders and other areas. For most of the next two decades, Wallinger worked on restoring the garden to the fine state it is in today, as she relates in her book, *Getrude Jekyll's Lost Garden.*[1]

NOTE

1. Rosamund Wallinger, *Gertrude Jekyll's Lost Garden* (Woodbridge, Suffolk: Garden Art Press, 2000).

9

Beatrix Jones Farrand (U.S.A., 1872–1959)

A. *Plan for a Suburban Garden* 1910

B. *Perspective for a Suburban Garden* 1910

Pen and wash, 27.9 × 49.8 cm; 45.1 × 29.2 cm

Environmental Design Archives, University of California,
 Berkeley (Beatrix Jones Farrand Collection, 1955-2)

Farrand, the important American landscape designer, worked mainly for very rich clients or universities. In this instance, however, she turned her attention to the challenge of designing a small suburban plot. This hypothetical exercise was published in her article "Laying Out a Suburban Space" in *Country Life* (March 1910). She wrote that a naturalistic treatment would not have been possible in such a confined area, that "irregular lines, winding walks and scattered trees would only look crowded. . . . Honesty and clearness of design are perhaps even more necessary in the treatment of the small places." She concluded, "Here a frank recognition of the boundary line is essential."

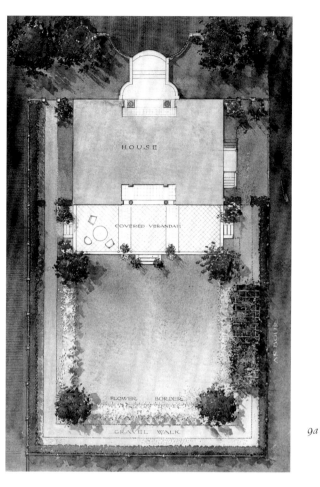

9a

9b

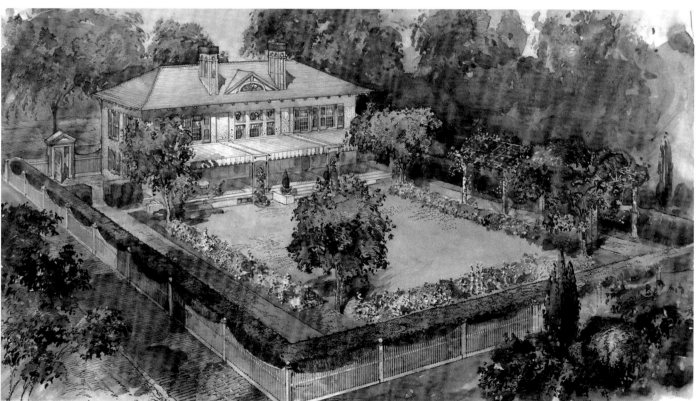

10a

10

George Hargreaves (U.S.A., b. 1952)

A. *Untitled* 1999
Pen and ink, 21.6 × 27.9 cm
Hargreaves Associates

Hargreaves Associates

B. *Revised Marsh* (*3.19.99*) 1999
Pen and ink, colored pencils, 30.5 × 101 cm
Hargreaves Associates

Plans for urban parks are increasingly called on to reconcile seemingly conflicting goals. The restoration of Crissy Field in San Francisco was no exception. When the National Park Service decided to restore the park, it was used by joggers, windsurfers, and dogwalkers, among others. Its past would also impose certain constraints on any new plan that would be developed. It had been the site of an airfield that played a significant role in early aviation history, and it was a National Historic Landmark. Hargreaves accommodated both active recreation and the restoration of a fragile ecosystem.

Two major natural features of the park are a twenty-acre tidal marsh and a lagoon fed with seawater. Both drawings are documents of the tidal patterns. The second is also an early plan for the site. Hargreaves's solution for accommodating recreational users and environmental concerns was to situate the marsh between the airfield and the parking lot prized by windsurfers, create an eight-foot overlook above the marsh at the end of the airfield, and construct a boardwalk that would snake across the wetlands from south to north. The overlook and boardwalk afford visual access to the wetlands while protecting their fragility. His plan is aesthetically pleasing as well, with the intentionally smooth, consistent curve of the grassy airfield serving as a contrast to the irregular, naturally evolving patterns of marsh vegetation.

10b

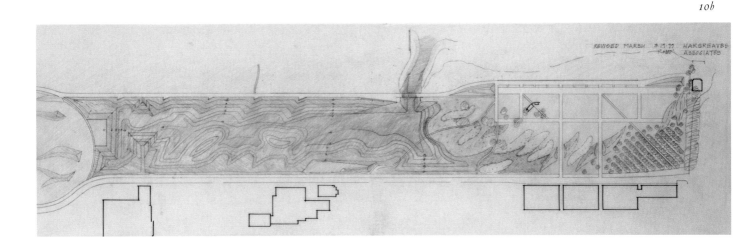

Parterres, Mazes, and Hedges

11

Gabriel Perelle (France, 1604–1677) and/or
 Adam Perelle (France, 1638–1695)

Fontainebleau: The Great Parterre c. 1670–90

Etching, 19.1 × 28.4 cm

Iris & B. Gerald Cantor Center for Visual Arts at Stanford
 University (Committee for Art Acquisitions Fund,
 1988.27)

During the sixteenth century in France, the flat terraced area adjacent to the château was divided into small, regular geometric sections. Known as parterres, these became a distinctive feature of the formal garden. With its beds of colored pebbles (and later flowers) defined by boxwood hedges, the parterre evolved from a static arrangement of small patterns into grander and more complex scroll-like patterns. At Fontainebleau, the royal gardens had included an earlier, smaller parterre. In the early 1660s André Le Nôtre created for the young Louis XIV a parterre so immense that it was best appreciated from the upper windows of the château. This etching, like many others by the Perelles, documents, with varying degrees of accuracy, the hallmarks of Le Nôtre's style.

During the eighteenth century, the taste for parterres gave way to the naturalistic English style, which gained a wide following throughout Europe. Many of those razed were restored at the end of the nineteenth century, when the taste for the formal garden returned.

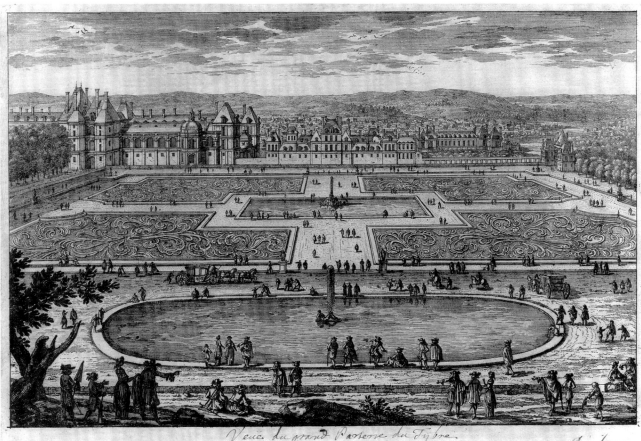

Veuë du grand Parterre du Tybre. avec Privilege

12

Paul Vera (France, 1882–1957) with
 André Vera (France, 1881–1971)
Four Studies of Garden Parterres c. 1912–25
Brush and watercolor, black chalk, graphite on off-white
 laid paper, 23.6 × 31.6 cm
Cooper-Hewitt, National Design Museum, Smithsonian
 Institution (Purchase, Smithsonian Institution
 Collections Acquisitions Fund, 1991-58-27)
[Shown only at Stanford and Ann Arbor]

The landscape architect and author André Vera, with his brother Paul, an illustrator and designer of decorative projects, collaborated on plans for and books about modernist gardens. Their crisp formalist compositions expressed innovative ideas such as thinking of the garden as a machine or ocean liner. Their designs for private gardens were geometric in character, often with features set at unexpected diagonals. Like Fernand Léger and other artists working in the aftermath of World War I, they believed order was essential. For their enclosed gardens (not open to the community), they favored brightly colored flowers, massed greenery of ivy or boxwood, and pruned fruit trees. Promoting new materials, such as concrete, which they used for traditional fountains and replicas of antique statues, they believed past and present should coexist in harmony.

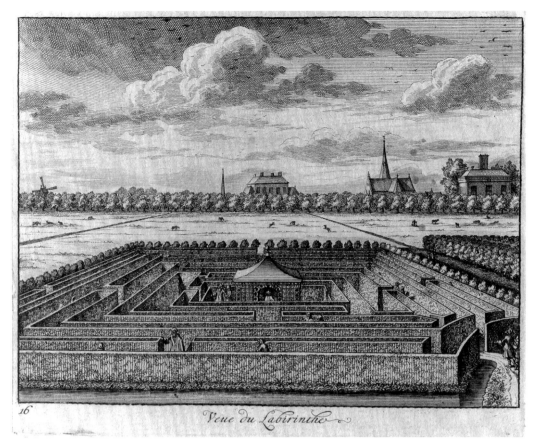

Veue du Labirinthe

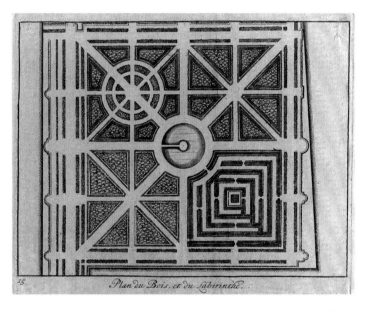

Plan du Bois, et du Labirinthe.

13

Joseph Mulder (the Netherlands, 1659/60–after 1718)

A. Plate 15: *Plan of the Woods and of a Labyrinth*

B. Plate 16: *View of a Labyrinth*

Etchings, each 13 × 16 cm

From *Views of Gunterstein* (Amsterdam, [c. 1680–90])

Iris & B. Gerald Cantor Center for Visual Arts at Stanford
 University (Robert E. and Mary B.P. Gross Fund,
 2000.34.15,.16)

In medieval Europe, the garden was a small space frequently
enclosed by hedges or walls, but by the late sixteenth cen-
tury, as it grew larger, its patterns became more complex,
not dissimilar to embroidery. An early gardening book by
Thomas Hill, *The Gardener's Labyrinth* (London, 1571), il-
lustrated patterns for knots and mazes. The seventeenth-
century labyrinth at Gunterstein in the Netherlands and its
adjacent squares of trees were geometrically laid out. This
set of sixteen etchings illustrates the garden of Magdalen
Poule at Gunterstein, constructed in the 1680s in the latest
French fashion, with trelliswork and an orangery.

14

Joseph Mulder (the Netherlands, 1659/60–after 1718)

A. Plate 10: *The Orangery and Hot House*

Etching, 13 × 16 cm
From *Views of Gunterstein* (Amsterdam, [c. 1680–90])
Iris & B. Gerald Cantor Center for Visual Arts at Stanford
 University (Robert E. and Mary B.P. Gross Fund,
 2000.34.10)

Gabriel Perelle (France, 1604–1677) and/or
 Adam Perelle (France, 1638–1695)

B. *Fontainebleau: The Orangery of the Queen* c. 1670–90

Etching, 18.8 × 28 cm
Iris & B. Gerald Cantor Center for Visual Arts at Stanford
 University (Committee for Art Acquisitions Fund,
 1988.26)

Citrus—long highly esteemed—were raised, as were other tender plants in a cold climate, in winter shelters. The Medici were among the first to collect and hybridize them; at their villa at Castello several hundred were set out in pots. At Fontainebleau, pots of citrus were arranged in pleasing patterns along the edges of the scrollwork parterres. At Gunterstein, the orangery and vegetable garden shared a separate, secluded enclosure, but were still visited by strollers. At Versailles, the orangery was situated on a lower terrace with a southern exposure, as was the vegetable garden (*potager*), where peaches and pears were espaliered on walls to hasten their ripening.

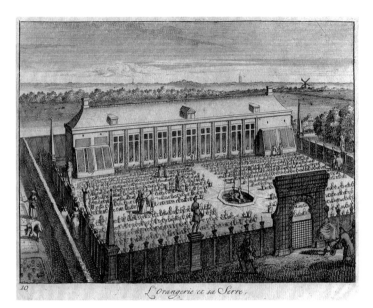

L'Orangerie et sa Serre.

14*a*

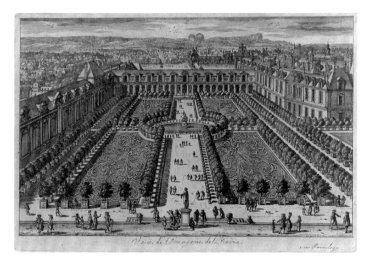

Veüe de l'Orangerie de la Reine.

14*b*

15

Jean-Baptiste Oudry (France, 1686–1755)
View of a Château in the Park of Arcueil c. 1745
Black chalk, heightened with white, on blue-gray paper,
 29.8 × 51.6 cm
Fine Arts Museums of San Francisco, Achenbach Foundation
 for Graphic Arts (Gift of Mrs. John Jay Ide, 1997.93.3)

This view of a formal garden shows the natural terrain regularized into terraces; the nearby river has been channeled to provide water for fountains and cascades. Oudry's study is one of a large group of similar size and execution. His delight in the interplay of the garden's proportions and levels can be seen in the rhythm of the cascade, which plays off the pattern of the nearby stairs, and in the soft textures and irregular silhouettes of the foliage, which act as a foil to the regularity and hard surfaces of the stairs and balustrades.

Traditionally these chalk studies have been thought to depict the deserted garden of the prince of Guise at Arcueil, not far from Paris. The ghostly château sketched in the background may be Arcueil (which was largely destroyed by 1752), but firm identification is only possible when the nearby aqueduct is shown, which is not the case here. A similar drawing, dated 1745, taken from a parallel vantage point, but slightly to the left, is centered on the flight of stairs (Musée de l'Ile-de-France, Sceaux).

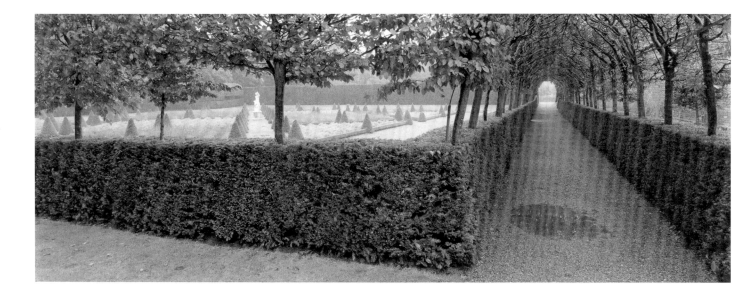

16

Lyle Gomes (U.S.A., b. 1954)

Hornbeam Arbor, Ham House 1998

Gelatin-silver print, 17.8 × 47 cm

Susan and John Diekman

Hedges have played a crucial role in separating garden areas, much as walls divide a house into rooms. Although wood pergolas or brick walls can also be used, tall hedges have been a popular choice. Since height is desirable, rather than relying on shrubs, beech and hornbeam trees have often been planted. Some hedges are interspersed with different varieties, offering variations in texture and color. At times, hedges align to focus on a vista; at other times they mask an adjacent area, then through an opening suddenly reveal it. In his eloquent photographs, Gomes emphasizes the delicacy of the leaves and the structure of the larger garden design.

17

Eugène Atget (France, 1857–1927)

Garden of the Musée Carnavalet 1898

Albumen-silver print, 22.2 × 17.5 cm

Collection Centre Canadien d'Architecture/Canadian
 Centre for Architecture, Montréal (PH1981:0878)

In this small courtyard, the miniature hedge functions as a ribbonlike decorative pattern, intended to be enjoyed when viewed from windows overlooking the garden. In France, hedges are still kept very low, as they were in sixteenth-century parterre designs. The elegant restraint of the architecture acts as a foil to the garden's minimalist use of plant material arranged in curvilinear scrolls.

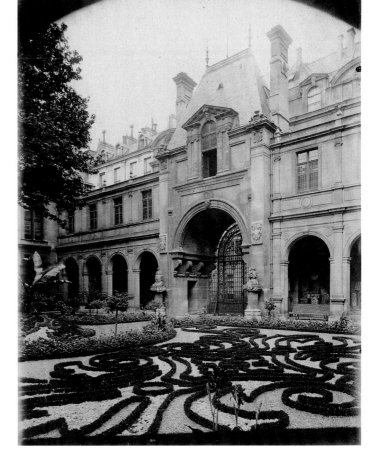

18

Becky Cohen (U.S.A., b. 1947)

The Getty Center: Central Garden with Pool c. 1998

Pigment print, 16 × 25.5 cm

Becky Cohen

The Getty Center, spreading across a hilltop in the Brentwood area of Los Angeles, has been compared to an Italian hill town. Among its separate and distinct features is a garden designed by the minimalist artist Robert Irwin, who had not previously worked with plant material. Irwin created a pathway descending amid boulders and under sycamores, following a stream down to the focal point: a circular area packed with plants of high color and distinctive textures. At the center is a sunken pool in which ribbons of tightly pruned red azaleas have been planted in a mazelike arrangement. His quixotic choice of plants has evolved since the opening of the garden.

Cohen has been photographing the garden and its plantings regularly since October 1998.[1]

NOTE

1. Becky Cohen, *Robert Irwin Getty Garden*, photographs by Becky Cohen, text by Lawrence Weschler (Los Angeles: The J. Paul Getty Museum, 2001).

Textures, Shapes, and Colors

19

William Merritt Chase (U.S.A., 1849–1916)
An Italian Garden c. 1909
Oil on canvas, 40.6 × 55.6 cm
Chrysler Museum of Art, Norfolk, Virginia
 (Gift of Edward J. Brickhouse, 59.79.1)

Chase painted garden and park subjects over many years, from early views set in Prospect Park in Brooklyn, which featured a solitary woman seated on a bench, or a mother and daughter playing in the foreground, to works in which the garden itself received full attention. Late in his career, Chase, like Sargent, traveled to Europe in the summer months, but unlike Sargent, who took many tours (cats. 28, 31), Chase settled at Villa Silli near Florence. In this paint-ing he has focused on the subtle and varied textures of plants in his garden, weaving a tapestry with the interplay between the handsome old planters lining the open path and the highly decorated wall and gate, elevating what might have been commonplace elements into a serene and satisfying composition. The sun-drenched scene was first exhibited at the National Academy of Design in New York in 1910.

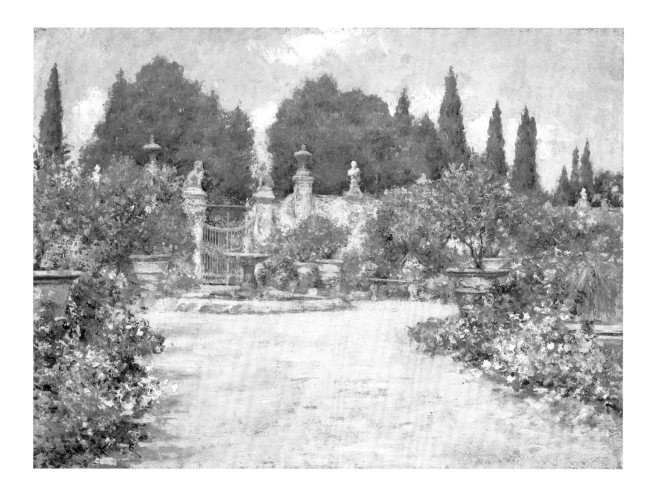

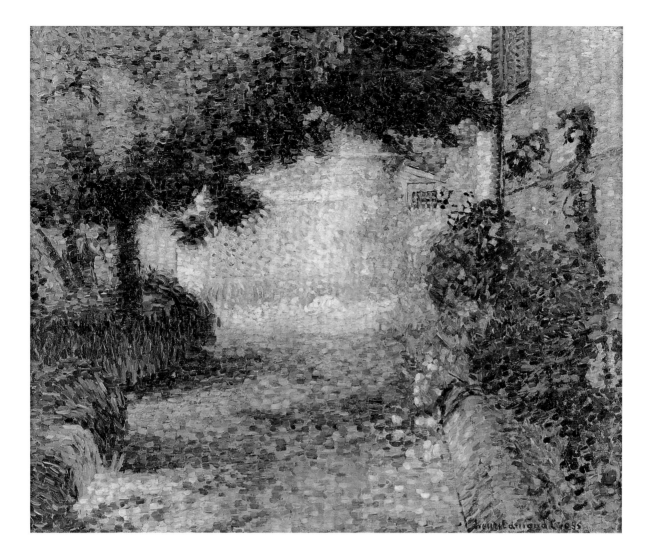

20

Henri Edmond Cross (France, 1856–1910)

Garden at Saint-Tropez c. 1900

Oil on canvas, 53.3 × 63.5 cm

Milwaukee Art Museum (Purchase, Marjorie Tiefenthaler;
 Bequest and partial gift of Louise Uihlein Snell Fund of
 the Milwaukee Foundation, M1996.29)

Cross was born Henri-Edmond-Joseph Delacroix to a French father and an English mother. Once he became a professional painter and printmaker, he translated his last name into English ("of the cross") and then abbreviated it to avoid being overshadowed by the earlier painter Eugène Delacroix. In the 1890s, Cross, who had trained as a realist, moved to the South of France to a town near Saint-Tropez and began to paint out-of-doors. At this same time he adopted the small, juxtaposed brushstrokes of Neo-Impressionism.

In *Garden at Saint-Tropez* Cross's main interest was to capture the effects of the brilliant Mediterranean sun on the colors and the textures of this private garden. By placing strokes of color side by side rather than using his brush to give volume to what he sees, Cross conveys the way dappled light, filtered through shade trees, appears to break up the forms of the flowers, trees, and bushes, and to pick out the individual stones that compose the wall of the house.

21

Gustave Baumann (U.S.A., b. Germany, 1881–1971)
Grandma Battin's Garden c. 1915
Woodcut, 31.5 × 33.6 cm
Fine Arts Museums of San Francisco, Achenbach Foundation
 for Graphic Arts (Gift of Dr. William McPherson
 Fitzhugh Jr., A006029)

Baumann's woodcut of a cottage garden in Brown County, Indiana, focuses on the bright, clean colors and shapes of its simple flowers. Such midwestern yards with hollyhocks, morning glories, and nasturtiums were perfectly married to the simple farm cottage with its narrow porch and picket fence. Such small planting areas enlivened what was otherwise an unadorned expanse.

A prolific printmaker, Baumann moved to Santa Fe in 1918, whose majestic landscape he depicted in dark, deep tones. His attraction to colorful flowers remained, evident in his gouaches and prints of marigolds and zinnias.

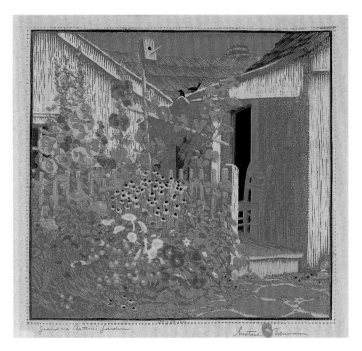

22

Theodore Wores (U.S.A., 1859–1939)
Saratoga Garden, Artist's Studio 1926
Oil on canvas, 40.6 × 50.8 cm
Fred M. Levin and Nancy Livingston

On several occasions, Wores painted the garden at his studio in Saratoga, California, which he had established in 1926. Initially a retreat from his home in San Francisco, it became his permanent residence in 1929. The garden was planted and maintained by his wife, Carolyn. Wores paid homage to her gardening skills by depicting her in one of the oil paintings. The intense colors, bright light, and profusion of blooming cannas and dahlias evoke the heat of late summer. The large pergola introduces an Italianate element into a typical California garden of that period.

Associated with the California Impressionist movement in the early decades of the twentieth century, Wores depicted gardens throughout his career. In addition to those painted in the Bay Area, on two trips to Japan in 1885–87 and 1892–94 he developed a lifelong interest in floral motifs. On other trips abroad he painted the gardens of the Alhambra in Spain. For Wores, flowers embodied symbolic associations and aesthetic appeal. Their frequent appearance in his work represents his ardent desire to link art to nature.

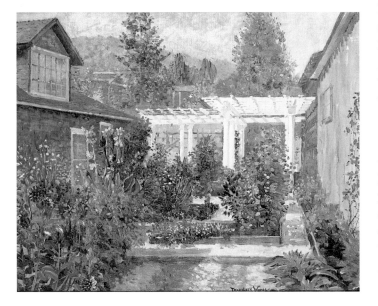

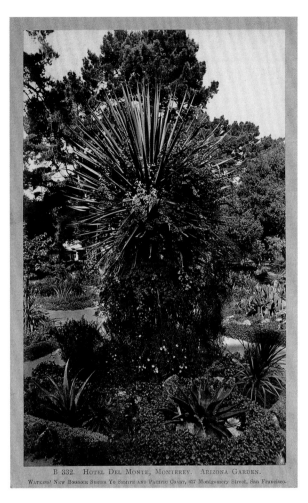

23a

23
Carleton Watkins (U.S.A., 1829–1916)

A. *Hotel del Monte, Monterey: Arizona Garden* 1880s

Albumen print, 19.5 × 12.2 cm

From *Watkins' New Boudoir Series To Semite and Pacific Coast*

Anonymous

B. *Hotel del Monte, Monterey: Arizona Garden* 1880s

Albumen print, 12.5 × 20 cm

Published by Taber Studio, San Francisco

Iris & B. Gerald Cantor Center for Visual Arts at Stanford
University (Museum Purchase Fund, 1972.18.3, 1972.16.1)

In 1881 Rudolph Ulrich was hired to design an Arizona Garden for the Hotel del Monte in Monterey by Charles Crocker who, with Leland Stanford and Collis P. Huntington, owned the resort. Its 165 acres featured a maze of Monterey cypresses, topiary chess pieces, an Arizona Garden, and climbing roses. With plants brought by rail from the Sonora Desert in Mexico, Ulrich created formal Victorian patterns in rock, shell, and cactus. Not strictly a cactus garden, it included many succulents, particularly agaves. Their unusual range of textures and shapes ranged from prickly, hairy, and bristly, to barrel-shaped or spiky, and they bloomed in unexpectedly vivid yellows and reds. The upper view focuses on one island and its plantings. The lower view of the garden's circular and scalloped beds shows some thirty people standing still long enough to have the photograph taken. A sense of the garden's scale can be gauged by comparing the ten-foot spires of the saguaro cacti to the smaller visitors. After long neglect, the garden has recently been replanted.

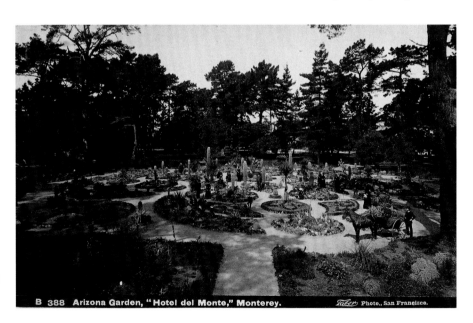

23b

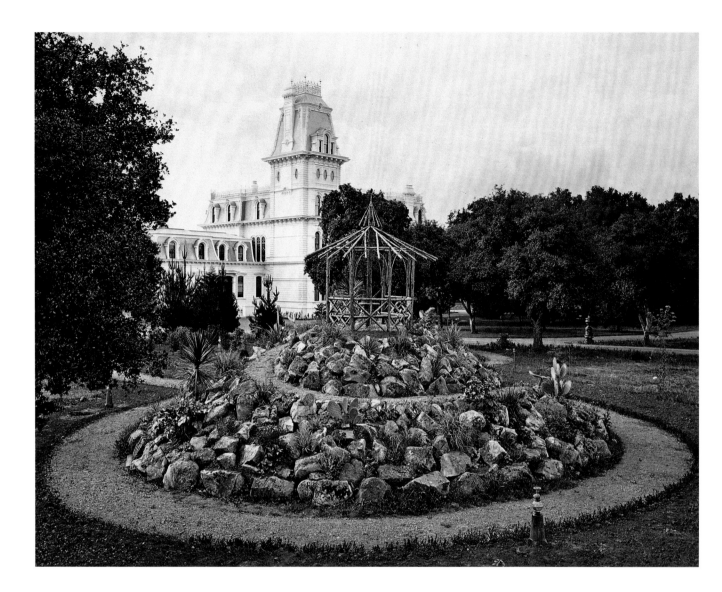

24

Carleton Watkins (U.S.A., 1829–1916)

Plate 17: *The Rockery* c. 1874

Albumen print, 28 × 35.5 cm

From the album of 63 photographs, *Thurlow Lodge*

Stanford University Libraries, Special Collections

At the same time that Rudolph Ulrich designed the garden for the Hotel del Monte in Monterey, he was building private gardens for Leland Stanford and for Milton Latham on the San Francisco peninsula. In 1874 Latham commissioned Carleton Watkins to photograph his new summer home, Thurlow Lodge, in Menlo Park (cat. 122). Set in an open, flat landscape close to the bay and punctuated by century-old valley oaks, the estate's grounds included an expanse of lawn, a trout pond, greenhouse, and stables. This view, with the house in the background, features the rockery with its extensive use of serpentine. Its relative size can be better understood by noting the circular path leading to the top, where a gazebo was located. The small size of the cacti make it clear that the rockery was only recently constructed. The garden and estate no longer exist.

25

Lee Friedlander (U.S.A., b. 1934)
Biltmore, the George W. Vanderbilt Estate,
 Asheville, North Carolina 1994
Gelatin-silver print, 14 × 33.6 cm
Collection Centre Canadien d'Architecture/Canadian
 Centre for Architecture, Montréal (PH1994:0192)

Friedlander's photograph of the Biltmore estate was part of a seven-year project undertaken by the Canadian Centre for Architecture to photograph selected gardens and parks created by Frederick Law Olmsted (cat. 97). The image captures the formal and naturalistic elements of Olmsted's landscape in a unique way. By placing in the foreground a fir tree that has been shaped and planted in a pot by human hands, Friedlander draws the viewer into the scene while emphasizing the contrast between the intimate, textural view of the austere south terrace and the sweeping grandeur of Olmsted's deer park between the scientifically managed estate forest and the Great Smoky Mountains.

Biltmore, located outside Asheville, North Carolina, was the country retreat of George Washington Vanderbilt, grandson of the industrialist Cornelius Vanderbilt. Purchased for its mild climate and views across the French Broad River to Mount Pisgah and the Great Smokies, the overfarmed, overlogged land was transformed by Olmsted. Approached by Vanderbilt in 1888, the landscape architect undertook this, his last and largest project, with vigor and enthusiasm, working with the architect Richard Morris Hunt to marry the formality required by the 250-room French Renaissance château with the natural character of the approach road and the topography of the land itself. The plans included formal terraces, gardens, a small high-roofed garden pavilion, and a dramatic entrance court lined by an avenue of tulip trees. Olmsted created a shrub garden or ramble that is part wild and part cultivated, with curving paths and evergreen shrubs as the transition between the formal terraces and increasingly naturalistic landscape that unfolds as one moves away from the château. A series of footpaths leads through a forested vale, over streams, and, eventually, to a pond and waterfall deep in a wooded glen.

Water Displays

26

Giovanni Battista Falda (Italy, 1648–1678)

A. Plate 10: *Villa Aldobrandini:*
 Fountain of the Shepherds

Etching, 21.2 × 28.7 cm
From *Le Fontane di Frascati* (Rome: G. G. de' Rossi, c. 1691)
Iris & B. Gerald Cantor Center for Visual Arts at Stanford
 University (Mortimer C. Leventritt Fund, 1976.227)

Andreas Cornelis Lens (Belgium, 1739–1822)

B. *Villa Conti: Cascades* c. 1764–68

Pen and wash in brown ink with touches of gouache,
 17 × 25.4 cm
Iris & B. Gerald Cantor Center for Visual Arts at Stanford
 University (Gift of Paula Zurcher, 2000.59)

Both the etching by Falda, who documented fountains in
Rome and Frascati, and the later drawing by Lens, a Belgian
painter who visited that area in the 1760s, depict water dis-
plays—a conspicuous feature of the large villas built by
wealthy Roman families at Frascati.[1] Situated high in the Al-
ban Hills and looking across the Roman Campagna toward
the distant city, these summer residences, which were con-
structed in the closing decades of the sixteenth century and
later expanded, dominate the same terrain where Roman
Imperial villas once stood. About 1563, on the ruins of Lu-
cullus's villa, the philosopher and poet Annibale Caro built
a simple casino, reviving the fashion for such sites in Fras-
cati. That property was later acquired and expanded by Sci-
pio Borghese; it then passed through a succession of owners,
including Cardinal Ludovico Ludovisi and Lotario Conti,
who made major modifications. Late in the nineteenth cen-
tury it was acquired by Duke Leopoldo Torlonia, whose

property it was when John Singer Sargent painted there (cat.
130). Today Villa Torlonia (formerly known as Villa Lu-
dovisi, then as Villa Conti) is a municipal garden. In con-
trast, Cardinal Pietro Aldobrandini's villa, among the most
spectacular to be built, having funds from his uncle Pope
Clement VIII, was rapidly completed in the opening decade
of the seventeenth century and has remained essentially un-
modified. Its extensive water theater attracted and was de-
scribed by many visitors. The property was acquired by the
Borghese family, but late in the nineteenth century it re-
turned to the Aldobrandini family, who occupy it today.

Falda's view of the Villa Aldobrandini shows a level
higher up the mountain above the water theater. The scene
at the Fountain of the Shepherds and upper cascades is ani-
mated by water tricks (indicated by dotted lines), which
erupt on the long, steep staircase, catching at least one vis-
itor by surprise. (In another etching Falda shows the water
reservoir of Villa Ludovisi.) A hundred years later, Lens
shows the rushing cascades of what was then called Villa
Conti. Although such water displays were the focus of these
gardens, with time the water flow has lessened, or ceased,
and today's visitors must imagine the surprises and sounds
of yesterday.

NOTE

1. Carl L. Franck, *The Villas of Frascati, 1550–1750* (London: Alec
Tiranti, 1966). Franck's volume includes historical views, among
them Falda's etchings of Aldobrandini and Ludovisi, 120, fig. 125,
87, fig. 86. Franck credits the design for the aqueduct and overall
arrangement at Villa Aldobrandini to Giovanni Fontana and the
hydraulic effects to Orazio Olivieri, who earlier worked at the Villa
d'Este in Tivoli. See Franck, 124 n. 131, 125 n. 135.

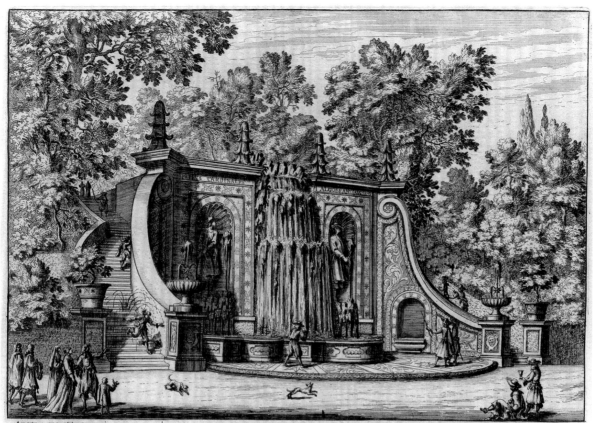

ALTRA FONTANA PIV SOPRA ALL'ANTECEDENTE FONTANA RVSTICA DEL TEATRO DELLA VILLA ALDOBRANDINA DI BEL-
VEDERE A FRASCATI, CON GIVOCHI D'ACQVE NELLE SCALE.

10

Gio·Batt·Falda del et scul· Gio·Iacomo Rossi le stampa in Roma alla Pace co Pri del SP.

26a

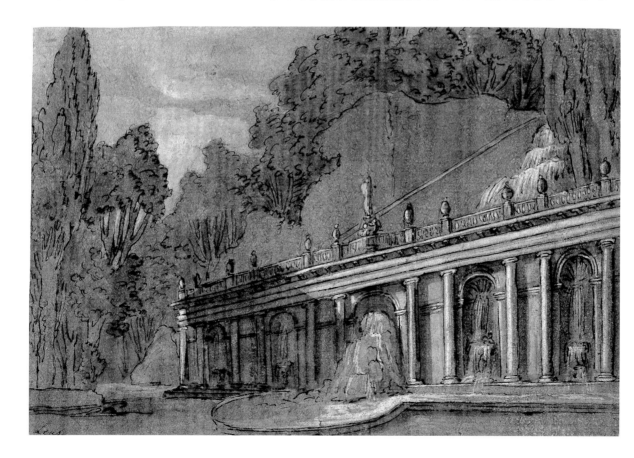

26b

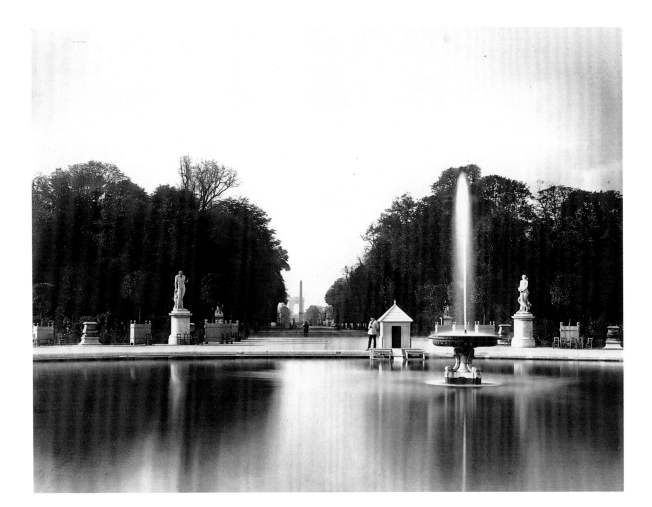

27

Charles Soulier (France, before 1840–after 1876)

The Tuileries, Looking West toward the
 Arc de Triomphe c. 1865

Albumen-silver print, 19 × 25.1 cm

Collection Centre Canadien d'Architecture/Canadian
 Centre for Architecture, Montréal (PH1981:0992)

This westerly view along the historic vista from the Tuileries Palace (today the Louvre) toward the Arc de Triomphe shows the crucial role water plays in garden design. The large, circular reflecting pool with its single jet provides a visual rest before the eye is swept down the garden's long central spine. The main avenue dates back to Catherine de' Medici's mid-sixteenth-century compartmented garden, which was widened and extended a century later by Le Nôtre, and further extended in the 1830s to create a suitable approach to the Arc de Triomphe. During the Second Empire, under Baron Haussmann's renovations when many broad boulevards were introduced, the Champs-Elysées was widened, lined with rows of trees, and flanked by lawns in the English style.

28

John Singer Sargent (U.S.A., 1856–1925)
Fountain at Aranjuez c. 1902–3
Watercolor over pencil, 25.5 × 35.7 cm
Brooklyn Museum of Art (Purchased by Special
 Subscription, 09.809)

Sargent's interest in gardens dates back to the early 1880s, when he began to paint scenes from contemporary life. By 1900 watercolor became in his own words his "almost" favorite medium and the one he used for his extended summer travels with their many garden visits. Sargent's ease of execution and ability to convey sensations of light and fresh air are astonishing. Using different brushes he rapidly laid out large areas of color on a dry sheet of paper.

In this watercolor, he deftly brushed in highlights of the fountain's stonework and statuary against pale green and violet shadows and the darker greens of the surrounding trees. The garden, located to the south of Madrid, was the summer palace of Philip II. Built in the sixteenth century, its abundant water came from diverting the Tagus River, which made possible a special island garden. About the same time Sargent made this watercolor, he also visited Queluz, a summer palace in Portugal (cat. 31).[1] A few years later, in 1907, he painted at several villas in Frascati near Rome (cat. 130).

NOTE
1. Elaine Kilmurray and Richard Ormond, eds., *John Singer Sargent*, exh. cat. (London: Tate Publishing, 1998), 223–25, cats. 114–16, for similar garden watercolors.

29

Lyle Gomes (U.S.A., b. 1954)
Cascade, Stourhead 1994
Gelatin-silver print, 17.5 × 48 cm
Private collection

Stourhead in Wiltshire, created in the mid–eighteenth century, is among the best-preserved English landscape parks. As in other gardens of that era, the numerous monuments scattered throughout the grounds are often handsomely reflected in its lakes. In the 1730s Sir Henry Hoare, the cultivated aristocratic owner, traveled to Italy and later collected Claude Lorrain's paintings of that landscape. Hoare designed Stourhead as a classical landscape, making references to Virgil: the larger lake represents Lake Avernus, with its entrance to the underworld.

Gomes has photographed a wild area, near the smaller lake, where a cascade suddenly appears and empties into the lake below. The toned photograph, with its mysterious hints of purples and browns, captures the changing textures of the leafy woods, the bubbling falls, and the smoother surface of the lake.

30

Claes Oldenburg (U.S.A., b. Sweden, 1929) and Coosje
van Bruggen (U.S.A., b. the Netherlands, 1942)

A. Model for *Spoonbridge and Cherry* (small study) 1986

Wood, paint, pencil, felt tip, nails, plastic tree, and spoon,
21.6 × 32.7 × 32.1 cm

Collection Walker Art Center, Minneapolis, Acquired
in connection with construction of the Sculpture
Garden, 1986

Claes Oldenburg (U.S.A., b. Sweden, 1929)

B. *View of Spoonbridge and Cherry,*
with Sailboat and Running Man 1988 (see fig. 9, p. 23)

Pastel and paper collage, 85.1 × 50.8 cm

Collection Walker Art Center, Minneapolis, Acquired in
connection with the commissioning of *Spoonbridge and*
Cherry for the Sculpture Garden, 1991

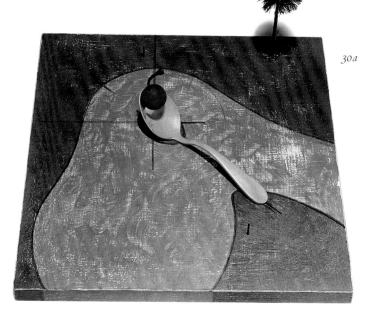

30a

On September 10, 1988, the Minneapolis Sculpture Garden
officially opened its tree-lined paths and squares to the pub-
lic. Several major works were commissioned for the garden,
including Oldenburg and van Bruggen's twenty-nine-foot-
high *Spoonbridge and Cherry* fountain. They created the first
model with a spoon from their kitchen. Oldenburg made the
pastel to celebrate the garden's opening.

The actual fountain's gigantic pale gray spoon with a deep
Bing-red cherry affixed to the tip of the bowl rises from a
free-form pond. The spoon and cherry were fabricated of
aluminum over a steel armature and coated with successive,
sanded-down layers of epoxy fairing compound. The spoon's
bowl rests on an earthen mound within the 150-foot-long
pond. At the base of the cherry's stem is a circle of valves
from which water flows that makes the fruit's surface gleam.
From the top of its curved stem, a fine spray of water is emit-
ted. Meant to catch the sunlight, it occasionally creates a
rainbow. In the winter, when covered by snow, it resembles a
super sundae.

Today, the fountain provides a joyous focal point for the
central north-south allée, surrounded by a pond in the shape
of a linden-tree seed. The sculpture engages in a playful dy-
namic with the surrounding landscape. It is characteristic of
the artists to depict ordinary objects in monumental scale,
altering the viewer's relationship to the geography in which
the objects are situated.

Statuary and Vases

31

John Singer Sargent

(U.S.A., 1856–1925)

Queluz c. 1902–3

Watercolor over pencil, 25.3 × 35.4 cm

Brooklyn Museum of Art (Purchased by
 Special Subscription, 09.835)

On his almost annual summer travels Sargent made many watercolors of garden subjects, especially statuary and fountains, drawn in strong, direct sunlight. This composition was taken in the royal summer palace garden built for Pedro III at Queluz, near Lisbon. Designed by Jean-Baptiste Robillon between 1753 and 1782, it was famous for its canal lined with polychromed tiles (variously characterized as extravagant and exuberant). The formal garden includes large parterres for evening promenades. Sargent has balanced the pair of visitors seated on a bench at the left against two statues at the right, and in turn contrasting these figurative elements against the dark surrounding greenery.

Although Sargent treated his watercolors rather casually, he did exhibit them at London galleries from 1903 on, where they were much praised for their vigorous execution. After Sargent joined the Royal Watercolour Society in 1904, his spontaneous handling of the medium helped revitalize the moribund organization. D. S. MacColl in the *Saturday Review* (April 1, 1905) wrote: "It is not the work of a brooder or dreamer; it is more like an athletic exercise with shape and space and light."[1] Royal Cortissoz found Sargent's color "beyond praise" and "gloriously saturated in light."[2] The Brooklyn watercolor belongs to a group of more than eighty purchased in 1909 from an exhibition at the Knoedler Gallery in New York (cat. 28).[3]

NOTES

1. Quoted in Linda S. Ferber and Barbara Dayer Gallati, *Masters of Color and Light: Homer, Sargent, and the American Watercolor Movement* (Brooklyn: The Brooklyn Museum of Art, in association with the Smithsonian Institution Press, 1998), 127 n. 31.

2. Quoted in ibid., 129 n. 40.

3. Ibid., 137, for information about the watercolors acquired by the Brooklyn Museum from Knoedler and the precedent set for American museum collecting.

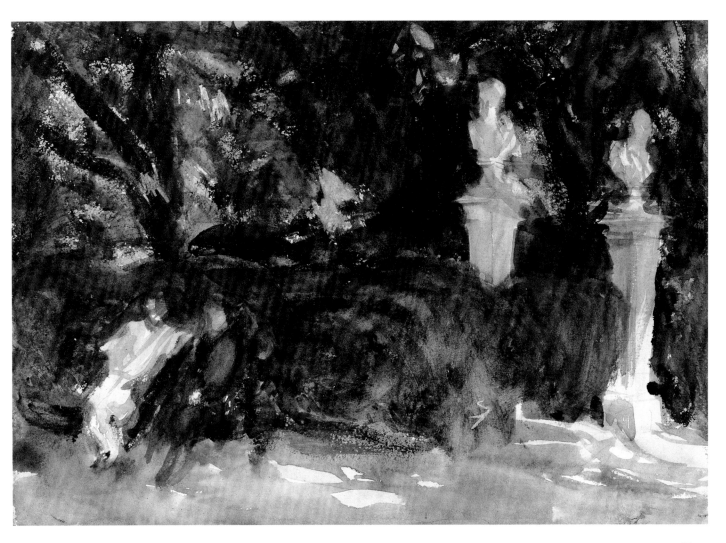

32

Bill Brandt (Great Britain, b. Germany, 1904–1983)

A. *Statue and Mausoleum in West Wycombe Park*
 c. 1940

B. *Chiswick House Garden with Sphinx* c. 1945

Gelatin-silver prints, 22.9 × 19.4 cm; 23 × 19.4 cm

Collection Centre Canadien d'Architecture/
 Canadian Centre for Architecture, Montréal
 (PH1986:0085, PH1981:0707)

Sculpture has figured prominently in garden design since antiquity. Sculptural groups sit in the center and at the borders of fountains. Statues are placed at regular intervals along main paths, imparting rhythm to otherwise straight walks. They can act as the focal point at the end of an axis, and, as in Brandt's photographs, they also surprise and delight the garden visitor who suddenly comes upon them in a clearing.

During the 1940s Brandt photographed English gardens and their statuary. He has represented the statuary at Chiswick and Wycombe as contrasts to their surroundings. The sphinx, which was a recurring sculptural motif at Chiswick, becomes a silhouette against tree-filtered light; at Wycombe, smooth white marble stands out against the variety of textures and the darker tones of the plant material. These two garden views function as studies in mood as well. Contemplative, wistful, and solitary, the statuary of Chiswick and Wycombe await the gaze of the garden visitor.

33

Stefano della Bella (Italy, 1610–1664)

The Young Cosimo III Drawing the Medici Vase
 (see fig. 1, p. 6)

Etching, 30.7 × 27.5 cm

From *Six Views of Rome* (1656)

Iris & B. Gerald Cantor Center for Visual Arts at Stanford
 University (Museum purchase, with funds given in
 memory of Carol A. Kilner, 1999.161)

The monumental Roman vase acquired by Ferdinand de' Medici in 1571 was displayed in the garden of the Villa Medici in Rome. A century later, della Bella, drawing instructor to the son of his patron Cosimo II, made an etching of the boy copying the vase in his sketchbook. Shown with other remnants of Roman antiquity—a fragment of architectural molding, a herm, and an obelisk—the vase was accorded a prominent place, suggesting its rank among Cosimo's possessions. Della Bella portrayed the garden as an outdoor collector's cabinet, where the Medici, through the display of antiquities, assumed their place in the illustrious lineage of gods and heroes whose images they owned.

Represented on the vase is the Sacrifice of Iphigenia, the tragic event necessary to revive the winds that would enable the Greek ships to sail to Troy to reclaim the kidnapped Helen. Iphigenia is shown slumped at the foot of an altar to the goddess Diana, who stands holding her bow. Della Bella has dramatized the scene by grouping the figures more closely than on the actual urn (now in the Uffizi Gallery, Florence) and by accentuating the swirling patterns of the acanthus-leaf molding.

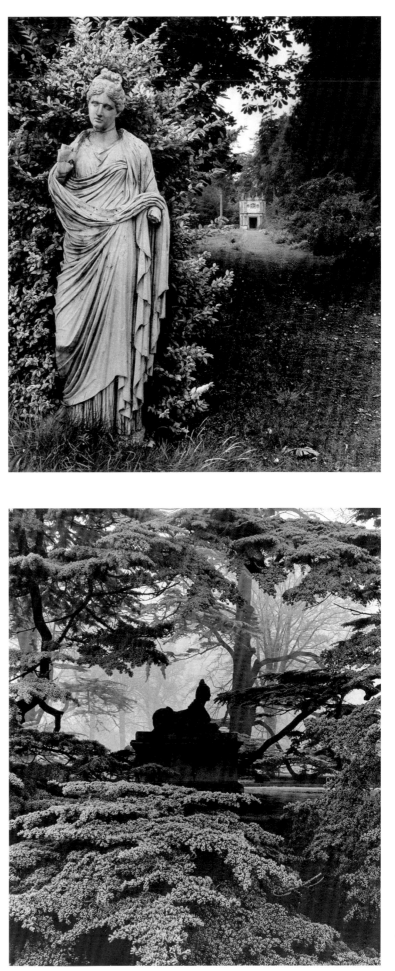

32a

32b

34

Eugène Atget (France, 1857–1927)

Versailles: Copy of the Medici Vase 1903

Albumen-silver print, 17.5 × 21.6 cm

Inscribed: "6312/Vase par Cornu"

The Art Institute of Chicago (Restricted gift of
 Mrs. Everett Kovler, 1963.1008)

The gardens of Versailles (cats. 67–79) carried on the tradition of ancient Roman and Italian Renaissance gardens by featuring monumental vases that were created by a small army of sculptors and metalsmiths, who were either appointed to the royal household or members of the French Academy and their students. The vases were based on those of ancient Greece and Rome and fashioned of white marble or bronze. This is one of six copies after originals in the Medici and Borghese collections.[1] Their prevalence in the upper terraces of the gardens, close to the palace, and their extensive reference to antique sources point to a connection between the achievements of the Roman empire and of the ambitions of Louis XIV.

Some vases were situated to accentuate the borders of fountains and contained jets and ducts that sprayed and poured water. Others served as planters or rose up from the flat expanse of the parterres on pedestals of varying heights. Still others lined stairways leading to different levels of the garden. Their decorative motifs also reflected their location: vases that lined fountains often had sea creatures as handles or clustered at their base, whereas those intended for parterres were ornamented with floral swags or other playful touches. Except for the fountain urns and those that contained plants, vases served the same function as statuary: they were focal points of royal symbolism often celebrating French battle victories.

About 1900 Atget began his extended documentation of old France. Among his early locations was Versailles, where on his first trip he photographed several of the large vases and statues as focal points in the surrounding landscape. Atget often photographed the same object from several vantage points; in some taken at close range, graffiti is legible.

NOTE

1. John Szarkowski and Maria Morris Hambourg, *The Work of Atget*, 4 vols. (New York: The Museum of Modern Art, 1981–85), vol. 3, 163, 168, fig. 18.

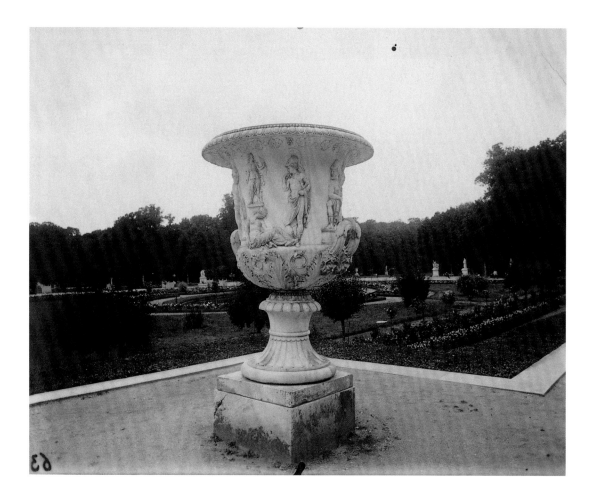

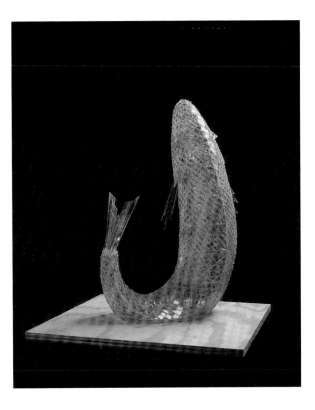

35

Frank O. Gehry (U.S.A., b. Canada, 1929)

Model for *Standing Glass Fish* 1986

Wood and Mylar, 55.9 × 40.7 × 30.5 cm

Collection Walker Art Center, Minneapolis, Acquired
in connection with construction of the Sculpture
Garden, 1986

The Sage and John Cowles Conservatory is the dominant
architectural feature of the Minneapolis Sculpture Garden.
Originally conceived as a building that would allow visitors
to enjoy sculpture and horticultural installations in verdant
surroundings, it also provides a welcome passageway in win-
ter from the parking lot to the Walker Art Center and Guth-
rie Theater. The landscape architects Barbara Stauffacher-
Solomon and Michael R. Van Valkenburgh designed the
plantings in all three glass houses that make up the conser-
vatory, treating Gehry's oversize glass fish with particular
reverence. His twenty-two-foot-high
wood, stainless steel, and glass sculpture
dominates the central house, rising from
a small pond filled with water lilies and
surrounded by Washingtonia "feather
duster" palms and calamondin orange
trees. The palms were deliberately selected
because the shape of the dried fronds on
their tree trunks echoes the glass "scales"
of the fish. The fish is a personal and recur-
ring image in Gehry's work, a fond remem-
brance of the live carp his grandmother
used to buy at the market and leave swim-
ming in the bathtub each week before
she prepared gefilte fish for the family's
Friday night dinner.

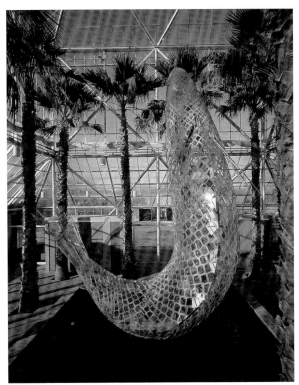

Frank O. Gehry, *Standing Glass Fish*, 1986.
Collection Walker Art Center. Gift of Anne Pierce Rogers
in honor of her grandchildren, Anne and Will Rogers, 1986.

Structural Features

36

Margo Davis (U.S.A., b. 1944)
Casino of Pius IV in the
Vatican Gardens 1976
Gelatin-silver print, 26.7 × 26.7 cm
Margo Davis

A casino is a small building, often with a loggia, which was designed as a summer retreat, an intimate place to rest or converse. Located near the primary residence, its surroundings often included espaliered trees. An important garden feature of the greatest late-sixteenth-century Italian gardens, Villa Lante in Bagnaia and Palazzo Farnese at Caprarola, the concept survives today in such small garden buildings as a gazebo.

The first phase of the Vatican Gardens began about 1510, when Donato Bramante designed the Belvedere Court, which connected to the papal palace. Its architecture recalled imperial Roman villas and included a large display of antique statuary. The Casino of Pius IV was built some fifty years later, designed by the archaeologist-architect Pirro Ligorio, who is thought to have originated the iconographic program at the Villa d'Este at Tivoli (p. 137). At the Vatican Casino for Pius IV, Ligorio used stucco details on the architecture, placed ancient urns on walls, and prominently positioned the central fountain. During the eighteenth century, the Vatican Gardens were relandscaped in the more naturalistic and then fashionable English style. Davis's photograph highlights the dominance of architecture and sculpture in shaping that garden's experience.

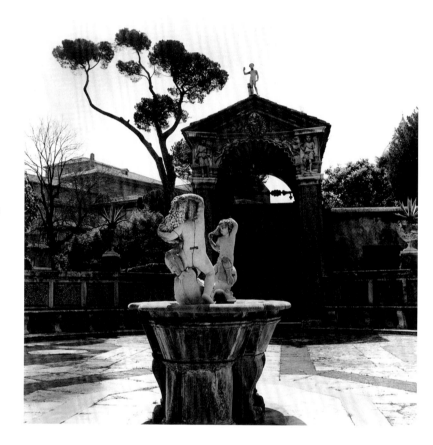

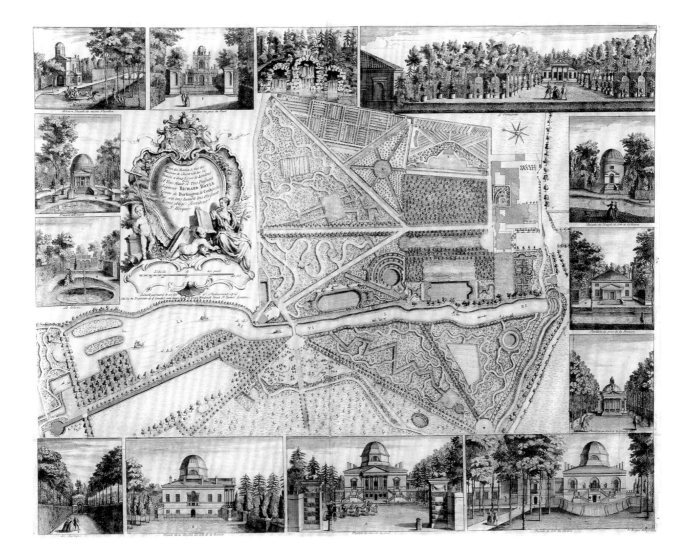

37

Jacques Rocque (Great Britain, b. France, 1704–1762)
Plan of the Garden and Views of Chiswick 1736
Engraving and etching, 61.2 × 77.5 cm
The Minneapolis Institute of Arts (Gift of
 Martha B. Groetzinger, P.79.161)

At Chiswick, Lord Burlington conceived the house and gar-
den in the fashionable Neoclassical style. Below Rocque's
central plan of the grounds are three views of the main res-
idence, which with its domed roof, pedimented portico, and
symmetrical stairways was a handsome variation of the Ital-
ian Renaissance architect Andrea Palladio's Villa Rotonda.
Chiswick's other buildings and temples designed by Lord
Burlington were also indebted to Palladio. Pictured above
at the center is the Cascade with its three rustic stone
arches, a feature associated with William Kent, a much

sought-after garden designer in the 1730s by England's no-
bility and landed gentry.

Born in France, Rocque arrived in London before 1734,
setting himself up as a printmaker and publisher of garden
maps and views, as well as a surveyor. His most individual
achievement was the composite of a plan with surround-
ing views. Some of Rocque's prints were published with
both English and French descriptive titles; they were also
reprinted or copied by another London publisher, Robert
Sayers, in the 1750s.

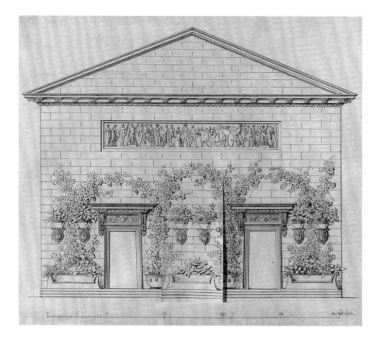

38

Anonymous (Germany, early 19th century)
Design for a Garden Structure c. 1815–20
Pen and ink, 38.5 × 44.2 cm
Private collection

This finished pen-and-ink drawing with its measured scale
would have been presented to a patron. Ornamenting the
structure in the Neoclassical spirit with a frieze and pedi-
ment, the unknown architect first drew an allegorical sculp-
ture of a woman as a decorative motif between the two door-
ways, but then on a separate sheet added a simpler option
for a ledge with two pots of plants similar to those on the
doorways' other sides. The design for such a substantial
stone building would have been intended for an extensive
garden.

39

William Henry Hill (U.S.A., active early 20th century)
Lathe House, San Gabriel Sanatorium c. 1905
Albumen print, 18.4 × 23.5 cm
Stephen Wirtz Gallery, San Francisco

In contrast to the sober and closed appearance of the
preceding design for a garden building is this lathe house
designed to be open to air circula-
tion and to protect plants from
excessive exposure to the sun.
Where in colder climates shelter
for tender plants was indispens-
able, in California's warm climate
the lathe house was of equivalent
importance.

 Early in the twentieth century,
Hill photographed the Pasadena
area, documenting houses and gar-
dens, from rose-covered bungalows
to cactus gardens.

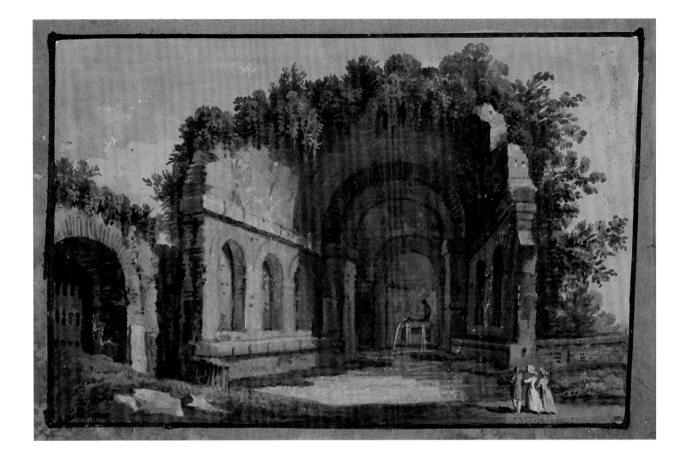

40

Attributed to Xavier della Gatta

 (Italy, active c. 1780–1800)

Grotto and Fountains of the Nymph Egeria, Rome

Gouache, 11.1 × 16.3 cm

Iris & B. Gerald Cantor Center for Visual Arts at Stanford
 University (Committee for Art Acquisitions Fund,
 1976.251)

A focal point of Italian sixteenth-century gardens, grottoes offered shade, cooling water, and privacy.[1] Constructed of irregular natural forms, they were often embellished with shells, mosaics, coral, and other stones. Della Gatta's gouache depicts the ancient ruins of the Roman grotto of Diana's nymph, Egeria. In 1594 the grotto was described by the sculptor Flaminio Vacca as having "a fountain under a large ancient vault, which it still enjoys, and the Romans go there during the summer for recreation." He further wrote of an inscription in the grotto's pavement that told the sad story of the nymph who had fallen in love with her brother, and as she wrote wishing for his return, she "wept so bitterly that Diana moved to compassion converted her into a live spring."[2]

This drawing in its decorated mount was originally part of an album of similar studies, presumably of other Roman ruins. A young English gentleman might well have purchased such an album as a souvenir of his Grand Tour with an eye to its future use in designing his own garden at home.

NOTES

1. For further information, see Naomi Miller, *Heavenly Caves: Reflections of the Garden Grotto* (New York: G. Braziller, 1982).

2. David R. Coffin, *Gardens and Gardening in Papal Rome* (Princeton: Princeton University Press, 1991), 30.

41

Eugène Atget (France, 1857–1927)

Roman Colonnade, Parc Monceau, Paris 1911
 (see fig. 4, p. 12)

Gelatin-silver print, 17.7 × 21.6 cm

Collection Centre Canadien d'Architecture/Canadian
 Centre for Architecture, Montréal (PH1984:0305)

Created in the 1770s, Parc Monceau was situated northwest of Paris and later enclosed within the city. Designed for the duke of Chartres by Louis Carrogis (called Carmontelle) its plan offered a fanciful historical and geographic tour. Its follies, or *fabriques*, intended to amuse and divert, included a Turkish tent, an Eygptian obelisk, and this Roman colonnade based on the famous one at Hadrian's Villa in Tivoli. In the 1860s the park was refurbished as part of Baron Haussmann's improvements to modernize Paris (cat. 44).

42

Pellerin & Cie. (France, 19th century)

Paper Model No. 6 Kiosk c. 1870–80

Lithograph, colored by hand, 38.1 × 47.9 cm

From the series *Nouvelles constructions faciles pour jeunes enfants*

Cooper-Hewitt, National Design Museum, Smithsonian
 Institution (Museum purchase in memory of
 Peter Cooper Hewitt, 1953-66-1)

[Shown only at Stanford and Ann Arbor]

This sheet from the series *Easy, New Constructions for Young Children* was designed to be cut up and assembled as a toy garden (compare cat. 5A). Although the title indicates it was marketed for young children, the intricate silhouettes of the kiosk, the figures of two women and a man, and the trees and fences all demanded more skilled hands.

From early in the nineteenth century, popular prints, called *images d'Epinal*, were made in Epinal, a small town near the German border, first as woodcuts, later as lithographs. The Pellerin family publishing firm was the most famous of several companies that began by publishing political broadsides and playing cards but by midcentury began to design primarily for children. Among their many paper models were projects for theaters, clowns, trains, castles, puppets, soldiers, birds, insects, and garden structures.

5a

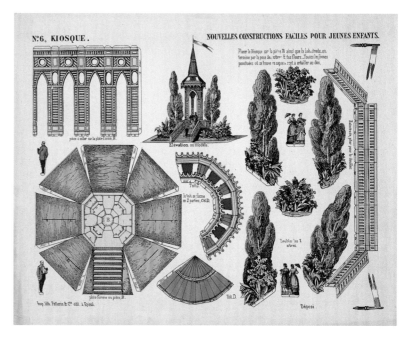

42

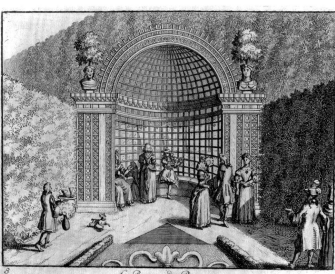

Le Berceau du Parterre

43
Joseph Mulder (the Netherlands, 1659/60–after 1718)
A. Plate 8: *Bower on the Parterre*
B. Plate 11: *Gate to the Orangery*

Etchings, each 13 × 16 cm
From *Views of Gunterstein* (Amsterdam, [c. 1680–90])
Iris & B. Gerald Cantor Center for Visual Arts at Stanford
 University (Robert E. and Mary B.P. Gross Fund,
 2000.34.8,.11)

Trelliswork, among the most fragile of garden structures,
is featured in these two views of the garden at Gunterstein
(for other views of the same garden, see cats. 13, 14). Trellis
structures, in the seventeenth century recently imported
from France, remain popular garden accessories. Today at
the famous rose garden Bagatelle, in Paris's Bois de Bou-
logne, one can see similar, more elaborate, trelliswork where
rose canes reach above the top of the trellis and appear to
sprout from vase-shaped forms that ornament the upper
structure in a wonderful metaphor of nature and artifice.

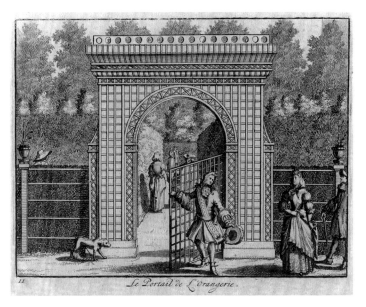

Le Portail de L'Orangerie.

43b

44

Charles Marville (France, 1816–c. 1878)
*Gate to the Parc Monceau on the Boulevard
de Courcelles, Paris* c. 1862
Albumen-silver print, 26.3 × 40.8 cm
Collection Centre Canadien d'Architecture/Canadian
Centre for Architecture, Montréal (PH1986:0468)

Parc Monceau's original geographical tour began with a Chinese gate and included an Egyptian pyramid and Roman colonnade (fig. 4, p. 12). During Baron Haussmann's extensive changes, Monceau was renovated by Adolphe Alphand, director of parks. His collaborator, the architect Gabriel Davioud, designed the handsome grill entrance gate, based on the one at Place Stanislas in Nancy. Still in place, the entrance and small park are surrounded by elegant residences which date to its restoration. Marville was commissioned to record many of Haussmann's projects, among them the redesign of the Bois de Boulogne (cat. 94).

45

William Chambers (Great Britain, b. Sweden, 1723–1796)
*Design for a Bridge in the Chinese Style for Sanssouci,
Potsdam* 1763
Pen and ink with watercolor over graphite, 31.4 × 46.8 cm
Collection Centre Canadien d'Architecture/Canadian
Centre for Architecture, Montréal (DR1981:0024)

Both practical and picturesque, bridges became a ubiquitous element of eighteenth-century garden design. They could inspire architects to flights of fancy and covered a range of styles: rustic structures of rough-hewn stones or tree branches; imposing Roman or Italianate models; and such an exotic Chinese conception as in this drawing. Designed for Frederick II of Prussia, but not built, the project can be dated by a receipt signed by Chambers in 1763, which includes detailed instructions for the building materials, progressing from stone, brick, or wood for the base to lighter materials for the upper decorations, including tin and linen.

Chambers, who began teaching himself architecture while on trading voyages to India and China, turned to full-time architectural study in 1749 at the Ecole des Beaux-Arts in Paris. He became famous as a proponent of Chinese-style architecture and garden design, with his best-known work being the Pagoda at Kew Gardens outside London.

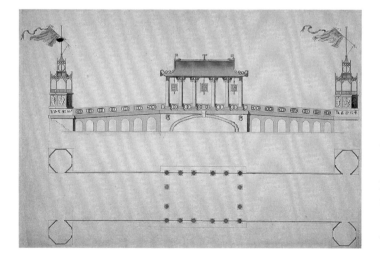

Gardeners at Work

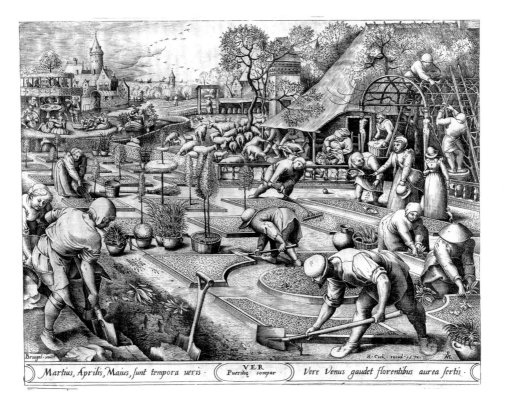

Martius, Aprilis, Maius, sunt tempora ueris · VER Pueritiæ compar Vere Venus gaudet florentibus aurea sertis ·

46

Pieter van der Heyden (the Netherlands,
 c. 1530–active 1572)

Spring (Ver) (after Pieter Bruegel the Elder) 1570

Engraving, 22.8 × 28.7 cm

From *The Four Seasons* (Antwerp: Hieronymus Cock)

The Metropolitan Museum of Art (Harris Brisbane
 Dick Fund, 1926, 1926.72.57)

In this rare portrayal of a garden in which the workers are accorded the artist's undivided attention, Bruegel depicts them with sympathy and dignity. The women plant and water; the men dig, cultivate, and prune. Standing at the right, the mistress oversees, but she is a minor figure in this rhyth-mic representation of physical labor. Bruegel's sharp eye has taken in the varied array of tools and potted plants, the designs and textures of the raised beds, as well as the men's bent postures and the women's careful hands as they handle the transplants.

This engraving was part of a set of the *Four Seasons* commissioned by the major Antwerp publisher Hieronymus Cock. Bruegel's pen drawing, which served as the basis for the print, is dated 1565 (Albertina, Vienna). The engraver, van der Heyden, completed only *Spring* and *Summer* before Bruegel's death in 1569.

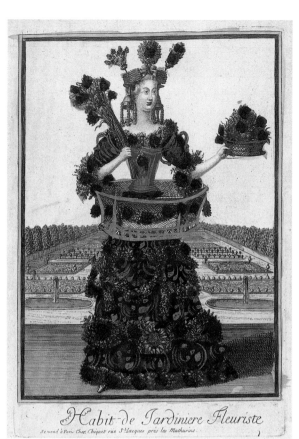

Habit de Jardiniere Fleuriste

Se vend à Paris Chez Chiquet rüe St Iacques près les Mathurins.

47

Nicolas de Larmessin II (publisher)
 (France, 1645–1725)
A. *The Costume of the Flower Gardener*
 (*Habit de Jardinière Fleuriste*)
B. *The Costume of the Fountain Maker*
 (*Habit de Fontainier*)

Engravings, colored by hand and gilded, each c. 28.2 × 20 cm
From *Habits des Métiers et Professions* (Paris, [c. 1690–95])
The Minneapolis Institute of Arts (The Minnich Collection,
 The Ethel Morrison Van Derlip Fund, P.14,765,762)

Larmessin's *Costumes of the Trades and Professions* included
some seventy-five engravings of different professions. The
figures wear fantastically conceived costumes and carry the
tools of their trades. Prints from early editions were some-
times embellished by extensive hand-coloring and occasion-
ally even gilded, as are these impressions. The popular se-
ries was later reprinted and inspired many imitations.

The Flower Gardener wears a large basket around her
waist for gathering flowers. The Fountain Maker, with the
more inventive and less comfortable-looking of the two cos-
tumes, is dressed as a three-tiered fountain. The uppermost
bowl forms his hat, and the sheet of water that cascades
down resembles a veil. One leg is a male and the other a
female caryatid, whose lower halves substitute for knee-
length boots.

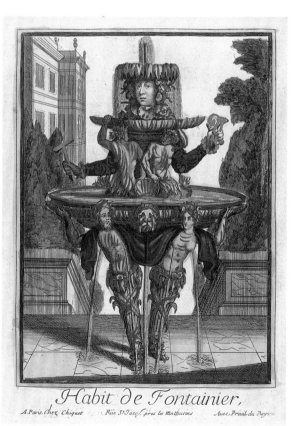

Habit de Fontainier.

A Paris Chez Chiquet Rüe St Iacq. près les Mathurins Avec Privil. du Roy.

48

Martin Engelbrecht (publisher)
(Germany, 1684–1756)

A. *Male Designer of Formal Gardens*
(*Kunst und Blumen Gärtner*) (see frontispiece)

B. *Female Designer of Formal Gardens*
(*Eine Blumen Gärtnerin*)

Engravings, colored by hand, 32.4 × 17.8 cm; 32 × 20.3 cm
From *Sammlung der mit ihren eigenen Arbeiten und Werchzeugen
eingekleideten Künstlern, Handwercken und Professionen*
(Augsburg, [c. 1735])
The Minneapolis Institute of Arts (The Minnich Collection,
The Ethel Morrison Van Derlip Fund, P.14,813, 814)

Engelbrecht oversaw the design and publication of *Collection
of Costumed Artists, Craftsmen, and Professionals, with Their Tools,*
which illustrates both male and female gardeners. These par-
ticular impressions are colored by hand. The man (described
in French as the gardener of the parterre, but in German as
the art-and-flower gardener) stands on a path in front of sev-
eral small parterre compartments. The text below identifies
the plants and his tools. In the foreground is a plan of the
house and parterre (23). The gardener stands framed by two
potted citrus, an orange (21) and a lemon (22). Supporting a
flower pot with carnations (2) in one arm, he holds a rake and
hoe, plus other tools. Red and white roses ring his sleeves and
collar (1). His hat is decorated with hyacinth (5) and white
lily (4), and his belt with tulips (11) and peonies (10). The
woman (described with the same distinctions in French and
German) carries a large straw basket filled with flowers. Her
inscription identifies far fewer flowers. She wears a straw hat
adorned with flowers (1), her upper arms bear similar rows of
red and white roses (3), and her skirt is decorated with swags
of flowers (12). She stands between two exotic potted plants:
a yucca (14) and an aloe (13).

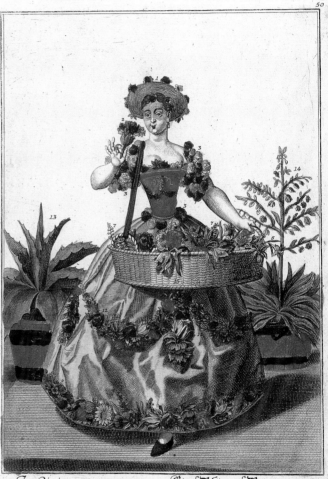

Jardiniere pour parterre. Eine Blumen Gärtnerin.
1. *Chapeau de paille orné de fleurs.* 1. Strohut mit Blumen geziert. 2. *un bouquet de fleurs.*
2. ein Blumen Strauß. 3. *Roses blanches et rouges.* 3. Rothe u. weiße Rosen. 4. *Tulipe.* 4. Tulipan. 5.
Pione. 5. Beonien Rosen. 6. *Iacinte.* 6. Merzen becher. 7. *marjolaine.* 7. Majoran. 8. *Soucis.* 8. Ringel-
blumen. 9. *rose musquee.* 9. Muscat Rösel. 10. *tourne sol.* 10. Sonen blumen. 11. *renoncule.* 11. Ranuncu-
le. 12. *fleurs attachées ensemble.* 12. ein Blumen gehäng. 13. *Aloe.* 13. Aloe. 14. *un Iucca.* 14. Iucca.
15. *Panier.* 15. der Korb.
Cum Priv. Maj. M. *Engelbrecht excud. A.V.*

48b

49

Robert Benard (France, b. 1741)

A. Plate I: *Agriculture, Jardinage* (Gardening Tools: Pruning Ladders, Hoes, etc.)

B. Plate II: *Agriculture, Jardinage* (Gardening Tools: Watering Cans, Scythes, etc.)

C. Plate I: *Agriculture/Jardin Potager, Couches* (Raised Beds for a Kitchen Garden)

Engravings, each 35.5/36 × 22/22.3 cm

From Denis Diderot and Jean Le Rond d'Alembert, *Encyclopédie, ou Dictionnaire Raisonné des Sciences, des Arts, et des Métiers, par une société de gens de lettres* (Paris: Chez Briasson, David, Le Breton, Durand, 1751–65 [text], 1762–72 [plates])

Private collection

Diderot and d'Alembert's monumental *Encyclopédie* was published over two decades—its texts in seventeen installments (1751–65) and the separate illustrations in eleven portfolios (1762–72). In *Agriculture, Gardening* the first two plates illustrate tools, followed by several parterre patterns, then pruning techniques. (Information about plant material was given only in the text volumes, under specific headings, such as *arbre*, which included lists of trees with descriptions of their character and habits.) In the next section, *Agriculture/Kitchen Garden*, engraved by Benard after designs by Louis-Jacques Goussier (1722–1799), the illustration of the raised beds in a kitchen garden includes a few gardeners at work.

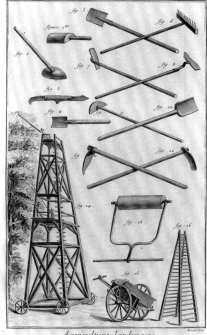

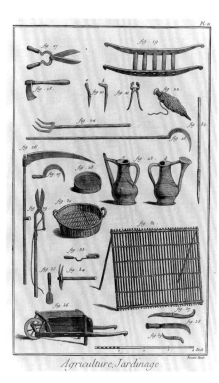

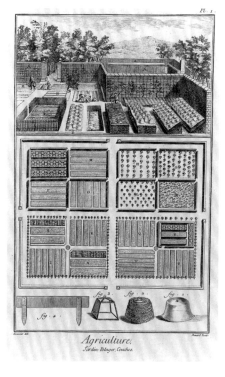

49a

49b

49c

50

Honoré Daumier (France, 1808–1879)

My Graft of a Cherry Tree on an Apricot Tree
* Did Not Take . . . (Ma greffe d'un cerisier*
* sur un abricotier n'a pas pris . . .)* 1845

Lithograph, 25.2 × 22 cm

Plate 7 from *Pastorales*, published in *Charivari*

Iris & B. Gerald Cantor Center for Visual Arts at Stanford
 University (Museum Purchase Fund, 1999.71)

Even as the audience for gardening was expanding, images
of gardeners at work remained rare. Of Daumier's numerous
caricatures, the few references to gardening lie within the
framework of the satires on the behavior of Parisians. One
shows a woman watering her potted plants on a little bal-
cony, inadvertently dousing the head of the gentleman on
the floor below as he leans out the window. In this scene,
a middle-aged man, obviously an inexperienced gardener,
shares his frustration and disappointment with his wife.

51

Gavarni [Paul-Guillaume-Sulpice Chevalier]
 (France, 1804–1866)

My Cedar of Lebanon (Mon cèdre du Liban) 1846

Lithograph, 19.5 × 16.5 cm

From the series *Faits et Gestes du Propriétaire*

Private collection

Whereas Daumier poked fun at the novice gardener for his
failure, his contemporary Gavarni took aim at the extrava-
gant hopes and wistful boasting of a middle-aged bourgeois
to his gardener. A gifted commentator on the Parisian social
scene and friend of the aesthetes Jules and Edmond de Gon-
court, Gavarni largely directed his early satires at frivolous
young students and partygoers, but in later years he broad-
ened his scrutiny to all levels of society, drawing street
sweepers and handymen.

Historic Gardens

Over the course of history, certain gardens have stood out for their innovations, whether as feats of engineering and hydraulics; for the variety and imagination of their plantings; for their fountains, statuary, and architectural follies nestled decoratively into the landscape; for the breathtaking vistas they offer; or for the clever ways in which their designers incorporated soothing natural retreats into crowded urban settings. This section of the exhibition presents, in chronological order, an overview of some of the most notable Western European and American gardens and public parks. It begins with late-sixteenth-century Italian gardens of powerful patrons of Church and state (the Medici garden at Pratolino and Cardinal d'Este's villa at Tivoli), followed by seventeenth-century French formal gardens (Vaux-le-Vicomte and Louis XIV's Versailles), eighteenth-century English gardens as natural landscapes (Stowe and Virginia Water at Windsor Great Park), and late-eighteenth-century gardens as private philosophical retreats (the Désert de Retz, Ermenonville, and Méréville). The section closes with urban parks in London, Paris, and New York, focusing on historic gardens that have been redesigned, as well as newly created parks.

Medici Villas

Among the many gardens created for the powerful Medici dynasty during the second half of the sixteenth century were those at Castello, Petraia, and Pratolino, in the hills to the northwest of Florence, and the Boboli Gardens, behind the Pitti Palace in the city. First to be developed, under the patronage of Grand Duke Cosimo I, were the gardens at Castello and in Florence. Later, his elder son, Grand Duke Francesco I, commissioned work at Pratolino.

The four gardens were among those documented in a remarkable series of fourteen lunettes of Medici villas painted for Grand Duke Ferdinand I by Giusto Utens (Lazzaro, fig. 11). The gardens contained similar statuary and fountains in the formal areas, which were enclosed by generous woods (*bosco*) of cedar, ilex, laurel, and oak. Designed and created during the same period and primarily by the same sculptors, each garden was nonetheless distinctive. For example, of the two created for Cosimo I, one was for summer retreats and the other for court functions.

In 1538 Cosimo, a ruler of wide-ranging interests, commissioned the sculptor and architect Niccolò Tribolo to design figures for the garden at Castello.[1] His fountains and statuary glorifying the Medici were at the heart of an iconographic program, evidently devised by the historian Benedetto Varchi. The allegorical celebration of the local geography—its rivers, mountains, and towns—and of the patron and his family, rather than of the expected mythological gods, marked a significant innovation in Italian garden design. During the 1540s at Castello, Tribolo supervised work on aqueducts, fountains, a tree house, and the planting of fruit trees. The artist and historian Giorgio Vasari in his *Lives of the Most Eminent Painters, Sculptors & Architects* described at length Tribolo's work, particularly the iconographic themes of its statuary. But he also wrote of the clever routing of water, which passed from a figure at the top of the hill above a reservoir into a grotto, under two terraces, and into a labyrinth below, before feeding the central fountain.[2] Since the Medici family controlled extensive landholdings, sites with abundant springs were readily available; from these, water was transported by aqueducts (both ancient Roman and newly constructed) to their villas. After Tribolo died in 1550, Vasari helped to direct work at Castello from 1554 until his death in 1574, following his friend's original plans. Vasari contributed to the famous shell-and-pebble grottoes with their various domestic and exotic animals—a goat, camel, elephant, wild boar, and unicorn. From the horn of the unicorn flowed pure water, symbolic of the Medici's power to bring water not only to their gardens but also to the populace at large. Two sculptors helped carry out Tribolo's plans at Castello: Bernardo Buontalenti, who also worked at Pratolino and at Petraia, and Bartolommeo Ammannati, who briefly supervised work at the Boboli Gardens.

In 1549 Cosimo and his wife, Eleanor of Toledo, commissioned Tribolo to design the Boboli Gardens, a project that involved many of the city's finest sculptors. Unlike Castello, the Boboli's extensive collection of contemporary and Roman statuary celebrated mythology, with Neptune, Venus, Oceanus, and Ceres presiding over different areas. This practice of promi-

nently displaying statuary revived a Roman custom, as did the varied use of water in grottoes so characteristic of Medici gardens.

Horticulture, although a lesser feature, was not overlooked: archival records of the 1560s show the addition of trellised orange trees and extensive plantings of bulbs. At Castello, the garden's horticultural strengths were also well documented, in particular its exotic specimen trees and the practice of breeding strangely shaped varieties of citrus. As early as 1549 the unusual plant material and hydraulic system were noted by the French naturalist Pierre Belon; an English visitor, William Thomas, described the garden as "one of the excellentest thynges in all Europe."[3] As Castello's visitors spread word of the many wonders, it influenced subsequent garden designs.

The rugged topography of the region was symbolized at Pratolino in the single figure of the Colossus of the Apennine Mountains. The mood at Pratolino reflected the personality of its patron, Grand Duke Francesco I. Although cunning and cruel as a ruler, the duke also showed a strong interest in science and art, and was the founder of the Uffizi Gallery. Pratolino's extensive grounds, designed by Buontalenti, included grottoes concealed in the woods and displays of water that startled and drenched visitors. Designed as an escape from court formality and as a place for romantic idylls, it was preferred by Bianca Cappello, the duke's mistress and later his second wife, to other residences.

Among other writers, the poet Torquato Tasso visited Pratolino, praising the garden's delights, "Pleasant and stately grove / Your scented foliage spread forth cool and green."[4] By contrast, Michel Montaigne, in the journal of his Italian trip in 1580–81, found the site "inconvenient . . . sterile and hilly, nay even without springs, that he [the duke] might have the honour and glory of bringing the water from five miles off."[5] However, Montaigne had high praise for Pratolino's water tricks and grottoes: "A walk fifty feet wide, and about five hundred paces long . . . on two sides there are . . . very handsome parapets . . . along these parapets

there are springing fountains in the wall, so that all along the walk you see nothing but these fountain jets. At the bottom is a handsome fountain. There is a marvel of a grottoe with many niches and rooms; this part exceeds anything we ever saw elsewhere."[6] A decade later, Salomon de Caus studied its hydraulic systems and introduced them to German and English gardens. In 1604 Giovanni Guerra sketched its statuary and grottoes, as well as decorations of other gardens, for his patron Cardinal Pietro Aldobrandini, who was planning his own spectacular villa at Frascati.[7] Written and visual evidence focus on Pratolino's most inventive features: water games in grottoes with automata and the monumental statue of the Apennine Mountains. Stefano della Bella, an artist closely associated with the Medici court, portrayed these features in a set of six views, as well as recording festivals held in the Boboli Gardens (cat. 99).

The transitory nature of gardens is illustrated by the rapidity of change: even during the late sixteenth century, statuary and fountains were relocated and new plantings introduced. By the early seventeenth century, an enormous stone amphitheater replaced the green terraces behind the Pitti Palace in the Boboli Gardens and a new area with a small island—the Isolotto—was configured, whose major fountain was surrounded by pots with lemon trees. The following centuries, unfortunately, brought widespread neglect and disfiguring alterations. During the eighteenth century, Castello's *bosco* was cut down and Tribolo's major fountain moved to Petraia.

The innovations of the English landscape designer William Kent at Stowe and Chiswick were informed by his experience of Pratolino. (However, the landscape style he introduced in England destroyed many Renaissance gardens there, and, later in Italy, their formality was replaced by green lawns and meandering paths.) By the 1820s Pratolino's palace was undermined by extensive leaks from the lower grotto. Of its many small garden structures only a chapel hidden in woods survives. Late in the nineteenth century, when

the Demidoff family took up residence, certain, often crude, restorations were undertaken. In the 1830s and 1840s, at the Boboli Gardens, three labyrinths were lost in widening the paths to accommodate carriages. In 1865, when Florence became the temporary capital of Italy and Victor Emanuele II chose Petraia as his royal residence, the area near the palace was replanted with bedding plants in the Victorian style.

Many Medici gardens are now owned by the Italian government. One of the earliest, however, Villa Medici in Fiesole, is still in private hands. (Arrangements can be made to visit.) Completed in the mid–fifteenth century, it was later favored by Lorenzo the Magnificent, who conversed with poets and philosophers in this intimate terraced setting. The central location of the Boboli Gardens in Florence has ensured their continued popularity, which likely helped safeguard them against the radical changes that took place in the summer hilltop villas.

The once remote gardens at Castello and Petraia, now surrounded by industrial suburbs, are little visited, difficult to find, and lack almost all of the charming water features. At Castello, the first impression is bleak: a school occupies the residence, its parking lot taking the space once given to refreshing fish pools. However, the garden behind the building is open to the public and very much worth seeing for the ingeniously decorated grottoes and remarkable display of more than five hundred well-tended citrus in pots—impressive reminders of the intellectual and horticultural accomplishments of the Medici. At nearby Petraia, although much altered, a pair of fish pools remain, as do portions of the old *bosco*, with its old cypress, laurel, and holm oaks on the hillside above, recalling its past and offering present seclusion.

Perhaps the most haunting Medici garden and the least well preserved is idiosyncratic Pratolino, recently acquired by the city of Florence. Under the brooding presence of the Colossus of the Apennines, garden historians may recall its strange magic as they walk among its few remains. In the words of the sixteenth-century poet Raffaello Gualterotti:

> Here—its every grace presents
> Art and Nature together in competition,
> And between them is perceived
> The grandeur of the soul . . .[8]

BETSY G. FRYBERGER

NOTES

1. Sources consulted include David R. Coffin, "The Wonders of Pratolino," *Journal of Garden History* 1, no. 3 (1981): 279–82; and Claudia Lazzaro, *The Italian Renaissance Garden* (New Haven and London: Yale University Press, 1990), 167–89. Lazzaro's Appendix I lists sixteenth-century plants and trees; Appendix IIA and IIB list chronologies of work on the Medici gardens at Castello and Boboli.

2. Giorgio Vasari, *Lives of the Most Eminent Painters, Sculptors, & Architects* (*Le vite de'piu eccellenti pittori scultori ed architetti*), trans. Gaston du C. de Vere, 10 vols. (London: Macmillan and the Medici Society, 1912–15), vol. 7, 15–27 (Castello), 36 (Boboli).

3. Quoted in Lazzaro, *The Italian Renaissance Garden*, 168.

4. Quoted in Judith Chatfield, *A Tour of Italian Gardens* (New York: Rizzoli, 1988), 92.

5. Michel Montaigne, *The Diary of Montaigne's Journey to Italy in 1580 and 1581*, trans. E. J. Trechmann (New York: Harcourt, Brace and Company, 1929), 106.

6. Ibid., 106.

7. Lazzaro, *The Italian Renaissance Garden*, see especially 136–37, figs. 126–28, and 55, fig. 48 of the tree house.

8. Quoted in Coffin, "The Wonders of Pratolino," 281.

52

Stefano della Bella (Italy, 1610–1664)

A. *The Ancient Oak with a Tree House*
B. *The Avenue of the Fountains*
C. *The Villa*
D. *The Grotto of Pan and Fame*
E. *The Grotto of Cupid*
F. *The Giant of the Apennines*

Etchings, each 24.6 × 36 cm
From *Six Views of Pratolino* (Paris, [c. 1650–55])
Herbert F. Johnson Museum of Art (Purchased with funds
from the Herbert F. Johnson, Class of 1922, Acquisition
Fund, 80.058.001–006)

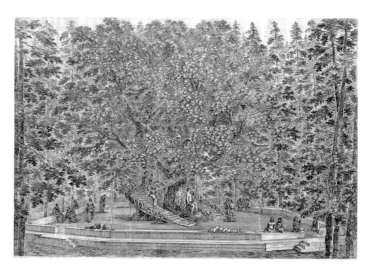

52*a*

In 1569, the year after Grand Duke Francesco I purchased land at Pratolino, workers began to transform a rugged, hilly farm and woodland area into a formal garden surrounded by woods. Francesco hired Bernardo Buontalenti as architect of the residence and designer of the garden. Della Bella, who had been a court artist to the Medici and helped design and record festivals at the Boboli Gardens, had resided in Paris until about 1650. When he returned to Florence, close to eighty years after the garden's creation, he made the set *Six Views of Pratolino*. The unnumbered sequence leads from the lower portion of the garden along the main avenue up to the villa, then to its famous grottoes, and finally to the Giant of the Apennines.

Many sixteenth-century Italian gardens featured "ornaments" created from nature—trees fashioned into houses or rough hillside openings transformed into refined grottoes. Vasari described a tree house at the Medici garden at Castello where ivy enhanced privacy; at Pratolino, an ancient oak with distinctive double staircases led to a dining platform, as is clearly shown in della Bella's etching (A). Although the tree house was hidden, being situated in densely planted woods (a mix of fir, pine, cypress, myrtle, and horse chestnut), it was also formally isolated, being set off by an octagonal area, beside a sculpted fountain.

The second illustration shows unsuspecting visitors approaching the villa, under arching jets of water along the path; other jets sprayed from below—the element of surprise served as an appropriate introduction to what lay ahead (B). The villa, situated at the crest of a steep hill, was

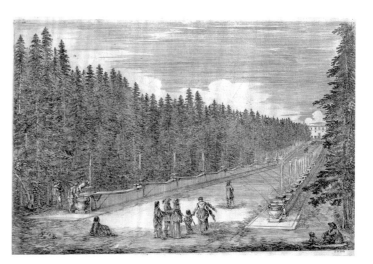

52*b*

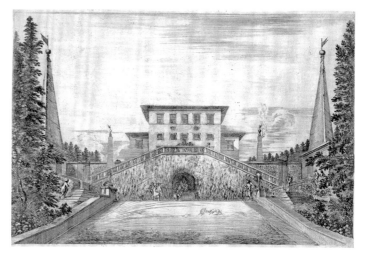

52*c*

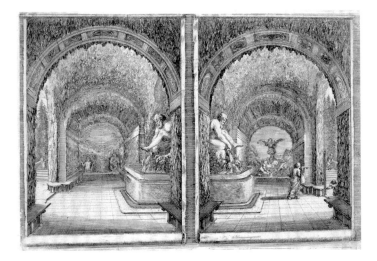

52d

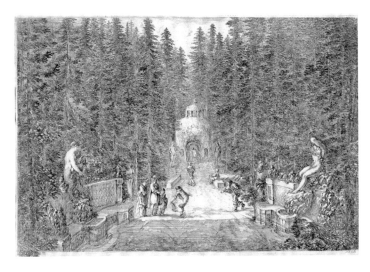

52e

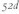

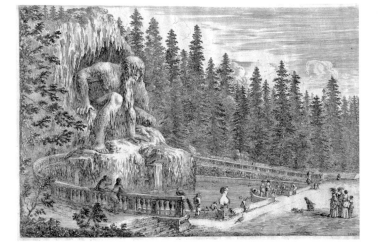

52f

approached from below by the avenue of the fountains, which provided the garden's major vertical axis.

The residence was built on a terrace above a large grotto with several chambers; its front facade faced south, overlooking a narrow formal garden that was bounded on both sides by cascading water (C). Behind the villa, to the north, lay a smaller hilltop garden, not visible from the main entry.

Pratolino's most distinctive—and most remarked on—features were its grottoes with their water automata. The largest chamber, which lay beneath the palace, was embellished with stones, pebbles, eroded tufa, mineral deposits, and even large pieces of coral. Animating these underground spaces were life-size automata (D). An early visitor described how they functioned: in the Grotto of Pan (at the left), the figure of the Roman god rose, played his pipes, and sat down; while in the Grotto of Fame (at the right), winged Fame blew a trumpet and presided over a servant presenting a cup of water. These have long since vanished.

The Grotto of Cupid was hidden in the woods and appeared to have been carved out of the hill (E). Montaigne described its cavelike interior as "encrusted" with spugna, a soft volcanic stone. Its condition is no longer so magical; nature has reclaimed much of its artful creation.

The thirty-five-foot Giant of the Apennines looms over a pool of water (F). Created by the Florentine sculptor Giambologna in 1579, it began as a river god but was completed as the personification of a mountain. The lower part, carved from rock, was large enough to accommodate several rooms; the upper portion, sculpted from spugna, contained a chamber behind the giant's eyes from which visitors could view the landscape below. In 1580–81, when Montaigne saw the sculpture, it was only partially built; today it is one of the few features to have survived.

The Villa d'Este at Tivoli

The Villa d'Este at Tivoli was among the villas built in the second half of the sixteenth century on hills around Rome by wealthy families as retreats from the city's heat and humidity.[1] Situated southeast of the city in the Tiburtine Hills, where the Roman poet Pliny tended his garden, the villa at Tivoli was created for Cardinal Ippolito d'Este of the powerful Ferrarese family. Frustrated in his own papal ambitions, the cardinal helped elect Julius III pope and was rewarded with the governorship of Tivoli. Ironically, the cardinal had much of the town of Tivoli destroyed and the course of the Aniene River diverted to ensure an adequate supply of water to his garden. The Villa d'Este was initially celebrated for its powerful design of intersecting paths, stairs, and terraces, its multitude of fountains and other inventive displays of water, and its fine collection of Roman statuary. The residence, a former monastery, was situated above the garden whose vertical drop provided the pressure necessary for the many fountains, grottoes, and cascades. Scholars have suggested that the site was aligned with what was then called the Temple of the Tiburtine Sibyl (now known as the Temple of Vesta) at Tivoli, to whom a principal fountain was dedicated.

Pirro Ligorio, the architect and scholar appointed by the cardinal to study and excavate statuary at nearby Hadrian's Villa, also served as "antiquarian" to the cardinal and is credited with the garden's design. Ligorio's thematic program glorified the Este family in frescoes, some based on Ovid's *Metamorphoses*, in the residence and in the garden statuary. Originally, the garden was entered at the lowest level, symbolic of primordial nature, through a covered arbor that concealed the hill-side studded with statues. (Today visitors unfortunately enter at the upper level adjacent to the residence, which negates the original intention and surprise.) A statue of the many-breasted Diana of Ephesus (Mother Nature) still stands on the lowest terrace. Symbolic of nature's bounty, once she stood amid herbs and fruit trees arranged in a labyrinth with large fish ponds nearby. Today only the pools and a few ancient trees remain.

On the upper levels, human achievement was recognized in individual fountains. The largest and most impressive is the Fountain of the Tiburtine Sibyl (also known as the Oval Fountain). The pool, carved into the hillside, is lined by an arcade with statues. Above sits the majestic sibyl with a young boy, after a Roman work; on a nearby miniature mountain, the winged Pegasus alights. Where his hoofs strike the ground, a spring erupts, a source of divine inspiration. From this fountain, the long Avenue of the Hundred Fountains cuts horizontally across the garden, its waters flowing slightly downhill to empty into the Fountain of Rome (also called Rometta) at the opposite terminus.

On the central vertical axis was situated the major Fountain of Hercules, from whom the Ferrarese cardinal claimed descent. Although there were several statues of the god, none survive. Located at the heart of the garden, the fountain is set on a horizontal axis between the grottoes of Venus and Diana, which illustrate Hercules' legendary choice between Vice and Virtue. Herculean was the cardinal's and Ligorio's accomplishment in taking a raw slice of nature and creating a synthesis in which plants, paths, water displays, and statuary intersected. At the highest level is the cardi-

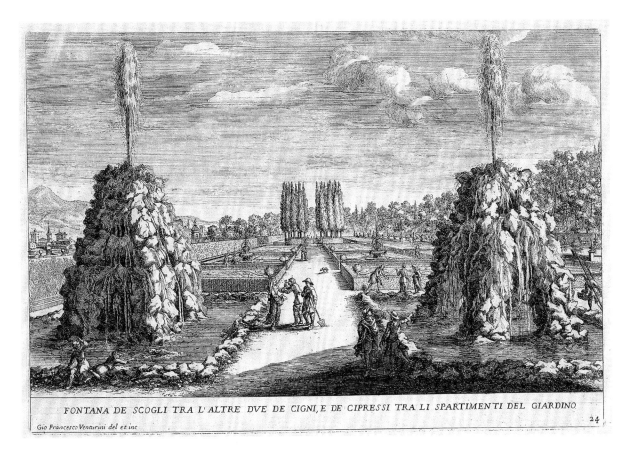

FONTANA DE SCOGLI TRA L'ALTRE DVE DE CIGNI, E DE CIPRESSI TRA LI SPARTIMENTI DEL GIARDINO

24

Gio Francesco Venturini del et inc

55*b*

nal's walk, a secret garden whose narrow terrace connects to the palace. Christianity, although seemingly absent, was constantly referenced through mythological analogies, readily apparent to the cardinal's contemporaries, but less so to visitors of today.

Work progressed from 1550 until the cardinal's death in 1572. The succession of ownership passed in a complicated fashion away from the Este family, then back to it in the early seventeenth century. Some statuary removed by the Este family was later returned, but the original sequence and intent were destroyed. Work continued periodically on unfinished fountains, but other plans were abandoned. Almost a century later, in the 1660s, when Gianlorenzo Bernini created the goblet (*Bicchierone*) fountain and designed the famous cascade below the Organ Fountain, repairs were

in progress. By 1688, however, it was noted that many fountains had ceased to function.

The state of the garden has been documented in periodic inventories and described in travel books and diaries by its many visitors. Among those who recorded their impressions were Montaigne in 1581, Antonio dal Re in 1611, and John Evelyn in 1645.[2] Salomon de Caus's 1615 technical treatise of hydraulic systems, while not specifically about Villa d'Este, became a major source of information for later French, English, and other European gardens indebted to Tivoli.[3]

The Villa d'Este exerted an immediate and deep influence on French design. Etienne Dupérac's engraving of 1573 and its copies spread its fame. The printmaker Israël Silvestre, who sketched at Tivoli, later became Louis XIV's official recorder of royal gardens.

During the eighteenth century, the Villa d'Este's decline accelerated. In the 1750s some Roman statuary was sold. The last of the Este family, Maria Beatrice, married Archduke Ferdinand Habsburg. The property passed to the Habsburgs who further neglected it. Yet the unkempt appearance of the abandoned garden, rather than deterring, attracted the admiration of artists associated with the French Academy in Rome. Among those who drew the ruins was Jean-Honoré Fragonard, whose red-chalk studies captured their majesty in neglect. Cardinal Gustav von Hohenlohe, who resided at the villa from 1850 until his death in 1896, undertook extensive restorations and tried to make it again a center of cultural activity, inviting artists, among them Franz Liszt, who was a frequent guest from 1870 to 1884.

The Villa d'Este and other Italian villas of the sixteenth and seventeenth centuries exerted a major influence on American garden design after being rediscovered by Charles A. Platt in 1894 and Edith Wharton in 1903.[4] Both artist and writer published books that helped to create an American taste for that style. Following World War I, the villa's administration was assumed by the Italian government. During World War II, residence and garden were damaged by bombs dropped by the Allies, necessitating major repairs.

With the passage of centuries, some changes were irreversible. The charming Fountain of the Owl, with its water-powered metal songbirds, long vanished, is too complicated to reconstruct. The powerful cascades below the Organ Fountain were added about 1930, after the 1924 publication of Luigi Dami's book about Italian Renaissance and Baroque gardens.[5] The revival of interest in historic gardens, coupled with the new government administration, meant that the Villa d'Este's long neglect and uncertain future had ended. Conservation continues: the frescoes in the residence can again be seen and several grottoes have undergone repair. The garden plantings have received less attention, however. No trace remains, and there has been no replanting of the pomegranates or oleanders that once were trellised on walls, or of the herbs and fruit trees that populated the lowest level. The elm, sacred to Neptune, is largely absent. The ancient cypresses and holm oaks that line the paths remain the most impressive of the plantings at the Villa d'Este, which is today, as it was earlier, the most visited of all Italian gardens.

BETSY G. FRYBERGER

NOTES

1. Books consulted include David R. Coffin, *Villa d'Este* (Princeton: Princeton University Press, 1960); and Claudia Lazzaro, *The Italian Renaissance Garden* (New Haven and London: Yale University Press, 1990).

2. John Evelyn, *The Diary of John Evelyn* (Oxford: Clarendon Press; New York: Oxford University Press, 2000).

3. Salomon de Caus, *Les Raisons des forces mouvantes* (Paris, 1615).

4. Charles A. Platt, *Italian Gardens* (1894), reprinted (Portland: Saga Press/Timber Press, 1993). Edith Wharton, *Italian Villas and Their Gardens* (New York: The Century Co., 1904).

5. Luigi Dami, *The Italian Garden*, trans. L. Scopoli (Milan and Rome: Bestetti & Tumminelli, 1925).

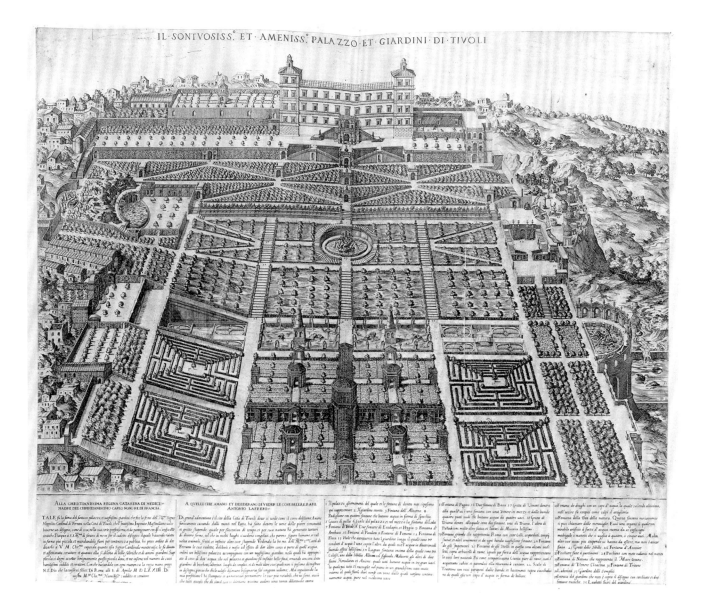

IL·SONTVOSISS.·ET·AMENISS.·PALAZZO·ET·GIARDINI·DI·TIVOLI

53

Etienne Dupérac (France, c. 1525–1604)

General View of the Villa d'Este in Tivoli 1573

Engraving, 50.6 × 56.9 cm

The Metropolitan Museum of Art (Harris Brisbane Dick
 Fund, 1941, 41.72)

Dupérac's wide-angle, aerial view conveys the boldness and
originality of the Villa d'Este at Tivoli's long, horizontal
axes, linked diagonals, and abundant statuary and foun-
tains; however, it distorts its proportions, broadening the
lower level. In spite of clearly differentiated areas, the view
makes clear that this was a garden of changes and surprises,
unlike the static and compartmentalized designs of the Re-
naissance. The fame of the garden is evident in contempo-
rary poems, manuscripts, and paintings, as well as Dupérac's

popular view, its reissue and copies. The engraving's legend
identifies thirty-five points of interest, from the palazzo (1)
at the top to the labyrinths (32), herb areas (33), and en-
trance gate (34) of the lower level. Among the major features
were the Avenue of the Hundred Fountains (13), the Foun-
tain of Rome (19), the Oval Fountain or Fountain of the
Tiburtine Sibyl (14), the Fountain of the Owl (21), the Foun-
tain of the Dragon (23), the Water Organ (24), and the Fish
Pools (27). (Although four pools are shown, only three were
built.) Today, the Fountain of Rome survives in only a few
fragments and the Water Organ has been substantially al-
tered. Several features shown, in fact, were not completed,
among them the Fountain of Neptune.

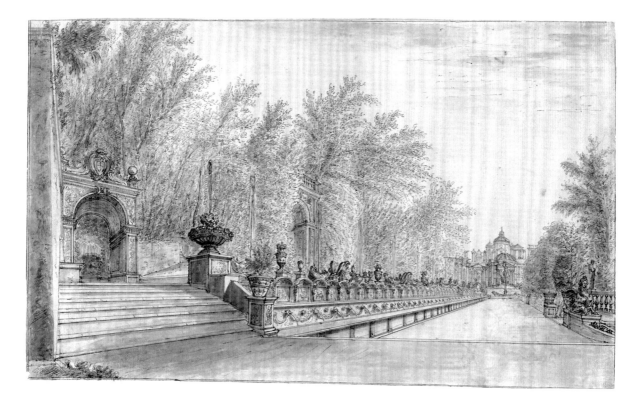

54a

54b

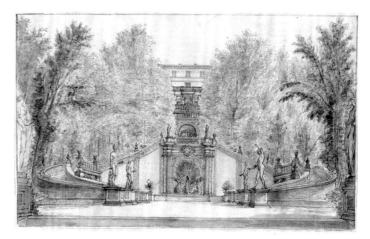

54

Israël Silvestre (France, 1621–1691)

A. *The Villa d'Este: Avenue of the Hundred Fountains*

B. *The Villa d'Este: Fountain of the Dragons* (fig. 2, p. 7)

Pen and brown ink, graphite, with pink and brown washes,
20 × 33.7 cm; 20.3 × 33.3 cm

Fogg Art Museum, Harvard University Art Museums
(Bequest of Frances L. Hofer, 1979.59A,B)

Silvestre visited Italy in 1640, 1642–43, and again in 1650. Most probably on his second trip he made an album of some thirty-five studies, including views of the Villa d'Este. Scholars have noted the accuracy of his sketches and that when he reworked the subjects for etchings, published in 1646, he took greater liberties. Still in his twenties when he sketched at the Villa d'Este, Silvestre's touch was light and fresh, unlike his later more formulaic renderings. For each drawing, he chose a revealing vantage point from which several major features could be seen. The dominant horizontal axis of the Avenue of the Hundred Fountains, with its small, carved fountains, is contrasted to the hillside of trees; in the distance, the avenue terminates in the Fountain of Rome. By the 1630s repair was needed on the fountains because water had worn the surface (today the problem continues: moss covers the decoration). In the Fountain of the Dragons, located at the heart of the garden, he pictured the steep terrain, ascending balustrades, and a glimpse of the palazzo. The fountain, in front of a niche and surrounded by curving stairs lined with small fountains, is again softened by overhanging trees. The large statues in the foreground disappeared long ago.

55

Giovanni Francesco Venturini (Italy, 1650–after 1710)

A. Plate 19: *Fountain of Proserpina*
 (*Fontana di Proserpina Contingua*)

B. Plate 24: *Fountain of the Sweating Spire*
 (*Fontana de Scogli tra l'altre due de cigni*)
 (see p. 138)

Etchings, 22.5 × 33.7 cm; 21.5 × 32 cm
From *Le fontane del giardino Estense in Tivoli* (Rome:
 G. G. de' Rossi, [c. 1691])
Fine Arts Museums of San Francisco, Achenbach Foundation
 for Graphic Arts (Loan from Mr. and Mrs. Marcus Sopher
 Collection, A063239)

Venturini's twenty-four etchings, *The Fountains of Villa d'Este in Tivoli*, made in the 1680s, record the last period when the Villa d'Este was well maintained and still a magnet for travelers. His views, much like Silvestre's of some fifty years earlier, show the garden's many aspects, realistically enlivened with strolling visitors. Both artists included a view of the famous Avenue of the Hundred Fountains, but by the time of Venturini's visit, a high hedge had grown up. Plate 24 shows two unusual fountains on the lower level, spires whose many small openings allowed water to bubble gently, creating a continuously changing form.

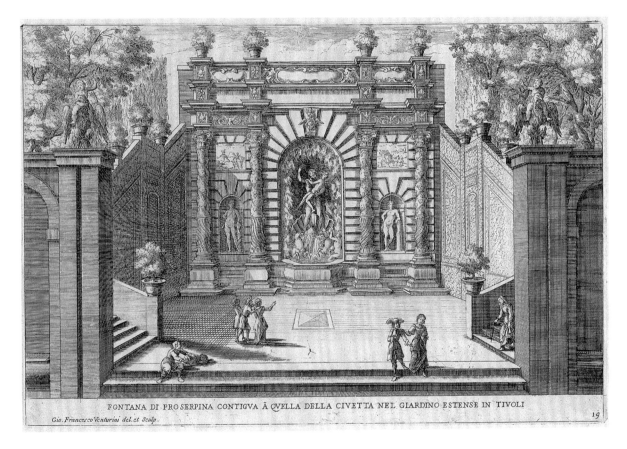

FONTANA DI PROSERPINA CONTIGVA À QVELLA DELLA CIVETTA NEL GIARDINO ESTENSE IN TIVOLI

Gio. Francesco Venturini del. et Sculp.

19

55a

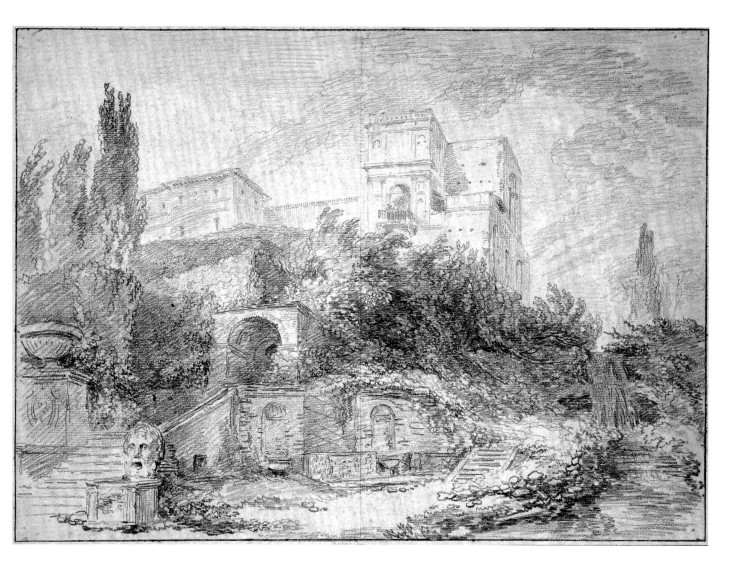

56

Jean-Honoré Fragonard (France, 1732–1806)
*Belvedere of the Villa d'Este at Tivoli: Seen from
the Fountain of Rome* 1760
Red chalk over light black chalk sketch, 35.5 × 49.3 cm
Courtesy of the Fogg Art Museum, Harvard University
Art Museums
Collection of Jeffrey E. Horvitz
[Shown only at Stanford]

The magic of the Villa d'Este's water displays was upstaged by Versailles's grandeur. During the eighteenth century, however, the site was rediscovered by artists. In 1721 the director of the French Academy in Rome considered it the most beautiful waterworks in Italy. By 1749 Charles-Nicolas Cochin found it "beautiful, although almost abandoned," but thought the Fountain of Rome "more ridiculous than pleasing."[1] Fragonard is known to have spent much of the summer of 1760 at the Villa d'Este. His many red-chalk studies brilliantly catch the garden poised between splendor and decay. While noting the persistence of some of its architectural and sculptural remains, his preference lay in celebrating nature's triumph. This view was taken near the fountain dedicated to ancient Rome (much of which was later destroyed). Fragonard, ignoring the sculpture, concentrated instead on the water flowing between rank, weedy growth on the hillside. Drawings such as this were not meant as preparatory studies but as complete in themselves; several were exhibited in Paris at the Salon of 1765. In a later garden subject, Fragonard created a fantasy of an artist seated drawing amid plants (cat. 128).

NOTE
1. David R. Coffin, *Villa d'Este* (Princeton: Princeton University Press, 1960), 130.

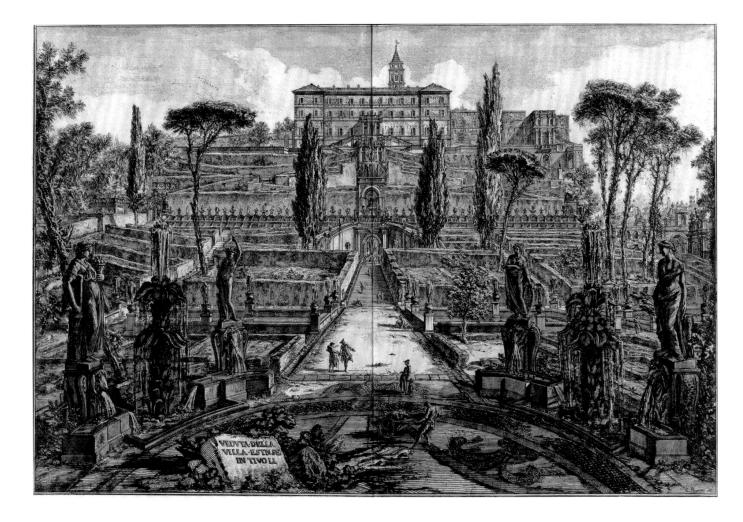

57

Giovanni Battista Piranesi (Italy, 1720–1778)

The Villa d'Este in Tivoli c. 1766–74

Etching, 46.7 × 69.8 cm

From *The Views of Rome*

Iris & B. Gerald Cantor Center for Visual Arts at Stanford
 University (Mortimer C. Leventritt Fund, 1976.98)

Late in his career, Piranesi made three large etchings of gardens, including the Villa d'Este and the Pamphili Garden in Rome—both famous for their collections of antique statuary. Given his obsession with Roman archaeology and his explorations at Hadrian's Villa at Tivoli, this view of the Villa d'Este was almost certainly made in conjunction with such an excavation. Piranesi's view was taken straight on, emphasizing the verticality of the terraced garden above, the long horizontal Avenue of the Hundred Fountains, and, on the lower level, the exaggerated dimensions of the few trees

and antique statuary. To Piranesi the Villa d'Este was an architectural construct of interlocking paths and hedges, with statuary as its dominant presence.

The towering cypresses that appear in so many later views were not part of the original plan. Planted in a circle, probably between 1610 and 1640, they have become the garden's most distinctive and recorded feature, pictured by Maxfield Parrish as the frontispiece to Edith Wharton's influential 1904 book, *Italian Villas and Their Gardens*.

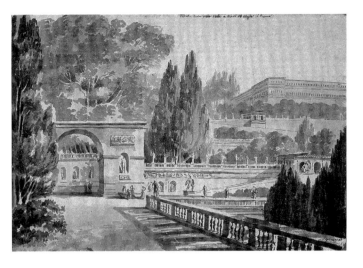

58

François-Marius Granet (France, 1775–1849)

The Villa d'Este at Tivoli c. 1805–25

Pen and wash in gray ink over pencil sketch, 23.4 × 33.4 cm

Iris & B. Gerald Cantor Center for Visual Arts at Stanford
 University (Purchased with funds given by Nancy B.
 Tieken in honor of Betsy G. Fryberger and the catalogue
 of the drawing collection, 1996.32)

In this view Granet, like Piranesi, saw the garden as an architectural construct. Standing near the Fountain of the Tiburtine Sibyl, he looked across the garden and up the hill, seeing lines of balustrades dissecting the garden. To show its scale, he drew small figures, like those of Piranesi, dwarfed by their surroundings. The ample use of gray wash in the many cast shadows and leafy trees softened the hardness of the balustrades and walls.

Granet helped support himself by the sale of such drawings as this, presented on decorated mounts. Granet, who arrived in Rome in 1802, at first admired its Roman antiquities; later he found its churches, convents, and clerics, as well as its countryside, congenial subjects. He remained in Rome for almost twenty years, periodically visiting France. On Granet's return to France, King Louis-Philippe appointed him in 1830 the first curator of the new Musée Historique of Versailles, where he made evocative watercolors of its celebrated grounds.

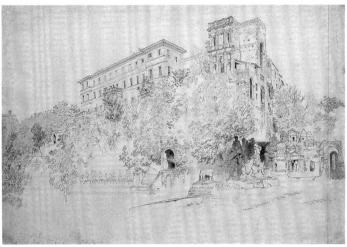

59

James Baker Pyne (Great Britain, 1800–1870)

The Villa d'Este, near the Fountain of Rome

Pencil, 37.3 × 55.2 cm

Iris & B. Gerald Cantor Center for Visual Arts at Stanford
 University (Purchased with funds given by Nancy B.
 Tieken in honor of Betsy G. Fryberger and the catalogue
 of the drawing collection, 1996.48)

This pencil study is taken from the opposite side of the garden from that by Granet. Pyne stood closer to the palazzo, whose facade he drew in considerable detail, but much remains masked by trees. His focus was the Fountain of Rome, the most complex of the Villa d'Este's fountains. It celebrated classical Rome in a group of miniature buildings (at the far right), the she-wolf with Romulus and Remus (in the foreground), and the seated figure of Roma holding a spear (in the shadows). To the left can be seen the Avenue of the Hundred Fountains.

In the 1840s Pyne traveled extensively on the Continent, making watercolors and lithographs of famous and picturesque sites mainly for tourists. Since this sheet is annotated "Tivoli" and numbered "4," it seems probable that he planned to publish a set of views, but evidently did not.

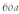

60a

60

Gustave Eugène Chauffourier
 (Italy, b. France, 1845–1919)
A. *The Villa d'Este: Man Seated*
 on the Stairs to the Upper Level
B. *The Villa d'Este: Fountain of the Dragons*
 (see fig. 8, p. 20)
C. *The Villa d'Este: View from the Upper*
 Terrace over the Lower Garden
Albumen-silver prints, 21.8 × 27.9 cm; 28 × 21.7 cm;
 21.3 × 27.6 cm
Collection Centre Canadien d'Architecture/Canadian Centre
 for Architecture, Montréal (PH1984:0634, 0628, 0635)

Cardinal Gustav von Hohenlohe was in residence at the Villa d'Este from 1850 until his death in 1896. Hoping to restore it to some measure of its former grandeur, he ordered that repairs be undertaken, but then the property reverted to the Habsburg family and was again neglected. Archduke Franz Ferdinand visited only occasionally.

The photographer Chauffourier was active in Rome in the 1870s. Born in Paris, he traveled to Italy before 1869, establishing himself first in Palermo as a "French photographer." About 1871–73 he moved to Rome and set up a studio on the Via del Corso. After a decade of activity there, he traveled as far as Turkey and Russia before returning to Italy in 1894. His sons Pietro and Emilio assisted and later continued the business. Often the stamp "EPC" appears on their negatives; it does not on these.

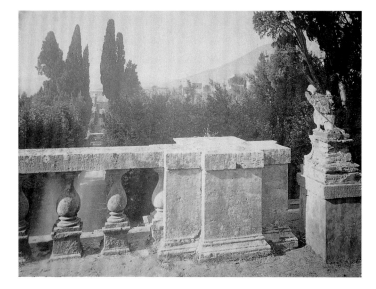

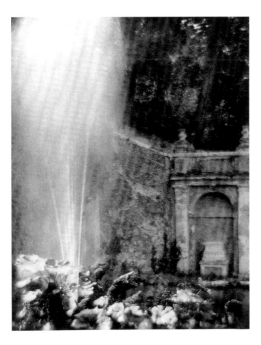

61

Baron Adolf de Meyer (U.S.A., b. Germany, 1868–1949)
The Villa d'Este: The Fountain of the Dragons early 1900s
Gelatin-silver print; printed c. 1940, 35.4 × 27.7 cm
Collection Centre Canadien d'Architecture/Canadian
 Centre for Architecture, Montréal (PH1987:1165)

The Fountain of the Dragons is located at the heart of the garden, where the central vertical axis intersects the major longitudinal one. Its spout rises higher than any other, symbolizing its dominance. The iconography combines the myth of the dragon that guarded the apples of the Hesperides with that of the Este family, who looked back to Hercules as a powerful ancestor.

By the late 1890s de Meyer was exhibiting his photographs in London and Paris and achieved rapid success with his soft-focus portraits of society figures. In 1907 his work was shown by Alfred Stieglitz at his 291 gallery in New York and later published in *Camera Work*.

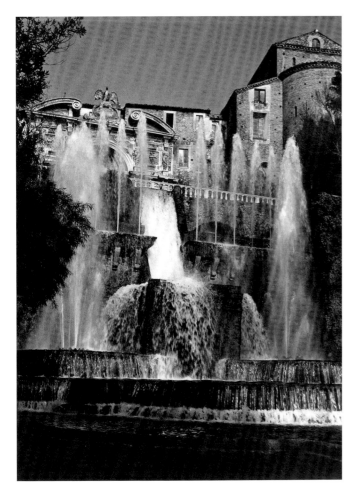

62

August Kreyenkamp (Germany, 1875–1950)
The Villa d'Este: The Organ Fountain c. 1937–38
Gelatin-silver print, 22.9 × 16.9 cm
Collection Centre Canadien d'Architecture/Canadian
 Centre for Architecture, Montréal (PH1980:1052)

The hill from which water flowed to the lowest garden level with the fish pools was not emphasized in the original plan; a century later, in the 1660s, Gianlorenzo Bernini created a series of cascades, simulating the smaller ones that flowed naturally from the hillsides at Tivoli. The Organ Fountain that today dominates the garden with thunderous noise and descending tiers of vertical spouts is a far more recent addition, dating from a renovation of about 1925–30. Kreyenkamp's photograph was probably made shortly thereafter. The decision to refurbish the water display—taken some two hundred fifty years after the garden's birth—was implemented with modern hydraulic techniques. Even as such changes were introduced, however, the original plan was respected to the point that a portion of the sixteenth-century fresco in the palazzo was repainted to show this new wall of water as if it had been there since the garden's beginning.

Vaux-le-Vicomte

Vaux-le-Vicomte is one of the earliest and finest examples of the style that became dominant in seventeenth-century France: the formal garden, with its symmetrical layout, clearly delineated terraces bisected by broad walks lined with clipped hedges, and imaginative displays of water. Set in a wooded landscape, Vaux's formal garden extends from the château like a ribbon unfolding. A parterre adjacent to the château leads to terraces along paths punctuated by urns (and, originally, statuary) and conical evergreens. Water plays a major role: a moat surrounds the château, which looks across terraces animated by fountains and a small cascade. The grandest use of water is revealed only at the far end of the terrace, where a long canal, flowing perpendicular to the garden, magically appears, preceded by a great cascade that announces its presence with increasing resonance. Vaux's garden arrangement is harmonious, but not grandiose; balanced, yet revealing subtle variations. The vista from the château extends in a long, narrow line, defined on either side by the woods, across terraces to a distant hill on whose peak stands a large statue of Hercules leaning on his club and looking back at the château. This mythological symbol of strength affirmed the power of the garden's owner, Nicolas Fouquet, minister of finance to Louis XIV, who was a successful financier and an intelligent, sympathetic patron of the arts.

At Vaux, some thirty-five miles southeast of Paris, Fouquet assembled for the first time the architect Louis Le Vau, the painter Charles Le Brun, and the landscape designer André Le Nôtre to direct work on the château and garden. Such collaborations stimulate cross-fertilization of ideas and rely on the varied talents of hydraulic engineers and horticulturalists, but history has credited Le Nôtre as the supreme guiding spirit. In spite of the magnitude of the project, which at one time evidently involved as many as eighteen thousand workers, château and garden were nearly completed within twenty years.

The opening celebration on August 17, 1661, to which Fouquet invited Louis XIV and his entire court, has been described by many, from the poet Jean de La Fontaine, a friend of Fouquet, to the scholar Jean-Pierre Pérouse de Montclos.[1] The entertainment included gastronomic delicacies and strolling in the gardens, where Molière's play *Les Fâcheux* was performed with a short ballet. The evening ended with a burst of fireworks. The king's reaction to this costly display was swift: Fouquet was arrested within a month, put on trial, and confined. Scholars have noted that Fouquet's downfall had long been plotted by his rival Jean-Baptiste Colbert, who was then rewarded with the title of finance minister. La Fontaine lamented the loss: "Fill the air with cries in your deep grottoes / Weep, Nymphs of Vaux...."[2] The property was retained by Fouquet's wife, but close to one thousand trees and many statues were removed to Versailles, where the same brilliant artistic trio who designed Vaux created a far grander, but less charming, ensemble. Thereafter, much of Le Nôtre's life was spent working for the king, redesigning royal gardens.

During the following two centuries, Vaux suffered neglect, as did most seventeenth-century formal gardens. One area was modified to conform to the new taste for picturesque English gardens. In the 1820s it was noted that potatoes were growing in the parterres

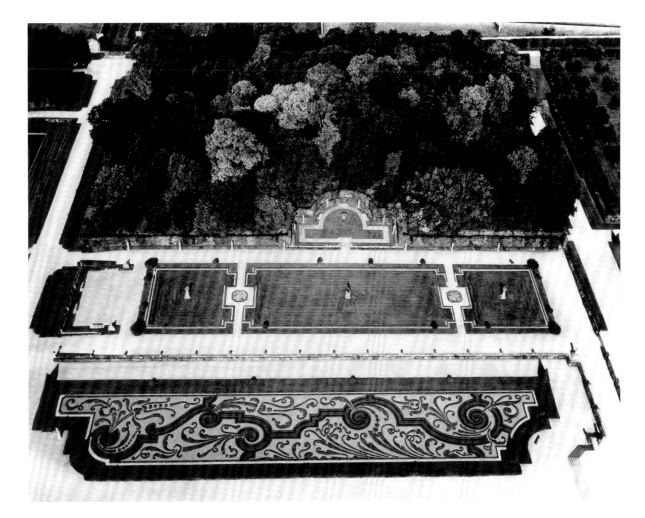

65

and statues and vases were overturned. In an abandoned state, it was purchased by the industrialist Alfred Sommier in 1875, a time when other formal gardens and châteaux were being restored by the newly rich. Sommier engaged the architect Gabriel Hippolyte Destailleurs, who was a scholar, collector of architectural drawings, and expert in restoration, who had also directed work at nearby Courances. By the time of Destailleurs's death in 1893 much had been accomplished at Vaux. Henri Duchêne consulted briefly. When Sommier died in 1908, his son Edme engaged Henri's son, Achille, who, with his father, was experienced in restorations. Using original documents, mainly the prints of Israël Silvestre, the younger Duchêne re-created grand parterres with elaborate embroidery patterns.

The great-grandson of Alfred Sommier, Patrice de Vogüé, now owns the property and has opened it to visitors. Some financial support comes from the French government, but to maintain the château and gardens the family has converted part of the stables to a restaurant and gift shop. Periodic candlelit tours of the garden and château (where seventeenth-century prints of the gardens are on view) are offered.

BETSY G. FRYBERGER

NOTES

1. Books consulted include Hamilton Hazlehurst, *Gardens of Illusion: The Genius of André Nostre* (Nashville: Vanderbilt University Press, 1980); and Jean-Marie Pérouse de Montclos, *Vaux le Vicomte* (London: Scala Books, 1997).

2. Quoted in Pérouse de Montclos, *Vaux*, 15.

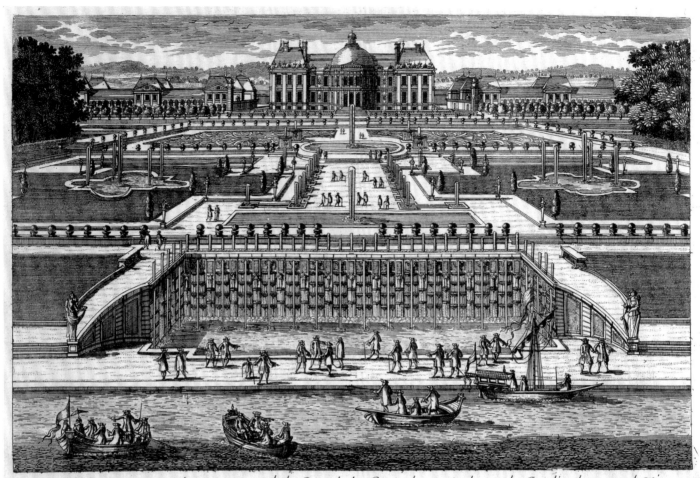

Veüe et perspectiue en general du Canal des Grandes Cascades, et du Jardin de Veaux le Vicomte
fait par Aveline Auec Priuilege du Roy

63

Pierre Aveline the Elder (France, c. 1656–1722)
*Vaux-le-Vicomte: General View of the Canal
and Cascades* (after Israël Silvestre) c. 1700

Engraving, 22.5 × 33 cm

Iris & B. Gerald Cantor Center for Visual Arts at Stanford
 University (Purchased with funds given by Nancy B.
 Tieken in honor of Betsy G. Fryberger and the catalogue
 of the drawing collection, 1997.105)

This view, taken from the hill facing the formal terraced
garden at Vaux, looks across the canal to the high stone wall
with its cascades, which are the great surprise of the garden,
being invisible from the château. The view continues across
terraces with basins and water jets, along broad paths lead-
ing to a large parterre with elaborate scrollwork designs, and
terminates on the imposing château (whose moat is also in-
visible from a distance). Water, so important in this garden,
proves difficult to represent; the cascades appear as solid
cylinders. Aveline's schematic rendering informs and dis-
torts in almost equal measure—a problem with many topo-
graphical views that one would like to turn to for firm evi-
dence. Not shown are the extensive woods that rise on either
side of the formal area, an omission that alters the propor-
tions. Also not visible is a kitchen garden, which lies to one
side of the central formal area. Professional printmakers,
like Aveline, generally worked from designs by others, in
this case Silvestre, whose drawings were reliable because he
visited the grounds.

64

Michael Kenna (U.S.A., b. Great Britain, 1953)

Reflection, Study 2, Vaux-le-Vicomte 1996

Gelatin-silver print, 19 × 20.4 cm

Iris & B. Gerald Cantor Center for Visual Arts at Stanford
University (Given in memory of Verna Stewart with funds
donated by Betty Moorman and the Committee for Art
Acquisitions Fund, 1997.72)

The garden's elegant patterns and proportions are accentuated in the miragelike photograph in which the château seems to hover over water. The pool of water (far smaller than it appears in the photograph) lies at the end of the parterre. The photograph, like the garden, surprises by offering an unexpected view. Kenna has enlarged the garden's dignity and elegance by surrounding it with clouds and reflections, which intensify both its substance and its mysteriousness.

The apparent absolute symmetry of the landscape is correct in spirit, but misleading in detail: the land is not flat, nor are the plantings symmetrical. One side is slightly elevated and within it each section is differentiated in arrangement and size—such fine adjustments are characteristic of Le Nôtre.

65

Marilyn Bridges (U.S.A., b. 1948)

Vaux-le-Vicomte: Aerial View of the Garden
and Orchard 1984 (see p. 149)

Gelatin-silver print, 37.6 × 47.4 cm

Collection Centre Canadien d'Architecture/Canadian
Centre for Architecture, Montréal (PH1985:0680)

The garden at Vaux, which had deteriorated during the
eighteenth century, was gradually reconstructed during
the late nineteenth and early twentieth centuries. The elab-
orate scrollwork of the parterres was designed about 1900
by Achille Duchêne, who with his father, Henri, restored
other seventeenth-century gardens. Achille worked into the
1920s at Vaux, where he made use of Silvestre's etchings of
the 1660s to help determine the garden's original appear-
ance. The scrollwork parterres, which emulate the spirit of
Le Nôtre as interpreted by Achille Duchêne, were pho-
tographed by Bridges from a single-engine airplane flying at
a low altitude.

66

Marion Brenner (U.S.A., b. 1944)

Vaux-le-Vicomte: Statue of Hercules 1998

Gelatin-silver print, 19 × 19 cm

Marion Brenner

The large statue of Hercules, which stands on the hilltop
across the canal from the formal garden, is the distant focal
point and can be clearly seen from the château and its for-
mal parterre. Copied after the famous Farnese Hercules in
Rome, the statue, while a recognized symbol of power, also
referred to Fouquet's accomplishments in constructing such
a stunning garden. Although not in place at the time of the
fateful visit of Louis XIV, the fact that Fouquet planned such
a statue shows his ambition and arrogance, which helped
precipitate his downfall.

Statues of Hercules ornamented many gardens; one of the
largest was erected in the eighteenth century at Weissen-
stein (now Wilhelmshöhe) in Germany. Visitors climbed to
the top of the statue, set on a two-story structure on a steep
hill, to view the surrounding garden with its ruins of a great
aqueduct and other follies.

Versailles

Versailles, the most famous and influential of French formal gardens, embodies all the characteristics of that style: rigid order and symmetry on the one hand and profuse variety on the other. Mankind's reshaping and manipulation of nature are everywhere in evidence. Geometric in design, the garden is divided by long, straight, sculpture-lined walks bordered with meticulously trimmed walls of hedges and trees. Broad terraces, filled with plants arranged in tapestry patterns, offer views of lower areas of the garden, such as the great green lawn and the Grand Canal, the latter two hundred feet wide and a mile long. Balustraded stairs ornamented with flower-filled urns and statuary link the terraces, which descend from the château to the canal. Tranquil expanses of water reflect the sky in basins and pools; jets and sprays of water animate the many fountains. Within the enormous scale of the garden lie the intimate spaces of its groves, where visitors are surprised by fountains and statuary that await contemplation. An abundance of sculptural works placed throughout the garden symbolizes the king and the glory of France, the classical gods, the seasons, the hunt, and the arts. An orangery of a thousand trees and a kitchen garden (*potager*) assured the monarch of a bountiful supply of fresh fruits and vegetables.

Set in the Ile-de-France, where many royal residences already existed, Versailles lies some twelve miles southwest of Paris. When it was used by Louis XIII in the 1630s as hunting grounds, the property was far smaller than today's immense park—his lodge overlooked only a simple, symmetrical garden. Louis later increased his holdings by acquiring the surrounding land and villages, but it was not until the early 1660s, under Louis XIV, that the huge landscaping program began. The swampy land was drained; earth was moved; a hydraulic system was installed to supply the many fountains; and trees and plants were brought in to create a magnificent garden. Louis XIV's principal designer was Le Nôtre, royal gardener and descendant of a family of gardeners to the king. While overseeing the construction at Versailles, Le Nôtre continued to design gardens for the royal family, among them Saint-Cloud and Marly, as well as gardens for private clients. Charles Le Brun, First Painter and Director of the Royal Academy of Painting and Sculpture, designed most of the statuary, both the free-standing figures and those adorning the fountains. Louis XIV took a direct interest in and at times supervised the progress of his gardens. He even wrote a short visitor's guide.[1]

The transformation of Versailles commenced in 1661, after Louis XIV's famous visit to Vaux-le-Vicomte, the new château and formal gardens of his finance minister Nicolas Fouquet.[2] Recognizing their superiority and suspecting Fouquet of embezzlement, Louis removed Fouquet from power and appropriated many of Vaux's trees and statues, transplanting them to Versailles. Most important, Louis engaged the artistic trio that had created Vaux, the architect Le Vau, Le Brun, and Le Nôtre.

The grand plan at Versailles remains today essentially unaltered in its divisions of woods and water and the placement of major avenues. Smaller, more enclosed areas like the groves were constantly being changed and renamed, fountains constructed and later dismantled, and statuary moved about. When festivals

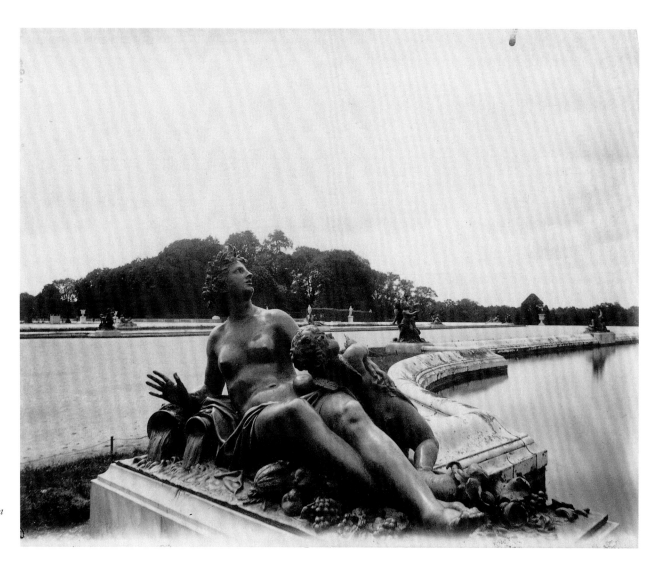

70a

were held, temporary structures and theatrical scenery were set up to accompany plays, ballets, concerts, and displays of fireworks in the gardens (cat. 100).

To accommodate the need for an ever larger water supply, a great machine was constructed at Marly to pump water uphill from the Seine to Versailles. Although enormous sums of money were spent to bring in water through an additional network of canals, there was never enough. Even today, when the fountains play on Sunday afternoons, the smaller ones flow first, and only after they are turned off is there sufficient water for the Fountain of Neptune to begin its display.

Neither Louis XV nor Louis XVI was as personally attached to the gardens as Louis XIV had been; moreover, Louis XIV's lavish spending meant that nei-

ther successsor had the finances necessary to landscape with the same degree of splendor, or even to maintain the existing garden properly. During the reign of Louis XV, who led a less public life, the most significant changes were made at the Trianon, the smaller château and gardens within the larger park.

Numerous paintings, drawings, and prints document Versailles's changing gardens. Most are now housed at the Musée de Versailles. Louis XIV commissioned a series of large paintings of the interiors of the groves (*bosquets*), which are exhibited in the Grand Trianon. In the 1690s, Silvestre and members of the Perelle family made detailed drawings and prints. Silvestre also illustrated Louis XIV's first festival in May 1664. The garden was transformed: hedges became

backdrops, stages were erected for performances of music and dance, and processions and banquets were held in secluded groves (cat. 100).

By the 1720s plantings had been changed to reduce the need for extensive pruning and to appear more naturalistic, as shown in Jacques Rigaud's etchings. In 1775, when many diseased, old trees were being cut down, the grounds were a scene of desolation. The reforestation that followed included close to eight thousand young oaks, poplars, and maples for the woods, with hornbeam and chestnuts lining the paths. Although most configurations were saved, the labyrinth was destroyed. Hubert Robert played a major role in laying out the newer Trianon grounds in the picturesque English style, with meandering paths and architectural follies, the best known of which are the rustic farmhouse and mill called the Hamlet. In addition to receiving the coveted commission to design the new setting for the sculptural groups of Apollo and his horses, Robert became the first official royal garden designer appointed since the death of Le Nôtre.

During the Revolution, after the arrest of the royal family, wives of the militia who occupied the grounds did the family wash in the fountains and hung it to dry on the once carefully trimmed hedges. In 1798 a Tree of Liberty was planted beneath the king's bedroom, the symbolic center of royal power, to celebrate the anniversary of Louis XVI's beheading. At the beginning of the nineteenth century, Napoleon directed very few funds toward the maintenance of the gardens, and those alterations he did commission were ordered for reasons of personal security. His second wife had the Hamlet restored in 1811, when it was the site of a royal festival. After Napoleon's death, Versailles ceased to be a royal residence. During the brief reign of Louis XVIII, the only change made to the park was the planting of the King's Garden over the old ornamental lake called the Royal Isle, which had been partially filled in.

Although Versailles is owned by the French government, Americans have helped to refurbish it. In the mid-1920s John D. Rockefeller Jr. began making gifts that over a decade totaled more than $130 million to restore the château. In the 1960s other Americans contributed to interior restorations. Recently, the American Friends of Versailles have been trying to raise some $5 million to restore the Grove of the Three Fountains, in whose design Louis XIV is reputed to have had a hand.

Since 1990 Pierre André Lablaude has been in charge of restoring its historic gardens, and he has written a well-illustrated history of Versailles.[3] Among his projects are the renovation of the groves, including planting hornbeam hedges, and rebuilding the elaborate trelliswork. The violent storms of December 1999 devastated Versailles: of the ten thousand trees felled, more than one thousand were in the formal gardens. Since trees need to be replanted about every hundred years, and the last planting was in the 1870s, the current planting is part of a greater project, now accelerated by the damage. Versailles is popular not only with tourists but with those in the neighborhood who use its more remote wooded areas for picnics. On Sunday afternoons, the grounds are festive and crowded. One can tour by bus or horse and buggy, jog or cycle, follow the fountains as they are turned on, or view the grounds from afloat on the canal.

MARY SALZMAN AND BETSY G. FRYBERGER

NOTES

1. Louis XIV, *Manière de montrer les jardins de Versailles* (Paris: Mercure de France, 1999).

2. Sources consulted include Alfred Marie, *Naissance de Versailles*, 2 vols. (Paris: Vincent, Fréal et Cie, 1968); Jean-Marie Pérouse de Montclos, *Versailles*, trans. John Goodman (New York: Abbeville Press, 1991); and Susan B. Taylor-Leduc, "Louis XVI's Public Gardens: The Replantation of Versailles in the Eighteenth Century," *Journal of Garden History* 14 (1994): 67–91.

3. Pierre-André Lablaude, *The Gardens of Versailles* (London: Zwemmer, 1995).

67a

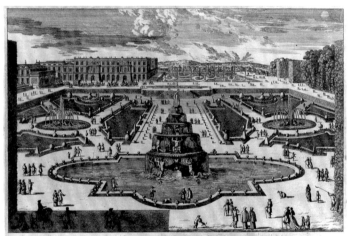

67b

67

Gabriel Perelle (France, 1604–1677) and/or

Adam Perelle (France, 1638–1695)

A. *Versailles: Title Page*

B. *Versailles: View of the Fountain of the Pyramid*

Etchings, 18.3 × 23.5 cm; 20 × 29.2 cm

From *Veües des plus beaux endroits de Versailles* (Paris: Nicolas Langlois, [c. 1690?–1700])

Iris & B. Gerald Cantor Center for Visual Arts at Stanford University (Mortimer C. Leventritt Fund, 1977.190; Committee for Art Acquisitions Fund, 1988.25)

Much of our knowledge of the gardens at Versailles as they existed during the reign of Louis XIV is derived from views by Silvestre, many reproduced in prints by Perelle and his family. The volume *Views of the Most Beautiful Places at Versailles*, published in Paris close to the end of the seventeenth century, provides information about not only Versailles but also other gardens, most shown in multiple views. Among the views are fountains or groves that no longer survive; their disappearance, however, is not necessarily due to the ravages of time but rather to the garden's evolution and redesign during the long reign of Louis XIV, who directed the gargantuan project from its inception in 1661 until his death in 1715.

The title page, typical for the period, contains the text framed within an architectural device, which is surrounded by such standard features as strolling visitors, elaborate pyramids with jets of water, and statuary. The Pyramid Fountain, also called the Water Pyramid, is located at the boundary of the North Parterre and the Water Walk, near the north wing of the palace. When the water is off, the sculpture resembles a tiered serving tray, but when it is on, the water streams down the platforms in sheets and resembles an ancient Eygptian step pyramid. Each level is held aloft by a different sea creature, whose size corresponds to the diminishing circumference of the tiers as they rise: tritons support the bottom level, then their children, then dolphins, and finally crayfish at the top. Most, but not all, of the principal pieces of sculpture at Versailles were executed by members of the Royal Academy after Le Brun's drawings. The Water Pyramid, fashioned in metal by François Girardon in 1668 and gilded in 1671, is still in place today.

68

Pierre Le Pautre (France, 1660–1744)

Map of Versailles 1717

Etching, colored by hand, 81 × 63.5 cm (central section);
 80 × 26 cm (each of two side sections)

(Paris: Morin and Vanheck, 1717)

Michael J. Weller

Because the gardens were constantly being reshaped and added to during both the seventeenth and the eighteenth centuries, new maps were issued to reflect these changes.[1] This hand-colored plan of Versailles, which includes the château, gardens, outlying park, and the town, is a later, slightly revised, edition of the 1710 *Plan général de la ville et du château de Versailles* and was published two years after the death of Louis XIV (1638–1715). The château and gardens lie at the center of the map and, as vast as they are, appear dwarfed by the surrounding park. The king's bedroom lies at the center of the château, directly facing the main path, or Allée Royale, which leads to the Fountain of Apollo at the opposite end of the gardens. Louis, France's self-appointed Sun King, identified with Apollo, sun god of Greek and Roman mythology. A small sun occupies the medallion at the top of the map's printed border.

NOTE

1. Pierre-André Lablaude, *The Gardens of Versailles* (London: Zwemmer, 1995), 74 (ill.) and a panoramic view, 67 (ill.). See also maps by Jean Chaufourrier of 1720, 78 (ill.), and of the large water parterre by Pierre Prieur of 1732, 61 (ill.).

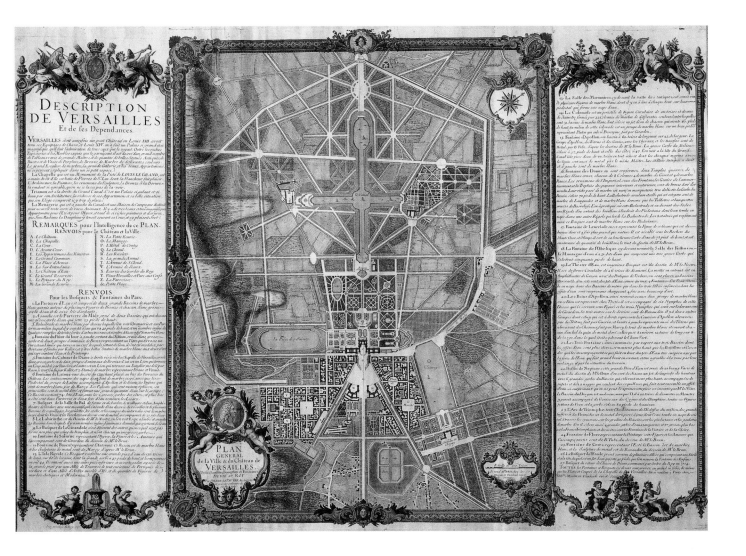

69

Neurdein Frères (X. Photo) (France, active 1870–1910)
Versailles: Fountain of Latona c. 1885–1900
Albumen print, 21.2 × 27.5 cm
Embossed stamp of J. Kuhn, rue de Rivoli, Paris
Stephen Wirtz Gallery, San Francisco

The Fountain of Latona, dedicated to the mother of Apollo, is situated on the main axis of the garden between the château and the Fountain of Apollo, which is located on a lower level and farther west, near the head of the Grand Canal. From where Latona stands atop the handsome tiered fountain with its many sculptural embellishments in a large round basin, she surveys the lower garden; behind her the great château looms above the broad flights of stairs. This page is from an album the Parisian firm Neurdein Frères made at the time of such large world's fairs as the Exposition Universelle of 1900. Such a distant and formal view was characteristic of the work of commercial photographers, in contrast to the more intimate and personal perspectives chosen by Atget (cat. 70).[1]

NOTE

1. John Szarkowski and Maria Morris Hambourg, *The Work of Atget*, 4 vols. (New York: The Museum of Modern Art, 1981–85), vol. 3, 163–64, fig. 4, as by Neurdein Frères.

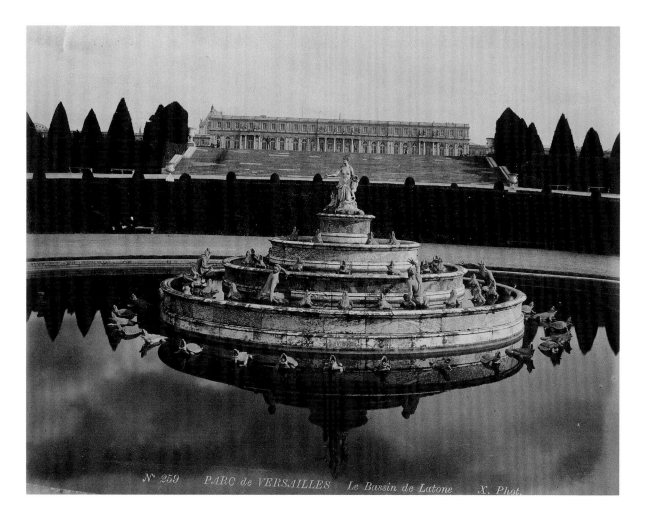

Nº 259 PARC de VERSAILLES Le Bassin de Latone X. Phot.

70b

70

Eugène Atget (France, 1857–1927)

A. *Versailles: The Water Parterre with the Statue of the
Dordogne River on the Upper Terrace* 1901 (see p. 154)

B. *Versailles: The Water Parterre with the Statue of
a Nymph and a Young Boy with Trident on the
Upper Terrace* c. 1903

Albumen-silver prints, each 17.5 × 21.6 cm

Inscribed verso (A): "6123/Versailles—Coin du Parc";
 (B): "6378/Versailles—Bassin du Nord"

The Art Institute of Chicago (Restricted gifts of Mrs.
 Everett Kovler, 1963.1026, 1963.929)

During the reign of Louis XIV this area was transformed
from a small area with beds arranged in patterns (*parterre-
de-broderie*) into the broad Upper Terrace still seen today. En-
larged in 1663 and doubled in size a few years later, it as-
sumed its commanding present configuration by 1690–91.
At the center of the symmetrical terrace are two long pools
in which the grand facade, with its balustrade of statuary of
the months and the seasons, is reflected, mingling with the
river gods and goddesses who line the pools—a visual and
symbolic convergence of château and garden. Eight bronze
statues representing the great rivers of France were placed
at the four ends of the pools, with nymphs reclining along
the sides. Closest to the château on the North Pool are An-
toine Coysevox's personifications of the Garonne and Dor-
dogne Rivers. The former is represented as a god, its smaller
tributary as a goddess.

Between 1901 and 1904, Atget often worked at Versailles,
making some five hundred glass negatives. More than one
hundred prints, once part of an album, are now at the Art
Institute of Chicago. Their inventory numbers, inscribed in
pencil on the verso, establish the sequence and year. In many
views of Versailles's vast collection of fountains, statues,
and vases, Atget often worked at close range and from mul-
tiple vantage points, making sculptural details so clear that
even the graffiti is legible.

Atget's photograph of the statue of the Dordogne shows
her reclining amid bountiful produce, her right arm resting
on two vases from which water copiously flows. He has cho-
sen to guide the viewer along the curved rim of the reflect-
ing pool, across a broad path, and deeper into the garden. In
another photograph, also taken along the North Pool, Atget
shows a statue of a nymph with a young boy holding a tri-
dent by Philippe Magnier. Following her gaze outward into
the garden, the photograph notes a few statues to the north;
to the west rise the tops of conical yews that presage the de-
scent to the fountains of Latona and of Apollo along the gar-
den's central axis.

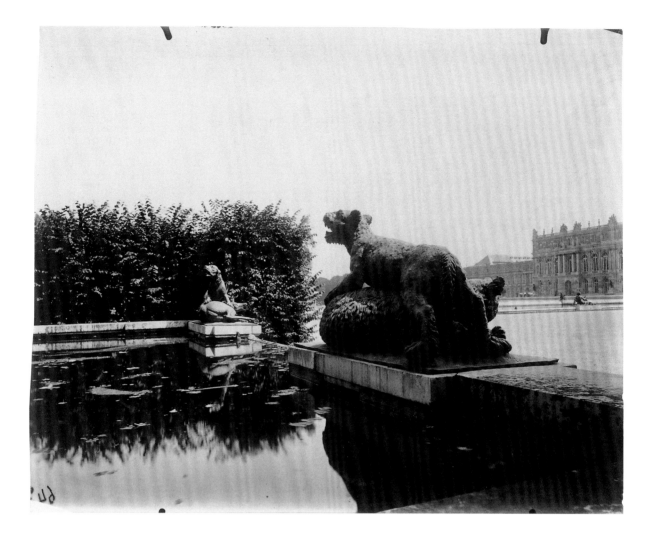

71

Eugène Atget (France, 1857–1927)

Versailles: Fountain of Daybreak with a Tiger
 Overcoming a Bear on the Upper Terrace 1904

Albumen-silver print, 17.8 × 21.9 cm

Inscribed verso: "6421/Versailles—Fontaine du Point du
 Jour—tigre terrassant un ours—par Houzeau"

The Art Institute of Chicago (Gift of Mrs. Everett Kovler,
 1963.941)

At the corners of the Upper Terrace are two small enclosed areas with pools that feature statuary of fighting animals. The fountains, one representing daybreak, the other evening, were designed by Jules Hardouin-Mansart; the bronzes were made by several sculptors, including Jacques Houzeau, who created this pair. Water from the mouths of the victors is projected into the upper pool, while that from the vanquished flows into the lower.

Although Atget had earlier photographed the large pools of the Upper Terrace, the inventory number on this photograph indicates a date of 1904. In *Tiger Overcoming a Bear*, Atget has looked back toward the château, across the reflecting pools; in another photograph of the same fountain in which a stag is felled by a dog, the view is from within its enclosure of trees. Unfortunately, such small fountains and much of the statuary and urns are often missed by casual visitors; the vast and varied repertoire of Versailles needs repeated visits—and the perseverance of Atget.

72

Eugène Atget (France, 1857–1927)

*Versailles: Statue of Bacchus with Raised Arm
 on the Parterre of Apollo* 1904

Albumen-silver print, 22.2 × 17.8 cm

Inscribed verso: "6457/Versailles—Coin du Parc"

The Art Institute of Chicago (Gift of Mrs. Everett Kovler,
1963.981)

Classical mythology provided the theme for much of the garden statuary—some figures were copied after the antique, some newly interpreted. Among those most frequently represented in various guises were Venus, Hercules, Apollo, and Bacchus. As god of fertility, abundance, and drink, Bacchus appears as one of four statues next to the château, then on the parterre of Latona as an infant with Silenus, and in a copy after a Roman statue in the Medici collection. Further statues were placed on the parterre of Apollo—as seen here—and in more secluded locations.

Atget eloquently photographed Bacchus and several distant statues against a dark vertical hedge, overhanging trees, and a strong horizontal band of conical yews. As Bacchus raises a bunch of grapes, it mingles with the leaves above, integrating sculpture and plantings in a way not possible in views taken on the vast open spaces of the Upper Terrace.

73

Eugène Atget (France, 1857–1927)

Versailles: A Grove near the Triumphal Arch 1904

Albumen-silver print, 21.9 × 17.6 cm

Inscribed: "6485/Bosquet de l'arc de Triomphe"

The Art Institute of Chicago (Restricted gift of Mrs. Everett
Kovler, 1963.1025)

Atget's images of Versailles's more intimate, wooded settings convey a mood of reverie. In this corner of the Grove of the Triumphal Arch, a sculpted bust and curved bench are seen against a background of trelliswork and woods—man-made features and nature in harmony.

After his early work at Versailles, Atget returned briefly in the 1920s. By then he was no longer examining individual monuments but composing in more pictorial terms, experimenting with light effects.

74a

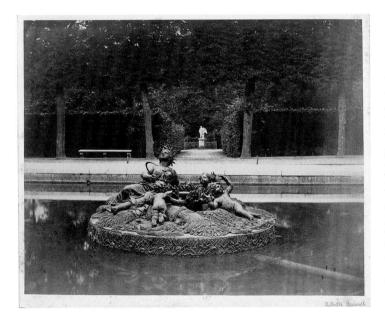

74b

74

Achille Quinet (France, active c. 1863–1900)

A. *Versailles: The Fountain of Flora (Spring)* 1868
B. *Versailles: The Fountain of Ceres (Summer)* 1868
Albumen prints, 19.5 × 25.1 cm; 19.3 × 24.9 cm
Iris & B. Gerald Cantor Center for Visual Arts at Stanford
 University (Gifts of Joseph Folberg, 1994.68.79, .80)

Among the profusion of smaller fountains at Versailles are
the Four Seasons, located in pools just off the central allée
leading to the Grand Canal. Placed at axial intersections, the
reclining groups, however, do not impede the vista. Flora,
goddess of flowers and symbol of spring, was executed by
Jean-Baptiste Tuby in 1672–75, after a design by Le Brun.
Resting on a bed of flowers, with a basket of freshly cut
cornflowers and anemones, she is surrounded by cupids
playing with garlands. Ceres, goddess of the harvest, was ex-
ecuted by Thomas Regnaudin in 1672–74, also after a design
by Le Brun. Surrounded by sheaves of wheat, she reclines ac-
companied by three cupids. At the time of Quinet's views,
the trees rightly narrowed, but did not obscure, the path's
sight lines. (Old trees loom too large; young ones do not
make the desired screen.)

Relatively little known, Quinet was from a family of pho-
tographers. By 1863 he was selling views of Paris and of Ital-
ian cities; in 1868 he deposited prints of Versailles at the Bi-
bliothèque Impériale. During the 1870s he photographed in
the Forest of Fontainebleau and farmers at work. He exhib-
ited at the Exposition Universelle of 1878.

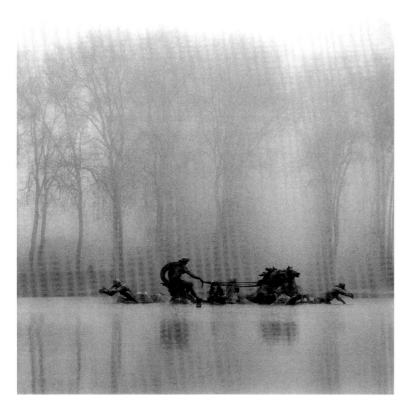

75

Michael Kenna (U.S.A., b. Great Britain, 1953)
Versailles: Chariot of Apollo, Study 2 1996
Gelatin-silver print, 15.2 × 22.8 cm
Michael Kenna and the Stephen Wirtz Gallery, San Francisco

Located conspicuously on the central axis, the Fountain of Apollo is the single most important and visible fountain: it glorifies the sun god, the symbol chosen by Louis XIV to convey his dominance. As Apollo's chariot breaks through the water, its horses charging vigorously, four tritons blow their conch shells to signal daybreak. Rather than dwelling on the obvious pomp and spectacle of Tuby's gilded lead statuary, Kenna chose to photograph a revelatory moment, illuminating the sun god's chariot as it rises to announce the day. A selection of Kenna's photographs of French formal gardens has been published in *Le Nôtre's Gardens* (1997).[1]

NOTE

1. Michael Kenna, *Le Nôtre's Gardens*, photographs by Michael Kenna, text by Eric T. Haskell, exh. cat. (Santa Monica, Calif.: RAM Publications, 1997).

76

Michael Kenna (U.S.A., b. Great Britain, 1953)
Versailles: Children of the Trianon 1996
Gelatin-silver print, 20 × 18.9 cm
Private collection

In 1698 the aging Louis XIV, in speaking with the architect Mansart, asserted that "the theme of youth must be present in everything we do." Children were a recurrent motif at Versailles, appearing in the guise of tritons, cupids, putti, satyrs, playing music, dancing, or attending gods and goddesses. Many of these charming sculptures that once inhabited the grounds are no longer; those that survive are generally without original gilding. Playful groups cluster at the corners of the reflecting pools on the Upper Terrace; groups of three support fountains along the Water Avenue; and three pairs play on the Children's Island Fountain. In remote areas of the Trianon are smaller statuary groups, like the example shown here.

In Kenna's photograph the expanse of the pool reflects the tall, surrounding trees, sparsely placed, and past their prime. Although their fragility is clear, the lower clipped hedges convey a sense of controlled order. Kenna balances nature and artifice, survival and decay.

77
Eugène Atget (France, 1857–1927)
The Trianon: The Hamlet (Le Hameau) c. 1923–24
Gelatin-silver print, 18 × 22.8 cm
Inscribed: "1258"
Iris & B. Gerald Cantor Center for Visual Arts at Stanford
 University (Museum Purchase Fund, 1972.7)

Mention of *Le Hameau*, the miniature farming village located
in the garden of the Trianon at Versailles, conjures up the
incongruous image of Marie-Antoinette playing milkmaid
with the ladies of the court on the eve of the French Revo-
lution. The Hamlet is worthy of note, however, as an exam-
ple of the eighteenth-century fashion for architectural fol-
lies that become an integral part of the picturesque style.

Built from 1783 to 1785, it was designed by the queen's
architect Richard Mique; the painter Robert consulted on
the project. It most closely resembles farm buildings of
Normandy, with their exposed timber construction and
thatched roofs, and its dilapidated look was intentional. In-
side, however, as was typical of the follies and fake ruins of
privately owned picturesque gardens, the rooms were richly
decorated in the latest style, with mirrors, gilded wall pan-
eling, and comfortably upholstered furnishings. The Ham-
let, as well as the surrounding gardens, served as a retreat
for the queen from the duties of palace life. There, she in-
vited only her closest associates for small dinner parties,
cards, and conversation.

78
Baron Adolf de Meyer (U.S.A., b. Germany, 1868–1949)
Versailles: Vista from the Upper Terrace Looking West
 early 1900s
Gelatin-silver print; printed c. 1940, 27.6 × 35.2 cm
Collection Centre Canadien d'Architecture/Canadian
 Centre for Architecture, Montréal (PH1985:1064)

De Meyer offers essentially the same imposing view that
Louis XIV once saw, confirming his mastery of all he sur-
veyed. Le Nôtre's design carries the eye across the Upper
Terrace down to the circular basin of the Fountain of La-
tona, continues along the broad avenue to the Fountain of
Apollo, and follows the Grand Canal until its termination in
the seemingly infinite woods beyond.

Although Versailles was designed to accommodate thou-
sands of courtiers, and today is the destination of innumer-
able tourists, most recent images focus on the garden's for-
mal structure, ignoring or eliminating its visitors. Pictures
from the time of Louis XIV, on the other hand, portray cel-
ebrations with throngs attending plays, listening to music,
enjoying banquets, and watching fireworks (cat. 100). Al-
though de Meyer's vista is humanized by the few visitors,
they appear overwhelmed by the scale of the landscape.

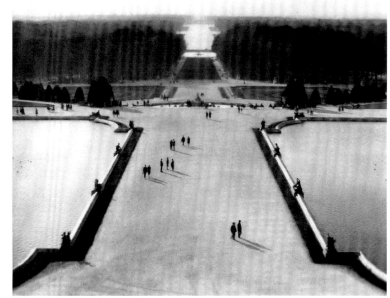

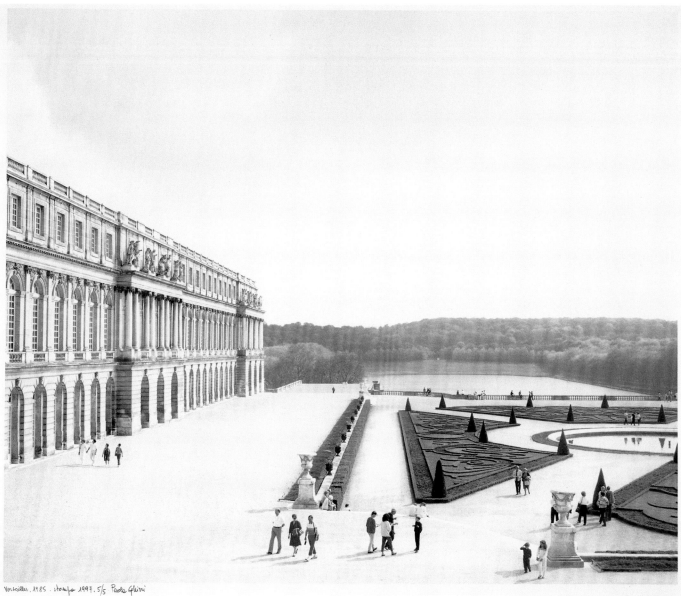

Versailles, 1985, stampa 1997, 5/5 Paola Ghirri

79

Luigi Ghirri (Italy, 1943–1992)

Versailles: The Upper Terrace 1985

Chromogenic color print; posthumously printed in 1997
 by Paola Ghirri, 36 × 43.5 cm

Collection Centre Canadien d'Architecture/Canadian
 Centre for Architecture, Montréal (Gift of the artist in
 honor of Phyllis Lambert's 70th birthday, PH1997:0046)

In 1985 the Italian photographer Ghirri was commissioned
by the French Ministry of Culture to document Versailles.
Informed by an appreciation of Le Nôtre's optical and per-
spectival illusions, Ghirri chose his vantage points accord-

ingly. From the Upper Terrace next to the palace, splendid
views spread in three directions. In this image, Ghirri
looked south toward the Orangery below, offering only a
glimpse of the famous parade of citrus in their white con-
tainers before passing to the distant lake and woods that
frame the garden's outer confines. His photograph empha-
sizes Louis XIV's desire for control—the carefully culti-
vated parterre (through which tourists pass ghostlike in the
pale haze of color) with its swirl of floral designs, the rhyth-
mic sequences of statues and urns, and the clipped ever-
greens.

Stowe

Stowe, in Buckinghamshire, is one of the earliest examples of the eighteenth-century English picturesque garden. Developed over the course of the century, it is a hybrid, the product of several different designers commissioned by a succession of proprietors. Although work began in the late seventeenth century, a coherent plan did not emerge until about 1715. The map of 1739 reflects Stowe's transitional character.[1] A long, straight avenue descends from the house, bisects the length of the garden, and ends in an octagonal basin, on the model of the French formal garden. However, the two halves created by this avenue are markedly different: the west side retains the earlier formal style, with vistas that focus on sculpture or architecture, while the east shows a more naturalistic landscape with meandering paths and bodies of water whose contours appear to follow the topography.

The period of Stowe's development most interesting to art historians dates from 1713 to 1750, during the ownership of Sir Richard Temple, Lord Cobham. His anti-Stuart, anti-Catholic, and anti-Whig nationalism is relevant to the garden's history for its influence on the siting and the symbolism of several of the garden's monuments. Stowe's design attests not only to the owner's personal ideology but also to the early-eighteenth-century taste for gardens of literary allusion. The first designers, the architect John Vanbrugh and the Royal Gardener Charles Bridgeman, began work in 1713. Bridgeman's design included severely trimmed hedges, parterres, a canal, and regularly planted trees along straight vistas. Stowe's "ha-ha," or ditch, which serves in place of a fence so that the garden appears to merge with the landscape beyond, was begun during Bridgeman's tenure.

Shortly after Vanbrugh died in 1726, the architect and garden designer William Kent was hired in the capacity of architect; in 1734, the gardens were added to his responsibilities. Until Bridgeman's death four years later, he and Kent collaborated. Kent was influenced by the poet Alexander Pope's ideas on gardening as an art and by Pope's garden at Twickenham. Stowe's glades, vales, vistas, waterways, grottoes, and follies created under Kent's stewardship embody complex literary and political references. Quotations of famous verses were inscribed on the follies and served as guides to the garden's symbolism. The overriding theme was the return to nature; however, Kent and Pope envisioned nature in literary terms.

The Elysian Fields, which occupies the more naturalistic eastern half of the garden's central axis, is both closely associated with Kent and highly literary in character. The stream that flows through this section, labeled the River Styx, pours forth from the mouth of a grotto. The visitor entered this underground chamber that alluded to the Muses and contemplated their contribution to the origins of poetry and the arts. The round Roman Temple of Ancient Virtue, a copy of the Temple of Vesta at Tivoli, housed four statues representing the greatest philosopher, poet, legal thinker, and military genius of antiquity. The Temple of Ancient Virtue looks downhill at the Temple of the British Worthies, making Britain the symbolic heir of the learned and heroic traditions of the ancient world. This semicircular monument contains sixteen niches

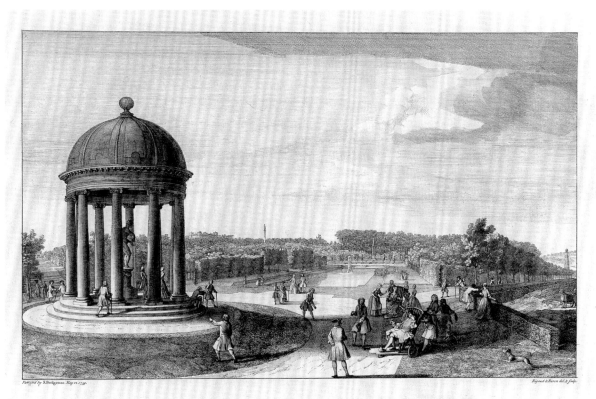

View of the Queen's Theatre *from the* Rotunda. *Veüe du* Theatre *de la* Reine *prise a coté de la* Rotonde.

for busts of accomplished British philosophers, writers, statesmen, scientists, and explorers such as John Locke, William Shakespeare, Pope, King Alfred, Isaac Newton, and Francis Drake. Lord Cobham's political and ideological views come through strongly in his choice of British honorees. The Temple of Modern Virtue, which has not survived, was built as a ruin to indicate how Cobham felt about the present condition of political and intellectual life in Britain.

By the late 1740s the taste for emblematic gardens was fading. Stowe, correspondingly, was given a more natural look with meandering instead of straight, plant-lined walks, and its pools were remodeled with uneven borders to resemble natural lakes. In 1744 "Capability" Brown, who would become a notable figure in the development of the picturesque garden, was ap-

pointed Stowe's chief gardener, having been promoted from the post of kitchen gardener. Although no specific evidence exists to document the extent of Brown's work, it is believed that he took over the naturalizing efforts just prior to Kent's death in 1748. Brown oversaw the landscaping of the Grecian Valley (begun in 1746), the last area to be developed.

Lord Cobham left no heir at his death in 1749. In 1752 the estate passed to his nephew Richard Grenville, Lord Temple. A 1769 plan of Stowe shows that the garden we see today is for the most part due to the intervention of Lord Temple.[2] The original formal style was completely altered, its terracing, beds, and pools replaced by expanses of lawn and clumps of shrubbery to the point that the entire garden took on the picturesque character of the Grecian Valley. Brown

left Stowe in 1751, and Lord Temple directed the rest of the landscape design himself, with the help of his gardener from his other estate at Wotton. Any remaining straight paths were broken up with shrubbery or trees; gravel walks were covered with turf; and trees were felled to open up a glade. Some of the monuments were altered to accommodate the mature state of the plants and trees. In 1770 Lord Temple welcomed a royal visitor, Princess Amelia, sister of George III. The Doric Arch, built for her visit, marked a new entrance to the garden and framed a breathtaking view.

Lord Temple's nephew, the future marquess of Buckingham, inherited Stowe in 1779 and added only a few touches. During his ownership and after his death in 1813, royal visits continued: George IV as Prince of Wales (1805 and 1808), Alexander I of Russia (1814), and Queen Victoria (1846). The third duke of Buckingham and Chandos, who died in 1889, was the last owner in the direct family line. The property subsequently passed to cousins. Stowe was sold in 1921, leaving family hands forever. During this sale, some urns, statuary, and architectural embellishments integral to the eighteenth-century buildings were also sold. In 1923 the house became a boarding school. The National Trust took over most areas of the gardens in 1967, but the house remains the property of Stowe School. Restoration of the gardens is ongoing.

During the eighteenth century, Stowe was the most visited and commented on of all English gardens. It inspired poetry, essays, and guidebooks by a host of different authors. The first guidebook, published in 1732, was titled simply *Stowe: The Garden*. A poem of 1732, "Stowe, the Gardens of the Right Honourable Richard Lord Viscount Cobham," attributed to Gilbert West and dedicated to Pope, is composed of mock-heroic couplets that imitate the poet's style; its text functions as an idiosyncratic, literary guide to the garden, with allusions to the libertine activities that took place in recessed areas of the groves. In 1739, after Bridgeman's death, his widow, Sarah, published *A General Plan of the Woods, Park and Gardens of Stowe . . . with Several Perspective Views in the Gardens*, with views by Jacques Rigaud. A guidebook of 1744 by the Buckingham bookseller Seeley went through several editions. In 1748 William Gilpin, who found the gardens too ornamental for his taste, published anonymously his *Dialogue on the Gardens . . . at Stowe*. Gilpin's text marks the change in taste from the emblematic to the expressive garden. George Bickham's *The beauties of Stow* appeared in 1750. Today one can also take a virtual tour of Stowe the garden at one of the several websites devoted to it.[3]

Perhaps Stowe's greatest admirer remained Pope, who paid tribute in his *Epistle to Lord Burlington* of 1731:

> Spontaneous beauties all around advance,
> Start ev'n from Difficulty, strike from Chance;
> Nature shall join you, Time shall make it grow,
> A Work to wonder at—perhaps a STOW.[4]

MARY SALZMAN

NOTES

1. Books consulted include Christopher Hussey, *English Gardens and Landscapes, 1700–1750* (London: Country Life Limited, 1967); and John Dixon Hunt, *Gardens and the Picturesque* (Cambridge, Mass.: MIT Press, 1992). See Hussey, pl. 118, for the earliest published plan.

2. Hussey, *English Gardens*, pl. 132.

3. See Gilbert West, *Stowe, the Gardens of the Right Honorable Richard Lord Viscount Cobham. Addressed to Mr. Pope* (London: L. Gilliver, 1732); *A general plan of the woods, park and gardens, of Stowe. . . .* (London?: S. Bridgeman, 1739); and George Bickham, *The beauties of Stow. . . .* (London: E. Owen, 1750). Seeley's and Gilpin's texts are mentioned in Hussey, *English Gardens*, 104, 112–13. John Tatter's website on the gardens at Stowe is particularly informative: http://panther.bsc.edu/~jtatter/stowe.html.

4. Alexander Pope, "Epistle to Lord Burlington," in *Epistles to Several Persons (Moral Essays)*, ed. F. W. Bateson (London: Methuen & Co.; New Haven: Yale University Press, 1951), verses 67–70.

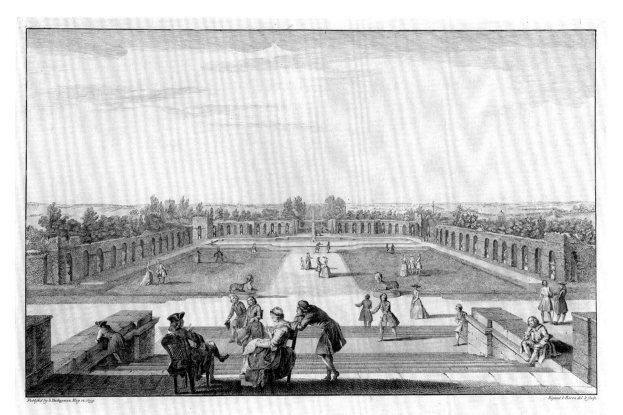

View of the Perterre *from the* Portico *of the* House.

Veüe du Partere *prise sur le* Perron du Chateau.

80b

80

Jacques Rigaud (France, 1681–1754)

Bernard Baron (Great Britain, b. France,
 1696–1762 or 1764)

A. Plate 8: *View of the Queen's Theatre from*
 the Rotunda (see p. 167)

B. Plate 16: *View of the Parterre from*
 the Portico of the House

Etchings and engravings, each 39.7 × 58.6 cm (sheet)

From *A General Plan of the … Gardens of Stowe …* (1739)

Collection Centre Canadien d'Architecture/Canadian Centre
 for Architecture, Montréal (DR1982:0096:008, 016)

In 1733 Bridgeman commissioned the French draftsman and engraver Rigaud to create views of the gardens. Rigaud was already well known for his 1730 illustrations of French royal houses and the gardens, *Les Maisons royales de France*. After completing the drawings at Stowe, Rigaud returned to France before finishing all the prints, which were then completed by Baron. The series of fifteen engravings and a map was finally published in 1739 by Bridgeman's widow, Sarah. Rigaud's views capture the balance between nature and architecture that Stowe's first designer sought to achieve. The Rotunda was designed by Vanbrugh, best known as the architect of Blenheim Palace. The parterre adjoining the portico of the main house is bordered by a dense hedge pruned into an arcade with niches for large urns. Rigaud's figures, principally members of polite society, appear interested in the beauties of Stowe, both its landscaping and its architectural follies, and in the self-conscious activity of displaying themselves to their equally cultured peers. Conveying the sense of garden as theatrical setting, the artist has prominently placed the owner and his wife in the foreground of several views as the principal actors.

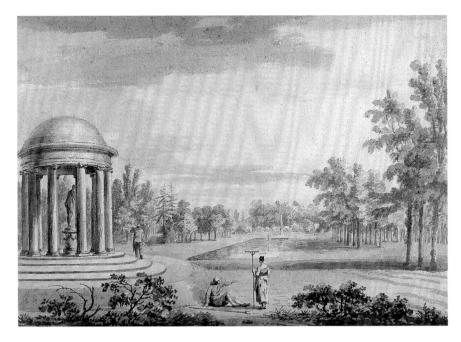

81

Jean-Baptiste-Claude Chatelain (Great Britain,
 c. 1710–1758/71)

A. *Stowe: The Rotunda and the Queen's Theater* 1752

Brown, orange, and gray washes over pencil, 21.3 × 31.4 cm
Yale Center for British Art (Paul Mellon Collection,
 B1975.4.1058)

B. *Stowe: The Gothic Building* 1752

Brown, orange, and gray washes over pencil, 23.2 × 32.4 cm
The Huntington Library, Art Collections, and Botanical
 Gardens, San Marino, California (74.16.E)

Of French Huguenot descent, Chatelain was sought after as
a drawing instructor. In 1752 he drew sixteen views of the
gardens at Stowe, which were published as a set of engrav-
ings by George Bickham the Younger the following year. The
strength of Chatelain's drawings lies in his ability to capture
the relation between the architectural monuments and the
rhythms of the landscape. He then adds small, generic fig-
ures to humanize the scene. *The Rotunda and the Queen's The-
ater* is notable for the addition of gardeners, rather than the
gentlefolk who typically made up the population of garden
visitors. The Gothic Building (1740–44) was designed by
James Gibbs and over-
looked the meadow known
as the Queen's Valley.
By the mid–eighteenth
century, the Gothic began
to be admired as a native
British style, as opposed
to classicism, an import
from Rome.

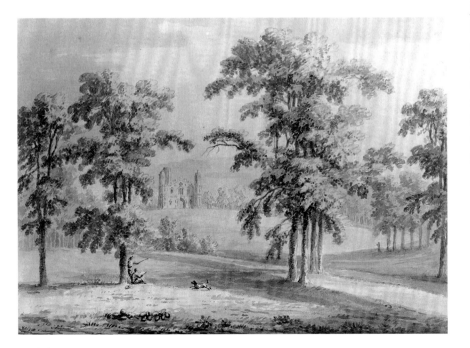

82

Thomas Rowlandson (Great Britain, 1756/57–1827)

A. *A Nobleman Improving His Estate* c. 1802

Pen and watercolor over pencil, 19.7 × 28.3 cm

B. *Stowe: Temple of the British Worthies*

Pen and watercolor over pencil, 27.6 × 43.2 cm

C. *Statuary at Stowe* (?) c. 1809

Pen and watercolor over pencil, 27.6 × 42.5 cm

The Huntington Library, Art Collections, and Botanical
 Gardens, San Marino, California (59.55.1117, 94.18,
 59.55.1129)

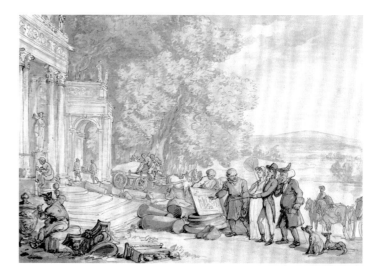

82a

One of the most prolific English draftsmen of the late eighteenth and early nineteenth centuries, Rowlandson is best known for his humorous observations of contemporary society. Though not specifically an image of Stowe, *A Nobleman Improving His Estate* illustrates the stylistic features then favored at country estates and hints at the legions of workers and artisans involved in the massive building campaigns. The ornate house with its grand portico opens onto the garden vista, cleared and groomed to look "natural." The owner, who often dictated aspects of the design, reviews a plan with his architect.

It is not known whether Rowlandson visited Stowe, whose topographical and architectural features were readily available in illustrated guidebooks. Although the Temple of the British Worthies was one of Stowe's best-known and surely the most political of its monuments, Rowlandson only lightly sketches it in the background. By fashioning it as part of a picturesque backdrop for elite leisure activities, he blunts the folly's political edge.

Rowlandson also depicts one of the chief occupations of visitors—observing and discussing the statuary. Because classical statuary showed the undraped human form, it provided a socially acceptable forum for ogling naked bodies. At the lower left, a group admires a copy of the Dancing Faun. A group at the right reacts to the endowments of the herm: the young women are appreciative, but their older escorts are disapproving. A pair of lovers on the path in the background reinforces the mildly erotic titillation of the scene.

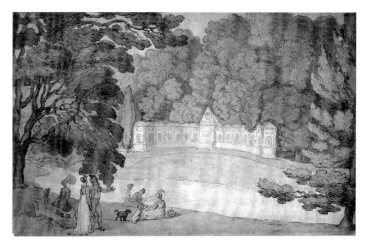

82b

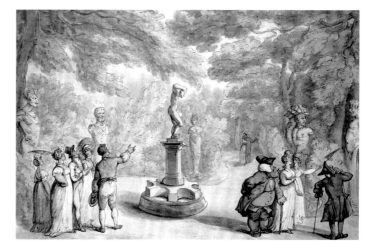

82c

Windsor Great Park

As early as the Doomesday Survey of 1086, the great wooded area in East Berkshire, Windsor Forest, was identified as a property of the crown. An oak planted some fifty years later still stands as an ancient reminder; Jane Roberts illustrates it in her comprehensive 1997 monograph on Windsor Great Park.[1] At one time, the grounds encompassed close to four thousand acres but were later reduced to less than half that size. For centuries it was used primarily as a deer park for hunting. Only after 1750 did its development as a royal park accelerate under the duke of Cumberland, who served as Ranger, or Keeper. After his death, the title reverted to the crown, and for the next fifty years George III and George IV actively managed the property, each monarch introducing fundamentally differ-

ent changes. Since gardening was ill suited to the park's poor soil and bad drainage, hunting and fishing constituted its major attractions. Nevertheless, Windsor Great Park's country pleasures held considerable attraction for the kings and queens of England.

Its main approach, the Long Walk (about two miles), dates from early in the seventeenth century. A hundred years later, it was widened to accommodate carriages, graveled, and lined with two rows of elm trees. Paintings and watercolors recorded its appearance, even as its lack of a central focus or a gatehouse was debated. Among the views taken are several by the watercolorist Paul Sandby, whose brother Thomas was employed at the Great Park from the 1750s to the end of the century. Thomas, whose background included

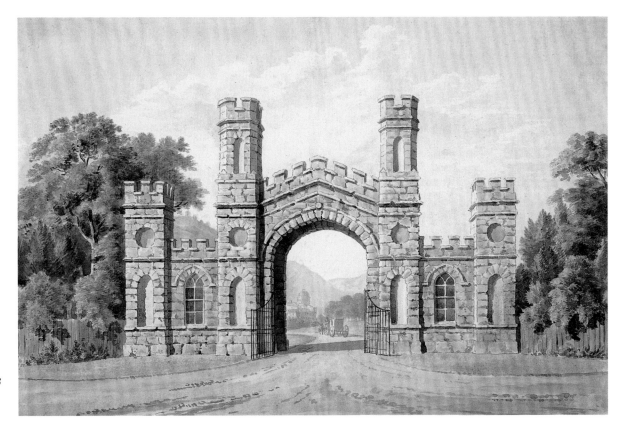

mathematics and mapping, submitted many plans, including one to embellish the Long Walk with a Gothic gatehouse, which was not carried out.

The park's major attraction was the lake called Virginia Water. Developed from a series of ponds and lakes, it grew to cover roughly 150 acres, making it the largest artificial lake in England. Early in the eighteenth century, Charles Bridgeman was appointed in charge of the royal gardens, but did little at Windsor. From about 1750 to 1800 Thomas Sandby's continuing role as Deputy Ranger provided continuity in the landscaping and architectural designs.[2] Between 1788 and 1802 a new nursery at Virginia Water was developed by the Surveyor General John Robinson. In four years, several million acorns were planted, as well as tens of thousands of saplings—mainly Scots fir, but also sycamores, mountain ashes, and others. For several weeks, the king followed the planting closely, inspecting thousands of holes.

George III, who received lessons from the architect and garden designer William Chambers, made drawings of small temples but was less motivated to beautify the land than to organize it more productively for agriculture. After the deer were removed and the land was surveyed and reduced to a more manageable 1,800 acres, sheep were introduced and farms established.

Whereas George III supported research on sheep, George IV used Windsor Great Park for pleasure. He requested designs for a hermitage, fishing temple, boathouse, and new bridges. In 1827 the new additions attracted the attention of J. M. W. Turner and William Daniell, both of whom made drawings at Virginia Water.[3] Fishing and boating were the main diversions of the royal family. The itinerary for their guests often led directly from the Royal Lodge to the Fishing Temple.

In 1830 William IV celebrated his ascendancy by sponsoring a dinner in the Long Walk for the "laboring class of people." Queen Victoria, who had visited as a child, came often in the early 1840s, before the acquisition of Balmoral. Prince Albert oversaw Windsor's operations for some twenty years, until his death in 1861. Concurrent with the decline of royal visits, areas of the park and lake were opened to the public.

By the 1850s a commission found that of the park's 1,652 trees (most over 150 years old), only 712 were sound. The Long Walk was replanted in 1879 and again in 1944, after elm disease destroyed many of the remaining trees planted by Charles II. Horse chestnuts and plane trees were chosen with the idea that after thirty years one or the other would be eliminated, but both are still in place. Today Prince Philip, duke of Edinburgh, oversees the property.

BETSY G. FRYBERGER

NOTES

1. Jane Roberts, *Royal Landscape: The Gardens and Parks of Windsor* (New Haven and London: Yale University Press, 1997).

2. Roberts illustrates many Sandby studies.

3. See ibid., 415–17 for drawings by Turner of the boating houses and fishing temple (Tate Gallery, London) and Daniell's print of 1827.

83

Thomas Sandby (Great Britain, 1721/23–1798)

*Windsor Great Park: Design for a Gothic
 Gatehouse for the Long Walk* c. 1759

Pen and watercolor, 31.6 × 47.9 cm

Collection Centre Canadien d'Architecture/Canadian
 Centre for Architecture, Montréal (DR1981:0025)

About 1750 Thomas Sandby, whose background included military mapping, began working at Windsor Great Park as topographer to the duke of Cumberland and remained to serve George III, George IV, and Queen Victoria. During his fifty years at Windsor Great Park, he contributed designs for many projects, beginning in 1754 with a portfolio of etchings, *Eight Views of Windsor Great Park.*

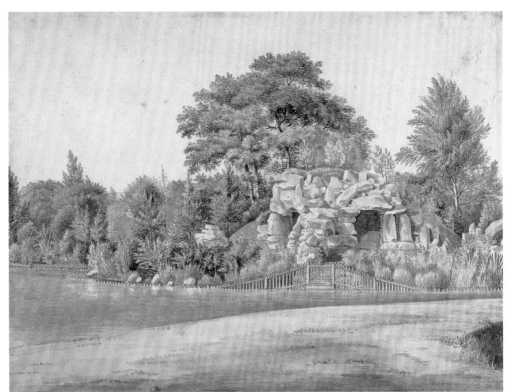

84a

84b

84

Thomas Sandby (Great Britain, 1721/23–1798)

A. *Windsor Great Park: Design for a Cascade and Grotto at Virginia Water* c. 1754

Pen and watercolor over graphite, 20.6 × 27.5 cm

Yale Center for British Art (Paul Mellon Collection, B1975.4.1390)

B. *Windsor Great Park: Design for Rockwork at Virginia Water* c. 1780

Pen and watercolor over graphite, 23.6 × 16.3 cm

Fine Arts Museums of San Francisco, Achenbach Foundation for Graphic Arts (Gift of Anthony Godwin Hail, 1964.137.4)

By the 1750s cascades were intended to look naturalistic, with roughly cut rocks interrupting the flow of water. The design for the cascade grew to accommodate a grotto. The care that went into the design is clear from the many sketches that exist. The Fine Arts Museums has a group of ten studies, but as Jane Roberts notes, not all such sketches were directly from the hand of Sandby.[1]

NOTE

1. Jane Roberts, *Royal Landscape: The Gardens and Parks of Windsor* (New Haven and London: Yale University Press, 1997), 482 n. 623.

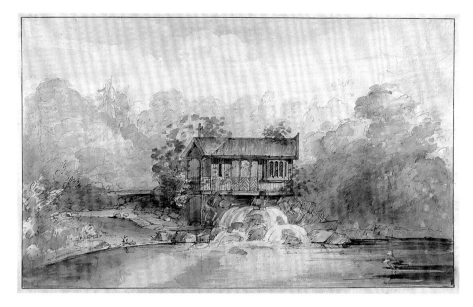

85a

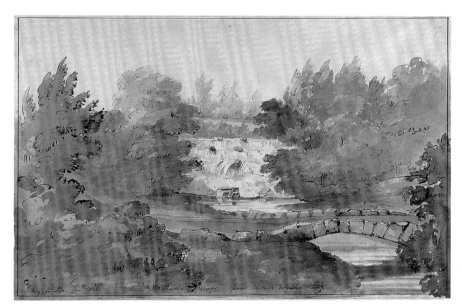

85b

85

Sir Jeffry Wyatville (Great Britain, 1766–1840)

A. *Windsor Great Park: Design for a
 Hermitage at Virginia Water* c. 1827

B. *Windsor Great Park: Design for a Rustic
 Bridge and Cascade at Virginia Water* 1828

Pen and wash in brown ink over graphite,
 18.4 × 30.2 cm; 20 × 31.8 cm

Yale Center for British Art (Paul Mellon Collection,
 B1975.2.135, .136)

From 1750 on, the growing series of ponds and small lakes at Virginia Water encouraged aquatic activities, which were interrupted by the storm of 1768. When the pondhead was rebuilt, the fleet of ships included fishing punts, rowboats, a Venetian gondola, and two frigates outfitted as men-of-war.

Shortly after 1825, when George IV took a strong interest in developing Virginia Water, Wyatville submitted designs for a new boathouse and hermitage, as well as for bridges and other improvements. Positioned above the falls between Johnson's Pond and Virginia Water, the hermitage was cited in local guidebooks until the 1860s, after which it presumably disintegrated.

The Désert de Retz

As its name suggests, the Désert, or wilderness, was an idiosyncratic garden. Created from 1774 to 1789, only a few years before the French Revolution, it is located in the village of Retz, some twelve miles southwest of Paris on the edge of the forest of Marly near Versailles. It exemplifies the style that evolved in France, which rejected the rationality and formality of Louis XIV and embraced new attitudes about nature and fantasy.

The Désert de Retz was built for and evidently designed by the wealthy patron François-Nicolas-Henri-Racine de Monville (d. 1797). Diana Ketcham's monograph traces its history and credits Monville with the plan.[1] However, since Monville's Parisian residence was designed by the celebrated neoclassical architect Etienne-Louis Boullée, some have attributed Retz to Boullée, despite the lack of supporting documents. In the 1940s, the Swedish art historian Osvald Sirén suggested the painter Hubert Robert, but again no documents support this attribution.[2] The Désert was the most extensively illustrated of some twenty gardens in the new Anglo-Chinese style issued by Georges-Louis Le Rouge in Paris in the 1780s.[3] The Le Rouge publication credits Monville as designer; Ketcham reaffirms this.

Acccording to Ketcham, in naming the garden "le désert," Monville implied that the wilderness spread over a great area and included the adjacent royal forest of Marly. Situated on one hundred gently rolling acres were a working farm with an orangery and kitchen garden. Elsewhere follies, or *fabriques*, were sited in the landscape. The most unusual and bizarre was the ruin of a monumental column, which served as Monville's residence. Other follies included a pyramid, a temple,

a tomb, a Turkish tent, a rustic bridge, and a grotto, offering a historical world tour, a popular English practice transplanted to France. In contrast to the oversize Broken Column, some follies were miniature structures. A small river and lake played only a minor role; the plants were diverse in origin, from North America, Africa, and Asia, as well as Europe.

The garden attracted prestigious foreign visitors. King Gustavus III of Sweden toured in 1784, and Monville sent drawings to Sweden; two years later, Thomas Jefferson came with the English painter Maria Cosway. (Both men later adapted aspects of the Broken Column for buildings of their own design.) Marie-Antoinette and the artists Hubert Robert and Louis Carrogis called Carmontelle visited; members of the public were issued tickets, provided that they were properly dressed.

The only Anglo-Chinese garden to survive the Revolution largely intact, the Désert's exotic plants were sold and the buildings taken over by the government in 1792. (Monville sold it to an Englishman, but the French government repossessed it.) From the mid–nineteenth century until 1936, the property was owned by the economist Frédéric Passy (who won the Nobel Prize in 1900) and his family, who lived in the Broken Column, adding windows and altering the roof.

Unlike many seventeenth-century formal gardens that were restored at the end of the nineteenth century by newly prosperous businessmen, the late-eighteenth-century picturesque gardens remained neglected. When the Désert was rediscovered by the surrealists in the late 1930s, Colette declared its "luxuriance is that of a dream, of a fantastic tale, of an

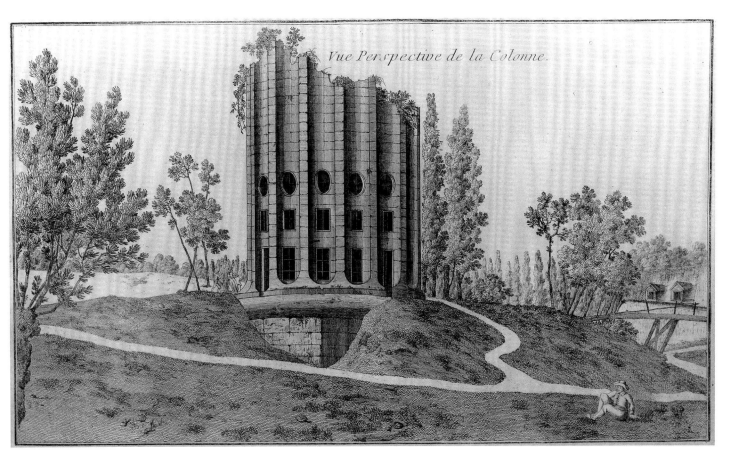

Vue Perspective de la Colonne.

86a

imaginary island" and worried that "having known the Désert under a stormy June sky, I tremble to see it changed, swept of its debris and blinking in the light of its new cleanliness."[4] Other visitors wrote of seeing goats climbing the stairs within the Broken Column.[5] Sirén thought that the setting possessed "to a remarkable degree the atmosphere of the Castle of the Sleeping Beauty."[6]

In 1960 it was rediscovered by an architectural student, Olivier Choppin de Janvry, who wrote his dissertation about it and became active in shaping legislation that forced repair of historic structures in private hands. André Malraux, Minister of Culture, championed the cause; in 1966 a law was signed, but not implemented. Only in the 1980s were renovation and conservation undertaken. The exterior of the Broken Column has been repaired, and the meadow, for-

merly a wilderness of volunteer trees, has been cleared and replanted. At present, the garden is open only infrequently.

BETSY G. FRYBERGER

NOTES

1. Books consulted include Diana Ketcham, *Le Désert de Retz* (Cambridge, Mass., and London: MIT Press, 1994); and Dora Wiebenson, *The Picturesque Garden in France* (Princeton: Princeton University Press, 1978).

2. Osvald Sirén, *China and Gardens of Europe of the Eighteenth Century* (New York: Ronald Press Co., 1950).

3. Georges-Louis Le Rouge, *Détail des nouveaux jardins à la mode* [also known as *Les Jardins anglo-chinois*]. . . . (Paris: Le Rouge, 1776–87?).

4. Quoted in Ketcham, *Désert de Retz*, 3, 27.

5. Quoted in ibid., 26.

6. Quoted in ibid., 2.

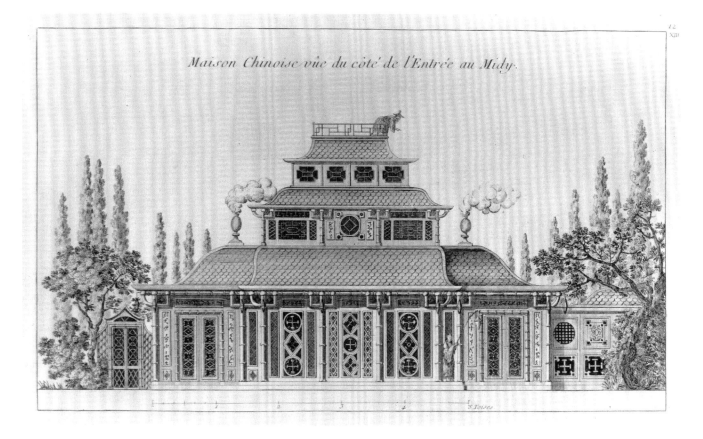

Maison Chinoise vûe du côté de l'Entrée au Midy.

86b

86

Georges-Louis Le Rouge (publisher)

(France, late 18th century)

A. *Désert de Retz: Perspective View of the Broken Column* (see p. 177)

B. *Désert de Retz: The Chinese House*

Etchings and engravings, 23.5 × 38.1 cm; 22.8 × 38.1 cm

From *Les Jardins anglo-chinois*, cahier 13 (Paris, 1785)

G. B. Carson

Le Rouge's publication, *Anglo-Chinese Gardens*, documented in twenty-one volumes the late-eighteenth-century French taste for gardens in the new style. The Désert de Retz was the single most illustrated garden, published in a separate installment with twenty-six views. The Broken Column rose some fifty-five feet high and spread fifty feet in diameter. While its oversize scale and cracked exterior suggest a violent destruction by a race of giants, its interior was furnished in the Louis XVI style with paintings and statuary. The feature most often illustrated was the Chinese house, its gate, and garden. Monville probably had seen William Chambers's book about Kew Gardens (1763), which included designs for a pagoda and house of Confucius.[1] In France, similar exotic structures had already been constructed at Lunéville. In the 1940s it was still possible to see the Chinese house, which collapsed and fell into the lake in the 1970s. Other exotic buildings, such as the Turkish tent, made of metal and fabric, disintegrated long ago, but replicas have been fabricated.

NOTE

1. William Chambers, *Plans . . . of Gardens and Buildings at Kew in Surrey. . . .* (London, 1763).

87

Michael Kenna (U.S.A., b. Great Britain, 1953)
Le Désert de Retz: Study 9 1988
Gelatin-silver print, 19 × 19 cm
Michael Kenna and the Stephen Wirtz Gallery, San Francisco

Kenna photographed the Désert during the period of its sal-
vation and renovation. The exterior of the Broken Column
is shown resurfaced, shorn of its nineteenth-century addi-
tions, and returned to its original aspect. The interior has
remained unfurnished.

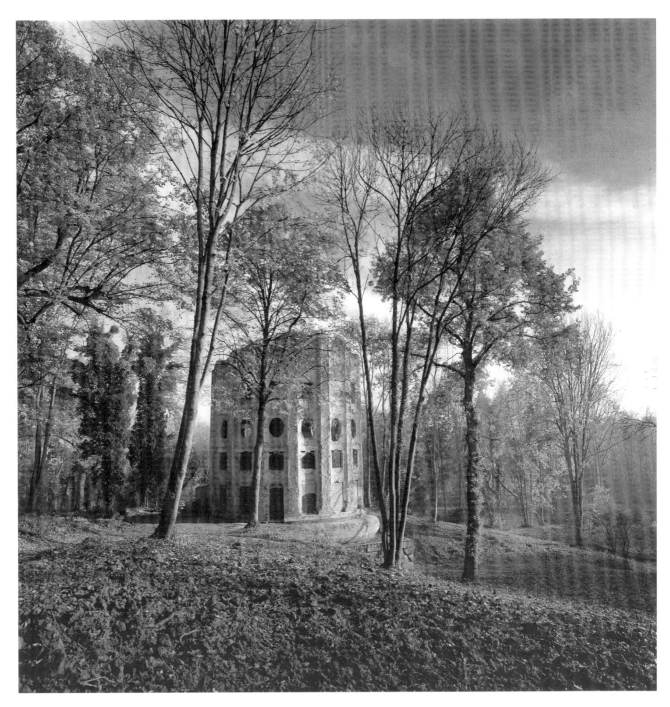

Ermenonville and Méréville

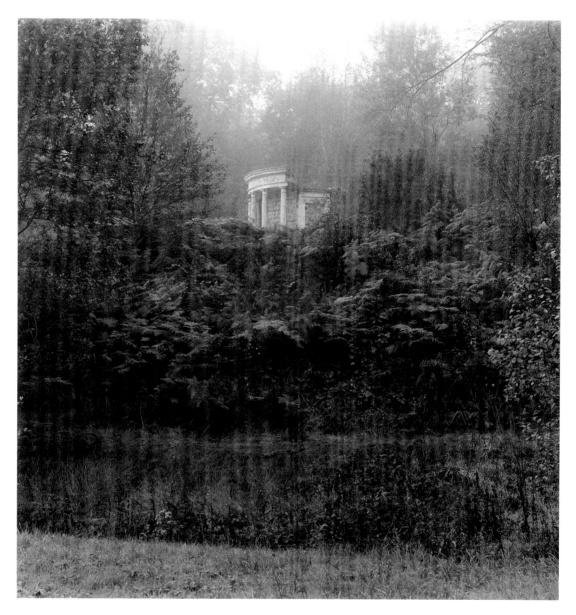

90a

Created in the same Anglo-Chinese style as the Désert de Retz, Ermenonville and Méréville featured less eccentric follies but arose from a similar desire to realize a personal philosophical statement. Ermenonville, the earlier garden, was begun about 1765 and is located to the northeast of Paris. Its enlightened patron, René-Louis de Girardin, conceived of it in classical and vernacular terms, using such natural elements of the landscape as cascades and grottoes with a fisherman's hut and a temple. Méréville, created some twenty years later, lies to the city's south, near Etampes. Its wealthy patron, Jean-Joseph Laborde, aspired to a lavish grandeur and monumentality, set in a dramatically enriched landscape. Hubert Robert's contributions to both gardens are discussed by Diana Ketcham in her essay in this catalogue.

In 1766, within a year of his return to France, after spending more than a decade in Italy, Robert was at Ermenonville helping the marquis de Girardin, recently returned from England, to design a park in the new style. Girardin in his landscape treatise, *De la composition des paysages* (1777), drew on his familiarity with the paintings of Claude Lorrain and Salvator Rosa, as well as those of Robert.[1]

The garden's initial fame was augmented by its association with Jean-Jacques Rousseau, who after residing at Ermenonville for extended periods died there in 1778. (Several monuments refer to the Swiss setting of Rousseau's *La Nouvelle Héloise* [1761].) Before the Revolution, Ermenonville was much visited. Among those who journeyed there were Thomas Jefferson with Maria Cosway. Today only a few pilgrims seek out Rousseau's tomb. The grounds, however, remain largely untouched, the monuments half hidden, and a gypsy encampment lies on its boundaries—continuing some of the original spirit of independence and inquiry.

The construction of Méréville began in 1784 under the architect François-Joseph Bélanger. Robert's correspondence from 1786 until 1792 with Laborde testifies to his long involvement, as do his many paintings of Méréville as well as other subjects that decorated the château. Construction involved reconfiguring the large, swampy basin into lakes with islands, tunneling into hillsides to link networks of grottoes, and placing stately monuments to grace its vistas. In 1789 the Revolution intervened; not until 1804, when Napoleon was crowned, did pre-Revolution gardens regain any interest. Laborde's son Alexandre wrote *Description des nouveaux jardins de France*... (1808), which documented and described many of these gardens.[2]

As Ketcham explains in her catalogue essay, most of Méréville's monuments were removed at the end of the nineteenth century to a nearby location to ensure their preservation. Today they can still be seen at the Parc de Jeurre. Méréville, however, remains unrestored and devoid of most monuments; its very existence is tenuous. A group of friends, Les Amis de Méréville, has formed to try to save it. On the rare occasions when it is open, one can experience its overgrown grounds, venture inside its grottoes, still miraculously ornamented with shellwork, and cross the few surviving bridges to the ghosts of islands that long ago sank back into the watery soil. No expanse of water remains to reflect the dramatic landscape. Only through Robert's paintings can one gain an idea of its former grandeur.

BETSY G. FRYBERGER

NOTES

1. René-Louis de Girardin, *De la composition des paysages, ou des moyens d'embellir la nature autour des habitations, en joignant l'agréable à utile* (Geneva and Paris, 1777).

2. Alexandre Laborde, *Description des nouveaux jardins de la France et de ses anciens châteaux* (Paris: Imprimerie de Delance, 1808–15).

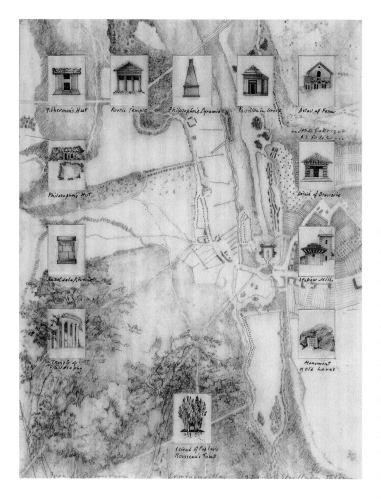

88

Barbara Stauffacher-Solomon (U.S.A.)

Ermenonville 1986

Pencil, pen, and colored chalk with collage, 28 × 21.5 cm
Private collection

Stauffacher-Solomon's delicate, evocative drawing of Ermenonville is based on the Le Rouge map of 1781 to which she has added small, individual collages of monuments and follies, most not shown in the earlier print. It is illustrated in the San Francisco–based landscape designer's book, *Green Architecture and the Agrarian Garden*, where her drawings of gardens from the Renaissance to the 1980s are accompanied by a thoughtful analysis of garden design and history. Stauffacher-Solomon characterizes "the Picturesque Garden" as "introspective and circuitous, melancholy and moral, narrative and romantic." Inscribing her drawing: "French Picturesque/Ermenonville," she annotated it "... the fabrique as follie ..." and further identified each monument/folly, reading clockwise from the bottom: "Island of Poplars/Rousseau's Tomb, Temple of Philosophy, Autel de Rêverie, Philosopher's Hut, Fisherman's Hut, Rustic Temple, Philosopher's Pyramid, Pavilion in Grove, Detail of Farm, Detail of Brasserie, Italian Mill, and Monument of Old Loves." Although most monuments and follies vanished long ago, many were illustrated in Laborde's 1808 publication. Stauffacher-Solomon's selection seems just, acknowledging classical and vernacular structures. Like Girardin, she emphasizes the importance of understanding a park landscape through a sequence of pictures. She sees this trait of late-eighteenth-century English and French gardens as significant for the subsequent design of "parks and parkways, golf courses and gardens, cemeteries and public landscapes."[1]

NOTE

1. Barbara Stauffacher-Solomon, *Green Architecture and the Agrarian Garden* (New York: Rizzoli, 1988), 37, 36 (ill.).

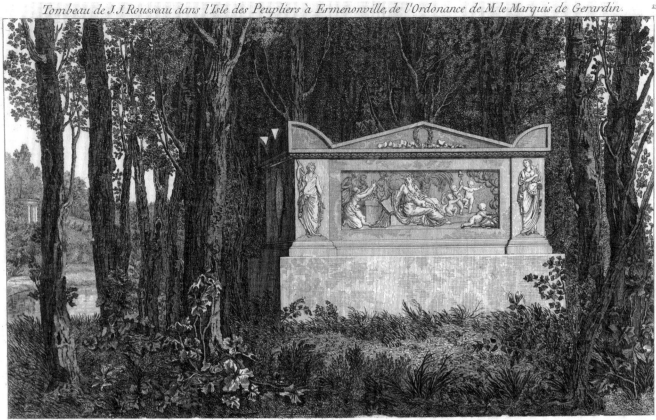

Rousseau est mort le 2 Juillet 1778 :'a Ermenonville

89

Georges-Louis Le Rouge (publisher)
 (France, late 18th century)

*Ermenonville: Tomb of Jean-Jacques Rousseau
 on the Island of the Poplars*

Etching, 23.6 × 38.6 cm
From *Les Jardins anglo-chinois*, cahier 9 (Paris, 1781)
Private collection

It is surprising that Ermenonville did not figure more prominently in Le Rouge's encyclopedic publication of Anglo-Chinese gardens; it was, however, represented by an unusually large and well-drawn illustration of Jean-Jacques Rousseau's tomb—a tribute to the philosopher's importance. The initial burial site's significance (his remains were later removed to Paris) is further emphasized in the two inscriptions: one above the composition, "Tombeau de J. J. Rousseau dans l'Isle des Peupliers à Ermenonville, de l'Ordonance de M. le Marquis de Gerardin," and one below, "Rousseau est mort le 2 Juillet 1778 à Ermenonville" (Tomb of J. J. Rousseau … Rousseau died July 2, 1778, at Ermenonville). The design of the tomb was based on that of the Roman emperor Nero; its adaptation for Ermenonville has been variously attributed to Robert, the sculptor Augustin Pajou, or yet another hand.

90b

90
Marion Brenner (U.S.A., b. 1944)
A. *Ermenonville: The Temple of Philosophy* 1997 (see p. 180)
Gelatin-silver print, 37.7 × 37.7 cm
Private collection
B. *Ermenonville: Stone with Inscription* 1997
Gelatin-silver print, 38 × 38 cm
Marion Brenner

Like many eighteenth-century garden temples, the one at Ermenonville derived from that of the Temple of the Sybil at Tivoli and, like its model, was situated high on a hill. Dedicated to Montaigne, the temple has six sturdy columns identifying the contributions of Newton, Descartes, Voltaire, William Penn, Montesquieu, and Rousseau. While acknowledging the past achievements of these men, the temple anticipates future accomplishments in its deliberately unfinished state; at its base lie columns to be erected for yet unknown philosophers.

Dispersed throughout the grounds at Ermenonville in addition to the conspicuously placed Temple of Philosophy and Tomb of Rousseau were other *fabriques*, huts, and a mill. Among the few that have survived are a rustic wooden bridge and several large rocks into which inscriptions have been carved. The partially visible inscription on the fern-covered rock is a quotation from Petrarch, the fourteenth-century Italian lyric poet. In his many poems about love, nature is often referenced. The first two lines of the poem read: "Di pensier in pensier, di monte in monte / mi guida amor, ch'ogni [segnato calle . . .]" (From thought to thought, from mountain to mountain Love guides me, for I find every trodden path to be contrary to a tranquil life). The inscription's text then skips to line 29 with "disegno co la mente il suo bel viso" (portray her lovely face with my mind). Elsewhere in this poem Petrarch speaks of nature in such phrases as "some solitary slope a river or spring, or between two peaks a shady valley" and "high mountains and harsh woods."[1]

NOTE
1. Claudia Lazzaro has identified the inscription as from Petrarch; see *Petrarch's Lyric Poems*, trans. and ed. Robert M. Durling (Cambridge, Mass., and London: Harvard University Press, 1976), 265, poem 129, lines 1–2, 29, and 264, commentary.

91

Hubert Robert (France, 1733–1808)

The Rustic Bridge, Château de Méréville c. 1785

Oil on canvas, 65.4 × 53.3 cm

The Minneapolis Institute of Arts (The William Hood
 Dunwoody Fund, 33.14)

As discussed by Ketcham in her catalogue essay, Robert was involved at Méréville over a number of years, during which he contributed ideas to its design and depicted the site in both fanciful and more realistic paintings. In some oils he portrayed structures and features in a single vista that could only have been companions in his mind's eye. Further com- plicating firm identification is the fact that today the to- pography is so changed. The rocky hillsides still harbor ex- tensive networks of tunnels and grottoes, which are virtu- ally invisible except for their discreetly placed entrances. The rustic bridge connected the hillside at the left to a man- made outcropping that is long gone. Looking from atop the hills, the artist depicted a narrow vista of the basin, en- livened by small figures in the foreground and towering trees. Robert's warm palette of yellows and greens in this small painting evokes a carefree summer day. In other paint- ings the mood is more grandiose or somber.

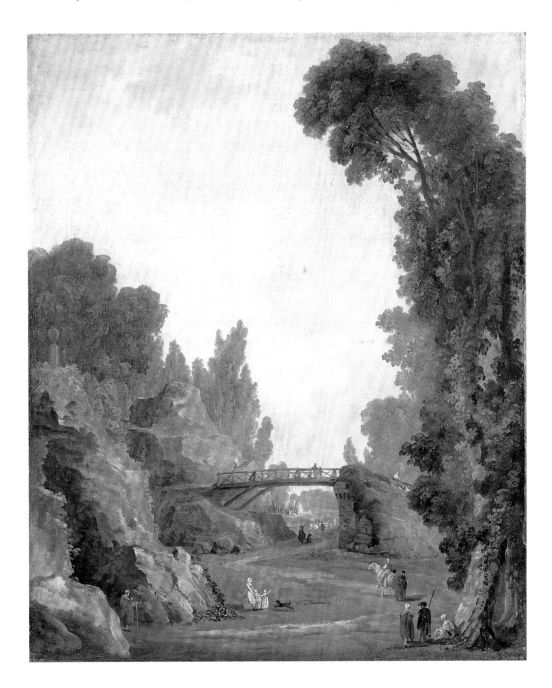

92

Marion Brenner (U.S.A., b. 1944)
*Méréville: Stone Bridge with Château
in the Distance* 1995
Gelatin-silver print, 25.5 × 20 cm
Marion Brenner

The château, seen in the distance, overlooks a large natural basin from its hilly location. The stone bridge, among the more conspicuous remains at Méréville, connected the hillside château with one of the constructed islands, which even early in the nineteenth century were subsiding. Where once bridges linked islands shaped as small hills, they now stand essentially at the water level. Although many volunteer trees have been removed, the landscape is essentially wild and neglected, a testament to the transitory nature of gardens.

London's Parks

With eight thousand acres of green space, London is among the greenest of all cities.[1] The two earliest parks—St. James's and Hyde Park—date back to the early sixteenth century, when Henry VIII set them aside for deer hunting (in 1532 and 1536 respectively). In the seventeenth century, with the Restoration of the Stuarts and return of Charles II from exile in France, the influence of Le Nôtre spread to London. Symmetry and order were brought to the previously informal pleasure grounds of St. James's Park with a long rectangular, ornamental canal. The author of this redesign is not certain; it may have been André Mollet, a young collaborator of Le Nôtre. Another French influence was the lawn game *Paille Maille* (or Pall Mall), similar to croquet. Charles II was fond of playing *Paille Maille* in the park, and, as a result, the rectangular stretch of lawn in front of the palace became known as the Mall, and the street on which it lay was named Pall Mall. Charles was also responsible for opening St. James's Park to the general public.

In the 1820s St. James's was redesigned by John Nash, whose plan for Regent's Park had radically altered the face of the city a decade earlier. Nash created a picturesque park, transforming the canal into a naturalistic lake and scattering clumps of flowering shrubbery and trees throughout the grounds. The lawns were divided by a series of winding paths, as Nash replaced all sense of order and symmetry with a studied informality.

Earlier in his career Nash had worked with Humphry Repton, who believed that landscapes had the potential to become unified, aesthetically harmonious gardens. Influenced by this philosophy, Nash's early plans for Regent's Park, a 550-acre park commissioned by the Prince of Wales, included a number of buildings within a "garden city," surrounded by forty or fifty residential villas. Critics found the space overbuilt, so the design was simplified. As finally constructed, however, Regent's Park still contained a zoo, a colosseum, and a Diorama building. The grounds were allowed to flood and freeze over the winter to allow ice-skating. By 1841 only a small portion of the park was closed to the public—the rest was available for entertainments.

Hyde Park's 615 acres date back to the reign of Henry VIII and contain the oldest stables in London. In the early eighteenth century, Queen Caroline oversaw the construction of the Serpentine Lake, which curves through Hyde Park into Kensington Gardens, where it is known as the Long Water. Hyde Park contains a number of monuments including the Marble Arch, initially designed by Nash to be the chief entrance to Buckingham Palace, later moved to its present location. The Prince Albert Memorial, sponsored by Queen Victoria to celebrate her husband, opened to the public in 1872. Recently restored, it stands as one of the great public sculptures of the Victorian era, combining massive scale with opulence. The design of these major parks has not been substantially modified since Nash's period.

There are several newer parks in London. Thames Barrier Park, the first new riverside park in fifty years, was opened to the public in November 2000. This park, named for its location near the Thames Barrier in a former industrial area of London known as the Docklands, is a twenty-two-acre site whose design reflects the industrial heritage of the area. In addition

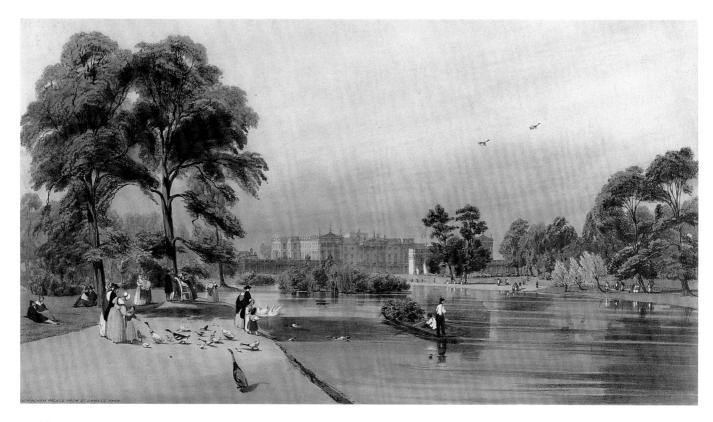

93a

to an impressive water feature, the park includes a heavily planted sunken garden called the Green Dock, which runs through the center of the park, contrasting with flat grassy areas on either side. These plantings were chosen for their resistance to serious ground contamination, a product of the various factories—a gas works, a dye factory, and an armaments facility—that used to occupy the location.

In addition to new parks, many smaller parks are being redesigned to keep pace with the demands of London residents. One such park is Mile End Park in London's East End, which was begun in celebration of the millennium. It features a variety of sections, including a Play Arena, Ecology Park, Artspark, Terrace Garden, Adventure Park, Sports Park, and Children's Park. These sections have been designed in response to suggestions from nearby communities, in striking contrast to the development of royal parks in earlier centuries.

LOUISE SIDDONS

NOTE
1. Books consulted include Susan Lasdun, *The English Park: Royal, Private, and Public* (London: Deutsch, 1991); and Guy R. Williams, *The Royal Parks of London* (London: Constable, 1978).

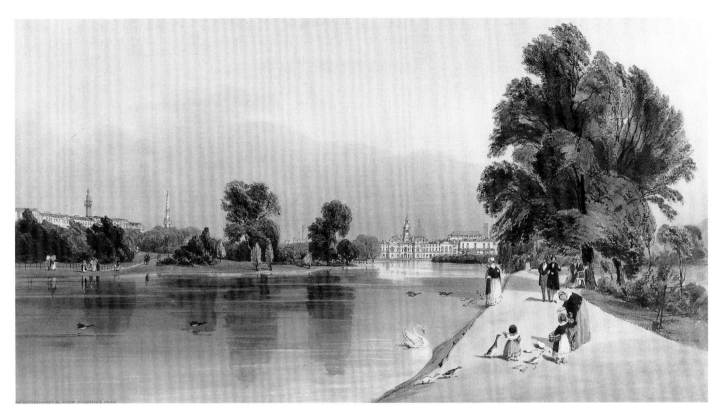

93b

93

Thomas Shotter Boys (Great Britain, 1803–1874)

A. Plate 10: *Buckingham Palace from St. James's Park* (see p. 188)

B. Plate 13: *The Horse Guard from St. James's Park*

Lithographs, colored by hand, 24.5 × 44.7 cm; 24.5 × 45 cm

From *Original Views of London as it is* (London, 1842)

Yale Center for British Art (Paul Mellon Collection, S239A, folio B)

Boys's speciality was watercolors and lithographs of picturesque buildings. He worked with Richard Parkes Bonington in France, recording medieval churches and crowded streets in such older cities as Rouen. His more famous set of color lithographs, *Picturesque Architecture of Paris, Antwerp,* *Ghent* ... (London: Thomas Boys, 1839), concentrates on older architecture, Parisian churches, and streets of Rouen, but no parks. In the London set, however, Boys included two views of St. James's, another of Hyde Park (cat. 112), as well as a view of London taken from the park in Greenwich.

In plate 10, Buckingham Palace is shown as modified by Nash several years earlier. The Marble Arch is in its original location, to the right of the lake. The second view, of the Horse Guard, complements the first, looking the other direction. Today the scene is different because a metal bridge across the lake was added in 1857 and trees obscure the distant view.

Paris's Reconfigured Bois de Boulogne

I will not describe the Bois de Boulogne. I cannot
do it. It is simply a beautiful, cultivated, endless,
wonderful wilderness. It is an enchanting place.
—MARK TWAIN, 1869[1]

During the mid–nineteenth century the Bois de Boulogne was transformed from the vast royal forest and hunting grounds, established in the late fifteenth century by Philip the Fair, to Paris's largest public park.[2] Situated to the west of the city, just beyond a loop of the Seine, the park roughly parallels the river's north-south arc. The Bois was named after the church built there in the fourteenth century by pilgrims en route from Boulogne-sur-Mer.

Despite its status as a royal preserve, the Bois had a reputation for danger. Its forest served as a perfect hiding place for poachers and brigands and as the site for other illicit activities. Poems, essays, and pamphlets—for example, *Duels, Suicides and the Loves of the Bois de Boulogne* (1821)—chronicled the adventures of outlaws, duelists, and lovers who took refuge there.

In 1777 its most famous residence, Bagatelle ("trifle"), was constructed by the count of Artois for his sister-in-law Marie-Antoinette, who bet that it could not be completed in under three months (it was built in two). Bagatelle's gardens were fashioned in the Anglo-Chinese style by the Scottish designer Thomas Blaikie, who had created similar gardens in Germany. This miniature château and its grounds, which included such rare trees as the monkey puzzle, were later incorporated into the park.

In 1789, as a consequence of the French Revolution, the Bois came under jurisdiction of the state. In 1852 it was ceded to the city, which designated it a public park. Because the Revolution had almost denuded the forest, few flocked to the Bois for leisure. Though Napoleon had ordered the park cleaned and reforested, it became a virtual wasteland after his fall in 1815.

The Bois's renewal took place under Napoleon III, who took London's Hyde Park as his model. Parks were part of the emperor's plan to bring a more hygienic way of life to the populace, which had suffered two cholera epidemics. In 1854 his city planner Baron Haussmann hired Adolphe Alphand, landscape engineer and director of the department of bridges and roads, to design and oversee the addition, expansion, and reconfiguration of Paris's parks as part of the modernization project. Alphand created a Grand Cascade for the Bois with rocks from the Forest of Fontainebleau and joined three rivers with an extensive hydraulic system. Thousands of new trees and innumerable flowers and shrubs ornamented the network of close to sixty miles of winding paths laid out by Alphand. The architect Gabriel Davioud designed new gatehouses, kiosks, and restaurants.

Among the most notable of the new areas was the Pré Catalan, a small park named after a legendary troubadour murdered in the vicinity after his return from Spain. It became a popular spot for dining, dancing, and watching performances in its open-air theater. The Jardin d'Acclimatation, a children's park with rides and a zoo, became another favorite destination.

The occupation of Paris in 1870–71 during the

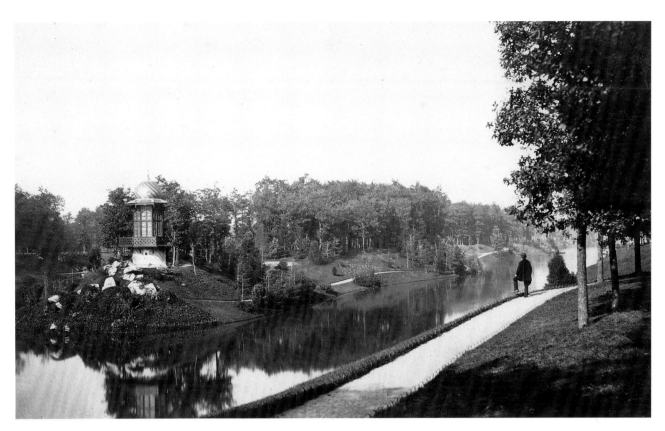

Franco-Prussian War, as well as the social upheaval of the Commune, was disastrous for the Bois's renovations, completed just a decade before—trees were cut down for firewood and for the military, plants neglected, and zoo animals killed for food. Subsequent repairs took over a decade, resulting in a better sports area, which included running trails, lawn tennis and lawn bowling courts, and polo grounds.

Toward the end of the century, the park became a fashionable playground, where Parisians boated, dined and drank, and attended horse races at Longchamps and Auteuil. Artists and writers captured the Bois's ever-changing panorama of stylishly dressed elites. Mark Twain described the luxurious carriages with liveried servants in *Innocents Abroad*. Marcel Proust reminisced about the daily excursions of Odette Swann in *Remembrance of Things Past*. Vincente Minnelli re-created these colorful displays in the opening and closing scenes of the film *Gigi*.

In 1905 the landscape architect and keeper of the Bois, J. C. N. Forestier, planned an extensive rose garden in consultation with the noted rosarian Jules Gravereaux. Today at Bagatelle thousands of roses are exhibited on trelliswork in the French style. The larger Bois, with its woods and lakes, encompasses some two thousand acres.

Today the Bois de Boulogne remains Paris's major park, although the luster of its earlier status as *the* gathering spot for society has faded. After World War I something of its early shady reputation returned, as the nocturnal park again became the site of debauchery and danger. During the day, however, the park remains a destination for public recreation with sports activities of all kinds, the legacy of Napoleon III's vision for a modern urban playground.

SUSANA SOSA

NOTES

1. Samuel Clemens, *Innocents Abroad* (New York: Library of America, 1984), 110.

2. Books consulted include Jean-Michel Derex, *Histoire du Bois de Boulogne* (Paris: Editions L'Harmatton, 1997); Jean-Jacques Lévêque, *Guide des parcs et jardins de Paris* (Paris: Pierre Horay Editeur, 1980); Michel Racine, *Le Guide des Jardins de France* (Paris: Guides Hachette, 1990); Marie de Thézy, *Marville/Paris* ([Paris]: Hazan, 1994); and Adolphe Alphand, *Les Promenades de Paris* (Paris: J. Rothschild, 1867–73).

94a

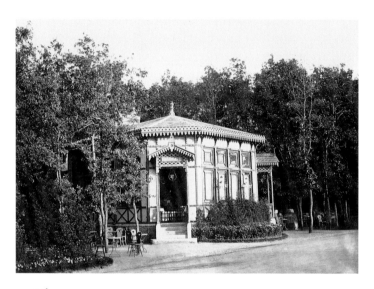

94b

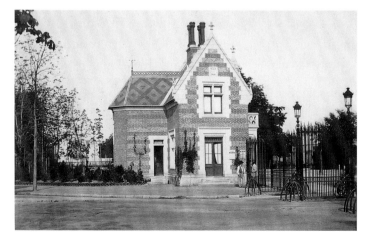

94d

94

Charles Marville (France, 1816–c. 1878)
Views of the Bois de Boulogne
A. Plate 16: *View of Path between Trees*
B. Plate 25: *View of the Café-Brasserie Pré Catalan*
C. Plate 9: *Southern End of the Great Lake,
 with a Man Looking at the Island* (see p. 191)
D. Plate 42: *Gatehouse, Porte Maillot*
Albumen-silver prints, 26.7 × 35.7 cm; 25.4 × 35.6 cm;
 21.2 × 35.2 cm; 22.2 × 35.6 cm
Collection Centre Canadien d'Architecture/Canadian
 Centre for Architecture, Montréal (PH: 1982:0151,
 1981:0510, 0895, 0509)

In 1858 Charles Marville prepared to photograph the Bois de Boulogne and a special studio was set up for him near the Porte de Madrid. Sixty views were selected for the album presented in 1862 at the Universal Exposition in London, where it was awarded a gold medal. Marville's landscapes show his fine sense of composition. In plate 16 several of the old trees are shown along a new winding road (the old Bois had been divided by rectilinear paths) (A). Among other features recorded were the racetrack at Longchamps and restaurants, like the one in plate 25 of the Brasserie Pré Catalan, so popular with artists (B). In plate 9 the tranquil lake scene is enlivened by a man (perhaps Marville?) standing at the water's edge (C). Many photographs document Gabriel Davioud's new gatehouses in scenes often animated by pedestrians, as in plate 42 (D). (The project on the Bois initiated a long collaboration between architect and photographer.)

During the 1860s and 1870s Marville photographed Paris extensively, documenting its vanishing past as well as its emerging grandeur. His *Album du vieux Paris* of 1868 contained more than four hundred images; other albums followed, one for the Exposition Universelle in Brussels in 1876, another in 1878. Earlier in his career, Marville had worked as a draftsman with a group of landscape artists associated with the Forest of Fontainebleau.

New York City's New Central Park

In 1858 Frederick Law Olmsted and Calvert Vaux developed a plan for an urban park in New York City to provide city dwellers with a rural landscape that engendered repose and the contemplation of nature.[1] Their ambitions were high: they wanted a great public place for a large and varied population, an urban park to rival London's Hyde Park and Paris's Luxembourg Gardens. They planned a park with flowing curves, open vistas, and picturesque plantings in the English naturalist tradition promoted by Andrew Jackson Downing, the American architect who believed that love of nature made people healthier members of society.

Central Park's informal walks and meadows were punctuated by formal structures, but to keep the distracting sights and sounds of the city at bay, trees were planted around the perimeter, while transverse streets carried crosstown traffic below the surface of the ground in open cuts and tunnels. Throughout the park, walks, bridle paths, and drives—distinguished in size for pedestrian, equestrian, and carriage use, and separated by bridges—were designed to conform to the site's natural topography. Two reservoirs, one old and one new, divided the park into two parts. Not unlike private estates in England, the upper park, between the new reservoir and One hundred sixth Street, included broad and sweeping expanses of greensward interspersed with groves of trees and bodies of water.

The more varied landscape of the lower park was designed with different uses and landscape effects in mind. A broad hillside broken by a series of rocky outcroppings just south of the old reservoir, the area with the finest natural scenery, was called by Olmsted and Vaux the Ramble. A sizable lake, a large playgound, and a parade ground provided other scenic elements along the western half of the lower park.

The most prominent feature of the park was its most artificial and formal—the Promenade or Mall, a long, straight pedestrian walk shaded by symmetrical plantings of elm trees. At its northern end was the Terrace, designed to be a framing device that would command fine views and also afford opportunity for polite and stately promenades. As a rule, Olmsted and Vaux avoided introducing buildings that called attention to themselves, believing that all structures should be subordinate to the landscape. The buildings were designed for the needs of the visitors, especially children: a dairy, a cottage, a carousel, a rustic shelter, a boys' house (to change clothes for sports), a casino (for refreshments), a mineral spring pavilion, and a boathouse.

Although Olmsted is most frequently associated with the design of Central Park, its creation was not the vision of a single individual. The writer and poet William Cullen Bryant made one of the first demands for a park in 1844. Along with Downing, Bryant kept the issue in the public eye. By 1850 creating an urban park had become a political issue, one endorsed by mayoral candidates and other New York politicians who believed the city needed an emblem of civic pride that also attested to its cultural sophistication. In 1853, by an act of the legislature, some 624 acres of rocky and swampy land were set aside for development. Four years later, the Board of Commissioners of Central Park hired Olmsted as superintendent, the farmer, writer, and publisher having turned designer

of landscapes. It was his partner, however, the English-born Calvert Vaux, who was trained as an architect; Downing saw his work in London and invited the young architect to return with him to the United States.

Once the design competition for Central Park was announced, Vaux approached Olmsted with the idea of working together to submit a plan. Their winning entry marked the beginning of a partnership that lasted until 1872, during which time they produced important designs for parks, college campuses, and planned communities. Olmsted continued to act as the landscape architect of the New York Department of Parks until 1877; Vaux held the position in 1881–83 and 1888–95.

Over the years, Central Park's physical features have responded to shifting aesthetic ideals, demands for recreational spaces, and maintenance priorities, but the overarching design has changed little. Early in the park's development, Olmsted found that gifts of statuary and animals compromised his desire to keep the park an organic whole. Guidelines became necessary for the placement of sculpture and the siting of a zoological garden. Olmsted and Vaux wanted neither, but their suggestions were ignored. Statuary was placed along paths, and wooden pens and sheds for animals were set up near the old arsenal at Sixty-fourth Street and Fifth Avenue. In the early 1870s the corrupt Tweed administration began to alter many details essential to the integrity of the park. Shrubs were cut out, the dairy was made more prominent, and a large zoo was planned for the upper park meadows. The ornate Bethesda Fountain, located north of the terrace, was inaugurated in 1873. A sizable piece of ground along the eastern edge of the park was given up in 1868 for the creation of a museum of history, antiquities, and art. Ten years later this became the Metropolitan Museum of Art. More land was used to expand the museum in 1885, an act later regretted by Olmsted and others. The old arsenal was used as a museum, housing the New-York Historical Society from 1862 to 1865, and then the American Museum of Natural History from 1869 to 1877. As use of the park increased, artists were among those drawn to the park as a setting for urban leisure. Olmsted worried that the landscape would suffer when large and sometimes disorderly crowds gathered for special events, such as the Columbus Day parade or a political rally.

Naturally, the city that framed the park changed drastically in the early twentieth century with the introduction of automobiles and high-rises. New demands were made on the park, specifically for more recreational facilities, such as tennis courts and a more permanent skating rink. Fewer open, tranquil, and pastoral areas remained as throngs of people gathered for outdoor theater performances, rock concerts, and in-line skating. In 1989 a Citizens Task Force on the Use and Security of Central Park was set up to deal with the growing numbers of homeless and the increasing incidents of attacks. Community groups and public hearings have broadened the spectrum of people involved in managing the Park.

Today, as in 1858, the caretakers of Central Park must balance protection of the landscape with the large crowds who gather for concerts and the like. During the city's fiscal crises in the 1970s, the park's physical deterioration accelerated, but in the last two decades, with the establishment of the Central Park Conservancy in 1980, significant private funds have been raised and used to great advantage. This pairing of public and private monies has made possible many renovations: refurbishing the ice-skating rink, rebuilding many smaller structures, and replanting extensive stretches of trees, shrubs, flowers, and lawn.

KERRY MORGAN

NOTE

1. Books consulted include Elizabeth Barlow, *Frederick Law Olmsted's New York* (New York: Praeger, 1972); Roy Rosenzweig and Elizabeth Blackmar, *The Park and the People: A History of Central Park* (Ithaca and London: Cornell University Press, 1992); and Witold Rybczynski, *A Clearing in the Distance: Frederick Law Olmsted and America in the Nineteenth Century* (New York: Scribner, 1999).

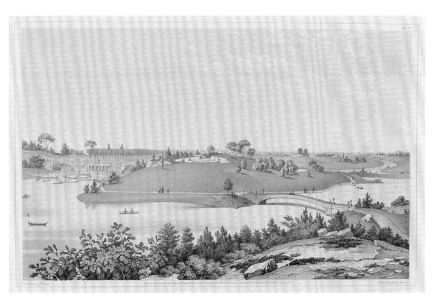

95a

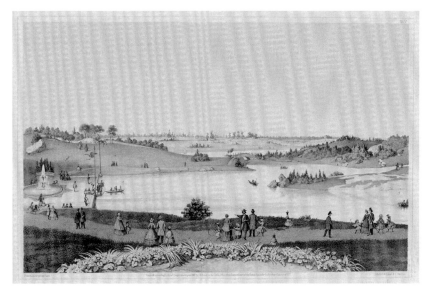

95b

95

George Wilhelm Fasel (U.S.A., b. Germany, act. 1850–65)
 and Edward Valois (act. U.S.A., 1840s–1860s)
A. Plate IV: *View of the Lake and*
 Terrace Looking South
B. Plate V: *View of the Lake Looking West*
Lithographs with tint stones, each 21.5 × 34 cm
From *Central Park Album* (1862) printed by Jacob Rau
The New York Public Library, Astor, Lenox and Tilden
 Foundations (Eno Collection, Miriam and Ira D. Wallach
 Division of Art, Prints and Photographs, 366)

The open vistas of these early views show the park's natu-
ral beauty as envisioned by Olmsted and Vaux. Following
the flow of the landscape along the lake's shorelines are
curved paths on which families enjoy their walks. In both
scenes boaters are out on the lake. As the park became more
heavily used, rules were promulgated and revised.

During the 1860s and 1870s Central Park was often illus-
trated in *Harper's Weekly*. In summer thousands gathered at
the Ramble; in winter skaters congregated. Trotting races
and fast driving were banned; speed limits were set for car-
riages and saddle horses; and commercial vehicles were not
allowed—to keep the park apart from the bustle of the city.
In 1865 gatekeepers counted annual attendance at 7.6 mil-
lion; by the 1870s four-fifths of these entered as pedestrians.
However, only on Sundays could working people get to the
park.

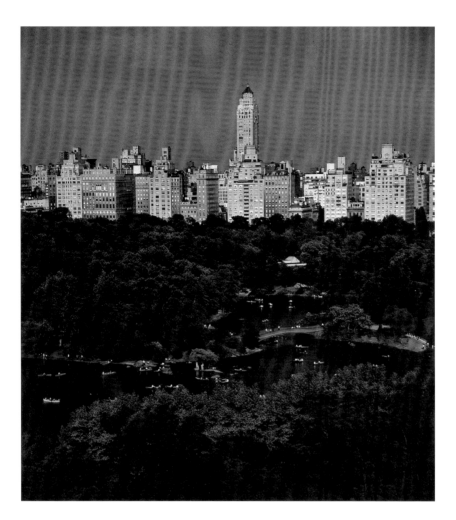

96

Peter Fink (U.S.A., b. 1917)

*Central Park, Looking to Fifth Avenue, from the Top
of the Dakota—Seventy-second Street*

Gelatin-silver print, 41.8 × 37.5 cm

The Art Institute of Chicago (Restricted gift of
Mrs. Dorothy Beskind, 1966.216)

Views of Central Park, taken from a distance in which the
landscape is seen below the strong urban skyline, capture its
appeal as an urban oasis. This view captures the mood of a
beautiful summer evening, when visitors linger into the twi-
light.

97

Lee Friedlander (U.S.A., b. 1934)

The Pond, Central Park 1990

Gelatin-silver print, 22 × 33 cm

Collection Centre Canadien d'Architecture/Canadian
 Centre for Architecture, Montréal (PH1993:0306)

In 1988 the Canadian Centre for Architecture undertook an ambitious project to photograph many of the parks, private estates, subdivisions, and cemeteries designed by Olmsted.[1] Its purpose was to investigate these places today, examining them from different perspectives in an attempt not only to document the physical and social changes that have transformed the original landscapes created by Olmsted, but to inspire us to inhabit these spaces, making them a part of our lives. Friedlander, one of three photographers selected,

subsequently spent seven years visiting and revisiting Olmsted's landscapes, including Central Park. The pond in Central Park and the Plaza Hotel, seen through a tangle of branches and leaves in Friedlander's photograph, show the wonder of the vast park's untamed elements in the midst of an urban environment. With reminders of the city never far away, Friedlander's camera finds the tranquility and repose that the creators of Central Park, Olmsted and Vaux, sought to provide for the city's inhabitants.

NOTE

1. Robert Burley, Lee Friedlander, and Geoffrey James, *Viewing Olmsted: Photographs by Robert Burley, Lee Friedlander, and Geoffrey James*, ed. Phyllis Lambert (Montréal: Centre Canadien d'Architecture/Canadian Centre for Architecture, 1996).

Garden Gatherings

Though the images in this section of the exhibition are arranged topically—entertainments and celebrations; fashionable outings and promenades; intimate gatherings; domestic scenes; and activities, games, and sports—the historical procession of these scenes carries us from a self-conscious use of the garden as theatrical backdrop for social and political display in the seventeenth and eighteenth centuries to the garden as a place of enjoyment, health, and refuge that admits a greater variety of activities and behaviors in the nineteenth, twentieth, and twenty-first centuries. Two of the most striking indications of this change are the increased number of women and children who venture into the garden without a male escort and the rise of the urban public park that welcomes people from all walks of life. Parks and gardens have evolved as enlightened and democratized places.

Festive Occasions

98

Jacques Callot (France, 1592–1635)
The Parterre of the Palace at Nancy 1625
Etching, 25.6 × 38.3 cm
Fine Arts Museums of San Francisco, Achenbach Foundation
for Graphic Arts (Gift of Dr. Ludwig A. Emge,
1971.17.468)

Callot, the major seventeenth-century French printmaker, began his career in Italy, working for Cosimo II, grand duke of Tuscany, assisting in preparing festivals and theatrical productions for the Medici court in Florence. On returning to France, he received commissions from Henry II, duke of Lorraine. Among Callot's many etchings, this scene of the palace gardens at Nancy stands as one of the few celebratory images he made during the grim Thirty Years' War period.

The care with which Callot approached this commission is evident from the two known preparatory studies (Musée Historique Lorrain, Nancy, and the State Hermitage Museum, St. Petersburg). Callot has placed the daughter of the duke in the lower center, holding a parasol, surrounded by members of the court, soldiers, and a crowd of onlookers who stroll on the great parterre. Below the scene, with its stagelike architecture, is Callot's dedication to the young Nicole: "This drawing, fashioned with the honors of springtime, beautified with objects of various pastimes, represents your time of life, Milady, during which each sweetness there enclosed is like another flower or precious rosebush which will unceasingly produce sweet-smelling roses whose fragrance will please mankind and Heaven."

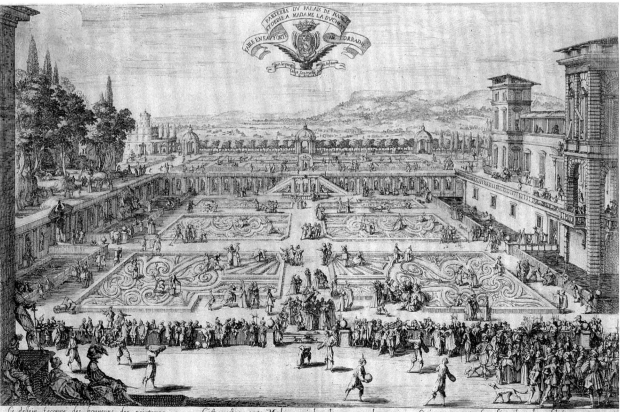

Ce dessein façonné des honneurs des printemps, C'est uostre aage, Madame où les douceurs encloses Qui pousseront sans fin des doux-flairantes roses
Emioliué dobiech de' diuers passetemps; Nous sont autant de fleurs, ou Rosiers precieux Dont l'odeur aggrera aux hommes et aux Cieux

99

Stefano della Bella (Italy, 1610–1664)

A. *Title Page*

B. *Third Scene: The Garden of Venus*

Etchings, 20 × 14 cm; 20.5 × 29 cm

From *Le Nozze degli Dei Favola* (1637)

Iris & B. Gerald Cantor Center for Visual Arts at Stanford
University (Robert E. and Mary B.P. Gross Fund,
1997.150.1,.4)

The print series *The Wedding of the Gods* was based on the
Medici festival, which took place on July 8, 1637, to celebrate
the marriage of Ferdinando II de' Medici to Vittoria della
Rovere, the daughter of another politically prominent fam-
ily. The production was choreographed and staged by Al-
fonso Parigi, an artist in the Medici employ. The festivities
were held in the Boboli Gardens of the Pitti Palace in Flo-
rence, in a temporary theater erected near the grotto in the
courtyard. The spectacle consisted of five scenes, each fo-
cusing on a different deity and each requiring a change of set.
The finale was overseen by all the gods, who looked down
from Mount Olympus.

The title page for the series shows
the wings of the Pitti Palace flank-
ing both edges of the page, with a
curtain between them. The audi-
ence is just visible along at the
bottom. The banner at the top
lists the names of the betrothed,
as well as that of Gio. Carlo Cop-
pola, the designer of the festivi-
ties. In the third scene, Venus,
the goddess of love, is shown
in her chariot, surrounded by
the Four Winds. Dancers and
cupids occupy the stage below,
designed as a formal Renaissance
garden lined with classical-style
monuments. Behind the build-
ings, trees typical of the Tuscan
landscape are visible.

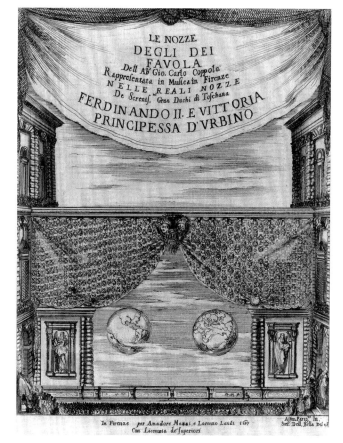

99a

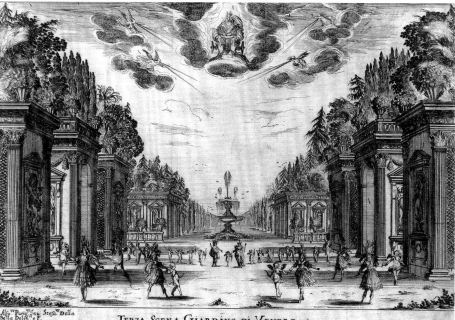

99b

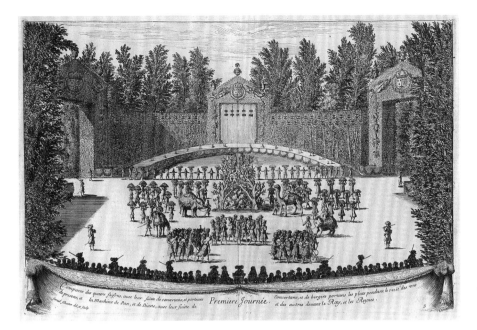

100a

100

Israël Silvestre (France, 1621–1691)

A. *First Day (Banquet of the King, Queens, Princes, and Ladies of the Court)*

B. *Second Day (Performance of Molière's Comedy-Ballet "The Princess of Elide")*

Etchings, each 41.8 × 53.9 cm (sheet)

From *Les Plaisirs de l'Isle Enchantée* (Paris, 1673)

Collection Centre Canadien d'Architecture/Canadian Centre for Architecture, Montréal (DR1984:1449, 1451)

The first of the three great festivals (*fêtes*) given by Louis XIV at Versailles, the Pleasures of the Enchanted Isle, took place the week of May 7–14, 1664. The occasion for this spectacle of music, dance, theater, games of skill, courtly promenades, and feasting was to honor the queen and the queen mother, but in truth the king wanted to impress his then-mistress, Louise de la Vallière. Six hundred guests attended.

The five festivities took place over eight days; Silvestre recorded the events of the first three.

The first day's banquet was staged in a set created for the festival in the Allée Royale. In the background, the king and his retinue are seated at a crescent-shaped table. Masqueraders stand in front of them to illuminate the scene with torches. In the middle ground, servants carry platters of delicacies; in the foreground are the male courtiers who were not invited to eat, only to watch.

On the second day the same setting was used, but with different scenery and stage props. Molière's troupe of actors performed a comedy-ballet written for the festival. Just under the stage, the tops of the musicians' heads can be seen. Jean-Baptiste Lully, the most famous composer of the period, scored the musical interludes. In the distance, the château is visible at the end of the Allée Royale.

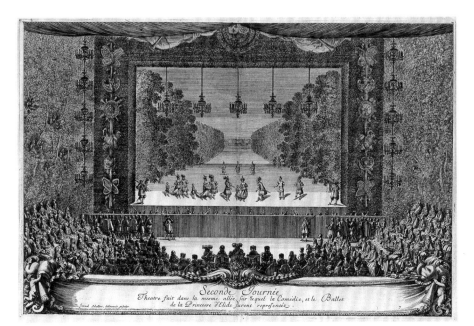

100b

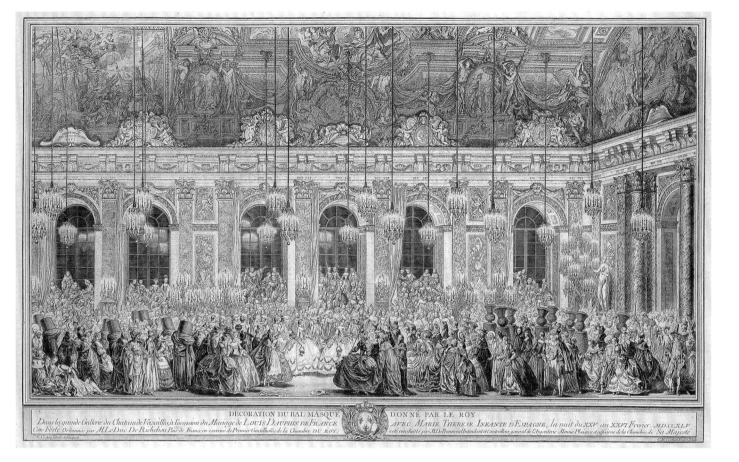

DECORATION DU BAL MASQUÉ DONNÉ PAR LE ROY

101

Charles-Nicolas Cochin the Younger

(France, 1715–1790) and Charles-Nicolas Cochin
the Elder (France, 1688–1754)

Decoration for a Masked Ball Given by the King
(*Decoration du bal masqué donné par le roy*) 1746

Etching with engraving, 47.8 × 77.8 cm

The Art Institute of Chicago (John H. Wrenn Fund, 1964.4)

This royal masked ball depicts Louis XV's reception in honor of the crown prince's marriage to the Infanta Maria-Teresa of Spain. It took place at midnight on February 25, 1745, in Versailles's great Hall of Mirrors. Costumed revelers appear in a variety of disguises, from the predictable shepherds and shepherdesses of French pastoral poetry and painting to the turbaned gentlemen of the Middle East who reflect the popularity of all things oriental. Inspired by the French formal garden, Louis XV himself and seven other guests came dressed as pruned yew trees, seen at the bottom right. Their choice attests to the enduring influence of the gardens at Versailles on the collective imagination.

Cochin the Younger was born into a family of artists. During the 1740s he was much in demand as an illustrator and as an engraver of official court celebrations. On this composition his father helped to complete the engraving. In 1752 Cochin was appointed to head the royal drawing collection.

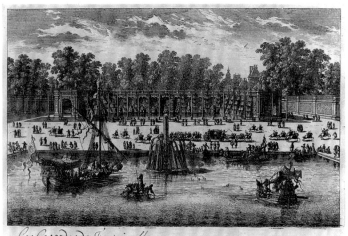

102a

102

Gabriel Perelle (France, 1604–1677) and/or
Adam Perelle (France, 1638–1695)

A. *Fontainebleau: The Large Cascades* c. 1670–90

Etching, 16.8 × 26.8 cm

Iris & B. Gerald Cantor Center for Visual Arts at Stanford
University (Mortimer C. Leventritt Fund, 1977.194)

Jacques Rigaud (France, 1681–1754) and Bernard
Baron (Great Britain, b. France, 1696–1762 or 1764)

B. Plate 12: *View from the Head of the Lake*

Engraving and etching, 39.7 × 58.6 cm (sheet)

From *A General Plan of the . . . Gardens of Stowe . . .* (1739)

Collection Centre Canadien d'Architecture/Canadian
Centre for Architecture, Montréal (DR 1982:0096:012)

Boating, nautical processions, and mock naval battles have been a traditional part of European garden festivities since the Renaissance. Roman water battles and formal processions down the Grand Canal in Venice provided the inspiration. Whether a garden belonged to the crown, such as Fontainebleau, or to a private individual, such as Stowe, it had to be a large enough area to sustain a lake or canal, and, correspondingly, its patron had to be wealthy enough to outfit guests with water craft and nautical regalia. The two prints depict two very different types of boating. At Fontainebleau, a flotilla of small ships is part of a larger royal festival that includes the arrival of a coach and attendants on horseback. At Stowe, the image is of an informal sailing party, and the mood is in keeping with Rigaud's other views of the grounds (cat. 80).

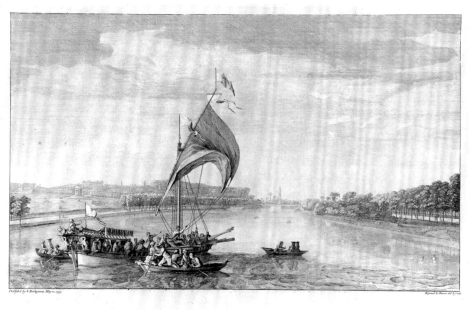

View from the Head of the Lake.

102b

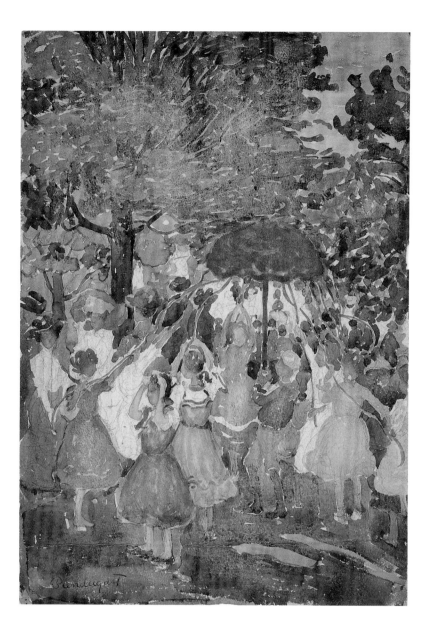

103

Maurice Prendergast (U.S.A., b. Canada, 1858–1924)
Maypole, May Day, Central Park 1901
Watercolor and pencil, 41.5 × 28.6 cm
Allen Memorial Art Museum, Oberlin College, Ohio
 (Gift of Mrs. Chauncey B. Smythe, 1980, 1981.7)

Beginning in 1901, Prendergast focused on New York's Central Park as a stage for pageantry that was particularly American. May Day represents a recurring motif in Prendergast's paintings, watercolors, and monotypes. The May Day picnics held in Central Park for children were organized by a variety of religious, ethnic, and civic groups beginning in the 1870s. Prior to this, group picnics in the park had been forbidden by statute. The celebrations attracted up to two hundred thousand children during the years Prendergast painted the subject. The artist captures the celebratory spirit of the holiday by focusing on the traditional dance around the maypole. This centuries-old fertility symbol involved young men and women dancing in opposite directions while intertwining colorful ribbons. A number of such maypoles were erected on the lawns in the park for these young revelers to twirl around, representing a vestige of rural community life that still had a place in a metropolitan public garden.

104

Garry Winogrand (U.S.A., 1928–1984)

Peace Demonstration, Central Park, New York City 1970

Gelatin-silver print, 25.7 × 39.2 cm

The Art Institute of Chicago (Gift of Boardroom, Inc., 1992.723)

Winogrand's photographs of New York show diverse people acting together in public spaces where the potential for freedom and political discourse exists. Sometimes gritty but never staged, his work has been recognized as an accurate and persuasive record of the feeling of the 1960s and 1970s. This photograph shows a "peaceful" demonstration, with many young people watching balloons being released into the sky. In the 1960s, Central Park Commissioners Thomas Hoving and August Heckscher were firmly committed to the idea of making the park an eclectic pleasure garden. In addition to closing the park to traffic on Sundays, they welcomed "happenings," rock concerts, and demonstrations, making the park a symbol of both urban revival and the counterculture. As antiwar protests heated up, more conservative New Yorkers regarded the young protestors with disgust, wishing to ban such people from the park as the lawns and shrubs became increasingly littered and damaged. Heckscher gradually and with regret came to see the need for setting limits on park use and developed stricter guidelines.

Fashionable Outings and Promenades

105

Thomas Rowlandson (Great Britain, 1756/57–1827)

Vauxhall 1785

Etching, engraving, and aquatint, colored by hand,
52.5 × 76.5 cm

Published in London by J. R. Smith, with engraving by
R. Pollard and aquatint by F. Jukes

Iris & B. Gerald Cantor Center for Visual Arts at Stanford
University (Mortimer C. Leventritt Fund, 1969.78)

At Vauxhall the landscape provides the backdrop for the
various social rituals shown in Rowlandson's print. Among
his most famous compositions, the print is based on the
large watercolor (Victoria & Albert Museum, London) that
was exhibited in 1784 at the Royal Academy. Presenting a
panoply of activities at this popular gathering spot for soci-
ety, Vauxhall resembles an elaborate stage, a theatrical space
where little social intrigues and dramas were played out
daily. The emphasis on spectacle at Vauxhall was reinforced
by such elaborate structures as the Gothic Orchestra and
supper box, which dominates the landscape in this print.
The cast of characters ranges from ladies of fashion to dan-
dies and soldiers, and includes a number of caricatures of
such society figures as the Prince of Wales and Dr. Samuel
Johnson. Dining at one of the numerous eating establish-
ments while listening to music, as well as promenading along
the illuminated paths lined with sculpture, were highlights
of this pleasure garden.

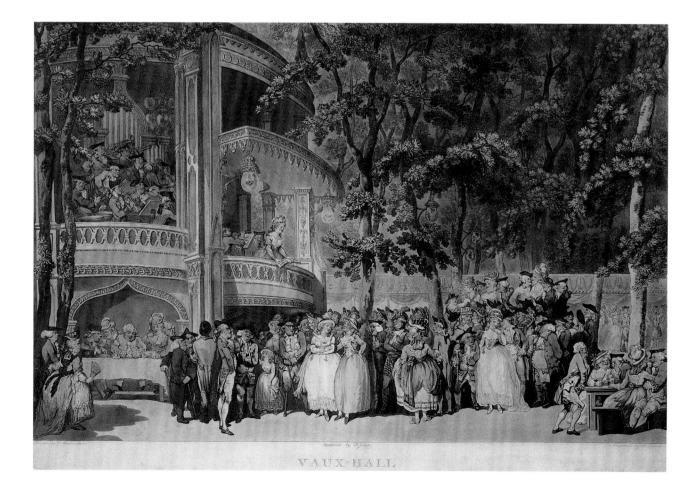

VAUX·HALL

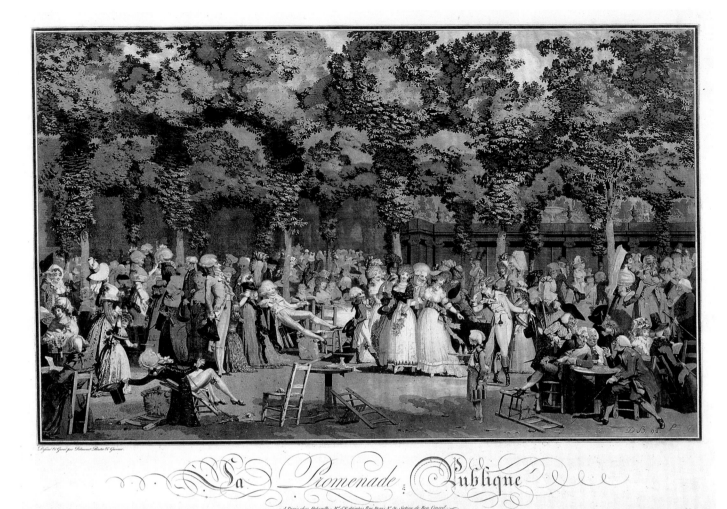

La Promenade Publique

A Paris chez Depeuille, M.ᵈ d'Estampes, Rue Denis N.º 38, Section de Bon Conseil

Imprimé par Blin fur

106

Philibert-Louis Debucourt (France, 1755–1832)

The Public Promenade 1792

Etching, engraving, and aquatint, 45.7 × 63.6 cm

The Minneapolis Institute of Arts (The William Hood
 Dunwoody Fund, P.85.32)

The Goncourt brothers, knowledgeable aesthetes and art collectors, were among the first to point out Debucourt's debt to Rowlandson's *Vauxhall*. Debucourt captures French high society and members of the nobility strolling under a canopy of chestnut trees pruned into arcades. He divides the picture space evenly between the airy treetops above and the dense crowd of humanity below and situates the viewer at the crossing of two long avenues to best display the throngs of promenaders. Figures choke the path that disappears into the background and they pass horizontally before the viewer like players on a stage.

Debucourt's view of a public garden functions on two levels: he satirizes the sheer number of people who wish to show off their finery and to watch the parade of the fashionable set; and he mocks individual types such as the dandies lolling in their chairs or blowing kisses.

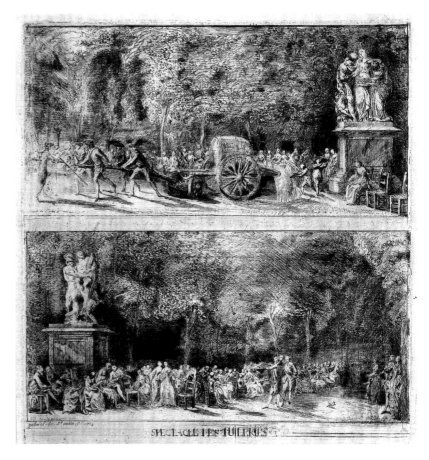

107

Gabriel-Jacques de Saint-Aubin
(France, 1724–1780)
Scenes from the Tuileries: The Chairs
and *The Water Cart* (*Spectacle des*
Tuileries: Les Chaises et *Le Tonneau*
d'Arrosage) 1760–63
Etching and drypoint, 20.7 × 19.5 cm
The Art Institute of Chicago (Robert Alexander
Waller Fund, 1950.1440)

Saint-Aubin, known as an incessant recorder
of Parisian daily life, hailed from a family of
artists. Draftsman, etcher, and occasional
painter, he drew on whatever scrap of paper
was at hand, producing small-scale images
that conveyed the teeming life of both town
and country.

Because the public gardens of the Tuileries
had become such a popular meeting place,
often there were too few seats. The problem
was solved with a chair rental service; the two empty chairs
in the foreground call attention to this innovation. The
crowds created yet another difficulty: raising dust on the dirt
paths, which had to be watered periodically. Saint-Aubin
treats the path-watering as if it were theater. The gardeners,
as light-footed as dancers, draw their water barrel with as
much ceremony as if it were the king's coach. The self-im-
portant park visitors even stop their conversations to watch.

108

Thomas Rowlandson (Great Britain, 1756/57–1827)
The Tuileries c. 1800
Pen and watercolor over pencil, unfinished, 27.3 × 40 cm
The Huntington Library, Art Collections, and Botanical
Gardens, San Marino, California (59.55.1133)

Rowlandson's study of a typical day at the Tuileries does not
merely depict the park's mix of social types who promenade,
converse, people-watch, and read but
also offers commentary on their vari-
ous motives. Rowlandson first traveled
to Paris in 1774. By the 1780s, after
having made several other trips to
the capital, he mastered the French
narrative watercolor genre and made
it his own idiom.

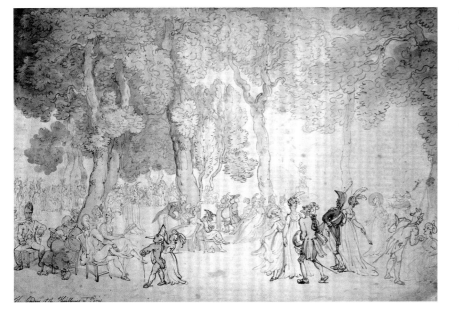

109

George Cruikshank (Great Britain, 1792–1878)

A. *Monstrosities of 1822*

Etching, colored by hand, 25.7 × 36.2 cm

The Minneapolis Institute of Arts (The Minnich Collection,
 The Ethel Morisson Van Derlip Fund, P.17,395)

B. *Monstrosities of 1825*

Etching, colored by hand, 24.1 × 38.6 cm

University of Michigan Museum of Art (Museum purchase,
 1989/1.71)

Several of Cruikshank's fashion caricatures of the 1820s
were set in London parks. The promenading, preening, and
ogling strollers either wear body-hugging clothes, cover
themselves in excessive amounts of drapery,
or combine the two extremes. In *Monstrosities
of 1822*, Cruikshank uses park statuary to
contrast the well-proportioned classical
nude with the modern body distorted by
the vagaries of fashion. *Monstrosities of 1825*
is a study in circles and spheres, contracting
and expanding volumes.

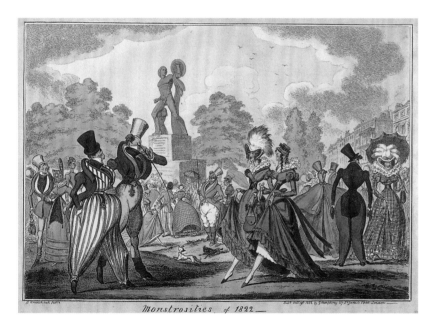

109a

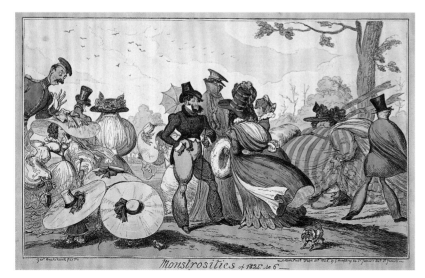

109b

APRIL. AVRIL.

JULY. JUILLET.

110

Robert Dighton (Great Britain, 1752–1814)

A. *April*

B. *July*

Mezzotints, colored by hand, each c. 35.2 × 25.5 cm

From *The Twelve Months* (London: Carrington Bowles,
 [c. 1780])

The Minneapolis Institute of Arts (The Minnich Collection,
 The Ethel Morrison Van Derlip Fund, P.17,033, 036)

Dighton, a singer and drawing master, specialized in popular "droll" subjects, including fashion plates in the form of calendar months. These were destined for both the English and French markets, as the bilingual legend makes clear. April's principal signs of spring are the primroses she admires, the sky that threatens rain, and the umbrella she prudently carries. The flat round basin with its single jet of water indicates that she stands in a formal, seventeenth-century-style garden. July, in contrast, is seated in the more fashionable Anglo-Chinese garden of the later eighteenth century, with its irregular topography and its architectural follies. She carries a parasol and fan to ward off the sun.

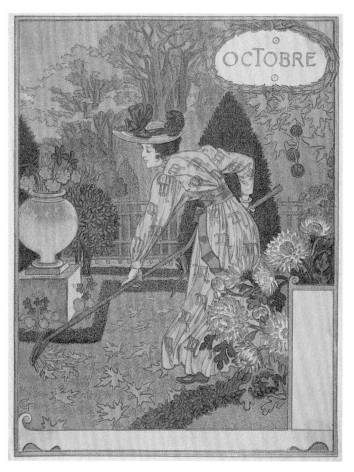

111

Eugène-Samuel Grasset (France, 1841–1917)

A. *February*

B. *October*

Gillotypes, each 20 × 15.5 cm

From *La Belle Jardinière* (Paris, 1896)

Iris & B. Gerald Cantor Center for Visual Arts at Stanford
 University (Purchased with funds given by Nancy B.
 Tieken in honor of Betsy G. Fryberger and the catalogue
 of the drawing collection, 2000.35.2, 10)

Images of women working in the garden are rare. Nonethe-
less, some of the earliest date back to medieval times, when
they were depicted mainly tending herbs and flowers or
weeding. By the late nineteenth century, women were in-
creasingly shown in their domestic roles, playing with
children, reclining elegantly on a bench, picking flowers,
or strolling. Grasset's 1896 calendar *The Beautiful Gardener*

shows a woman ostensibly at work, each month taking on a
different task. Whether raking or pruning, she is dressed in
a gown patterned and colored appropriately to the season.
Her fashionable accessories include billowing scarfs or large
hats, as well as the appropriate tool for the task.

Grasset, a printmaker and a designer of decorative arts
and stained glass, worked in the Art Nouveau style.

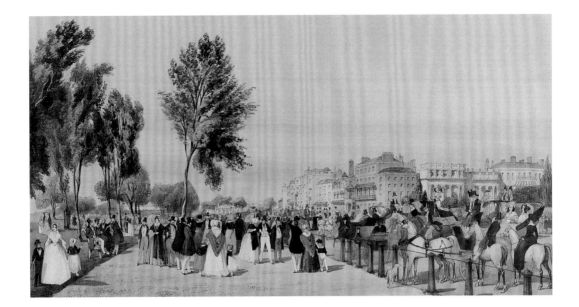

112

Thomas Shotter Boys (Great Britain, 1803–1874)

Plate 15: *Hyde Park from Grosvenor Gate*

Lithograph, 24.5 × 46.5 cm

From *Original Views of London as it is* (London, 1842)

Yale Center for British Art (Paul Mellon Collection,
 s239A, folio в)

Boys set two tranquil scenes in St. James's Park (cat. 93). In Hyde Park, however, he focused on its popularity as a gathering spot, with the latest fashions on display. Women in shawls and bonnets paraded in fashionable carriages, each with its uniformed driver.

113

Maurice Prendergast (U.S.A., b. Canada, 1858–1924)

Promenade in the Luxembourg Gardens c. 1907

Oil on panel, 22.9 × 30.5 cm

Frame by Charles Prendergast

University of Michigan Museum of Art (Gift of Charles H.
 and Katharine C. Sawyer, 1999/2.3)

Prendergast first saw the sixteenth-century painter Vittore Carpaccio's colorful paintings of processions in 1898–99 in Venice. Carpaccio's festive sense animates Prendergast's many paintings, watercolors, and monotypes of places of leisure and celebration (cat. 103). In 1907, on a visit to Paris, he painted small oils and water-colors of people enjoying the Luxembourg and Tuileries gardens. With bold and brightly colored strokes, he painted the gardens' promenaders or children playing amid statues, chairs, and a balustrade with flowerpots. The decorative frame, designed by his brother Charles, adds to the liveliness of the scene.

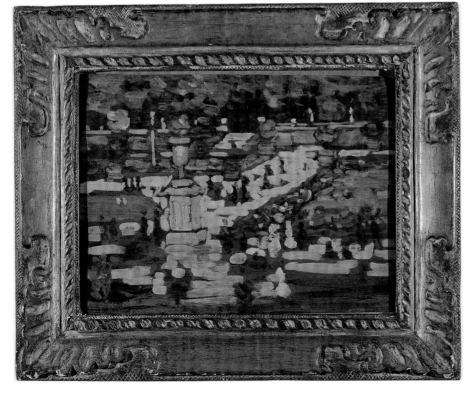

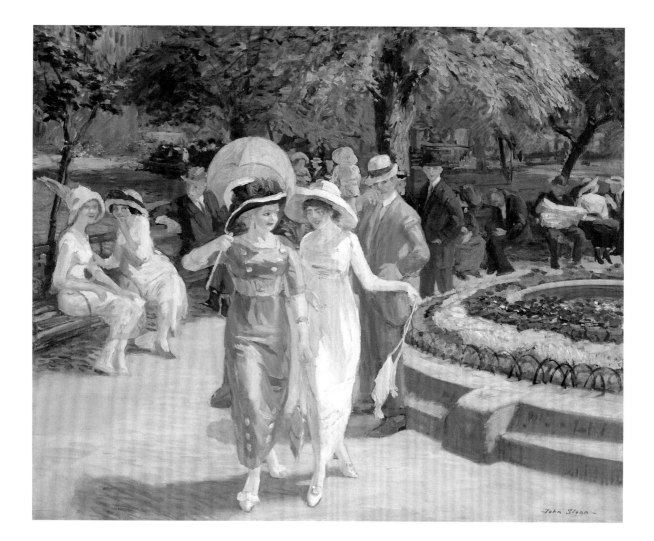

114

John Sloan (U.S.A., 1871–1951)

Sunday Afternoon in Union Square 1912

Oil on canvas, 66.7 × 81.9 cm

Bowdoin College Museum of Art, Brunswick, Maine

(Bequest of George Otis Hamlin, 1961.063)

In contrast to the elegant couples portrayed by John Singer Sargent in the 1890s, Sloan focused his attention on members of the working class. Sloan, like George Bellows, explored New York's underbelly, its tenements and bars, but he also recorded its artists, collectors, and visitors to the Metropolitan Museum. In his painting *Picnic Grounds* of 1906–7 (Whitney Museum of American Art), Sloan's socialist politics added strength to his characterizations of young working-class men and women but put off some critics and collectors used to more genteel subjects.

In several scenes set in Union Square, Sloan drew young women, probably secretaries who worked in the neighborhood, enjoying their independence. In this painting, two young women are being eyed by young men. In similar oils, two women walk in the rain, or sit on a bench, and chat while having their shoes shined, observed again by a young man. Sloan saw the square and park as places for potential encounters with strangers. He was in the habit of watching unobserved from his window, which had a view of Union Square.

Intimate Gatherings

115

Abraham Bosse (France, 1602–1676)

The Sense of Smell c. 1635

Etching, 25.4 × 32 cm

From *The Five Senses*

Iris & B. Gerald Cantor Center for Visual Arts at Stanford
University (Robert E. and Mary B.P. Gross Fund, 1996.5)

This depiction is both an allegory of the sense of smell and a genre scene of well-to-do visitors in a springtime garden. Lost in one another's company and the fragrance of newly picked flowers, the man and woman who descend the stairs notice neither the pot of carnations prominently placed on the balustrade nor the people in the garden below.

Bosse's rich record of French life during the mid–seven-teenth century included scenes of artists' studios, bakers at work in the kitchen, banquets, and still other garden subjects. He has featured in this view tapestry-patterned beds (some with bulbs), gardeners meticulously pruning the hedges, a central fountain rising out of a flat circular basin, and a grotto in the far background with jagged rockwork lining its back wall.

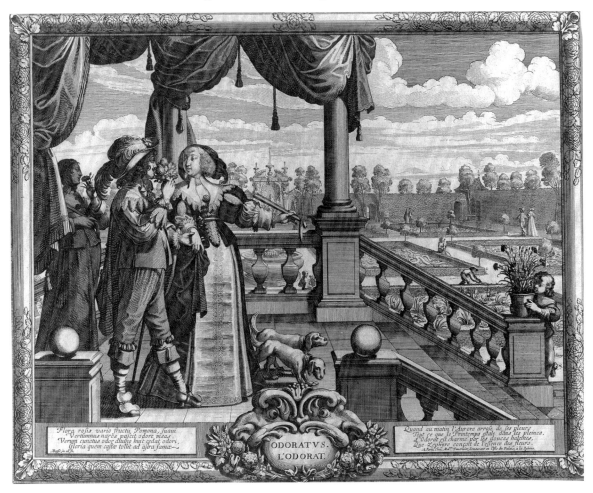

Flora rosis vario fructu, Pomona, suaui
Vertumnus narès pascit odore meas
Verum cunctus odor diuino huic cedat odori,
Gloria quem casta tollit ad astra fama

ODORATVS.
L'ODORAT.

Quand au matin l'Aurore arrose de ses pleurs
Tout ce que le Printemps estale dans les plaines,
L'Odorat est charmé par les douces haleines,
Que Zephyre conçoit de l'essence des fleurs.

FÊTES VENITIENNES FESTA VENETA

Gravées d'Apres le Tableau original peint par Watteau *Sculpta juxtà Exemplar à Watteavo depictum cujus*
haut de 1 pied 9 pouces sur 1 pied 5 pouces *altitudo 1 pedem cum 9 uncùs et latitudo 1 pedem*
de large. *cum 5 continet.*

Du Cabinet de M. de Jullienne.
Avec Privilège du Roy.

116

Laurent Cars (France, 1699–1771)
Venetian Fêtes (after Jean-Antoine Watteau) 1732
Etching and engraving, 50 × 37 cm
Iris & B. Gerald Cantor Center for Visual Arts at Stanford
 University (Membership Art Acquisition Fund, 1999.162)

Contemporaries acclaimed the work of the printmaker Cars
for his ability to translate a painting into the print medium
without its appearing to be a servile copy of the original.
Watteau's 1718–19 *Fêtes vénitiennes* (National Gallery of Scot-
land, Edinburgh) belongs to a category of painting called
fête galante, the term created by the French Academy to de-

scribe that artist's scenes of costumed revelers who retreat
to intimate garden settings. Though this imagery typically
depicts generic parks, Watteau was known to have visited
the estates of his patrons Jean de Jullienne and Pierre Crozat.

Venetian Fêtes comments on the conduct expected of polite
society. Outward displays of desire, as exhibited by the fel-
low who paws at the young woman seated next to him, are
disparaged as attempts to bend another's will to one's own.
Watteau transfers the work's eroticism from the revelers to
the voluptuous fountain statuary as a reminder that such
drives must be kept under control in social situations.

117

John Singer Sargent (U.S.A., 1856–1925)

The Luxembourg Gardens at Twilight 1879

Oil on canvas, 73.6 × 92.7 cm

The Minneapolis Institute of Arts (Gift of Mrs. C. C. Bovey
and Mrs. C. D. Velie, 16.20)

[Shown only at Stanford]

In depicting the Luxembourg Gardens at dusk, Sargent painted an isolated couple moving slowly across the setting famous for promenades and public sociability. The Minneapolis painting bears an inscription by Sargent to his friend Charles McKim, of the prominent New York architectural firm McKim, Mead & White. This subject exists in a more finished version of about the same size (Philadelphia Museum of Art). The area around the Luxembourg Gardens on the Left Bank attracted Whistler (cat. 118) and Henry James, who wrote of it in his novel *The Ambassadors*.[1]

Sargent, at twenty-three, although freeing himself from his academic training, was very conscious of the power of the annual Salons (to which he submitted a portrait of his teacher in 1879). Absorbing new points of view, Sargent studied the work of Camille Corot, Whistler, and the Impressionists. Over the next several years, Sargent experimented in freeing himself from his studio perspective and learning to represent scenes observed directly from modern life. In his mature garden views, which include many watercolors, Sargent often focused on a particular feature—a statue or fountain—radiant in sunlight (cats. 28, 31).

NOTE

1. Elaine Kilmurray and Richard Ormond, eds., *John Singer Sargent*, exh. cat. (London: Tate Publishing, 1998), 84–85, cat. 16.

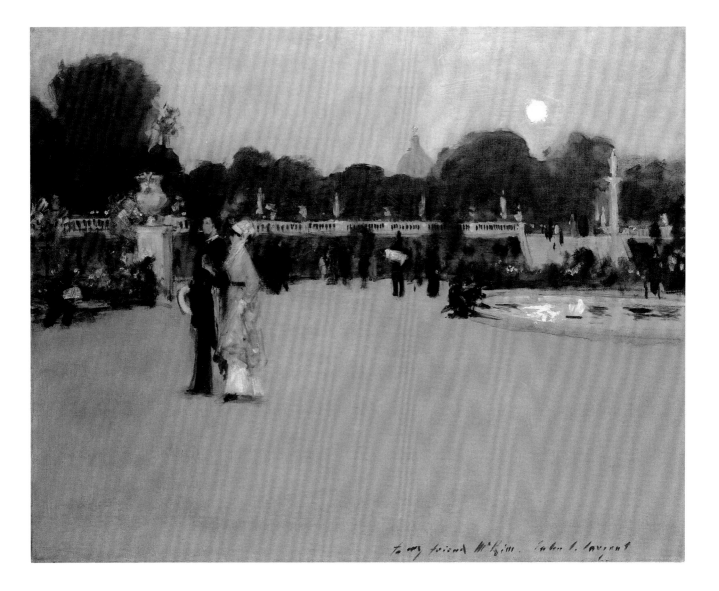

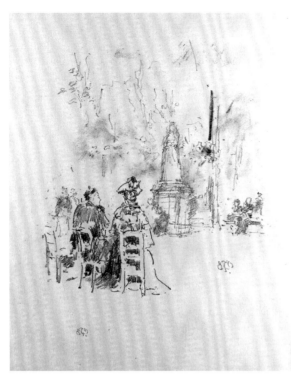

118

James McNeill Whistler (U.S.A., 1834–1903)
Conversation in the Luxembourg Gardens 1893
Lithograph, 29 × 23.5 cm
University of Michigan Museum of Art (Bequest of
 Margaret Watson Parker, 1954/1.438)

Whistler's sketches were quick impressions. In 1891, he had
drawn a group of friends at his house on Cheyne Walk in Lon-
don taking tea in the garden. In 1894 at his apartment on the
rue du Bac in Paris, he drew his wife, Beatrix, arranging flow-
ers in a plant stand, and another sketch of her talking with
her sister. Whistler drew a number of subjects in the Lux-
embourg Gardens, which were close to his studio. Working
with a lithographic crayon on transfer paper, he would send
the sheet to his printer in London. In 1893 he made three
lithographs set in the Luxembourg Gardens, mingling the
curve of the balustrade and planters with the clusters of
figures and statuary, under a high canopy of trees (cat. 124).

119

André Kertész (U.S.A., b. Hungary, 1894–1985)
Two Friends in the Luxembourg Gardens 1963
Gelatin-silver print; printed 1970s, 24.8 × 18.9 cm
The Art Institute of Chicago (Gift of Mr. and Mrs. Noel
 Levine, 1982.1741)

From 1925 to 1936 Kertész made his reputation as a photog-
rapher within the artistic community of Paris. For Kertész,
Paris would always be a city full of possibilities and fond
memories; it would remain an essential part of his soul even
after he immigrated to the United States. Although he did
not return to the City of Light for almost thirty years, he
never forgot his emotional connection to its working-class
inhabitants. His ability to produce images with great sin-
cerity, respect, depth, and, often, visual wit depended on his
loyalty to his subjects and to his aesthetic. His photograph
of two women visiting and gossiping with each other in the
Luxembourg Gardens is not only an observation of an ac-
tivity that frequently takes place in the park but also a com-
mentary on the social importance of parks.

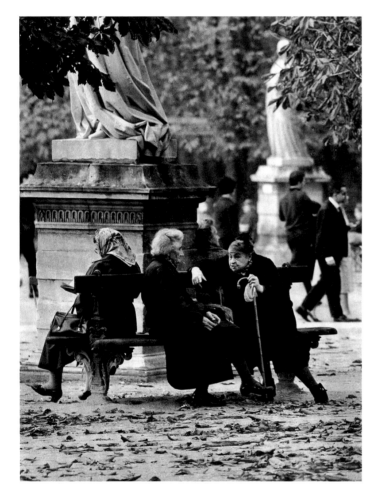

Domestic Scenes

120

Carl Guttenberg (German, 1743–1790)

Rendez-vous for Marly (after Jean-Michel Moreau,
 called Moreau the Younger) 1777

Engraving and etching, 33.6 × 23.5 cm

From *Seconde suite d'estampes, pour servir à l'histoire des modes,
 et du costume en France, dans le XVIII siècle, année 1776*
 (Paris: Moreau, 1777)

The Minneapolis Institute of Arts (The Minnich Collection,
 The Ethel Morrison Van Derlip Fund, P.17,028)

The three-volume luxury edition of fashion plates with accompanying commentary, known collectively as *Le Monument du Costume*, portrayed the way of life, fashions, and haunts of late-eighteenth-century Parisian high society and served as a practical guide for clothing and furniture designers. Volume one traced the social life of a young woman; volume two followed her into married life; and volume three focused on a young man about town. Moreau the Younger, a popular draftsman, engraver, and painter, was commissioned to design illustrations for volumes two and three.

This image depicts a fashionable young family on an outing to Marly. Marly, one of the royal gardens, located between Paris and Versailles, was a favorite site of well-heeled visitors and of seventeenth- and eighteenth-century artists. The formal gardens were destroyed during the French Revolution.

Le Rendez-vous pour Marly.

A.P.D.R.

121

Marie-Elizabeth Boulanger (France, b. 1809)

Mother and Daughter in a Garden c. 1836

Watercolor, 22.5 × 16.3 cm

Iris & B. Gerald Cantor Center for Visual Arts at Stanford
 University (Committee for Art Acquisition Fund,
 1978.36)

Unlike Moreau the Younger's image of the fashionable fam-
ily outing in the public gardens of Marly, this well-to-do
mother and child take the air on the terrace of a private hill-
top garden. This pair, gracefully framed by a tree and urn,
retreat from the world to enjoy one another's company.
Though they do not touch, they are linked through their
gazes. The child's hesitant gesture suggests she is asking
permission to play with a pet bird.

122

Carleton Watkins (U.S.A., 1829–1916)

Plate 27: *The Milton Latham Family* 1874

Albumen print, 28 × 35.5 cm

From the album of 63 plates, *Thurlow Lodge*

Stanford University Libraries, Special Collections

Milton Latham purchased property in Menlo Park in 1872
for his new wife; two years later, construction of the house
and garden of what was one of the largest estates on the San
Francisco Peninsula was completed. Commissioned to make
a series of photographs of Thurlow
Lodge by its owner, Watkins created
two copies of the album of photographs.
One album (now in Stanford University
Libraries) was originally given to David
Farquharson, the architect of Thurlow
Lodge. The second album, with slightly
larger prints, was made for the Latham
family (now in The Canadian Centre
for Architecture, Montreal). Watkins
photographed the mansion's lavishly
furnished interior and its extensive
grounds, with a greenhouse, well-

appointed stables, and a rockery (cat. 24). This view of the
family is typical for its time with the subjects posing com-
fortably, surrounded by their extensive estate (see Thomas
Hill's painting of the Stanford family, fig. 28).

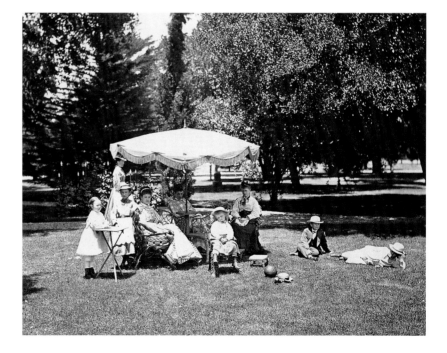

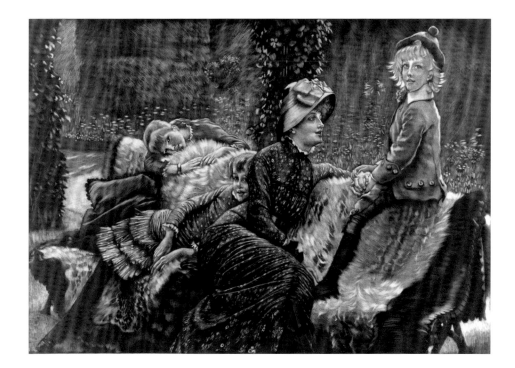

123

James-Jacques-Joseph Tissot (France, 1836–1902)
The Bench in the Garden 1883
Mezzotint, 41.5 × 56.2 cm
Iris & B. Gerald Cantor Center for Visual Arts at Stanford
 University (Mortimer C. Leventritt Fund, 1978.59)

This image of a garden scene touchingly remembered is
ostensibly idyllic but was conceived in melancholy. Tissot
lived in Paris until the Franco-Prussian War in 1870–71,
when he moved to London, where he remained until 1882.
In his house on Grove End Road in St. John's Wood, he de-
signed a garden with a pergola and pool often used as the set-

ting for his compositions. Tissot's garden was his private
and artistic refuge and a place of domestic tranquility. This
image of a young woman in bonnet and floral dress, who lov-
ingly gazes at her young son, might be any middle-class
mother spending the afternoon with her children in the
park. However, it is Tissot's mistress, Kathleen Newton,
with her daughter Violet, her son Cecil, and her niece Belle
in a scene Tissot created from memory. Newton had died of
tuberculosis at the age of twenty-eight in November 1882,
precipitating Tissot's return to Paris, where he made this
memorial.

124

James McNeill Whistler (U.S.A., 1834–1903)
Nursemaids in the Luxembourg Gardens 1894
Lithograph, c. 20 × 15 cm
Iris & B. Gerald Cantor Center for Visual Arts at Stanford
 University (Gift of Marion E. Fitzhugh and Dr. William
 M. Fitzhugh Jr. in memory of their mother, Mary E.
 Fitzhugh, 1963.5.76)

If for Tissot the garden was a personal retreat, for Whistler
it was an arena of sociability to be enjoyed and observed
(cat. 118). Rapidly sketching his impressions, Whistler drew
clusters of nurses and children. *Nursemaids in the Luxembourg
Gardens* was published in December 1894.

125

Ker-Xavier Roussel (France, 1867–1944)

Women and Children in a Park c. 1892–93

Pen and brown ink over traces of pencil,
20 × 30.5 cm

Iris & B. Gerald Cantor Center for Visual Arts
at Stanford University (Museum Purchase
Fund, 1971.32)

In the early 1890s, Roussel and his brother-in-law, Edouard Vuillard, were among the young Parisian artists who came in contact with Japanese prints and who admired their decorative compositions, unfamiliar to Western eyes. Roussel's and Vuillard's many outdoor sketches of domestic subjects were often of family members; sometimes Vuillard's photographs of such occasions aided in developing compositions. In this drawing Roussel has adapted a variety of textures in the Japanese manner and placed the women and children in a crowded arrangement, but the artist is far more interested in the resulting decorative patterns than in any social interaction. The drawing was squared for transfer to a larger painting, whose location is not known.

126

Edouard Vuillard (France, 1868–1940)

The Tuileries 1896

Lithograph, c. 31.5 × 43.5 cm

From *L'Album des peintres-graveurs* (Paris: Ambroise Vollard, 1896)

Iris & B. Gerald Cantor Center for Visual Arts at Stanford
University (Committee for Art Acquisitions Fund, 1980.74)

Vuillard's radically foreshortened walk conveys French notions of garden decorum that encourage even rambunctious children to keep on the paths.

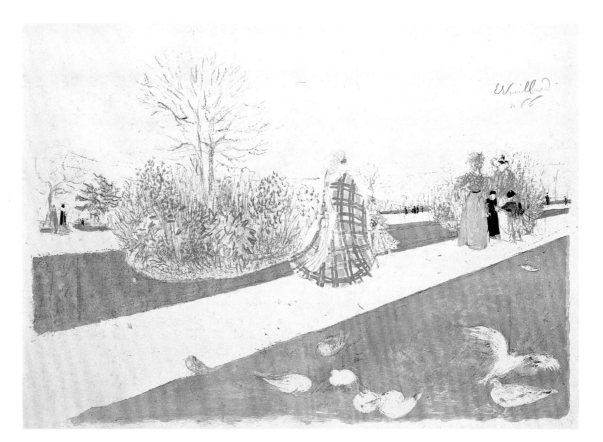

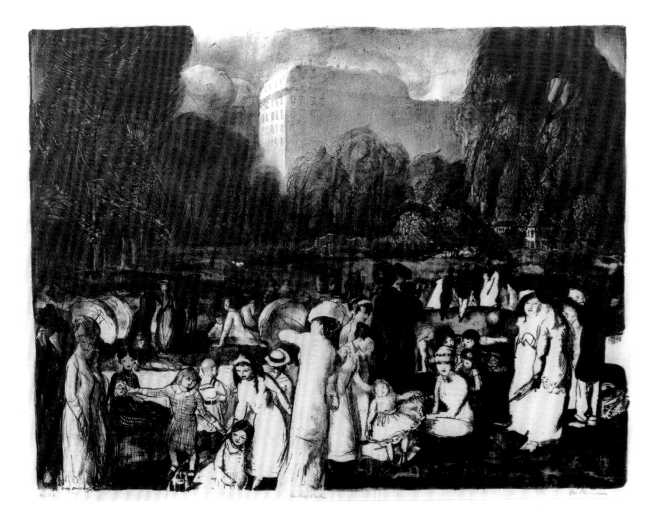

127

George Bellows (U.S.A., 1882–1925)

In Central Park 1916

Lithograph, 41 × 54.6 cm

Iris & B. Gerald Cantor Center for Visual Arts at Stanford
University (Gift of Dr. and Mrs. Ralph J. Spiegl, 1982.7)

Bellows brings an investigative turn of mind and masculine touch to his subjects. Exploring New York, he depicted its streets teeming with recent immigrants, gawky adolescent boys at play, boxing matches, and exercise classes at the YMCA. Although artistically inclined from a young age, Bellows was attracted to sports and ambitious to play basketball and baseball.

In 1905 he painted a *May Day* set in Central Park (Ira and Nancy Kroger Collection) and in 1913 *A Day in June* (The Detroit Institute of Arts). The lithograph *In Central Park* and

another darker, almost nocturnal, version of the scene, are reprises of the 1913 painting. Bellows had a tendency to exaggerate the features and poses of his figures and was criticized for constructing types rather than believable individuals. This is a clearly upper-class crowd of well-dressed women with their parasols and hats, little girls in pretty dresses, and gentlemen in straw boaters. In choosing such a subject, Bellows shows his conservative side, whereas his compositions of lower-class "kids" or sporting crowds highlight an innovative spirit.

Activities, Games, and Sports

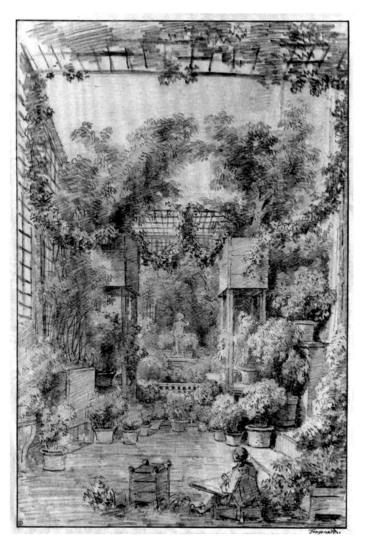

128

Jean-Honoré Fragonard (France, 1732–1806)
The Draftsman 1770s
Black chalk, 37.8 × 25.1 cm
The Metropolitan Museum of Art (Robert Lehman
 Collection, 1975, 1975.1.626)
[Shown only at Stanford]

In the summer of 1760 Fragonard stayed at the Villa d'Este, where he made many studies of its overgrown grounds, as well as of the waterfalls in Tivoli and its famous temple (cat. 56). In contrast, scholars have not been able to identify the private garden in which his draftsman works. The highly structured, symmetrical nature of the composition—with its clearly proportioned spatial recession, statue in the exact middle of the page, and "frame" of greenery and trellis-work—suggests that this is a theatrical, imaginary garden. Fragonard's framing device of trelliswork, garlands, and vines recalls designs for decorative prints, wall panels, and folding screens from earlier in the century.

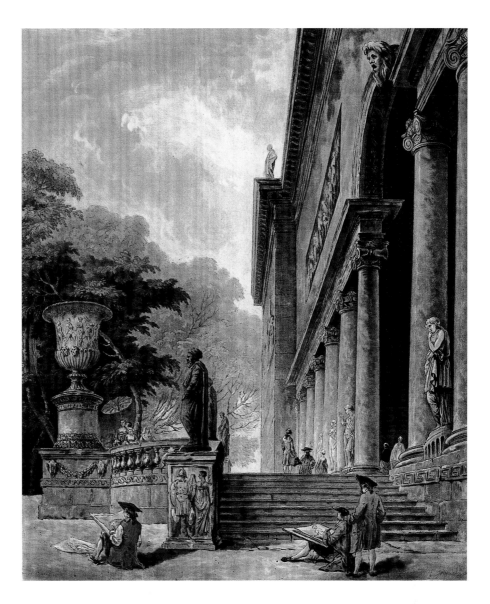

129

Jean-François Janinet (France, 1752–1814)

Colonnade and Gardens of the Medici Palace
 (after Hubert Robert) c. 1776

Etching and lavis-manner engraving printed in yellow, blue,
 red, and black inks from four plates, 39.5 × 30 cm
Cincinnati Art Museum (Bequest of Herbert Greer French,
 1943.428)

Through the medium of the color print, Janinet attempts to reproduce the effects of Hubert Robert's paintings of historic Italian gardens and classical ruins. Robert depicts art students of the French Academy at the Villa Medici in Rome. The firsthand study of the art of antiquity and of the Italian Renaissance was an obligatory part of their training. City and countryside, with their gardens, classical edifices, and ruins, attracted French artists throughout the eighteenth century. These students, seated in the foreground, try their hand at sketching both the large urn and the statuary lining the balustrade. Other visitors to the gardens, likely well-to-do tourists, mill about in the middle ground of the picture.

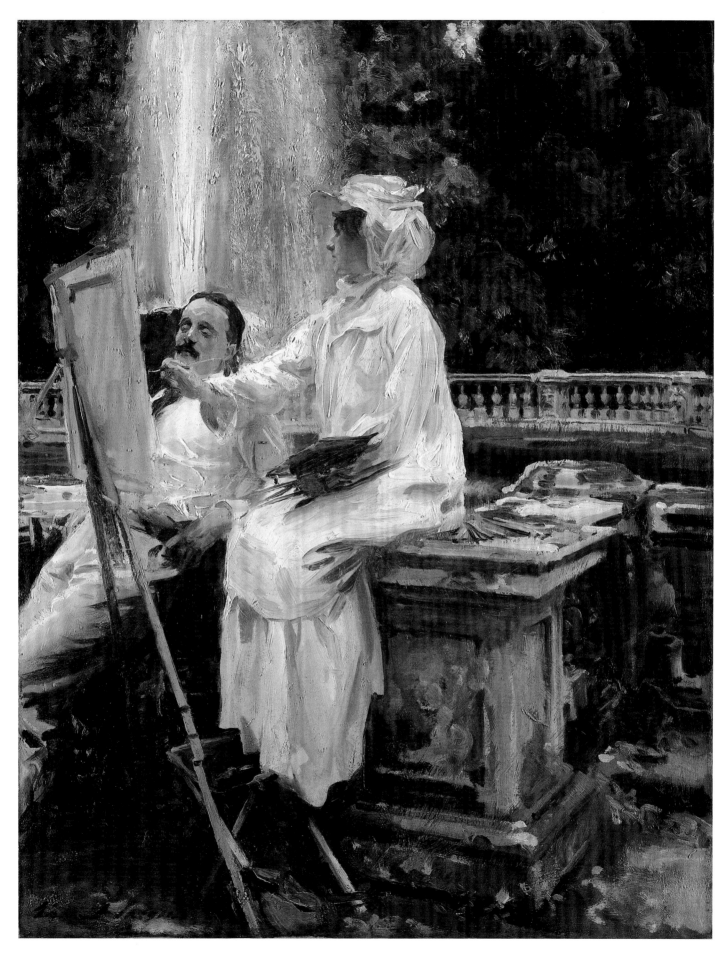

130

John Singer Sargent (U.S.A., 1856–1925)
The Fountain, Villa Torlonia, Frascati 1907
Oil on canvas, 71.4 × 56.5 cm
The Art Institute of Chicago (Friends of American Art
 Collection, 1914.57)
[Shown only at Stanford]

Villa Torlonia is among the surviving Baroque gardens at
Frascati in the hills south of Rome. Dating from the early
seventeenth century, the gardens were designed by the im-
portant Roman architect Carlo Maderno for the Conti fam-
ily. Situated on a steep hillside, the grounds were particu-
larly admired for their cascades, sweeping stairs lined with
balustrades, and panoramic views (cat. 26B). The duke of
Torlonia held the property until after World War II, when it
was damaged by bombing. It is now a public park.

By 1900, with his reputation as a portraitist assured, Sar-
gent took pleasure in painting landscapes on his extended
summer excursions. In 1906 and 1907 he painted at several
villas at Frascati with his friend and fellow artist Wilfred de
Glehn and his American wife, Jane Emmet, who is shown
painting in this scene. In his watercolors of gardens Sargent
frequently concentrated on a single feature: a statue, foun-
tain, or potted citrus tree seemingly suspended in a shaft of
sunlight. In this painting, he chose a more complex psycho-
logical moment: three friends' shared enjoyment, with Jane
painting, her husband watching, and Sargent portraying
their obvious pleasure.

131

James-Jacques-Joseph Tissot (France, 1836–1902)
The Croquet Game 1878
Etching and drypoint, 30.8 × 18.3 cm
Iris & B. Gerald Cantor Center for Visual Arts at Stanford
 University (Francis Alward Eames Fund, 1974.14)

From 1871 to 1882, years Tissot spent in London, his garden
in St. John's Wood served as a favorite setting. The garden
combined the relaxed attitude of the English with such for-
mal French features as a reflecting pool and a cast-iron colon-
nade after the one in Parc Monceau (in turn based on that at
Hadrian's Villa). In 1875 Tissot again took up etching, prob-
ably under the influence of Whistler and Seymour Haden.
He made use of his garden in several prints, including one
whose main feature was the colonnade. Tissot often showed
his mistress Kathleen Newton enjoying the garden's tran-
quility, resting on the grass, in a hammock, or in a wicker
chair.

Croquet, which became popular in Britain by the 1860s,
was a sport that women could play, as was tennis. Croquet
games were depicted by artists from Edouard Manet to
Winslow Homer. Tissot's etching closely reproduces his
painting (Art Gallery of Hamilton, Ontario, Canada) and a
gouache (Rhode Island School of Design, Museum of Art,
Providence).

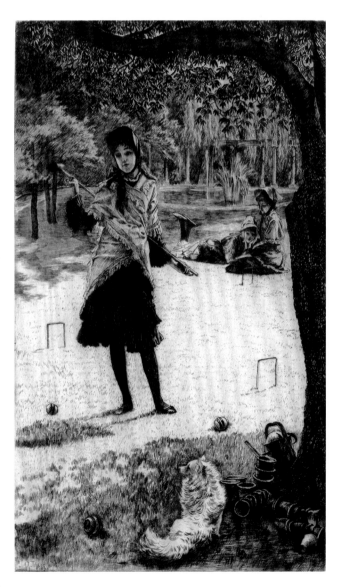

132

After Charles Parsons (U.S.A., b. Great Britain, 1821–1910)

Central Park, Winter: The Skating Pond 1862
 (see fig. 6, p. 17)

Lithograph, colored by hand, 51.7 × 68.8 cm

Published by Currier and Ives

The New York Public Library, Astor, Lenox and Tilden
 Foundations (Print Collection, Miriam and Ira D. Wallach
 Division of Art, Prints and Photographs)

Currier and Ives's prints of sports were mainly limited to historical events: the opening of the skating rink in New York's Central Park or the park in Hoboken, New Jersey, thought to be the site of the first official baseball game. Ice-skating immediately became a popular feature in Central Park; baseball was more controversial. Public schoolchildren were allowed to play ball in the park but not adults. Currier and Ives published more than ten views of Central Park, none more celebrated than Parsons's animated skating scene.

Nathaniel Currier started his New York-based printing business in 1835 and was joined in the 1850s by James Ives. Currier and Ives's seven thousand subjects, printed in some ten million copies, reflected and extended the popular culture and lifestyles of America. Drawn by staff artists and mainly hand-colored by women, the vast majority depicted events and people familiar to their rural or urban middle-class audience. Overall, Currier and Ives's prints reinforced a conservative American ideology in which sports, nature, and the family were mainstays.

133

William Glackens (U.S.A., 1870–1938)

Central Park: Skaters c. 1910

Oil on canvas, 42 × 74 cm

Mount Holyoke College Art Museum, South Hadley,
 Massachusetts (Purchase with the Nancy Everett
 Dwight Fund, 1955.180.I[B].PI)

Glackens, like Bellows and Sloane, pictured Central Park used by a broad urban mix. At times Glackens focused on boisterous children's activities, in which some critics found a too "brutal frankness of childlife in our parks and public squares, but it is indubitably life, and that is the main thing."[1] Glackens's lively paintings show children playing in New York and Parisian parks, rolling hoops, roller skating, and playing games—always in action. His painting of skaters is characteristic in its focus on moving figures within the park's enveloping setting.

Glackens was knowledgeable about late-nineteenth-century French painting and advised Albert Barnes to collect in this area. Glackens also selected American art for the Armory Show of 1913. His own work, however, did not develop in new directions.

NOTE

1. Quoted in William H. Gerdts, *William Glackens* (New York: Abbeville Press, 1996), 101.

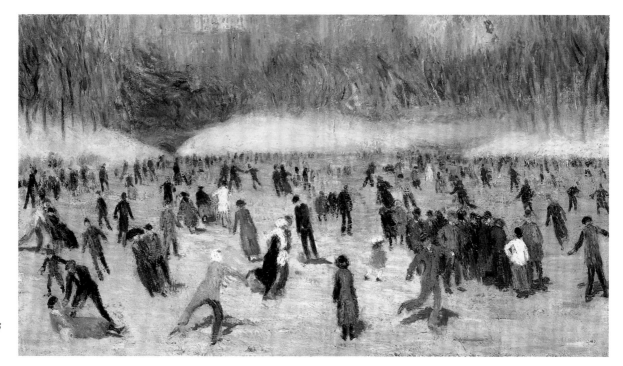

134

André Kertész (U.S.A., b. Hungary, 1894–1985)

The Actress Jacquie Monier in the Bois de Boulogne 1929

Gelatin-silver print; printed 1970s, 19.7 × 24.7 cm

The Art Institute of Chicago (Gift of Mr. and Mrs. Noel
Levine, 1982.1742)

The actress Jacquie Monier was an acquaintance of Ker-
tész's; they knew each other from the Café du Dôme, a pop-
ular meeting place in the 1920s for the young international
set as well as a gathering spot for artists and actors. Al-
though Kertész took commission work for illustration, re-
porting, fashion, and publicity to support himself, he made
many more personal photographs. It is likely that Kertész,
Monier, and others were visiting the Bois de Boulogne to-
gether on the day that this photograph was taken. Activi-
ties such as this were part of the casual friendships and easy
camaraderie of the avant-garde community.

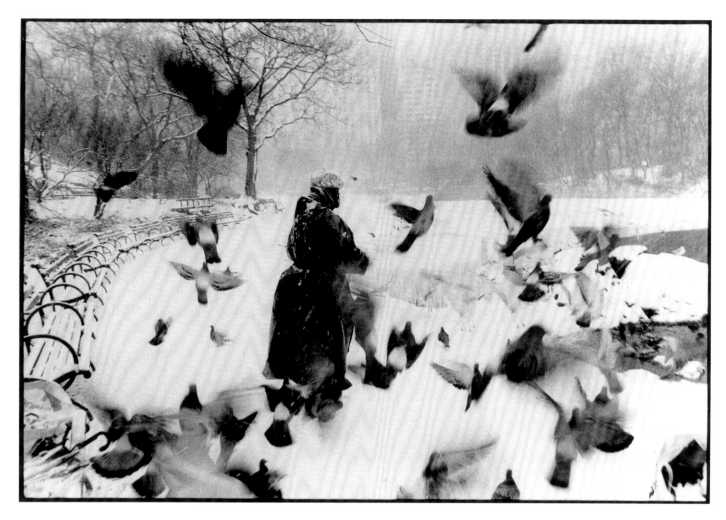

135a

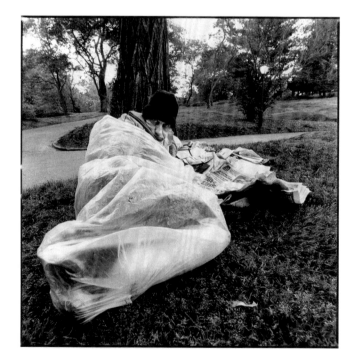

135b

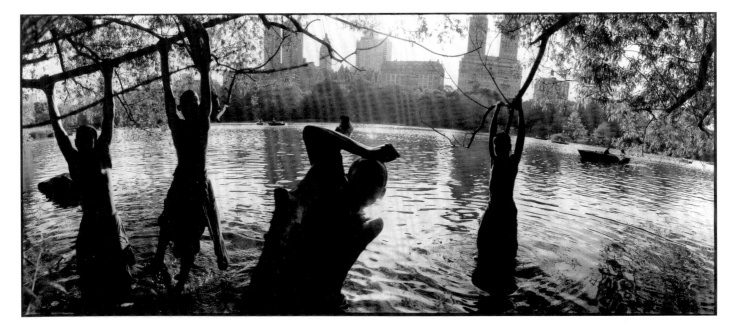

135d

135

Bruce Davidson (U.S.A., b. 1933)

A. *Untitled* (Lola Feeding Birds in the Snow)

Gelatin-silver print, 22.2 × 33 cm

Elizabeth K. Raymond

B. *Untitled* (Homeless Man)

C. *Untitled* (Bird-watchers under the Tree Canopy)
 (see fig. 10, p. 24)

D. *Untitled* (Four Boys Swinging on Tree Limbs
 over the Water)

Gelatin-silver prints, 26 × 26 cm; 26 × 26 cm; 14 × 33 cm

Iris & B. Gerald Cantor Center for the Visual Arts at
 Stanford University (Elizabeth K. Raymond Fund,
 2002.66–68)

Davidson's work shows how the park opens its hospitable heart to the city's inhabitants, offering temporary refuge for the homeless, privacy for lovers, spaces for family and impromptu gatherings, and places for contemplation as well as for recreation and sports. Central Park, Davidson suggests, is a place where nature and humanity interact. Each of the ninety-two photographs published in *Central Park* shows that juxtaposition.[1] Some views of natural features of the park include man-made structures such as bridges, paths, or sculptures. The bodies and physical features of people in the park become part of the landscape and in some cases even resemble natural phenomena like tree limbs and trunks. Bird-watchers who "worship" in the park are accorded special status because they are faithful observers of nature and they see things that other visitors do not see. A faithful observer himself, Davidson uncovers the "truth" of Central Park for the rest of us.

NOTE

1. Bruce Davidson, *Central Park*, preface by Elizabeth Barlow Rogers, commentary by Marie Winn (New York: Aperture, 1995).

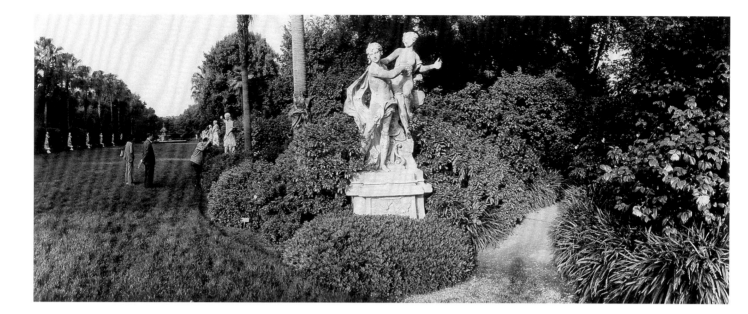

136

Laura Volkerding (U.S.A., 1939–1996)

The Huntington Gardens 1981

Gelatin-silver print; printed 1982, 20 × 50 cm

Collection Centre Canadien d'Architecture/Canadian
 Centre for Architecture, Montréal (PH1982:0802)

By 1904 William Hertrich began designing garden areas for
Henry E. Huntington's 200-acre estate in San Marino, Cal-
ifornia. Among the most admired of its many specialized
plantings are the camellias and roses, the Japanese Garden,
and the 12-acre Desert Garden—a vast expansion of Ru-
dolph Ulrich's earlier efforts (cats. 23, 24). Huntington's
splendid library, his palatial residence with its art collec-
tion, and the extensive gardens were established as an edu-
cational center and opened to the public in 1928.

In the 1980s Volkerding, who taught photography at
Stanford University, used the horizontal format extensively
for landscapes. In this view at the Huntington she has fea-
tured its North Vista Garden, with a lawn lined by sev-
enteenth-century statuary and plantings, set against the
backdrop of the San Gabriel Mountains. The white statuary,
glossy camellia leaves, and palm fronds are bathed in the
warm sunshine of southern California. Within this setting,
Volkerding observes several visitors, one taking a photo-
graph, an activity that captures and preserves the pleasure
of visiting gardens.

INDEX

Note: Italicized page numbers indicate illustrations.

Medici, Giulio de' (Pope Clement VII), 42

Medici, Lorenzo de' (the Magnificent), 42, 134

Medici, Marie de', 45–46

Medici family, gardens of, 132–36. *See also* Boboli Gardens; Petraia; Villa Medici, Castello; Villa Medici, Pratolino; Villa Medici, Rome

Méréville, 52, 53–60, 60n.5, 61nn.8,10,13, 181, 185–86, *185–86*; Robert and, 13, 24, 55–56, 57, 58–60, 61n.22, 181, 185, *185*

Merian, Matthaeus, the Elder, 45; *Scenographia Hortus Palatinus A Friderico Rege Boemia Electore Palatino Heidelbergae Exstructus 1620 Salomone de Caus Architecto* (after Jacques Foucquier), 45, *46*

Meulen, Adam van der, 49

Meyer, Baron Adolf de: *Versailles: Vista from the Upper Terrace Looking West*, 116, 164, *164*; *The Villa d'Este: The Fountain of the Dragons*, 147, *147*

Mile End Park, London, 188

Minneapolis Sculpture Garden, 22, 111; Cowles Conservatory at, 117, *117*

Minnelli, Vincente, 191

Mique, Richard, 164

Mitchell, Henry, 3

Molière, 148, 202

Mollet, André, 187

Mollet, Claude, 43, 51n.17

Momper, Josse de, 51n.18

Monet, Claude, 18, 63, 71, 72

Monier, Jacquie, 229, *229*

Montaigne, Michel, 133, 136, 138, 184

Montesquieu, baron de La Brède et de, 60, 184

Montmorency, 10

Monville, François-Nicolas-Henri-Racine de, 176

Moreau, Jean-Michel, called Moreau the Younger, *Rendez-vous for Marly*, 219, *219*

Morel, Jean-Marie, 50n.3, 53

Morgan, J. Pierpont, 21

Morris, William, 19

Morse, James Herbert, 69

Mount Auburn cemetery, Massachusetts, 15

Mulder, Joseph: *Bower on the Parterre*, 123, *123*; *Gate to the Orangery*, 123, *123*; *The Orangery and the Hot House*, 96, *96*; *Plan of the Woods and of a Labyrinth*, 95, *95*; *View of a Labyrinth*, 95, *95*

Musée Carnavalet, Paris, 18, 99, *99*

Museum of Modern Art, New York, garden of, 22

Napoleon I (Napoleon Bonaparte), emperor of France, 155, 181, 190

Napoleon III, emperor of France, 16, 190, 191

Nash, John, 15, 187

National Gallery of Art, Washington, D.C., 22

National Trust, 168

Natoire, Charles, 10

Naumkeag, Stockbridge, Mass., 21–22

Neurdein Frères, *Versailles: Fountain of Latona*, 116, 158, *158*

Newton, Ernest, 89

Newton, Sir Isaac, 60, 167, 184

Newton, Kathleen, 221, *221*, 227

Nicolson, Harold, 2

Nobilibus, Petri de, 50n.8

Oldenburg, Claes: and Coosje van Bruggen, *Model for "Spoonbridge and Cherry,"* 111, *111*; *Spoonbridge and Cherry*, 22; *View of "Spoonbridge and Cherry," with Sailboat and Running Man*, 23, 111

Olin, Laurie, 22

Olivieri, Orazio, 106n.1

Olmsted, Frederick Law, 3, 15, 24, 77–78; at Biltmore, North Carolina, 105; and Central Park, New York, 16, 64–65, 76, 193–94, 195, 197

Orlandi, G., 50n.8

Orléans family, 12

Oudry, Jean-Baptiste, 10, 13, 19, 26n.32; *View of a Château in the Park of Arcueil*, 10, *11*, 97, *97*

Ovid, 137

Pajou, Augustin, 55, 183

Palais Cardinal (Palais Royal), Paris, 47

Palazzo Farnese, Caprarola, 118

Palladio, Andrea, 119

Pamphili Garden, Rome, 144; Villa Pamphili, 47, 48

Paoletti, Ippolita, 36

Parc André Citroën, Paris, 23

Parc de Jeurre, 56, 58, 59, 181

Parc Monceau, Paris, 12–13, *12*, 16, 18, 122, *122*, 124, *124*, 227

Parigi, Alfonso, 201

Parrish, Maxfield, 20, 144

Parsons, Charles, *Central Park, Winter: The Skating Pond*, 17, 71, 228

Passy, Frédéric, 176

Paxton, Joseph, 2, 15, 76

Pedro III, king of Portugal, 112

Pellerin & Cie., *Paper Model No. 6 Kiosk*, 87, 122, *122*

Penn, William, 60, 184

Perelle, Gabriel and Adam: *Fontainebleau: General View*, 84, *84*; *Fontainebleau: The Great Parterre*, 93, *93*; *Fontainebleau: The Large Cascades*, 204, *204*; *Fontainebleau: The Orangery of the Queen*, 96, *96*; *Liencour: General View*, 84, *84*; *Versailles: Title Page*, 156, *156*; *Versailles: View of the Fountain of the Pyramid*, 156, *156*

Perelle family, 8, 84, 85, 154

Pérouse de Montclos, Jean-Pierre, 148

Perrault, Charles, 25–26n.21

Perrault, Claude, 25–26n.21

Petit Trianon, 57. *See also* Trianon, the

Petraia, Medici garden at, 132, 133, 134

Petrarch, 184

Phelan, James Duval, 21

Philip II, king of Spain, 109

Philip, Prince, duke of Edinburgh, 173

Philip the Fair, king of France, 190

Piranesi, Giovanni Battista, 10, 145; *The Villa d'Este in Tivoli*, 10, 31, 144, *144*

Pissarro, Camille, 18; *The Tuileries Gardens: Winter*, 88, *88*

Pissarro, Lucien, 88

Pitti Palace, Florence, 36, 45, 46, 201, *201*

Platt, Charles A., 3, 38, 139

Plaza Park, San Jose, 79

Pliny the Younger, 3, 137

Pope, Alexander, 2, 10, 166, 167, 168

Poussin, Nicolas, 8

Pratolino. *See* Villa Medici, Pratolino

Pré Catalan, Bois de Boulogne, Paris, 16, 190, 192, *192*

Prendergast, Charles, frame by, 213, *213*

Prendergast, Maurice, 20, 69, 71; *The Mall*, 71; *Maypole, May Day, Central Park*, 20, 71, 205, 205, 213; *Promenade in the Luxembourg Gardens*, 63, 213, *213*

Prospect Park, Brooklyn, 64, 65, 100

Proust, Marcel, 191

Pyne, James Baker, *The Villa d'Este near the Fountain of Rome*, 37, 145, *145*

Queluz, 20, 109, 112, *113*

Quinet, Achille: *Versailles: The Fountain of Ceres (Summer)*, 116, 162, *162*; *Versailles: The Fountain of Flora (Spring)*, 116, 162, *162*

Rabel, Daniel, 51nn.12,17

Rambouillet, 57

Raphael, 42

Regent's Park, London, 15, 16, 187

Regnaudin, Thomas, 162

Renoir, Pierre-Auguste, *Skaters in the Bois de Boulogne*, 71

PHOTOGRAPHIC CREDITS

DESIGN AND COMPOSITION: JEFF CLARK AT WILSTED & TAYLOR PUBLISHING SERVICES

TEXT: VAN DIJCK

DISPLAY: AVALON

PRINTER AND BINDER: FRIESENS